William Heinesen

Windswept Dawn

Translated from the Danish
by W. Glyn Jones

Dedalus

Dedalus would like to thank The Danish Arts Council's Committee for Literature and Grants for the Arts in Cambridge for their assistance in producing this book.

Published in the UK by Dedalus Limited,
24–26, St Judith's Lane, Sawtry, Cambs, PE28 5XE
email: info@dedalusbooks.com
www.dedalusbooks.com

ISBN 978 1 903517 78 9

Dedalus is distributed in the USA by SCB Distributors,
15608 South New Century Drive, Gardena, CA 90248
email: info@scbdistributors.com web: www.scbdistributors.com

Dedalus is distributed in Australia by Peribo Pty Ltd.
58, Beaumont Road, Mount Kuring-gai, N.S.W. 2080
email: info@peribo.com.au

Dedalus is distributed in Canada by Disticor Direct-Book Division
695, Westney Road South, Suite 14, Ajax, Ontario, LI6 6M9
email: ndalton@disticor.com web: www.disticordirect.com

First published by Dedalus in 2009
First published in Denmark in 1934

Printed in Finland by WS. Bookwell
Typeset by RefineCatch Limited, Bungay, Suffolk

THE AUTHOR

William Heinesen (1900–1991) was born in Torshavn in the Faroe Islands, the son of a Danish mother and Faroese father, and was equally at home in both languages. Even though he spent most of his life in the Faroe Islands he chose to write in Danish as he felt it offered him greater inventive freedom. Although internationally known as a poet and a novelist he made his living as an artist. His paintings range from large-scale murals in public buildings, through oil to pen sketches, caricatures and collages.

He published *The Black Cauldron* in 1949, Dedalus translation 1992. The cover picture of the Dedalus edition is a painting by William Heinesen. *The Lost Musicians* (1950) is considered to be his masterpiece and Dedalus published it in 2007 in a new translation by Glyn Jones. Dedalus will follow *Windswept Dawn* with *The Fair Hope* in 2011.

William Heinesen is generally considered to be one of the greatest Scandinavian novelists of the twentieth century.

THE TRANSLATOR

W. Glyn Jones read Modern Languages at Pembroke College Cambridge, with Danish as his principal language, before doing his doctoral thesis at Cambridge. He taught at various universities in England and Scandinavia before becoming Professor of Scandinavian Studies at Newcastle and then at the University of East Anglia. He also spent two years as Professor of Scandinavian Literature in the Faroese Academy. On his retirement from teaching he was created a Knight of the Royal Danish Order of the Dannebrog.

He has written widely on Danish, Faroese and Finland-Swedish literature including studies of Johannes Jorgensen, Tove Jansson, and William Heinesen and a History of Denmark.

He is the co-author with his wife, Kirsten Gade, of *Colloquial Danish* and *The Blue Guide to Denmark*.

W. Glyn Jones' many translations from Danish include *The Fairy Tale of My Life* by Hans Christian Andersen, *Seneca* by Villy Sorensen and for Dedalus *The Black Cauldron, The Lost Musicians* and *Windswept Dawn* by William Heinesen.

INTRODUCTION

This is a great writer's first novel, containing all the enthusiasm, charm, humour and – admittedly - some of the weaknesses of a first work. Written in the form of the Scandinavian "collective" novel, it is the story of a tiny community in which there is no central figure, but rather a series of characters intermingling with each other. Many of them are the first versions of figures who appear time after time in William Heinesen's novels: the "good" woman in the shape of Simona, the sectarian leader Reinhold Vaag, and a string of more or less caricatured figures such as the irascible and impossible Landrus, the pious voyeur Vitus and the drunken solicitor Morberg.

When he wrote this novel, William Heinesen had himself undergone, if not a religious crisis at least a period of religious reflection, partly occasioned by the early death of his brother, and this is fundamental to one of the novel's main themes. As always in his work, Heinesen is deeply opposed to the sectarian movements characteristic of the Faroe Islands, and whereas his later sectarians are portrayed with a certain bemused warmth, Vaag in this novel is shown to be a man who is always ready to stir in troubled waters to further his cause. He insinuates his way into people's trust and gains ground throughout the novel, and towards the end there are even signs that Landrus, otherwise his most outspoken opponent, is wavering in his hostility.

Does Morberg join the sect? No one considering his final conversation with Vitus can believe so, but he is clearly attracted to Vaag's sister, Tekla. This is one aspect of a further theme running through the novel, the relationship between religion and sex. Not least the anthroposophist Balduin reflects this.

The total population of the Faroe Islands at the time when this novel is set was about 23,000. It was a tiny population, subject to the vagaries of the elements. Heinesen has set his novel in a diminutive community in this minuscule country, but the perspectives go well beyond the confines of that community – and prepare the way for the later works with their cosmic perspectives.

TRYMØ

I

The boat that was to take the minister out to Trymø had been ready at the landing stage for almost half an hour. The oarsmen were becoming increasingly impatient – it was high time to get off if they were not to miss the favourable current. Finally the Reverend Martens appeared in the door of the parsonage. He waved reassuringly to the men, but otherwise continued to stand there like someone incapable of breaking out of a magic spell.

One of the men sprang ashore and ran up to the parsonage.

"We're going to miss the good current," he shouted.

"We're coming, we're coming," the minister assured him. "It's my wife. . ."

"Good heavens, I've hurried so much I'm quite out of breath," said the minister's wife, who now appeared in the doorway wrapped in an array of shawls and scarves.

A small bearded man with a blue bundle under his arm was standing down by the landing stage. He humbly approached the minister and his wife and murmured a blessing on them.

"Who are you, my good man?" asked the minister.
The little figure gave his name: Vitus – or Greypoint Vitus as he was usually called after the place he came from. He had an errand on Trymø and would like to ask the reverend to be so infinitely kind as to let him come along in the boat.

"Well of course," said the minister. "I can't see why not."

"Of course not, little man," his wife nodded, all out of breath. "You are most welcome."

"God bless you," whispered Vitus.

The parson and his wife were helped into the boat and seated in the stern. Vitus was given a seat in the prow. He was smiling gratefully.

The boat moved out into the fjord. There was a light breeze coming from the north, and the sky was calm and grey. The oarsmen put all their strength into making up for the lost time, occasionally glancing at the parson and his wife. The Reverend Martens was new in the parish. He was a middle-aged man with a sensitive face and heavy, thoughtful eyes. His wife was not like him at all, but was plump and friendly. She spoke a great deal and occasionally tugged at her husband's sleeve or placed a hand on his shoulder. The minister nodded to her as one nods to a child, but only rarely made any comment.

Out in the sound the wind was rather stronger. Dark, choppy patches emerged on the hurrying waters, and the boat bobbed about merrily as it progressed.

"This is fun," said Mrs Martens, gazing out across the water as though she was enjoying herself. "It's just like sailing among a lot of tiny dolphins poking their noses against the boat."

Vitus laughed approvingly from the prow.

"Well, isn't it?" smiled Mrs Martens.

"Aye indeed," nodded Vitus.

"Aren't you cold over there?" asked Mrs Martens.

Vitus shook his head.

"Oh, you must be," said Mrs Martens. "You'd better come over here, and I'll find a rug for you."

The minister straightened up. "Oh yes, just you come over to us if you're cold."

"Well, in that case, thank you very much," said Vitus and got up.

The oarsmen made room for him. They glanced at each other, and some of them could be seen to smile a little. Vitus settled himself down, and Mrs Martens wrapped him in a blanket.

"You look just like a miniature pope now," she said.

Vitus gave an embarrassed smile: "You are just too kind. . ."

"So you've got business on Trymø as well?" asked Mrs Martens in an effort to start up a conversation.

"Well, I'm really going out there on a visit," said Vitus. "It's such a long time since I was out there."

"Have you got relatives there?"

"Not really," Vitus hesitated. "But I'm distantly related to an old lady out there."

"Oh," said Mrs Martens in a show of kindly interest. "Is that who you're going to visit, then?"

"Not her herself, for she's dead now," replied Vitus after some hesitation.

"Well, her family then, her husband and children?" Mrs Martens tried to help him.

"Yes, yes," nodded Vitus. "And – well in general – if God gives me strength and is merciful to us all," he sighed as though concluding the conversation.

The oarsmen were deriving a little quiet amusement from these words. Vitus was not bad at finding answers. He knew how to get round things.

Mrs Martens opened a small bundle and took out a paper bag.

"Barley sugar," she said. "Do you like it?"

She offered the bag to Vitus and asked him to pass it on to the other men. The minister was also given a piece of barley sugar to suck.

The current churned around them audibly and gently. The broad expanse of water was a sandy grey, but there were long stripes of emerging sunshine along the horizon. To the north, Trymø raised its rocky cliffs towards the heavens. Mrs Martens offered other titbits around and went on chatting with Vitus. The minister himself took no part in the conversation, sitting staring down into the water as it swirled around the boat, clear and green.

Trymø kept changing shape as they came closer. It divided into two, opening out like a kind embrace. At the same time it grew lighter; the naked cliffs slid aside and gave way to grassy slopes. Now the village came into view . . . a collection of grey houses by a small inlet that had interposed itself between the island's two ridges.

"What a lovely little village," laughed Mrs Martens. "Just like a tiny bird's nest."

A group of people in their Sunday best were gathered at the

landing stage. The minister and his wife were helped ashore and taken to the parish clerk's house. Vitus stayed behind down on the landing stage. The sun was just breaking through. He went a little way along the shore until he came to a lonely place where a little brook was glittering among well-worn pebbles. There he took out a clothes brush from his bundle and spruced up his faded worsted jacket. His beard and the recently polished elastic sided shoes were also subjected to a brushing. Vitus liked to look decently dressed. He put the brush back into the bundle and sat down on a boulder. What now?

The sun had risen. It was a kindly, happy April sun, but it still didn't provide much heat. The bay was one great dazzling shimmer. Somewhere in all this golden light a flock of eider ducks was being cradled – they were just visible as dark spots if you screwed your eyes up.

The church bell began to ring. Aye, he probably ought to go to church. Vitus rose to his feet and tied up his bundle. How small this church in Trymø was, and how frail the bell sounded. It was not like the gentle, singing bells in Østervaag or Storefjord. He met some children walking hand in hand. They moved anxiously out of his way, but he called them across gently: "No need to be frightened of me, I don't harm little children." The children smiled shyly and drew back.

The minister and his wife appeared in the doorway in Gotfred the parish clerk's house. The minister was wearing his vestments. His face was pale and weighed down.

Vitus took up a position near the church door. He would modestly stay back there and wait for the very last to go in. At the same time he could take a look at these Trymø people. He knew several of them from an earlier visit to the island and nodded warmly to each one who met his gaze.

The first hymn started. Vitus found a seat near the door.

The congregation consisted almost entirely of women and children and elderly men – the young ones here had presumably gone off deep-sea fishing, just as they had from all the other villages. Children made up the greater part of the congregation. There were a lot of children on Trymø. Gotfred the

parish clerk alone had ten, nine of whom were daughters. They all sat in a row on one of the benches, fair-haired and dressed in their best clothes, and in the middle of the row sat their mother, buxom and plump – Vitus thought she looked like a huge hen. Redstones Ole and his wife and children were sitting on another bench. They were poor; the children were thin and dark-haired, with big eyes and narrow, melancholy mouths.

Vitus tried to concentrate on the text of the hymn, but he kept on losing the thread as worldly thoughts came into his head. Landrus, the grocer, was sitting just in front of him with his wife and daughter. Landrus had put on weight since Vitus had last seen him. He had always been tall, but now he was heavy – a real rock to look at. The sun shone in his thick, dark hair, which was beginning to turn grey at the temples.

The sermon started. The minister spoke slowly, his words falling gently like snowflakes in a thaw, and between his sentences he stood with his eyes closed as though his thoughts were far, far away. Vitus studied his face carefully. It was so intensely biblical; he looked like an apostle . . . not Peter, not Paul either, but one of the others, the quieter ones, the more troubled ones, doubting Thomas or perhaps even Judas Iscariot, for at times the minister looked as though he was being torn apart by contrition for some great sin.

Vitus abandoned himself to despondent thoughts. Aye, here he was on this island, but how were things to go for him here? And where was he to go afterwards? And where would his weary limbs be laid to rest some day? Somewhere in the ground when the time came, for that was simply what the good Lord decreed for us all. It was more important that he should save his soul. He clasped his hands firmly round his knees and concentrated for all he was worth on the minister's words.

But his thoughts wandered again and, against his will, concentrated on worldly matters. He thought of the main farm with its fences and attractive outbuildings, imagining rows of freshly baked loaves, jars of newly churned butter, fat white cheeses, bowls of junket, hanging legs of lamb – he

11

couldn't get all these wonderful things out of his mind again. Perhaps he should find a reason for going up to the farm after the service. But first he wanted to pay a visit to Landrus, the grocer, to whom he was distantly related, as Landrus' mother had been his half-aunt. He would presumably be able to get a bite to eat and find lodging for the night. Then tomorrow he would visit Farmer Harald.

Vitus pulled himself together . . . here he had been sitting again with his mind on foolish things and forgetting the only important thing there was. And now the sermon had come to an end without his having got anything out of it. To make up a little for this, he joined in the hymn singing at the top of his voice. Vitus had no need of a hymn book, he knew all the hymns by heart, at least the older ones, and here on Trymø it was still only the old ones that were used.

The sunshine was glittering on the tiny church windows, and a reflection of the shimmering water outside was dancing up under the ceiling. And the words of the hymn were full of light, too.

> The heavy air I'll cleave today
> With joyous cries and singing
> And music at your altar play
> With faith and comfort ringing

II

After the service, the minister and his wife had lunch in the main farm, as had been the custom from times immemorial. Not much was said at table. The minister sat lost in deep thought. His wife made various attempts to start a conversation, but she only made a little progress. Harald and his wife were by nature both taciturn and pensive.

When the meal came to an end, Harald cleared his throat and said in a solemn voice: "Well, as Mr Martens perhaps knows, it is the custom here that people come up to the farm after service if there is anything they would like to talk to the

12

minister about. It was the Reverend Tønnesen who introduced this custom, and we have felt it should be continued."

"Indeed, that's a good custom," said the minister.

"Well," said Harald. "Those who want to consult the minister usually wait in the other room until the meal has finished. There is no one waiting in there today . . . but my wife and I would ourselves like to seek your advice."

"Of course," said Mr Martens. "If only it's something I can help you with."

"Well," said Harald, fumbling for his words. "The fact is that we would like to ask your advice regarding our daughter. She is confined to her bed, though she's not ill, at least not physically ill. But she is in a strange state of mind, and when something goes against her she shuts herself off for long periods at a time."

Harald exchanged glances with his wife.

"And what has upset her now?" asked the minister.

Harald cleared his throat and had difficulty in finding the right words. Birita came to his aid: "Hilda is a very difficult girl; we've never found her easy to deal with. And unfortunately she's been spoiled; she's our only child, of course. I'll tell you what it is that's causing her to be so difficult at the moment."

Birita coughed slightly. She shook her head a couple of times, and it was obvious that she also found it difficult to talk about her daughter, but now it had to be done.

"Well," she went on in a calm, sharp voice, "We had a labourer here in the farm. She started flirting with him and we couldn't keep her away from him, though he was a nasty piece of work in every way."

"Aye," Harald broke in. "And now we've turned him off the farm; that was the only thing we could do."

The minister took a deep breath.

"But how old is your daughter then?" he asked.

"She's seventeen," said Birita. "And so she ought to be able to think like a grown up."

"But is this young man really so bad?" asked Mrs Martens.

"Well, I'm not sure that bad is the right word," said Harald.

"I don't want to judge my fellow human beings. He saw to his work all right, and he was both strong and willing, but he was drunk at times and brought shame upon himself in the village."

"Good heavens, that too," said Mrs Martens. "How old is he?"

"Twenty-three or twenty-four," said Harald.

The parson's wife stared ahead. "Yes, it's probably difficult to know what to do with young people at times. But, then, I take it he's returned your daughter's feelings, as they say?"

"Yes," said Harald. "I suppose so."

But now Birita got up, her thin face flushed scarlet.

"As for feelings," she said. "You can just imagine for yourselves the sort of feelings in someone who goes around carrying on with a decent girl, while another girl in the village is expecting a child by him."

"Oh dear," said the parson's wife.

Birita went across to the window and fiddled with one of the catches, pulling it up and then forcing it down again.

"What do you think we should do about it, Reverend?" asked Harald.

Martens shook his head. "We must pray for them and put the matter into God's hands. He will surely help."

"Aye, I suppose so," said Harald with a sigh.

"But . . . we thought of asking you to have a talk to Hilda to try and make her see sense," said Birita.

"But of course we would be only too happy to do that," said the minister.

"Then I'll go up and let her know you're coming," said Birita.

Mrs Martens sighed: "Seventeen — she's no more than a child after all. I think it will be best to deal with her gently."

"Perhaps it would be best if *you* talked to her," said the minister.

"Is this farm labourer still on the island?" asked Mrs Martens.

"No, he's gone to Holmvige. From what I've heard he intends going fishing on one of Sylverius' ships."

Birita came back a moment later. She was very pale and said in a loud voice and without looking up, "Oh, it's no use. I must apologise to you. . ."

"What's wrong?" asked Harald uneasily.

Birita wrung her hands: "She's simply not in her room, and – well, the fact is she's hidden herself away, confound the girl. So there's nothing to be done. Oh, she always has to bring shame on us, that daughter of ours, shame upon shame . ."

Mrs Martens went over to Birita and took her hand.

"Oh, it will all come out right," she comforted her. "Believe me, I have known so many young people with difficult characters, and they are often the very best of people when it comes down to it."

III

Landrus the grocer had realised that Vitus would be paying him a visit and so he had locked the door. But Vitus knocked on it, three cautious knocks at first, and then, shortly afterwards, equally diffidently again. When this had no effect, he went to the window and tapped on it quite gently with his fingers.

Landrus opened the window to reveal an irritated face.

"Good morning, and God's blessing on you," said Vitus. "I saw you in the church, so I knew you weren't away. How are you, my old friend?"

"Not so good," said Landrus.

He had intended saying something quite different, but the sight of Vitus's happy and neat figure made him feel a little ashamed.

"I hope it's nothing serious?" asked Vitus sympathetically.

"You can never tell." Landrus wrinkled his forehead in pain. "But come in, Vitus, and sit down for a while."

"You look well enough, though," said Vitus once he had settled down on the bench near the fire.

"Aye, there's nothing much to see," said Landrus with a rueful smile. "But I mustn't complain. And what about you?

You look well, too . . . but have you come to Trymø only to visit me?"

"No," replied Vitus. "I've got some other things to see to, but I wouldn't just pass your door. Well, you see, I had actually intended going to Holmvige, but the weather was so good today that I made this little detour as the minister was kind enough to let me come in his boat from Whitesands. And besides, its ages since I was last out here. . ."

"Really?" said Landrus.

Vitus screwed his eyes up and started working it out: "Yes, it must be about a year since. . ."

Landrus' wife came in carrying a tray of sandwiches and milk, and Vitus gave her a grateful look. Poor deaf Susanna was as kind and gentle as a child. Vitus set about the food, slowly and modestly despite the hunger that was ravaging his body. While eating, he kept a surreptitious eye on his hosts. Susanna's shining but uneasy eyes were full of kindness. Landrus on the other hand found it difficult to hide his irritation at the visit. Old Landrus' hospitality was sadly very limited. His eyes radiated a mixture of surliness and inventiveness. He stroked his face and beard with a large, red hand.

"Tell me, Vitus," he said. "You get around to a lot of places and know a lot of things – do you know anything about this disease called diphtheria? How does it show itself?"

Vitus immediately saw through Landrus. He finished chewing and then said, "Oh, diphtheria's not really anything to bother about – a bit of a cold and a cough, and you soon get over it."

Landrus turned away. Vitus was quietly amused at this clumsy effort to scare him away. He became a little too daring as he added, "I've had it two or three times myself."

Landrus swung towards him with a furious look.

"It's nothing to joke about, I tell you," he said quietly. "You know as well as I do that it's a wasting disease and terribly infectious. I really think that's what I've got, 'cause I've got a terrible headache both day and night."

"No, do you really mean that?" said Vitus, cautiously

16

changing the tone of his voice a little so as not to spoil his game. "Have you been ill for long?"

"Long?" Landrus gave him a suspicious look. "I've actually been poorly for several months."

Vitus nodded to indicate his concern. Landrus got up and went over to the window. He stared out for a moment. Suddenly, he turned round to confront Vitus with a look of open antagonism in his bright, round eyes.

"You don't believe me," he said. "But the fact of the matter now is that I won't accept any responsibility for you, and so I must ask you to leave as soon as you've finished your meal. That's how it is. Understand?"

"All right," said Vitus, looking down. He emptied the mug of milk and pushed it away. "But, you know, Landrus, if it's just out of – kindness towards me that you won't have me under your roof, I must tell you that you don't need to worry about that, for I'm not afraid of catching anything. . ."

Susanna pointed to the mug and looked enquiringly at Vitus. "Yes, please, just a drop more," he nodded.

Landrus ruffled his mop of hair and stared helplessly in the air. "You're not afraid, you say? Perhaps you think I'm lying? So you think I'm a liar? Do I have to hear that from *you*?"

"Don't get so worked up, Landrus," said Vitus with his mind on a night's lodging. "I haven't doubted your word for a minute."

Landrus sat down heavily on a bench. He folded his hands across his stomach and directed a brooding, impatient stare at his feet. The sunshine coming in through the window caught the tight brown pile on his homespun jacket.

Vitus thanked his host for the meal and uttered a lingering sigh. There was presumably nothing for it but to wait until Landrus's irritation had subsided. After a short while he made another attempt to draw him into conversation: "How's business, Landrus? They say you're doing well – that's rumoured even as far away as Storefjord. . ."

Landrus made no reply and did not move. There was something dangerous about his sunken head and his greying mop of hair. He looked like an angry bull. Vitus regretted the

confident tone he had adopted at first. But it was simply tempting to tease Landrus a little, and it was so to speak common practice for whatever reason. Now he had a feeling that Landrus was sitting ready to spring, with his neck bent, waiting for the right moment to throw himself at him and tear him to pieces. And so he did before long . . . Landrus got up, raised his shoulders and dug his clenched fists deep into his jacket pockets.

"Let me tell you once and for all that you can spare yourself all your sarcasm, you poisonous creep!" he thundered. "I give you a kind reception, you ungrateful dwarf, and then there you sit and make fun of me to my face. But let me tell you that you can only get away with that sort of thing for a time, and then there's an end to it."

"Yes, I know," said Vitus, involuntarily putting out his long, slender hands to defend himself.

Landrus had given vent to his anger and now adopted a rather gentler tone: "Now you've had a meal, and I would like you to go, you understand. And then make sure you behave yourself better wherever you go next. A man like you simply has to thank and thank and thank again when decent people are prepared to help in any way at all. Well, and now goodbye, you understand."

"All right then, goodbye." Vitus was humiliated. "And thank you for the meal."

Landrus held out a hand trembling with fury as though in a kind of conditional reconciliation. Vitus took his bundle. Susanna was at a loss to know what was going on and glanced uneasily from one to the other. Vitus nodded to her humbly as he backed out of the door.

The sky was troubled, with sunshine and scudding clouds throwing fleeting shadows on both the sea and the land. Vitus decided to go down to the landing stage to see whether the minister's boat was still there . . . he ought really to say goodbye to Mrs Martens, who had been so kind to him. But then someone called his name. It was Lars Dion – he could be seen beckoning with a bent finger at one of the windows at the other end of Landrus' long house.

"I suppose he turned you out, Vitus," laughed Lars Dion. "Aye, he's touchy these days is old Landrus."

Vitus went inside and was given a seat on the bench near the stove. Annette, Lars Dion's wife, was preparing a cup of coffee.

Lars Dion went on: "Aye, but you see I'm making life uncomfortable for him. You know I own half the house; it's my property because Landrus and I clubbed together to buy it long ago. We were good friends in those days, you know. But since he started making good money on drying fish and selling wool he's had big ideas and doesn't want us living here any longer. He's offered to buy us out, and he talks in terms of quite a lot of money, ha, ha."

Lars Dion produced a stiff smile and lit his pipe. Vitus was uneasy in his presence. Lars Dion was always full of humourless, dry laughter. In his youth he had been to sea on foreign ships and been mixed up in a host of things that had resulted in there being something alien and scornful about him.

"Our good friend Landrus," he went on, "should have toned things down a bit, he'd have been wiser if he had done. I'm getting my own back on him now by tormenting him in all kinds of ways, you know, and he's easy to torment 'cause he takes everything so seriously. And he's full of nerves as well; to begin with he's terrified of being ill, and then he believes in ghosts and spirits. And we're never in any doubt as to what he thinks and believes 'cause he shouts something terrible at his deaf wife, and his tongue's never still."

Lars Dion then went on to tell a good story about his neighbour. One night, Landrus wakens up to the sound of someone knocking on his window. He sits up in bed and sees a ghost looking in through the glass . . . only for a moment, and then it turns into smoke and disappears. It was Lars Dion and Torkel Timm who had been out playing around with some matches and a smoking bundle of tar-covered wood shavings. But Landrus had no more sleep that night; they had heard him lying there groaning and talking pitifully to his wife. He thought he had recognised the ghost – it was some man from Nordvig called Ole the Valley, who he had once

had a row with and wished all the torments of hell on, something that he had bitterly regretted ever since. For not long after that the man had drowned when he was wading through the Hallow Water stream one evening in the pouring rain. . .

Lars Dion shrugged his shoulders.

"When you're as daft as Landrus," he added, "you have to make sure you keep yourself under control." Then he suddenly changed tack. "Well, Vitus, what have you been up to since we last met? What news have you got? You wander all over the place and get your nose into everything. How's the sheriff at Storefjord? And his wife, is she still as fond of her clothes and as flighty as ever? And how long is it since you were in Holmvige? What are things like there? Is Sylverius still making as much as ever? He's going to marry Kristoffer's daughter here from Trymø soon, so our little Simona's going up in the world. . ."

"But it's still hard to understand why she wants him," interrupted Annette in a quiet voice. "He's so ugly; he looks just like a bull. And Simona could have had anyone she wanted, for there's no more beautiful a girl in these parts, that's for sure."

"Oh, she's not all that beautiful," was Lars Djon's opinion. "But she's probably a clever little thing and she knows how to put two and two together. – But this here Johan Morberg, the solicitor, they say he's come back to Holmvige a drunken wreck. Have you seen anything of him, Vitus?"

The coffee cups were placed on the table, and Vitus did his best to answer all the questions. Yes, the sheriff and his wife were always at each other's throats; it was a very unhappy marriage. They were both partly to blame, as is often the case. And the solicitor, yes, poor man, he was on the bottle all right, brilliant as he otherwise was. Thank God that both his poor parents were dead and so spared the shame. But as for Sylverius from Holmvige, well, he might well be only young, but he was really one of the wealthiest men in the country, for he had been incredibly lucky with his ships. And yet, compared to Justinus Forberg in Storefjord, he was still a mere child. Forberg's wealth was more

than a mortal could encompass: he had twenty ships or so and a slipway and a fish-drying factory; when all the buildings were put together they almost made up a small village in themselves. And he had recently had the confessionists' meeting house extended; there was room in it now for three hundred people, and there was electric light in it, and central heating. . .

Lars Dion's face twisted in contempt: "Yes, I suppose he's like all these sectarians and thinks he enjoys God's special grace, ha ha. But believe me, it'll all end in a crash sooner or later, 'cause that's what always happens with that kind of thing. One day the fishing will fail, or the prices will drop to nothing, and then he'll be left high and dry with his electric light and all those other fine things. These last years have been good times, but there's also something called a slump – and that's something people forget."

Vitus gave them all the other news and gossip, as he always did when visiting people who liked that kind of thing. But Lars Dion finally grew tired. He yawned and knocked out his pipe on the edge of the stove.

"By the way, Vitus," he said. "I've quite forgotten to ask you why you've come to Trymø. And how long do you intend to stay?"

"I've got to stay until the day after tomorrow at any rate," said Vitus. "The minister's boat's gone now."

"Really?" said Lars Dion, going across to the window. "Yes, I can see it's away. But tell me, Vitus, what are you really doing with yourself these days? I was about to say that the rest of us find it difficult to make ends meet through an honest day's work. But you used to have a little grocer's shop or something in Storefjord – have you given it up?"

Vitus smiled: "It wasn't what you could really call a grocer's shop; it was only a tiny stall. I sold sweets and little paper bags and other things you can make yourself. . . no, there was nothing to be earned from it."

"And haven't you tried any other way of getting some firm ground under your feet?" Lars Dion continued. "A man with your skill and ability . . ."

Vitus shuffled uncomfortably: "Bless you, Lars Dion, but that's not as easy as you think."

Lars Dion screwed one eye: "You're a wily old fox, Vitus. You never settle down, that's your problem; you prefer to move around."

Vitus looked down at his hands in embarrassment and uttered a few mild objections: "Do you think it's always such fun moving from place to place as I'm forced to do?"

"No, but you know," Lars Dion warned him, "you must see about changing your way of life now that you're getting on in years. Settle down and put some roots down somewhere or other. And if you can't feed yourself, well then, for God's sake, the local authority will have to help out. What are local authorities for otherwise?"

Vitus blushed and made himself very small.

"I've never yet received poor relief, thank God," he sighed.

"No, of course, not really, but in a sort of round about way, Vitus," laughed Lars Dion.

"Now, now," Annette interrupted. "I think you're being a bit hard on him."

Vitus gave her a grateful look.

Lars Dion walked up and down the kitchen floor, showing little sympathy for Vitus. He was clearly tired of his company and was keen for him to disappear.

"I think I'll just go out and see what the weather's like," he said. "Are you going to stay here, Vitus?"

"Well, to tell you the truth," said Vitus, "I haven't got anywhere to stay the night. Dare I ask whether you might have some modest place where I could sleep?"

"How long for?" asked Lars Dion mercilessly.

"Only until tomorrow," said Vitus. "I promise faithfully. . ."

"You promise faithfully," snorted Lars Dion.

"I think we might arrange something," suggested Annette.

"I'll be perfectly happy sleeping in the cowshed if there's some hay for me to lie on," said Vitus.

"Aye. You can have as much hay as you like," laughed Lars Dion, winking at his wife. "Both to eat and to lie in."

IV

But there was not much rest for Vitus that night in Lars Dion's stable.

The wind rose towards evening. A harsh, determined rushing sound came up from the shore and was echoed from up on the mountain; it was as though the island was waking up and taking a bleak sniff at weather it knew well. An hour later, the gale swept in from the sea and shook at the roofs of the houses. Vitus had taken his outdoor clothes off and hung them up where there was no danger of getting anything on them. He lay in the hay in his thick underclothes. There was a sweet and warm smell here; the cow sighed and contentedly chewed the cud in its stall. Vitus would probably have felt comfortable and slept well if the wind had not pressed so much on the draughty walls and pushed its cold fingers right down into the pile of hay, chilling him to the bone. He fell asleep a couple of times but woke again to feel the cold stinging him. In the middle of the night, when it became too cold for him, he crept out and tried to get into Lars Dion's kitchen, but the door was locked. He shuffled his way down into the hay and pulled up his legs beneath him. If only he had Mrs Marten's blanket to wrap himself in. . .

He slept for a moment and dreamt that the door opened and a man came in with a blanket in his arm. It was a tall, commanding figure, and he was himself dressed in a flowing blanket. But Vitus buried his head deeper in the hay in terror and woke up.

It was as dark as at the centre of the earth. The furious draught forced its way down under the pile of hay and felt like cold iron tongs. The cow uttered a prolonged, heavy sigh as though dreaming. Perhaps he could find a little warmth there. Vitus crept out of the hay and went across to the cow. It gave him a friendly sniff and licked his hands. He threw his arms round its neck and felt the welcome warmth.

Vitus stayed with the cow that night, alternately pressing his chest and his back against its warm skin. He kept more or less warm in this way and felt a sort of comfort in his heart

when he heard the way in which the biting wind whistled in the drying sheds outside. But there was no sleep for him.

When day came, he opened the cowshed door. The wind was dropping. So it was not going to be a real gale this time. When it was quite light he went up and knocked on the door, but no one came to open it. He returned to the cowshed. The cow gave him a maternal look and lowed just audibly. Vitus took a mirror and a brush from his bundle and tidied himself up. Then he went straight to Harald's farm. Two brown dogs approached him silently and started sniffing eagerly at him. "There, there, doggies," he calmed them down and patted them gently. One of them surrendered to him straight away and wagged its tail; the other followed him growling quietly.

In the living room, where the open peat fire had difficulty in breaking the everlasting gloom, Jardes the old shepherd was having his breakfast. As he chewed at his food, he turned a bearded face towards Vitus and stared at him for a long time before saying anything.

"I don't suppose you know me?" said Vitus.

"Yes I do," – Jardes was slow in answering. "There's no mistaking you even though my eyes are getting weaker."

"Can't you see very well?" asked Vitus, settling down by the fire.

"I can neither see nor hear as I used to," said Jardes, and that's because of old age. It bends us all down and makes us useless here on earth."

"Is Harald at home?" asked Vitus.

"No," Jardes was slow to provide the information. "He's not at home; he's out. But the mistress is at home, and she'll soon be here."

At that moment, Birita came into the room. She acknowledged Vitus with a nod and disappeared again. Before long, she returned with a dish, which she placed on the table near the fire.

"There's something to eat," she said in a cordial but by no means friendly voice. "I'll bring you something to drink."

Vitus thanked her humbly and folded his hands in front of the good food which he rarely had the chance to enjoy. There

was bread and butter, dried meat, smoked meat, sausage and cheese, all in generous helpings.

"Eat your fill," said Birita, placing a mug of milk on the table.

Vitus set about the food, decorously and not greedily. For a moment, everything around him was feast and oblivion. The flames danced in the fire and imparted a strange subterranean but delightful light on everything. A bluish light entered through the door. The gradually lessening rush of the wind from the inlet could be heard outside.

Jardes had finished his meal and rested his big, empty hands on the tabletop.

"Strange thing, this growing old," he said. "You'll soon feel it, Vitus. The world grows further and further away from you, but the other world comes closer all the time."

Vitus nodded and went on eating.

"That's because you're getting closer to the Kingdom of God," he said in a kindly voice.

"May Jesus grant that," said Jardes. "But it was a quite different world I was talking about, the world we old ones see more and more clearly . . ."

"I suppose you mean the hidden world," said Vitus, beginning to feel uncomfortable. The old man had the reputation for having second sight.

"That's right," nodded Jardes. "I must say not a night passes without my feeling something or other, and let me tell you that here, where you're having your breakfast, aye, just behind your back, the little people are standing and watching. . ."

Vitus kept his head down and didn't want to turn around to look. Neither was he keen to know what kind of little people Jardes was talking about.

"Aye, aye, Jardes, that's how things go," he said in an effort to get away from the subject.

"You could give them a few crumbs from your breakfast, and then you might enjoy it more yourself," Jardes went on.

"Of course," He pulled off a piece of sausage skin and gave it to the dog. "Aren't you working any longer?" he asked in an attempt to turn the conversation in a different direction.

"Work," the answer was a long time in coming. "Yes, I spin and card the wool. But it's a couple of years since I was out in the mountains. The others must look after the sheep now."

Before long, Farmer Harald appeared, followed by a black dog that immediately started barking when it discovered there was a stranger present.

"Be quiet," shouted Harald. "Oh, it's Vitus . . . good morning, good morning – have you had something to eat? Oh, that's fine."

"Aye, thank you so much for the lovely food," Vitus replied. "It's kind of you to give me such a wonderful meal; I could have managed on less."

"We're only doing what custom demands when strangers arrive," said Harald. "But you'll have to excuse me; I have a lot to do today."

"Farmer Harald," said Vitus. "I've got a little thing to ask you . . . I'm sorry, but do you think it might be possible for me to stay here for a time if I did odd jobs for you? I can spin and card and I can see to the animals, and . . ."

Harald shook his head.

"And I can knit, too," Vitus went on. "And bake if needs be."

"No," said Harald. "I can't take any more on, Vitus. I already have three old and partly useless people in my pay – aye, Jardes still does good work, I must say that for him. But, you understand, I can't provide for more on my little farm. . ."

"I didn't mean provide," said Vitus. "And I only meant for a short while."

"No," Harald shook his head.

"No, I suppose not; I can understand," said Vitus with no sign of bitterness.

"You're not the first one I've said no to, Vitus," Harald explained gently. "It's my unfortunate lot to have to say no to so many people."

Vitus nodded.

"Well, then I'll be leaving again in the morning. . .. But don't you think I could be given shelter here for the night?"

Harald frowned. "If I give you shelter for the night, then you'll ask for shelter again tomorrow, and what then?"

Vitus blushed.

"No," said Harald in conclusion. "Let others show an excess of kindness if they like. I've never done that and don't look for people's praise either. Those I look after, I look after, and they'll have nothing to complain about. But to do that I have to refuse others. That's how it is."

Vitus thanked him for the breakfast and took leave of the farmer and his family and also of Jardes, who was sitting in a corner of the living room, half hidden by his ashen beard.

The weather was clearing up now. There was a little snow in the mountains, and the air was cold and hostile, but the sea had settled. Vitus nodded to himself. Oh, so Harald wouldn't have him in the house, not even for a single night. My little farm, he had said. And most of the islanders were his tenants.

Vitus didn't want to spend another night in Lars Dion's cowshed. Oh well, perhaps it wouldn't be necessary. For instance, there was still Gotfred the parish clerk – he wouldn't deny shelter to a poor wretch. Should he try there? Vitus was not at all keen. Gotfred was a good, honest man, but he was strict and prickly.

But there was Kristoffer, too, the man whose daughter Simona was soon to be married to Sylverius from Holmvige. Vitus could simply make the excuse of bringing greetings from Sylverius. Admittedly, he had no such greeting to bring, but on the other hand no harm would be done if he made use of this innocent excuse. He knew Sylverius of course and had had many a good-natured chat with him over the counter.

Vitus found Simona alone at home. Kristoffer was out fishing and was not expected back until some time the following day. Her brothers were both fishing off Iceland on the Isabella, one of Sylverius's ships. But Simona was kind and gentle and asked him in. She was busy kneading dough for bread and held out her elbow in greeting. She looked radiant and lovely. It was certainly not surprising that Sylverius had chosen her before all others.

"Oh, you've got greetings for me," said Simona. "So you're coming from Holmvige?"

"Yes," said Vitus. "That's to say I've come by a roundabout route, for I've been in Storefjord, too, and then I went to Whitesands, and then the minister brought me out here to Trymø as a bit of a detour . . . And you're getting married soon. God bless that marriage, for you both deserve it."

He was fulsome in his praise of Sylverius – such a fine man; there was no one like him in the country, and his wealth had not made him arrogant. He was simple and modest in his way of life, helpful and understanding . . .

"And what about you yourself, Simona," Vitus went on. His eyes went all dreamy: "Aye, I remember you as quite a little girl, from one time I had an errand over here. You came and gave me a piece of cake or bread that your late mother had just taken out of the oven. . . I remember it as clearly as though it were yesterday. And it must be fifteen or twenty years ago now."

Simona laughed.

"I don't remember that," she said.

Vitus sighed. "Aye, time flies, and what's left? We come empty-handed, and we leave empty-handed . . . we're in the way everywhere."

"Didn't you have a little shop in some village once?" asked Simona. "I seem to have heard something about that."

"Yes," said Vitus. "A very small shop."

"And have you given it up?"

Vitus looked down: "Given it up? My dear child, it was so small that you could hardly talk of giving it up."

"Well, you look almost like a little merchant," said Simona cheerfully.

Vitus glowed at the flattery. "Aye, just imagine being a successful merchant."

"Well, what would you do if you were one?" asked Simona. "Would you make life comfortable for yourself? Would you like to be really rich, Vitus?"

She was smiling as she looked at him. Vitus was at a loss what to answer. Was she just mocking him? No, she was not.

He could see that on this charming creature's face. She was asking like the innocent child she was, without any intention of hurting him.

"I don't know," he said finally. "I've never thought that far."

"But if you played the lottery like Landrus here and won a lot of money," Simona went on with her joke. "Or if you were left something by a rich relative somewhere or other. . ."

"Relative," smiled Vitus.

"Yes, you must have relatives abroad," Simona believed. "You're a parson's son, aren't you?"

Vitus sighed. "Yes, they say so, and that's probably true. But that parson — he was a monster in human form, and thank God I've never either seen or heard from him. . ."

Simona had finished the dough and dried her hands on a tea towel.

"Whether he was a monster or not," she said, "he was your father after all, Vitus, and you must be proud of being a parson's son."

"Aye, if my poor mother had been a parson's wife," said Vitus. "Then I might even have been a parson myself," he said more cheerfully.

"And believe me, you'd have been just the man for the job," laughed Simona. "Well, now I think we two had better have a cup of tea."

Vitus chatted to Simona all that afternoon. He had to tell her about Holmvige, the place where she would soon be going to live. Simona was curious and keen to know, almost like a child. She wanted to know everything, every detail . . . it was almost embarrassing at times, as when she asked him whether he didn't think this solicitor called Morberg had lived a sinful life abroad, and was there not a relationship between him and Frida Olsen, who owned the hotel in Holmvige? But she was asking in her childish innocence. And she was as radiant and kind as the sun; being together with her was balm for the mind. Vitus's soul was filled with tenderness; it was as though he could feel how all the springs of kindness

were pouring forth from within her. He welcomed the thought that Sylverius should stroke this fair hand and pat this fine cheek. If only he himself could do something for this child of light, add just a little to her happiness in some way. But what could he do, a poor outcast, the child of shadow and sorrow. . .

Pray for her – he could do that. Pray that her future path might be light and without shadows.

And besides, there was another thing he could do. He knew lots of songs . . . he could sing one of the most beautiful for her. If that was all right. Vitus had a good singing voice; during his youth he had been highly thought of as a singer at dances, and the young people had learned many a good old dance ballad from him.

"Do you dance much here in Trymø?" he asked.

"Yes, quite a lot during the winter, especially around Christmas time," said Simona.

"That's my greatest delight," said Vitus. And in my youth I was not at all bad at leading the singing. – Do you sing the ballad of Blanke here?"

"I don't think I've ever heard it," said Simona. "How does it go?"

Vitus stood up straight and cleared his voice. "I'll see if I can remember it.

And he sang for her the ballad of Blanke, which tells how Hildebrand's sister was married and imprisoned in a heathen land. In attempting to rescue her, Hildebrand is drowned, but then the great horse Blanke finally frees her. In reward, the horse asks for a kiss and then turns into a noble knight and takes her home to her own country.

"That's a lovely ballad," said Simona.

"Yes," nodded Vitus. His eyes were glazed with tears.

"But it was still a pity that poor Hildebrand had to drown," said Simona.

Vitus shrugged his shoulders. "That's what the ballad says. And that's how it goes in the world: there's something sad about all beautiful things. . ."

V

That night, Vitus slept in a real bed with duvets and sheets. Through a small window with thin curtains the moon could be seen sailing by, sparkling in a small water carafe with an upturned glass round its neck.

It was a long time before he fell asleep. At times he felt happy, as though he had already come into the realm of the blessed, and at times deeply unhappy at the thought of how narrow and long the way was that twisted through the valley of life, a valley that was so bitterly cold and full of human beings.

JOSVA

I

The wedding between Simona and Sylverius had been fixed for the middle of May. It was to be held on Trymø. Something like three hundred invitations had been sent out. It was impossible to house so many people under one roof, but Kristoffer had arranged with several families in the village that they would provide sleeping accommodation for the guests he himself was unable to put up, and in addition a couple of large barns were to be taken into use. Simona's two brothers, Magnus and Josva, together with the parish clerk's son young Gotfred and other friends had set about doing these two barns up. One of them had to be proofed against the wind and rain and fitted out with places to sleep for the younger male guests, who were not too fussy. The other was decorated and made to look festive with the help of flags and pennants from Sylverius's ships. In addition, it had to be provided with a new firm floor for the dancing.

The landing stage was a hive of activity. Sylverius's big motorboat had made several journeys to the island and a host of boxes and barrels and baskets had been taken ashore and temporarily stored in Kristoffer's boathouse. And one morning another motorboat arrived with supplies for Landrus.

Kristoffer went around with an anxious look on his face. He felt painfully superfluous in the midst of all this bustle. The only thing he could do was ensure that the boxes marked *Glass* were treated with care. He had put them in a separate group in a corner of the boathouse. For the time being there was nothing for it but to leave all these goods untouched until the hotel owner from Holmvige arrived. These were Sylverius's orders. But Kristoffer felt ill at ease going around doing nothing and not knowing which way to turn. Three

hundred guests! He had visions of this crowd of people, and the thought pursued him and prevented him from sleeping. And if he did finally doze off, he dreamt he was being suffocated by packing cases full of broken jars and bottles.

It was a demanding time for Simona herself, too. She was looking forward to having it behind her. And yet, of course all this was wonderful, wonderful beyond the imagination. She woke each morning with a feeling as though she were about to go off and fly. And rain or shine, she was up before anyone else; she couldn't stay in bed but had to go across to the window and catch a glimpse of the island of Husø and think of Sylverius and their future home at Holmvige, the big new house that was waiting for her. And then out she went to wake her friends. She had a lot of them, not least at this time, when the girls of the village flocked around her, outbidding each other in their efforts to be useful or simply to be close to her. And there was plenty to do: the floors had all to be washed and scrubbed clean. And the big dance floor, too, had to be scrubbed and strewn with fine, white sand from the mouth of the river. And when this had been done, the most difficult problem of all remained: the food for all these guests! But the only thing was to rely on Frida Olsen, the hotel owner from Holmvige. The entire wedding feast depended on her. Simona could actually panic when she thought of how terrible it would be if this Frida were prevented from coming for some reason or other . . .

But Frida Olsen came. She was a tall, corpulent woman with reddish hair and a young face, though with a somewhat reserved look about her. She might be about thirty years of age. Frida had a staff of women, both young and old, with her, and they were immediately set to work. All she herself did at first was go around and inspect everything. She said little, but her mouth was performing a chewing motion all the time.

"Your kitchen's far too small," she said mercilessly to Kristoffer.

This sent cold shivers down his back.

"Yes, I thought it might be," he replied, staring around despondently.

Frida chewed on.

"We'll manage, though," she said. "We're prepared for all sorts . . ."

Kristoffer gave her a trusting look.

"But where on earth do you imagine all these people can eat?" asked Frida.

"Well," explained Kristoffer, "most will be eating in the barn, the one with the new floor, and then Gotfred the parish clerk has made his house available. And we can find room for a few as well . . ."

There was a preoccupied smile on Frida's face as she now turned away from Kristoffer, absorbed in her own thoughts. She sat down lazily on a chair, panting as though she was already worn out.

Kristoffer gave her a pained look. So this was the woman they were relying on . . .

But Frida got up again before long, composed and authoritative and with angry eyes. So perhaps she was not so bad after all.

II

There were not many festive occasions on Trymø, and a grand wedding such as the one being prepared was a unique event. It was the season of white nights, and the young people on the island were up early and late to bed. Simona's brothers and their friends simply never got to bed; they spent day and night in the barns taking a snooze now and then when it suited them.

But finally, the two barns are ready.

It is an evening with a golden sky and not a breath of air; the young men are standing looking at their work. The two buildings for the party look rather peculiar, and no one is entirely satisfied with them . . . they seem bizarre and eccentric as they stand out among the inoffensive buildings making up the rest of the village and they most resemble a couple of half grotesque, half absurd magic castles.

Young Gotfred, the parish clerk's son, explodes in a wild laugh: "Heavens above, the visitors are going to have a good laugh. But it's your responsibility, Josva, you crazy fool."

"Me?" says Josva in surprise. "I've done no more than the rest of you."

But the entire band turns towards Josva: "Of course you have. You know perfectly well you've been the driving force, clumsy fool that you are."

Josva shakes his head, but he goes along with the fun, there's nothing else for it.

"All right, I'll accept the responsibility as the rest of you are running away from it.

"Come on, let's carry him shoulder high," suggests Gotfred.

"No, stop it," says Josva, struggling against them. But he is quickly overcome, lifted up and carried down to the shore to the accompaniment of laughter and singing.

> To the grave he was borne
> By warriors four
> By warriors four . . .

Down by the landing stage he is dumped on a stack of fish.

Landrus appears in the warehouse doorway and shouts. "Keep off that heap, you depraved wretches."

"Hey, what's got into him?" shouts Gotfred in reply, moving closer to Landrus and threatening him. The entire group follows.

"Well, you should keep away from my stacks of fish," says Landrus, changing to an explicatory tone. "You can easily dirty the tarpaulins, you know, and I can't have that."

Gotfred gives him a friendly pat on the shoulder: "Landrus, you old sourpuss, what was that you called us? Depraved wretches? Surely you don't want to insult us, a crowd of honest fishermen coming to buy from you?"

"No, I'd no intention of insulting you," Landrus brushes it aside. "I just meant . . ."

"On an evening like this it'd be more like it if you offered

us a glass of rum," Gotfred interrupts him. "Just think how much we buy from you in the course of a year and throughout the long winter – tobacco, braces, pepper, teapots and safety pins . . ."

Landrus gave in: "You can have a glass of rum."

It is dark inside the warehouse, and the air is heavy with dust and fumes. Landrus is at home in these surroundings and moves nimbly around among the packing cases and sacks.

"The air in here actually makes you feel full," says Gotfred. "Aye, you're really a fortunate man, Landrus."

"Me, fortunate?" Landrus pours some rum out in a small cup with a missing handle and hands it to Gotfred. "No, you young lads, you're the fortunate ones. You're not bothered by rheumatics, aches and pains and the evil there is in people."

Gotfred prods him in the side: "Aye, but you've got your warehouse, your shop and a chest full of money under your bed, and we don't."

"Good health can't be bought with riches," says Landrus darkly and assumes a distant and prophetic look: "You know . . . once you've collected some worldly goods, the destructive powers are there immediately . . . moths, rust, mites and rats."

"You should buy yourself a ship," suggests Gotfred. "You can afford it."

"God help me," laughs Landrus meditatively.

But suddenly he jumps up with a grunt and slaps the top of a sack of flour with his hand so the dust rises in a suffocating cloud. "There, what did I say – those confounded moths."

"I think it was only a harmless butterfly," says Gotfred, "one of those that fly by night . . . it's so dark in here. You should have a big window put in at the end so you can get some sun and fresh air in here."

Landrus has got flour dust down in his throat and coughs: "Sun – no, good heavens, I don't want too much of that in here, it only makes everything smell and go off."

The cup has done the entire round.

"Well, thanks for the drink," says Gotfred. "We'll go and think something up now . . . we weren't really finished with

carrying you aloft, Josva. You got away too lightly, you wretch."

"Why's he got to be carried aloft?" asks Landrus.

Gotfred shrugs his shoulder. "Well, Josva's such a gentle lad, he's such a wimp."

The entire bunch of them burst out laughing. Josva joins in so as not to be made a figure of fun any more than is already the case.

"By the way," he suggests. "What about seeing which of us can climb along High Cape Ridge this evening? What do you say, Gotfred – dare you have a go?"

"Leave that sort of mad prank alone," warns Landrus.

But Josva is already outside and on his way along the shore.

"Stop him!" shouts Gotfred. "He's had too much to drink, he's out of his mind."

Josva starts running. The others chase him. Out by Hallow Water his brother Magnus catches up with him and holds him from behind.

"I've got him," shouts Magnus, forcing him to his knees in the grass.

But Josva gets to his feet again, frees his arms and pushes his brother away with such force that he falls over. Then Josva runs on, across the stream in two bounds and climbs like a cat up the slope to High Cape and right out along the edge.

But now Egon, Lars Dion's son, is immediately after him and tries to get hold of his leg. Josva turns round towards him and threatens: "Get off me, or I'll push you off."

Egon is horrified to see his face.

"Are you *angry*?" he asks.

Josva hurries on without answering.

"He's crazy," shouts Egon to the others in an agitated voice.

Josva has reached the place where the ledge, the shelf, starts. He steps out on to it.

"That's enough now, Josva," Gotfred shouts furiously after him. "We're not going to be responsible for this."

The High Cape Ridge is a narrow rocky ledge that runs like a window sill along the steep slope, fifteen or twenty

metres above the sea. It is generally considered inaccessible and people are frightened of it because a farm servant from Blackwater Farm once fell down from it and drowned. That's a couple of generations back. What the unfortunate man was doing up there was never explained.

Josva moves along the shelf foot by foot, holding tight on to the uneven surface of the wet rock face. He is hot from running, drunk from the heat; the sweat is running down his forehead and neck; his heart is beating like clockwork. The first part is the most difficult, and a couple of times he feels dizzy. For a chill moment he regrets his idea, but he won't go back now. A little further along there is a small grassy slope. He lies down on it on his stomach and digs down into the grass with his hands. Ah – it's bliss to rest. He is out of sight of the others here; they are over there trembling on his behalf, and not one of them dares follow him.

Josva has a boundless sense of wellbeing, suspended there between heaven and earth. A gull swoops past and utters a brief, surprised squawk. That cocky young Gotfred . . . what's he thinking now? Josva has been longing to really humiliate him some time, indeed humiliate all of them, for he's tired of being a butt for their jokes even if they don't really mean any harm when they tease him. But that's how it is, he can't assert himself among them – he is made of different stuff from them. Softer stuff perhaps. It is this thought that can sometimes make him crazy and destructive. Like just now when he knocked his brother over, there was no need to do that . . . Magnus thought it was all fun and games, so he was probably rather surprised.

Josva lies there until he feels rested and refreshed. Actually, he wouldn't mind lying here until Judgement Day. Then as far as he is concerned they could have their wedding and they could feast and dance as much as they want. And the ships could go off on the summer fishing without him. Then the crew of the Isabella could find someone else to tease and taunt.

Josva has often thought of leaving, going abroad, sailing in distant waters in some foreign ship. That's probably what

it will be sooner or later. If only it could be as early as tomorrow.

He realises it is wet where he is lying; there is water percolating and dripping from the moss-covered cliff above his head. He gets up and continues clambering along, slowly and carefully; he is perfectly calm and collected now.

The cliff above the shelf starts bulging out more and more. He has to lie on his stomach and wriggle forward. But now the shelf becomes wider and goes on like a hollowed out passageway in the cliff; you have to crawl on your stomach or on your knees, but otherwise it is quite easy here; you can lie here without having to hold on to anything. He is overcome by a kind of infatuation with this cave: he could sit here in the dry even in pouring rain. And the water is lapping far down below on the shore, sounding like voices in playful, light-hearted conversation.

Josva stays in this cave for a long time. He fancies spending the whole night there. But that would be a pity for Simona and his father; they would be beside themselves with anxiety if he didn't go home.

He crawls on through the hollow passageway. In one place there is an opening in the floor, a draught-filled gap through which the foaming green water can be seen far below. The roof becomes higher and higher, and it is now possible to walk upright. But suddenly the shelf comes to an end. There is no going any further; there is nothing but the smooth, wet rock face.

Well, so there is nothing for it but to turn back. Josva is suddenly overcome by a strange disquiet; it is as though he only now recognises what a dangerous escapade he has embarked on. He turns back, quickly and with fear in his body. It produces a sense of suffocation to creep through the hollow passage, and the sight of the gap in the floor makes him really shudder. Once back at the green slope, he feels completely exhausted; he simply dare not continue along the first, narrow part of the shelf; every pore in his body turns to ice at the mere thought of it.

He lies clinging to the grass for a long time without being

able to make up his mind. He gradually starts to feel unsafe here, too; it is as though the entire grassy slope is slowly moving, being drawn down into the deep. A few cackling gulls are circling around down there, their crazy laughter as it were ripping the silence to shreds. He clambers back to the hollow passage. It was so comforting here only a short while ago – strange, but now it is icy cold, frosty cold such as to make your teeth chatter. He lies down and looks out over the edge. The air is becoming less clear as the evening mist rises from the sea. The water is clucking sleepily on the shore. Perhaps this is where the farmhand from Blackwater Farm spent his last hours, beneath this black, miserable roof, before he fell to his death. Death! A strange harsh word . . . it was as though he were hearing the naked sound of this word for the first time . . . a stone grinding roughly against another stone, an empty echo in the fells, and then nothing more.

The fog grows thicker. The gulls are laughing scornfully somewhere out there, sounding like busy human voices. Or are they actually human voices?

Now there is the sound of oars rising through the mist. And young Gotfred's voice: "Hallo! Josva! Say where you are. There's a rope ready to rescue you with; they're up on the ridge with it."

Josva listens with a beating heart. But he makes no reply. It might well be they've made arrangements to come to his aid. But it will be an irretrievable disgrace to accept this help, to allow himself to be saved and taken home like some underage idiot that has set out on something he can't get out of without the help of others.

Quick as lightning he clambers back, along the grassy slopes and beyond; all dizziness and anxiety have gone.

"Josva!" come the shouts again, impatient, plaintive.

But now he is once more on firm ground. He climbs up along the High Cape Ridge. Magnus, Egon and the others are standing here, listening. Gotfred's voice can be heard shouting from the boat far below.

Josva lies in wait behind a boulder.

"No, he can't have fallen," he hears Magnus explain.

"Egon's kept watch here all the time, he'd have heard the splash . . ."

"No, he couldn't have missed it," asserts Egon.

Josva sneaks in on the group No one notices him until he is standing in the midst of them. Egon is the first to become aware of him; he gasps and turns pale as a sheet.

"What the hell," says Magnus in a low voice. "Are you here?"

And suddenly a wave of relief and a sense of liberation goes through the group. "He's here!" shouts Magnus over the ridge down to Gotfred. "The wretch has come back. Everything's all right." And Gotfred's distant voice can be heard replying through the mist: "Then give him as much of a drubbing as he can take."

III

Magnus and Josva spent the evening before the wedding at Holmvige. They had gone there to fetch their share of a delivery of brandy that they and their shipmates had ordered. They had been trying the drinks. They were in an elated mood, and the upshot was that they organised a dance. The two brothers from Trymø got the dancing underway with the Ballad of Benedict.

Daniel, the young farmhand that Farmer Harald had turned off the farm, joined in the dance. When they had sung the Ballad of Benedict right through, he went across to Josva and slapped him on the shoulder: "Come outside with me for a moment, there's something I want to tell you."

They went outside. Daniel drew Josva over to a corner behind some drying sheds.

"I suppose you'll have a drink with an old acquaintance," he said.

Daniel was half drunk and perhaps rather over-friendly: "Let me tell you, Josva, I've always liked you . . . I've always been able to rely on you, 'cause you're one of those who think more than they speak."

He took a bottle out of his back pocket. Josva took a swig from it.

"What do they think about me over there on Trymø?" Daniel asked.

He put the bottle to his lips and looked at Josva with red, intoxicated eyes. Daniel was a tall, sturdy figure, self-assured and defiant by nature.

"What do people think of you?" replied Josva rather hesitantly. "They think you're going to leave the girl you've got into trouble. Perhaps that's really what you intend to do?"

Daniel laughed: "Leave her? Did they really think I was going to stay on out there as a day labourer? Or work for her father, Redstones Ole?"

"Well, he at least doesn't need to have any more children in the home," said Josva. "He's got plenty already. Don't you intend paying for the child?"

"Oh yes, I've no intention of getting out of that," said Daniel. "That's why I wanted to go to sea – that's the only job that gives you a bit of money in your pocket. But then I couldn't find a ship to sail on. No one needs a hand, and I've tried all over. . . ."

Josva thought for a moment. Then he said, "Listen, you can take my place on the Isabella. Let's agree on that. I'll tell the skipper."

"You're a good guy," said Daniel, slapping him on the shoulder. "But why are you staying at home?"

"I'm going to go abroad," said Josva.

Daniel handed him the bottle: "Cheers! It was a piece of bloody good luck meeting you here this evening. I'd just about given up otherwise. And you must admit that it was a dirty trick of Harald to throw me out all of a sudden like that," he added.

"You shouldn't have run after Hilda," said Josva.

"Hilda!" Daniel began speaking in a low voice: "I'll tell you something, Josva, if you don't let it go any further: it wasn't me that started all that. Aye, you can believe me or not, as you like, but I'm telling you that Hilda wouldn't leave me alone. I told her about the girl from Redstones and all that, but it had

42

no effect on her. And you bet she was upset when I was forced to go away. Just imagine, she wanted to go off together with me. Well, I don't know what you think. But you'll keep it to yourself, won't you? I don't want it to come out, and I trust you. – No, you see, Josva, the girl was *in love* with me, so much in love she could hardly contain herself."

Daniel leaned back and chuckled quietly.

"Aye, I've never known anything like it before," he said.

The schnapps had set Josva's head buzzing. He pictured Hilda's face and dark hair, her young and still undeveloped figure.

As though in a dream, Daniel lit a cigarette.

"But tell me something," said Josva. "Weren't you particularly keen on her?"

Daniel took another swig from the bottle, which he then handed to Josva.

"Oh, to Hell with it all," he said evasively. "Have another drink and let's go back to the dance."

IV

Josva did not take part in the festivities that night. He stood for a while looking at the chain of dancers. Then he went out again and wandered around aimlessly.

The gleaming bay was already reflecting the morning light. The smoky grey outline of Trymø could just be made out in the distance. He went down to the shore and found a few flat stones which he started to skim on the water. There was the sound of cocks crowing round the village.

He continued to see an image of Hilda. It was such a short time since she had still been a child, decorating herself with daisy chains. "The girl's in love with me, so much in love that she can hardly contain herself" – the words kept ringing in his ears.

He sat down by the mouth of a stream and stayed there for a long time. The water babbled past with a sound like tiny cracked bells. Gulls sat in silent rows on the ridges of some

houses down by the shore. The sky gradually became flushed in the north east, and suddenly the sun was there, huge and dark red.

Josva drifted back to the dance hall. There were only a few dancers left, a dozen or so young men who wanted to do full justice to the Ballad of the Long Serpent before finishing. Their shoulders and shoes were covered in grey dust. Magnus was among them.

Daniel appeared in the doorway. He was blind drunk and swinging an empty bottle around. Now he approached the ring of dancers and started tapping the dancers' backs with the bottle − a tap on each one as they glided past. None of them took any notice at first, but when it was repeated, some-one gave Daniel a shove so he lost his balance and fell down on the dust-covered floor. Josva went across and helped him up.

"Let's get you home," he said. "You'd better get to bed."

"Oh, to Hell with it all," Daniel growled. "I'm going out to Trymø with you."

The dance hall was drenched in sunshine by the time the Ballad of the Long Serpent was finally sung to the end. Magnus went to the door and sniffed the air. A bright red morning sky and light cloud along the horizon. That could only mean rain.

"I think we'd better get home straight away," he said to Josva, who was supporting the drunken Daniel and dragging him along. "And leave him to look after himself. Lay him down somewhere or other where the sun can shine on him. He'll wake up all right when it starts to rain."

But Daniel was not in the mood for sleeping.

"You won't let me down if I know you right," he said. "You'll take me with you out to Trymø."

He went with them, unsteady but determined.

The brothers untied the boat and pushed it out. Daniel came right out to the edge of the jetty and stood there swaying.

"You'll not forget me, will you?" he shouted. And he started to sing:

> Her lips are like a rose so red,
> And her eyes like a falcon grey . . .

"This is going to go wrong," said Magnus. "We must get him away from the jetty."

They rowed in again, and Magnus sprang ashore.

"I knew you would," shouted Daniel.

He made to step down into the boat, but slipped and with a cry fell into the water.

"There. Grab him," shouted Magnus.

Josva bent over the edge of the boat, but everything went black for him. He stuck both arms down into the water to his shoulders, but he couldn't get hold of Daniel, who to the accompaniment of strangled groans was working his way away from the boat.

There was a new splash – Magnus had jumped into the water and was getting closer to the drowning man. Josva stayed in the boat. He saw how Daniel clung on to his brother so that he had difficulty in keeping his head above the water. Now Magnus freed one arm and thumped Daniel's head with his clenched fist as though he were going to murder him. Daniel gave in, and Magnus held both arms around him and swam backwards in towards the jetty.

One of the assistants from Sylverius' store had turned up. He got down on his stomach at the edge of the jetty and took hold of Daniel's jersey. They managed to pull him ashore. A couple of Sylverius' other assistants had come down to the jetty.

"Is he alive?" shouted Magnus.

"You bet your life he is," came the reply. "And he's fighting back if anyone goes near him."

Magnus lay down on the pavement gasping for breath. The water ran from his clothes and formed a network of stripes on the loose stones of the quayside.

Josva pressed his eyes together and put his hands to his head. He felt an intolerable pain in his soul: Why had he sat there without lifting a finger, he who after all was as good at swimming as Magnus? No, he hadn't even touched an oar to

go to their aid. He had been paralysed with tension, paralysed with fear. He was still trembling throughout his body.

"That could have been a nice mess," said the shop assistant. "Aye, he's got you to thank for not drowning, Magnus. Incidentally, you gave him a proper one on the head. . . . I almost thought you'd kill him."

"Aye, he was completely crazy," said Magnus. "But let's see about getting him home."

The sun had disappeared, and clouds were scudding across the grey sky.

"I think we can raise the sail once we get out of the bay," said Magnus. "Have you gone to sleep, Josva? Get to the oars."

Josva obeyed woodenly.

They rowed out of the bay. There was still a patch of dark red morning light in the eastern sky. Once they had got away from the point, they raised the sail. Trymø stood out black against the grey clouds. Half way between the islands, where the open sea had its freedom, there were high waves caused by the current. Josva sat at the tiller. Magnus was cold in his wet clothes and started swinging his arms to keep warm.

The boat bobbed away. The air became dark as though evening were approaching. Josva sat with the tiller in his hand, feeling how he was gradually recovering as though from a dream or a fall.

NO ONE TREADS THE DANCE BENEATH THE SOD

I

Young Gotfred was standing down by the landing stage; he had been appointed steward and given the task of offering guests a welcoming glass as they arrived. He had the bottles lying in a pile of straw between some stones. There was schnapps and cognac for the men and port wine for the ladies. Gotfred was wearing a badge with a blue cross on his chest.

A couple of boats had already arrived. These were guests from Sandfjord, but they were total abstainers and had refused the welcoming drink. Gotfred had stood there feeling like a rejected tempter. But there he could see the minister's boat approaching.

"I wonder what to do," he thought. "Do I offer the parson and his wife a glass, or will that look inappropriate?" In point of fact, this welcoming glass was almost thought of as some kind of medicine, a pick-me-up after the journey. And suppose the minister or his wife was just in need of a stiffener? The weather was admittedly good, but even so, the trip from Whitesands was pretty long, and there was always a bit of a breeze out in the sound even in the finest summer weather. And when you had been sitting still in a boat for a couple of hours . . .

Young Gotfred decided to consult his father. The parish clerk was in the sitting room leafing through a hymnbook. He pushed his glasses up on his forehead and considered the question.

"Yes," he nodded seriously. "You can offer a glass to the minister and his wife. To my mind it would be impolite to miss them out. If Mr Martens thinks it unsuitable, then that's up to him . . . all the other ministers I've had anything to do with have accepted this as a good old custom here."

Sylverius and Simona had come down to the landing stage to receive the minister. They were both wearing their finest clothes. The minister and his wife were helped ashore. Young Gotfred approached them with glasses and bottles.

"May I offer you a glass of wine to buck you up after the journey?" he asked cautiously.

The Reverend Martens shook his head. But his wife smiled happily: "Yes, a glass of wine would be lovely . . . I must admit I have been a bit cold on the way over."

She emptied her glass in a single draught. The minister stroked the thin beard on his chin, looking pale and strained like someone about to collapse beneath a burden. His wife shook Sylverius's hands heartily and embraced Simona. The minister gave a weary nod: "It looks as though we are going to be fortunate with the weather . . ."

More and more boats came as the day progressed, and Young Gotfred had plenty to do down on the landing stage. Bottle after bottle was emptied, and new supplies had to be fetched from the boathouse, where Sylverius had his stock of wine.

There was a buzz of voices in Kristoffer's house. Every single seat was occupied, both in the sitting rooms and the kitchen. This was where the older guests had congregated; the younger ones were milling around in the dance hall, where it looked as though a start was being made to the dancing.

The minister and his wife had been given the best bedroom in Kristoffer's house, with a view across the bay and the islands of Husø and Skaalø in the background. The minister had stretched out on the bed to rest after the journey, but his wife, who was not tired, had gone downstairs to talk to Simona, whom she had promised to help with various things.

The minister immediately fell asleep. But after a short time he woke up to hear someone starting to hum and sing in the adjoining room. Judging by the voice, it was a young woman, and she was singing modern dance tunes. He could not avoid hearing every word: the wall separating the two rooms was thin, and in addition there was a door that had not been

properly closed. He was also aware of the smell of perfume. Strange, he thought – on this island so far from civilisation.

The merry humming was occasionally replaced by an incompetent attempt at whistling.

The minister abandoned his attempt to sleep and decided to get up. However, just as he was about to poke his leg out of the bed, the door to the adjoining room opened and a lady appeared . . . a youngish lady in a flowered night-dress, with dark, frizzed hair and an unusually red mouth that was pointed for whistling. It took her a moment to discover the minister, and then she disappeared with a little shriek.

The Reverend Martens continued to stare at the door. He nodded heavily: Oh, that too, that too. Like this as well. A firm and bitter smile appeared on his face. Before long, he got up and found his wife. "Come up to our room," he said. "I've something to tell you."

He sat down heavily on the bed.

"Do you notice the smell of perfume in here, Karen?" he whispered.

Yes, Karen could smell it. "It's coming in from the next room," she said.

The minister nodded.

"Well, is there really anything strange about that?" said his wife.

"Do you know what happened in here a moment ago? . . . Well, you see, while I was here having a rest, the door opened and a lady came in. She was half undressed and wearing a lot of powder . . ."

Karen laughed.

"Sshh", said the minister. "We must keep our voices down, for she's still in there, and every sound carries."

"Well, I suppose she came in by mistake," said his wife. "Or perhaps curiosity . . . she presumably didn't expect to find anyone here."

The minister gave a weary smile: "You are something of an ingenue, and an ingenue you will remain, Karen. You don't see the context. You don't understand that this was a new . . . a new assault. An extremely clumsy assault, I must admit, for

the lady was definitely not very attractive. But you can see how many different games they are playing . . . they never give up. I'm on the edge of a precipice all the time. But I'll keep my balance all right, you can be sure of that Karen. They shall see that I stand firm, that I refuse to be moved."

The minister's face had become as resolute as if beaten in iron. His nostrils were distended and his mouth closed so tight that it turned white and took on an almost cruel expression.

"My dear," said Karen, gently stroking his hair.

She sighed, but added with a smile: "Well, we can easily discover who that lady was. Wait here a moment, and I'll make some discreet enquiries."

The minister got up and went across to the window. He was breathing heavily and raised his clenched fists. "I will not be cowed. They shall not win."

His wife returned. She took his arm, whispering and laughing warmly. "It's the sheriff's family from Storefjord in there. So it was the sheriff's wife you saw."

"The sheriff's wife?" said the minister, lapsing into thought. "Oh well, that fits quite well with my hypothesis. You yourself once told me that this sheriff's wife was not what one might call the most matrimonially well balanced of women . . . I mean: Can't you see straight away how it all hangs together?"

A certain joy of understanding lit up the minister's face for a moment. He nodded like a man who has all his facts in order.

"But whatever it is or it isn't," he said. "You must surely see we have to have a different room."

"There's no need for that," said his wife. "You say yourself that you're able to fight off any attack, don't you?"

"Yes," said the minister, but the next moment a look of wild desperation came over him. "You mustn't let me down, Karen. You've promised not to," he almost hissed.

"There, there, take it easy." His wife gave a deep sigh. "Well, in that case the only thing to do is to ask Kristoffer to give us a different room. But what reason are we going to give?"

"I can talk to him myself."

"No, for heaven's sake leave that to me."

She had tears in her eyes and was staring sadly ahead.

"Do you mean I might easily . . . give it away?" asked the minister. "No, in that case you underrate me, Karen. So far there's not a soul apart from you and me, and then . . . the powers concerned that has the slightest idea of the traps that are being set for us, the web they are trying to capture us in."

"No, but then make sure you don't let it out either," said Karen, holding him tight.

The Reverend Martens patted her back to reassure her.

II

Young Gotfred's arms were tired and he was stiff from standing and serving the wine. He would have liked a glass himself, but that would be an insult to the blue badge. Admittedly, he wasn't a member of any temperance society; the badge was a present and didn't commit him to anything. But even so . . . he would limit himself to a bottle of beer.

He went up to Landrus' shop. People in their Sunday best were to be seen everywhere in the village and there were unfamiliar faces at every window.

The shop was full of customers. A poster bearing the words "Sale" and "Big Reductions in Price" was attached to one of the beams supporting the loft. Inside, from the adjoining room, there was the sound of singing and of loud voices in conversation. Landrus himself was going around in the little crowded shop praising his wares. He was happy and cheerful and had a red mark on his forehead. His daughter Gregoria was standing at the counter busily opening some bottles. The corks were sticking and giving her problems. She was smiling and all out of breath after her exertions.

"Let me help you," said young Gotfred, reaching an arm across the counter.

She handed the corkscrew to him and started arranging her dishevelled hair.

"You're not wearing your plaits today?" said Gotfred.

"I've got my hair taken up." Gregoria blushed.

"That must be a sign you're growing up," laughed Gotfred. "By the way, have you noticed I'm wearing the badge you gave me the other day?"

Gregoria squeezed her brown eyes together: "I didn't give it you . . . it was here on the counter, and you took it yourself. But just you keep it, then you can't drink too much."

"Yes, but if I fancy a drink," said Gotfred, "I'll just put the badge in my pocket meanwhile."

"Yes, of course you can," said Gregoria. "But then you can't put it on again, 'cause then you'll have broken your promise."

"Will you ask for it back then?" asked Gotfred.

Gregoria nodded.

"And will you give it to someone else?"

"Perhaps." Gregoria looked him in the eye. It was only for a second, but it was enough for Gotfred. It warmed him to the bottom of his heart, and he blissfully drank his beer."

"Gregoria!" shouted Landrus. "Don't stand there doing nothing. You can see there are people waiting to be served."

"Does that only cost 45 øre?" asked a man from Kvandal, pointing to a teapot with a price label stuck on.

"Only 45 øre," nodded Landrus.

He took the teapot down and put it on the counter.

"But there's just a small fault with it," he continued. "The handle isn't fixed all that well."

"No, so I see," said the man from Kvandal. "Well then, but it's not worth 45 øre in that condition."

"Then what will you give me for it?" asked Landrus gently.

"I don't know whether I want it at all," replied the man. "But I don't think it's worth more than 25 øre."

"You can have it for 35 øre," nodded Landrus. "Then you've got a jolly good bargain. I can't go down any further because then I'll be cheating myself."

"And what a pity that'd be," someone was heard to comment. It was Egon, Lars Dion's son, who had just come into the shop and was knocking out his pipe on the doorpost.

Landrus gave him a look as though he was ready for a fight. "Oh mind your own business. Or go in and tell your family to stop making all that din in there. It sounds as if it's coming from my own sitting room, and some people have been asking if I run a drinking den here at the back of the shop.

Egon laughed to the others standing there and filled his pipe again. He pointed his thumb at the sign up under the ceiling.

"It's a curious coincidence, isn't it, Landrus, that you've got your sale on just at the time of the wedding," he said.

"Keep your nose out of things that don't concern you, you wretch," said Landrus in a slightly nervous voice.

Egon was enjoying himself. "Aye, 'cause the rest of us who spend our lives here on Trymø don't get as much as a box of matches at a reduced price. How is it you're being so daft with strangers, Landrus?"

"Am I being daft with strangers?" said Landrus weakly. "I think you're the one who's daft, you don't know what you're talking about."

Egon shook with pent-up laughter.

"Aye, isn't it curious to see how many nice cheap things you've been hiding away from us in here! And now they're all appearing almost like magic."

"I've been keeping them on one side to have them all ready for the sale," said Landrus staring helplessly at the poster.

"Have you by any chance been damaging them yourself to buy them more cheaply?"

Landrus was furious, frothing in his beard. But now young Gotfred came to his aid and shouted to Egon: "It's not all that surprising that the odd thing comes unstuck, the way your father screams and yells next door."

Egon took his pipe out of his mouth and looked at Gotfred in amazement.

"Aye, it's dreadful to hear," Landrus chimed in. "I've been feeling ashamed of it all day. What on earth are they drinking in there? "

"Drinking?" said Egon with a vicious look in his eyes. "They're making a decent attempt at practising the bridal

dance, and surely they've as much right to do that as you have to keep a shop. It's our house as much as yours."

"Bridal dance," snarled Landrus. "Anyone can hear it's anything but the bridal ballad they're singing. It's nothing but bawdy old sea shanties your father's bawling out. And Torkel Timm's there, I can hear . . . and you're quite happy to pour brandy into that old drunk."

There was a thud on the wall, and Annette's voice could soon be heard scolding.

Landrus gave a harsh, humourless laugh. "Aye, you can hear for yourself, he's getting the ticking off he deserves."

Egon felt obliged to join in the laughter.

"That's their problem," he said dismissively. "Incidentally, Landrus – have you been branded? Or what's that red mark you've got on your forehead?"

Landrus raised his hand to his forehead. There was general laughter in the shop, and Egon disappeared with a smug look on his face.

Landrus was fuming: "It's a scar after a burn, so there's nothing funny about it."

Young Gotfred made an effort to look serious. Landrus gave him a grateful look.

"It's a good job you told him where to get off," he said. He bent across the counter and whispered, "There's no charge for that beer. It's a present from me."

III

During the course of the afternoon, the sun disappeared in a haze. It floated there like some huge swollen moon above the horizon. Then the disk was encompassed in an ocean of red. The haze condensed into a fog.

But during the evening the air became clear again; the fog dissolved into small puffs of cloud making their way up under the steep mountainsides and there they settled down.

Josva drifted about alone down near the shore, where the boats had been drawn ashore and arranged in long rows.

Jakob the Granary was sitting in one of the boats, rowing in the air as though his life depended on it, singing and mumbling to himself the while. A few strangers were gaping in amazement as they looked at the happy simpleton.

The bay reflected the yellow sky, and the swell licked at the shore with a satisfied, sleepy sound. The white patches of cloud shone like snow up in the dark patches below the mountaintop. Josva felt the urge to go up there.

The fields were dressed in a dewy grey. He went past the big farm, which lay as though in deep sleep beneath the summer-green turf roofs. Somewhere under that roof lay young Hilda in her dreams of love.

A few lines of the ballad of Benedict struck him:

> The king's fair daughter Margrethe
> She suffered both sorrow and rift.
> She hastened to plead with her father dear
> Dressed but in a silken shift.
>
> The king's fair daughter Margrethe
> She fell at her father's knee.
> A boon I pray you grant me
> Dear father, do grant it me.
>
> I want no more of the kingdom
> But a kirtel of coarsest cut.
> I will work for my meat and drink
> Like any other poor slut.
>
> I want no more of the kingdom
> Than a kirtel of homespun grey.
> Give me but young Benedict,
> And the kingdom we'll leave for aye.

He stood for a long time looking at the low houses and the patches overgrown with angelica, in whose deep twilight there was a secretive green glow.

There was a radiance up above the mountain top. The great

white clouds moving slowly along the horizon were blue and clear in the light. Across the surface of the sea the current made its presence felt with long, silent lines in the water.

Josva could not get the verses about Margrethe's distress out of his head. As a boy he had shed many a tear over this ballad. Since then he had not given it much thought. But now it was as though it had come to life for him again.

> I want no more of the kingdom
> Than a kirtel of homespun grey.
> Give me but young Benedict,
> And the kingdom we'll leave for aye.

But the father will not grant poor Margrethe her wish . . . Benedict, who has fallen in love with her, must pay with his life.

> Young Benedict lies stretched out in death
> And the blood from his body has flown.
> In sorrow fair Margrethe must yet draw breath
> Though troubled so sore and alone.
>
> There must be those who are living today
> Whom God has given a better fate.
> My life I must live and my sorrows allay,
> My heart is now stifled, with suffering sate.
>
> To St Mary's Church the body they bore
> So sorely troubled at heart
> Margrethe stood by the altar floor
> And lighted the candles with tender art.
>
> The maiden walks in the gloom of the church
> With sorrow she is filled and with rue.
> My prayers go to God to grant me the joy
> Of dying this day here with you.

Josva had to smile to himself. Here he was again, moved just as

he had been as a boy when together with Magnus he learned the ballad by heart.

He got up and walked down to the village again. Down on the road he met young Gotfred, ambling along with his hands in his pockets and a happy look in his eyes.

"I can't get any sleep either," he said. "They're sitting telling ghost stories in our living room. That's not a suitable thing for good Christians to listen to. And that farmer from Kvandal's the worst of the lot."

"Sounds as though it's just the thing for me," said Josva.

"Incidentally, what's this I hear about you?" said Gotfred. "The skipper says you've signed off the Isabella. Do you intend staying at home this summer?"

"I intend going abroad as soon as I can find an opportunity," replied Josva looking away.

He went into the parish clerk's front room. Old Jardes's beard was glinting in the light from the peat fire, and soon afterwards Josva caught sight, too, of Rasmus, the wealthy farmer and poet from Kvandal. He was stretched out comfortably on one of the settles, with a secretive smile on his wrinkled old face. The room was full of people, mostly young men who had no wish to take a rest.

It was Jardes who was talking. He spoke slowly, but very clearly, like someone who refuses to be ignored or misunderstood.

"Aye, you see, when a man dies, his soul doesn't rise up straight away. It hovers first on earth for a time and visits the places where the dead man used to spend his time. I remember from my childhood how I saw my grandfather's soul after he died. It floated up above the roof at first, like a bit of a rainbow. That was in the middle of the day. But I saw it again in the evening; and then it looked like a white bird with wings like human hands. And all night long we could hear it sitting on the roof and complaining, for grandfather had had an unhappy life. I've never heard a sound like it either before or since . . . half way between a crow screeching and a human voice. And the poor soul wandered around the house like that for several days, sometimes like a rainbow, sometimes like a

little dark cloud in the middle of a bright day . . . until God in His mercy took him home."

Jardes fell silent.

"But the Grave Sow," one of the young men asked. "You've seen that as well, haven't you, Jardes?"

"Not exactly seen it," said Jardes. "But I've had trouble with it. It was on the island here, a bit north of Redstones. There was a girl there who had given birth in secret and buried the child in the ground. And one evening, many years later, I happened to be going past the place. Aye, and I almost fell over something alive. It was late in the autumn, a night without a moon, and I couldn't see beyond the end of my nose end, and at first I thought it was a sheep. But I soon realised which way the wind was blowing, for the brute went on playing about in front of my feet and trying to make me fall. I could hardly stay on my feet; I kicked and stamped and tried to hit it, but nothing had any effect on it. And I prayed and cried out to God: God have mercy on me. But the little devil wasn't even frightened of the name of God. Aye, I was in such dire straits as I've never been in either before or since. But then I managed to get up on top of a big boulder, and there I sat until it started to grow light. And in the morning twilight I could clearly hear how the beast dug its way down into the ground."

Jardes knocked out his pipe on the edge of the fireplace.

"Have you ever come across fairies?" asked a voice from the corner of the room.

"No," said Jardes. "Well, yes, that's to say I've seen that Erla, Raven Erla who lives down in the boulder in Weaver's Valley. That was one evening many many years ago. I was a young man in those days. I'd been out to get some peat, and on my way home I went through Weaver's Valley and found a curious bird perched there on the big boulder, a raven with a white head. And before long I saw there was a young girl standing by the stone . . . she had her back to me but she was looking at me over her shoulder, and her face was completely white, but her hair was black. But suddenly, she'd gone. – Aye, that's how it was," sighed Jardes. "It was a few days after this

58

that Gregorius, Landrus' father, died, so Erla had something to forewarn of. Aye, you see more and more of that kind of thing as you get older, and the more the visible world fades before you . . . But I must go, it'll soon be day again . . ."

Jardes got up with difficulty.

"Thank you for all you've told us," said Farmer Rasmus.

"Oh, God bless you, there's nothing to thank me for, replied Jardes. "Good night, and may Jesus light your path."

Magnus got up from his settle and stretched with a yawn: "Oh, the old yarn-spinner."

"Well, do you think they're all only tall stories?" asked the farmer from Kvandal.

"Aye, what else?" said Magnus. "Ghosts and spirits and trolls . . . how can they exist? What are they going to live on, for instance? Are they supposed to eat grass or soil?"

"They're not alive in *that* way," said the farmer from Kvandal quietly.

"You not going to pretend that *you* believe in them, Rasmus?" laughed Magnus.

"Believe and believe," said Rasmus. "Of course you don't have to believe everything you hear. But some of it's both likely to be true and it's beautiful, and in any case it's got some . . . inner truth."

"Oh, just listen to the poet from Kvandal," smiled Magnus.

Rasmus found it difficult to get a word in edgeways for the young men's laughter: "Aye, I believe in the good old faithful trolls, they're not to be sneezed at. And you young 'uns are no better in any case. What about when you're at sea . . . you've got your phantoms and spectres and your visions in spite of engines and electric light and all that. – Well, but let's get some sleep and gather strength for tomorrow."

. . . Josva slept uneasily that night. He dreamt there were people dancing in an enormous hall. Many thousands of people were taking part, in fact it was really all the people in the world coming together here to dance. But outside in the darkness stood Margrethe, the princess: she had Hilda's face and dark hair, her eyes were swollen with tears and she held out her hand imploringly to him.

He awoke and remembered the dream. What was it Margrethe had asked for? Why did she hold out her hand to him? He fell asleep again. And Hilda was there again . . . now she was quite naked, only dressed in her long black hair, and she looked evil, like a troll. He stared into her eyes . . . they grew bigger and became like caves as black as night, and at the same time it was as though he was gliding out into a windswept, desolate darkness.

He woke a second time, still shuddering with vertigo. The cocks were crowing in the dark golden sunshine, and the house was already humming with human voices.

IV

Frida Olsen had a wilful and disagreeable manner, but it had to be said for her that she knew how to get things done. It was a sheer miracle the way she could organise things. Kristoffer shuddered to think how these wedding days would have gone without her. All these people had to have breakfast, dinner and supper, and there was only room at table for fewer than twenty at a time, so there were people eating there from morning to evening.

Kristoffer had undertaken to ensure that all the guests came to table as there was room for them. He was tireless in his efforts to look after them. He even went around in the village and dragged people out of their houses . . . there was to be no staying away here. On this day, the wedding day itself, everyone was to have a good time insofar as he was able to ensure it.

There were still a few who stayed at home, and there was nothing to be done about them. These were the very old and those who for some reason or other could not be got in the mood for a party. Things were difficult for Magdalena, the local teacher's widow: her grown-up daughter was ill, and her son had recently died of consumption, like his father. Elias from the River House had been paralysed for years and had to leave it to others to ensure that his wife and children did not suffer hardship.

But there was one thing Kristoffer could do to give these poor people a bit of pleasure. He could take some of the wedding dishes to them.

Kristoffer touched cautiously on the subject with Frida.

"Not on your life," she said and turned her back on him.

Kristoffer went outside for a moment to think things over. It was ridiculous to allow himself to be dominated by that woman.

He went back and said in a subdued voice: "Well, you know, I still intend that those people I was talking about should have a share of the food from the wedding . . ."

Frida Olsen faced him angrily: "I've told you it can't be done, and I only say that once."

Frida Olsen sat down on a chair and said quietly, "Let me tell *you* something now . . . ever since I arrived on this island, you've got in my way. I will simply not have you in the kitchen. Otherwise I'll pack my things and go back to Holmvige this minute. Have you got that, you interfering busybody?"

Kristoffer flushed, but he did not lose his temper. These were harsh things to say to an old man who was even the bride's father. She was dreadful, was this Frida. But on the other hand they simply couldn't do without her. She was a bit like the sea . . . it couldn't be tamed, but on the other hand you could get it under control if you used a bit of cunning and adapted to it.

He adopted a worried tone: "You know, I've done what I could to make the job easier for you, so I don't think I deserve to be treated like this."

Frida got up, turned her back on him and murmured, "Oh, I don't know . . . In any case, I've not asked for your help."

Kristoffer went on: "And as for that bit of food for the sick people, I don't understand how you can be so cruel . . . Have you never been ill yourself?"

"No," replied Frida with a toss of her head.

"Or had to look after anyone who's ill?" continued Kristoffer.

"You can take the food to them yourself," she suddenly broke in. "I can't do without any of my helpers."

"Yes, I'm quite happy to do that," said Kristoffer.

"Ugh," Frida puffed. "You can have one of the maids to help you," she added sullenly, but now placated. "Only get a move on, we've no time to waste."

V

The minister, dressed in his vestments, was sitting in his room. His wife had managed to persuade him not to move out of the big attic room in Kristoffer's house. The sheriff's wife was bustling about next door. She was still humming, but she had now turned to hymns, and her voice was brittle and pious.

"She's just putting it on," whispered the minister. "Now she knows it's us in this room . . ."

"Well, don't think about it any more," said Karen.

"No, you're right."

The minister took her hand.

"There's nothing to be frightened of. And so we'd better forgive the little woman and pray for her. When all's said and done, she's only a poor tool in the grip of some fiendish power. But that power's not going to get me down either."

He got up and clenched his trembling fists. The veins swelled up in his pale temples: "You'll see, you tempter, you murderer."

The church bells started to ring. A heavy look of peace spread over the minister's face. He nodded to himself, "I know, God, You will give me the strength to fight my battle to the end."

The bridal procession had assembled down on the road. There were over a hundred in it, all young people and all in their finery. Mrs Martens had had the task of arranging the young men and women in pairs and was contentedly viewing what she had accomplished. As the procession started moving, the crack of rifle shots could be heard from both near and afar. Sharp echoes were cast back by the rocks. All the dogs in the village started to bark, and a few innocuous tame ducks had the fright of their lives and took off quacking wildly,

flying high over the roofs and only landing again far out in the bay.

The little church could not accommodate all these people. Some of the procession had to remain standing outside the parsonage.

The sound of hymn singing poured out of the open church door. It could be heard throughout the village. The teacher's widow opened the windows so her sick daughter could hear it properly. She lay there listening with big open eyes and folded hands . . . it was as though the sounds came from all around, as though the entire valley, the mountain-sides and the shore were populated with people singing. And at the same time the sick room was filled with the scents of spring . . . sweet and acid vapours from wet ditches and germinating greenery, and the smell of newly tarred house walls and fermenting seaweed from the bay. Now and again there was also the wild, restless scent of the sea and of distant parts.

Then the hymn singing came to an end. The only sound to be heard was the occasional long, protracted trill of a curlew or the lowing of a cow in the mountains.

VI

In the profound silence there was a ticking as though from a clock. It was a motorboat approaching from Holmvige. It came alongside the landing stage and put two passengers ashore, after which it immediately backed out and set course for Holmvige again.

The new arrivals were a solicitor by the name of Morberg and Greypoint Vitus. They went up to Kristoffer's house, but found no one at home except the kitchen staff, all of whom were busily occupied.

"So we missed the welcoming drink," said Morberg. "We didn't anticipate that. What shall we do?"

"Well, that doesn't worry me," said Vitus. "Thank you very much for letting me come out here with you."

The solicitor called to an elderly woman who was busy arranging a pile of plates.

"What on earth," he said. "Here we come all thirsty and tired after the long journey from *Trans Siberia* and haven't had a bite or a drink for four days. Especially drink," he added.

The woman looked at him suspiciously, but said, "If its schnapps you mean, there's some over here in the cupboard."

She took a bottle and glasses. The solicitor downed a large glass and then filled it for Vitus.

"I think I'd rather wait," said Vitus defensively. But it was no good. Morberg forced the glass down him. "You really must show you've been properly brought up, Vitus. – You who pretend to be so refined. Come on, we'll take this bottle and go over to the church."

"God help you," said Vitus. "You're surely not going to take the bottle with you into the Lord's own house?"

"No, you're right," said the solicitor. "We wouldn't get much pleasure out of it there. I think we'd better sit up in the field and wait till they come out of church."

"I'd have liked to be in church with them," sighed Vitus.

"Oh, rubbish," said Morberg. "To begin with, they're probably already married, and secondly you can't get into the church, you can see how full it is. No, we'll sit outside amidst the nature God made for us and wait, and meanwhile we'll refresh ourselves with this heavenly drink, as it's called in the Psalms of David. Don't you know the Psalms, Vitus, you with that biblical face of yours?"

"Oh, don't make fun of me," said Vitus. "I'm not really well up on the Bible or on anything else, whether it's heavenly or earthly."

They wandered up through the meadows. Morberg became quite ecstatic.

"Vitus," he exclaimed. "Have you ever in your restless wanderings and wasted life experienced a more magnificent moment than this? Behold the sun, in its newborn radiance, and behold how the clouds have forsaken the heavens and are resting on the sea. And mark this scent of grass and plants, of dawning life. Nowhere can you experience heaven and earth

as you can on an island in spring in the midst of the ocean. Cheers."

He raised the bottle to his lips and took a gulp.

"Come on, Vitus, we'll sit down here. Ah . . . if only I could sing, and if only there was a song that could really express this moment."

Vitus stared at the solicitor, half in wonder, half in fear.

"You talked about the Psalms a moment ago," he said.

"I did indeed," replied Morberg. "Do you know any of them? That wouldn't surprise me, you know. If you've got a decent voice, then start singing for God's sake. But let me have a dram first."

Vitus's face registered some strange emotion.

"I don't think my singing's up to much," he said. "But . . . I know a lot of hymns . . . whether they're up to the Psalms of David, I don't know."

He laughed gaily.

"It doesn't matter in any case," said the solicitor. "Well, get on with it."

Vitus bared his head, cleared his voice and began:

> Awake and strike thy lyre,
> And sing to morn with the heavenly choir.
> Arise, dear soul, once more arise,
> And with your praises fill the skies.
> And with your glorious banners unfurled
> Forget the sorrows of the world.

"Forget the sorrows of the world," repeated Morberg. "Wonderful. And then this old contorted, ecstatic melody. I must say, you're pretty good."

Vitus got up and pushed his chest forward. He was in the mood now.

> Oh yes, I'll to the heavens rise
> And praise our Lord unto the skies.
> God's realm is my eternal home
> Where in the end my soul shall come.

The eternal praise of God I'll sing
And to His house my heart I'll bring.

"You impress me, Vitus," said Morberg. "You look almost like a saint as you stand there . . . a statue of a saint from Trondheim Cathedral."

Vitus blushed and continued in an emotional voice:

No more have I from which to part
Than songs or praise from all my heart,
And all the other deeds of life
Are nothing more than worthless strife.
You never will reject my sighs,
But wipe the tears that stain my eyes.

"Go on," said the solicitor. Vitus dried his eyes:

And now I see the sun arise
To make its crossing of the skies
Oh God, how great is my delight
When I can put my foes to flight
And know that Christ, the Son divine,
Of victory is the eternal sign.

"Hey," Morberg interrupted him. "You're nothing like the wretch you pretend to be, Vitus, I see that now. You're a kind of quiet wise man. I'm actually starting to have respect for you. You look so indescribably transfigured when you sing. Cheers."

Now the church bell started ringing, and the bridal procession appeared in the doorway.

"Oh," said Vitus enraptured.

A shot rang out at that moment, and then more.

"They're shooting!" shouted the solicitor. "What's going on?"

Vitus pulled at his coat tails and gently brought him to his senses. "They're shooting for the bride and bridegroom. They're shooting blanks. There's nothing to be afraid of."

Morberg put his hands to his head: "Oh, of course, I ought to have known that. It got me all worked up."

He sat down and had a dram to quieten himself down.

"No, you know, Vitus, I just hate and loathe anything concerned with death. I hate death, you know. To be shot just as you're there enjoying the sunshine."

"But death's a release," said Vitus.

"Release?" snarled the solicitor. "Rubbish. Death's simply meaningless and terrible. Look . . . you're looking like a saint again. A really horrible, self-satisfied saint . . . a heavenly snob. One of those down-at-heels, crawling, but nevertheless pompous heavenly kite-flyers. Wipe that bloody smile off your face, for heaven's sake, or I'll smash your skull with this bottle."

Vitus pushed one shoulder forward to defend himself and moved a little away from the solicitor. He had tears in his eyes again and murmured to himself, "God help us . . . now the demon drink's really got hold of him."

"Vitus," said the solicitor, this time in a gentle voice. "I'm probably making a complete fool of myself to you, wise man that you are. But you must forgive me. That's your speciality, of course, isn't it . . . to suffer and to forgive. But you can still appreciate me, let me tell you, for I'm the only man who really understands you. I understand you all, you curious medieval, subterranean figures who teem out in the cold daybreak of the new age . . . dazzled and confused . . like crawling insects when you lift a stone."

Vitus nodded politely. What on earth was this nonsense all about?

Morberg opened his eyes wide: "I *understand* you, you see . . . I can *see through* you. I see through everything and everyone."

He stretched and laughed. A strange, almost unpleasant laugh, thought Vitus. It reminded him of the cry of a great northern diver.

The bridal procession was moving slowly homewards from the church.

"What a lovely, blessed sight," said Vitus emotionally.

"Yes, . . . just look," said Morberg quietly. "This shining river of youth beneath the radiant sun reflected by the sea. Man is a delightful creation after all. There's much of the divinity in him."

"He's created in God's image," said Vitus.

The solicitor went on: "And just look at Simona, the bride. She is simply radiant with happiness. It really warms your heart to see her. Just imagine that there are people who are so happy Vitus."

Vitus nodded and dried his eyes.

"But they're admittedly a minority," the solicitor went on. "They're a kind of luxury that nature allows itself now and then."

He closed his eyes and added, "They are like the white foam on the vast dark oceans . . . those murky depths swarming with disgusting vermin."

He got up and smashed the empty bottle against a boulder.

"We all of us finish down in those hungry depths sooner or later," he said.

"But in the end we all gather together before the throne of God," said Vitus.

VII

It had been something of a problem to Kristoffer as to how to seat everyone at the great wedding table so that no one should feel pushed aside. It was usual for the newly married couple to sit at the end of the table, and it was considered an honour to be given seats near them. Kristoffer had had Simona and Sylverius placed at the centre of the broad side of the long table and had given the minister and his wife seats at one end and the sheriff and his wife seats at the other. And thus he had arranged things so that no one could be upset.

It was not long before the guests livened up. The solemn atmosphere from the church still made its mark on the way people were dressed, and the wedding mood had some

difficulty in making inroads. Mr Martens sat staring ahead with expressionless eyes, as though his thoughts were far, far away. Farmer Rasmus had made up a little speech, but just as he was about to give it, he was overcome by doubts. He was going to compare the bride with the Sleeping Beauty from the untouched island of legend and fairy tale, and the bridegroom with a prince from the land of daylight and action. But as she sat there, with wakeful, slightly strained eyes and a firm little mouth, Simona was full of reality and not in the least bit like a fairytale princess, despite her mass of fair hair. On the other hand, Sylverius could certainly be compared to a fairytale prince. There he sat, looking ahead with dreamy eyes and a slightly timid smile on his full face. No, that speech would have to be re-thought.

But now the sheriff rose with a glass raised in his hand. He was dressed in a morning coat; his moustache was turned up at the ends, and he was wearing a pince-nez. It gave him the appearance of a town-dweller. But he was certainly not a man used to speaking; he stumbled and hesitated and repeated himself time and time again: "Being gathered together around this bridal couple, we all feel as though we were standing before something great and strange. And when we all feel so intensely that we are facing something that will plant a seed and bear fruit, it is especially because we know the bridegroom and know that he has *determination*. He is one of the few men in this country that have shown they have determination. And when he has gone so far that he is in command of an entire fishing fleet and thus brings wealth and work to his town, then it is his determination we can thank for that. It is determination of this kind we need most. And when he has also found himself a bride whose beauty needs no further description, well, that is because he has a determined eye that knows what it is looking at and knows how to *strike*. So let us drink their health!"

"Long live determination," shouted Morberg.

There were other speeches that were listened to patiently and politely. But the real jollity only started when the meal was approaching its end and the flower-decorated sheep's tail

was circulated. All those at whom it stopped had to produce a rhyme before passing it on. And they had to be quick about it. If they had nothing else to say, they could always manage with a rhyme such as: "Rhyming and speaking are not for me, and so I pass on this tail to thee". But that kind of platitude was not thought much of; it could at a pinch be accepted from the women.

Many of the guests had turned up with ready-made rhymes that suited the occasion, and those that were quick at repartee were given the most challenges. Farmer Rasmus had been to many weddings, and as he also had an unusual memory, things went smoothly for him; he always had a rhyme to hand and from his abundance he could even pass one on to the man sitting next to him, the sheriff, who was not particularly gifted at this kind of thing. Young Gotfred was one of the quickest rhymesters, and his rhymes cause more amusement than most of the others because they were more mischievous and disrespectful.

"He's a bit on the cocky side, this young man," said the sheriff to Rasmus. "Can't we rap his knuckles in return?" The farmer from Kvandal immediately had a rhyme ready. It was not a sharp one, but good-natured and aimed at Gotfred's fair hair and rosy cheeks. The sheriff read it out:

> Gotfred is white like a newly washed lamb
> But his face is as red as a pickled ham.

Gotfred replied:

> A blind hen there did pick up a corn
> And where did it come from? – The ram with no horn!

That caused merriment. Rasmus ruffled his white mane of hair and pretended to look devastated, and Morberg shouted, "Bravo. That got him." But Gotfred gave his son a furious look to warn him.

The sheriff waited for his opportunity and took his revenge again with the help of the Kvandal farmer:

> Gotfred has horns like a little kid
> And buts and tosses o'er all, I'll bid

Young Gotfred was there immediately:

> Might well he have butted there just right
> Just watch your glasses and jewellery bright

"Good," said Morberg. He got up with his glass raised and made to give a speech, but he was pulled down again . . . The sheep's tail was by his plate, and if he wanted to say something, it had to be in rhyme. He put his hands to his head and thought deeply, but just at that moment he couldn't think of a single rhyme. Shaking his head, he passed the tail across the table to Young Gotfred: "You're the man to do it," he said. "So let's hear something about me."

> That Morberg can't rhyme, it is a shame,
> However, his nose is as sharp as a dram.

"Hey, this is starting to go too far," said the sheriff with a laugh. "Don't you think it's best to stop while the going's good?"

Kristoffer took the opportunity to wish everyone welcome, and Gotfred the parish clerk got up and sang a hymn from the table. On this solemn occasion he had chosen a particularly long and difficult grace from the "Spiritual Songs" and sang it with all his art to an old melody that had been passed from father to son in his family over many generations.

The verses piled up one on top of the other, and it was as though Gotfred himself grew with the hymn; he acquired the look of a preacher holding forth, and a sense of both ecclesiastical and profane uplift came from him.

VIII

The guests congregated outside in the home field by the house, and the parish clerk took the bride's arm and arranged a ring of dancers. The bridal dance was soon in full swing, to the ballad of Jacob and Rebecca.

All the guests, including the older ones, took part in the bridal dance. Even old Jardes with his 93 years joined in the ring.

Only the minister and his wife were missing from the dance. Immediately after the wedding breakfast, the minister had withdrawn to his room. Here, he sat on the edge of the bed with laboured, staring eyes and a forehead bathed in cold sweat.

"We must get home this very evening," he said.

Karen sat down beside him and laid her arm around his shoulder.

"Do you want to go back already?" she asked gently. "Wouldn't it be better to wait until tomorrow?"

"No," said the minister. "We'll go now, straight away."

His wife sought to persuade him: "But you know there were so many things we ought to do first. Don't you remember . . . we were supposed to be visiting the sick. Have you forgotten that?"

The minister got up.

"No," he said. "But we're not going to do it on this occasion. Pack our things. We've got to go straight away."

"Good Lord," sighed his wife. "I'd been thinking we were going to have a bit of fun this evening."

"Fun?"

The Reverend Martens had adopted his composed, strained look.

"I don't think you understand, Karen. This is not the time for fun. We are surrounded by . . . enemies on all sides here."

"Are there any others apart from . . . her?" asked his wife.

The minister frowned and for a moment had an almost hateful look about him. "Yes, there are others. There's both the sheriff himself and then this Morberg, the solicitor. And

there's that wealthy farmer Harald and his wife. Do you remember they once wanted us to talk to their daughter . . . I realise now that that was a trap."

"Oh, God help us," sighed his wife. "Oh well, then . . ."

"We can defend ourselves better in our own house," said the minister. "And I'm a bit worried about you as well. I won't mince my words."

His wife got up.

"About me? What on earth do you mean? Do you think I could let you down?"

"Not directly," said the minister. "But you're so . . . so human. No, don't misunderstand me; I know it's our duty to be good to our fellow human beings. But people in our situation live in a way in a state of siege, don't we? We have to take extreme care of ourselves, to have our eyes and ears open and be careful what we say."

"Well then in that case there's nothing for it but to get away," said Karen anxiously.

The minister and his wife secretly took leave of Kristoffer and the newly married couple.

"We'd so much have liked to stay," said Karen. "But my husband isn't well . . ."

"What's wrong?" asked Simona sympathetically.

"Oh," replied the minister. "I . . . I . . ."

"He's had a nasty turn," explained his wife. "Something to do with his nerves."

"You're a good one," the minister whispered animatedly once they were seated in the boat. "Something to do with my nerves. That sounds fine."

Relieved, he settled down on the thwart.

"Oh yes," he said with a little smile. "We'll get through this all right."

IX

But the dancing continued.

When the bridal dance came to an end, guests immediately

73

started on the ballad of Charlemagne. It was young people from the island of Skaalø, from the ancient villages of Kvandal and Kirkevaag, who embarked on this dance, headed by a Farmer Sverre, who was well known all around for his skill as a ballad leader. Sverre was a sharp little man and did not draw attention to himself in the dance, but he had a voice of steel and the staying power of two men. He had gathered together the best singers from among his own villagers, and it was not long before the ballad was being sung with a force like that of waves breaking.

> They saddle the horses and armour bright
> Hungering to go into battle
> With horns to their lips they ride to the fight
> Rocking the walls of the castle.

At the same time the pace was increased, and the dance became fierce and furious . . . it was nothing for the old folks, and if the women were to keep their places in the chain they must not be too feeble.

When the ballad telling of the Battle of Roncevalles had been danced to the end, Sverre and his men immediately started on another ballad about Charlemagne. But at the same time, a start was made elsewhere on the Ballad of the Long Serpent, Ormurin Langi – these were folk from Husø who were not going to be outdone by the Skaalø men. For a time, the two ballads struggled for supremacy and fought each other like foaming dragons, but Charlemagne got the upper hand and went off with the victory. So the Husø men had to slip into the enemy ballad or stay silent. However, the vanquished men bore their defeat with dignity, and when this ballad came to an end, they received satisfaction . . . The Long Serpent glided forward in all its splendour, this time with the wind in its sails.

Josva surrendered to the dance and felt he was being uplifted into its extraordinary, fluid realms. Aye, the world was really different in the dance; everyday life was no longer present, fading away like something hugely unimportant in the

distance. And people one knew in everyday life – here, in the dance, they revealed new qualities one would not have expected of them. Gotfred the parish clerk and Farmer Harald, indeed even Landrus and Lars Dion were all transformed, raised up and borne by a greater power than that of everyday life. They were no longer creatures of speech, but of song, filled with the spirit of festive harmony.

Josva came to think of an experience in his childhood . . . a foreign schooner had been stranded on the north coast of Husø and smashed to bits in the surf. There had been no people on board the ship when it hit the shore; the crew had left in the lifeboats, and no one knew what fate had befallen them. But some time after this, a body floated ashore on Trymø. It was in December, and the weather was dark, with winds from the south and wet snow. The body was buried temporarily in the churchyard, as the final burial ritual could not be carried out before the minister came. But time passed; Christmas came, and the minister was still prevented from coming out to the island. There was nothing for it but to postpone the Christmas dance until the funeral service had taken place. But then the minister finally came at New Year. And as soon as he had read the service for the dead, the chain was formed for the dance. The parish clerk led the singing with the ballad of Saint Nicholas conjuring up the drowned clerics and bringing them back to life. And this prepared the way for the dancing, which went on merrily evening after evening, right until Epiphany.

When the Ballad of the Long Serpent had been danced to the end, young Gotfred came across and pulled at Josva's sleeve.

"Come on, let's go and have a drink together," he said.

"I thought you were an abstainer," chuckled Josva. He could tell by Gotfred's eyes that he was not entirely sober.

"Abstainer," Gotfred shrugged his shoulders. "It's a sad fate to be an abstainer at a party, let me tell you . . . it's easier in everyday life."

Gotfred had a bottle standing in the passage behind the barn. They each took a swig. Gotfred was in exuberant spirits.

"I'm going to have a girl this evening," he said. "I just can't catch her; she runs away from me like a vision in a dream. But I'll catch her, so I will. Oh well, I'd better hurry. See, I'll leave the bottle here, so you can always have a dram if you feel like it."

Josva stayed behind in the passage for a moment. Evening was approaching, and there was a thick fog. The dancers' voices rang out monotonously like the rushing of a river or the breaking of waves against a shore. Now came the Ballad of Aasmund, the King of the Huns. Josva could just make out the refrain:

> Play happily on earth,
> No one treads the dance beneath the sod.

Echo was busy up among the rocky crests, as though there were dancing up there, too. A young couple hurried past and disappeared in the mist. He could hear their tender, smiling voices.

A great sense of melancholy overwhelmed him for a moment. He came to think of Hilda . . . she was not at the wedding, so she was presumably at home, longing for Daniel, eaten up by longing while everyone was dancing down there . . .

He drifted aimlessly through the fields and sat down on a boulder. It smelt mild and of moss. I dreamt of her last night, he thought . . . she held out her hand to me, as though begging me. I wonder what she wanted. And later she stared at me, dark and uncanny so that I became quite dizzy.

If only she were here now, he went on, even if she were in the guise of a troll. He closed his eyes and abandoned himself to his dreaming: The mists part and a figure glides forth, silently, and approaches him. It is she. She is naked, and her long dark hair heavy with the rain . . .

> Play happily on earth,
> No one treads the dance beneath the sod

came the sounds of the refrain from the dance hall.

> . . . neath the sod,

came the reply from up in the mountains.

Josva got up and went back to the dance hall. But he had no desire to take part now. Everything had suddenly become so irrelevant to him. "*She* isn't here," he thought.

It was still early in the evening, but he felt curiously out of sorts, as though he had been dancing a whole night long. Perhaps it would do him good to have another drink. He remembered Young Gotfred's bottle and went off behind the dance hall. There was someone in the passageway . . . a courting couple presumably. No, it was a single female figure. She was pressing herself against the wall, obviously thinking no one would see her in the dusk, but when Josva approached her she suddenly took flight. Josva followed her. He thought it was Hilda's figure. He lost sight of her for a moment; she had hidden behind a wall of Angelica Farm, but when he approached she jumped up with a little cry and made off up across the fields. He lost her again. However, he had a feeling she was not far away and he thought he could hear her trying to catch her breath. He stood there, his mouth open, to listen. No, it was probably the sound of a little waterfall up in the rocks.

The fog was dense and dark. He was not entirely sure where he was.

"Hilda", he called.

What did he really want with her? And what should he say to her if she came? . . . And perhaps it was not her, but another girl he had been chasing. Or perhaps it was not a real girl at all, but one of the little people. But never mind, whoever it was or was not – she had disappeared, and here he was alone in the field. Standing like some strange fool.

The fog spun its web around him; his clothes acquired a pale grey nap, and he felt the cool wetness in his eyelids. He felt almost a desire to sob. But it was not exactly from sorrow

. . . it was something else. As a child he had heard the merman weep and sob down in the seaweed on quiet summer evenings . . . and now he was standing here in the wet dark like a lovesick merman.

Josva is filled with self-disgust and tries to make himself hard. Aye, however you look at things, he is and always will be a fool, a half-crazy idiot. He won't grow up like other young men of 18 or 19. It's more likely he'll be going the other way, back into childhood.

For a moment he feels quite crushed, totally ashamed of himself.

"Hilda," he whispers out into the fog.

And suddenly the figure of the girl appears again . . . and this time it is not a dream, but reality. She walks towards him, and he can clearly see that it's Hilda. She is dressed in her finest clothes.

"Josva," she says. "Oh, how you frightened me."

He approaches her. They stand face to face. He feels giddy and doesn't know what to say.

"Are you . . . going to the dance this evening?" he finally stutters.

"No," replies Hilda.

"But you're dressed up for it?"

"I was going to go," says Hilda. "But . . . people are always talking about me. I hardly dare show myself."

Josva is trembling as though he is cold. Here is Hilda. This is really her in the flesh, her dark hair and her curving eyebrows. He feels the urge to hold her tight or to take her in his arms and lift her up and carry her away . . .

But he remains rooted to the ground.

"Are they talking about you?" he asks.

"You know . . . all that about Daniel."

Hilda comes quite close to him and starts fiddling with a button on his waistcoat.

"Josva," she says with tears in her voice. "You must tell me the truth about Daniel . . . He's not gone to America, has he?"

"No," Josva can tell her, no longer trembling with excitement. "He's over in Holmvige and intends going out fishing on the Isabella."

"Oh, then I ought to have gone to the dance after all. Only I daren't. But then I thought it was so dark in any case. And perhaps I might meet someone I knew . . ."

"Let's sit down on this mound," says Josva, thinking at the same time that she had only come to him in order to hear about Daniel.

He puts his arm round her waist. Her damp hair touches his cheek. He kisses her neck, and she makes no attempt to stop him.

"And they tell me he was drunk the other day and fell into the water?" Hilda goes on.

"Yes," says Josva. "He was dead drunk . . . It was my brother who saved him."

Shivering with cold, Hilda holds him close to her and whispers, "You're so good, Josva . . ."

"Good? What do you mean?"

Josva suddenly feels the urge to reveal himself as anything but good. He says, "*I* could have saved him, too, but I didn't . . ."

Hilda looks at him uncomprehending. Josva laughs, as though this were actually intended to be amusing.

"Were you there as well?" says Hilda. "But wasn't it enough that *someone* saved him?"

She laughs as well, as though slightly surprised.

"Oh, it's cold here," she says and huddles up.

"Well, perhaps we'd better be going," says Josva.

He makes to get up, but Hilda holds on to him and pulls him back down.

"No, not yet," she whispers.

He feels her wet face against his. She kisses his forehead, his eyes, his cheeks, and their mouths meet. They slide down from the mound into the wet grass.

"Oh, how it smells of tansy," whispers Hilda.

The mist is full of fine drizzle. There are sounds of water seeping everywhere in the grass.

"You're going to be wet through," says Josva. "Your hair's so wet it's sticking to you."

"Yes, I suppose I'd better get home now," says Hilda. "The mist's rising as well . . . unless dawn's breaking."

She suddenly gets up and he does nothing to keep her back.

"Goodbye, Josva," she says.

"Goodbye, Hilda. . . . No, wait a bit; let me say good night properly."

But she has already disappeared in the mist.

" . . . I had her here," thinks Josva. And only now that she has gone does he fully appreciate that she has been close to him. The scent of her hair, her wet face, her heaving breast . . . How was it, he had kissed her and almost been one with her, and they had almost been one with the moisture, the grass and the fine drizzle.

He bends down and plucks a handful of tansy. Aye, that's what it had been like . . . they had lain there surrounded by the scent of tansy; he'd been aware of that strange perfume all the time. He could sob with happiness as he stood there. But suddenly he remembered the words he had just spoken: "*I* could have saved him, too, but I didn't." That was a nasty thing to say. Or perhaps rather a foolish thing to say. She had taken it as a joke. If only she knew . . .

And again Josva feels the urge to sob. Like the merman sitting among the seaweed abandoning himself to his tender feelings and suffering with joyful, stifled sobs . . .

X

Throughout the evening, young Gotfred had tried to get close enough to Gregoria to talk to her, but he had not managed to catch her on her own . . . sometimes she was sitting with her parents, and sometimes she was together with girl-friends of her own age. A couple of times she took part in the dance, but even here it was not possible for him to get close to her for she was dancing in the middle of a long row of girls

who all appeared to be watching him curiously and attentively.

Landrus gave him a friendly nod and asked him to sit down beside him.

"You're a sturdy young man," he said. "That good-for-nothing Egon prefers to hang about in a filthy shop in Holmvige rather than go to sea and plough the waves like a proper man."

"So doesn't he intend going to sea again?" asked Gotfred.

"No," Landrus informed him, and his voice became confidential. "He's going to learn commerce with Sylverius . . . You see, it's Lars Dion getting up to his tricks. He presumably wants to open up out here and put my nose out of joint."

"He'll not be able to manage that," said Gotfred encouragingly.

Landrus gave a bitter smile: "With Sylverius behind him it's probably not completely impossible . . . oh well, we'll see. – By the way, do you know how it all ended yesterday evening? Well, you see, they went on making a din at Lars Dion's, and they finally thumped on the wall so hard that a shelf of jars containing herbs fell down in my shop. But, you know, I'll make them pay for it. Besides, I've got so many other bones to pick with them. I'll have a talk to this solicitor Morberg as soon as he's sobered up, for justice can't simply shut its eyes to that sort of thing. Herbs are terribly expensive items."

"Yes, obviously," said Gotfred absent-mindedly.

Landrus gave him an extremely friendly look. "For you see, if it once goes to court I've plenty of good cards in my hand. They're not going to get away with it, the wretches."

"No, don't you hesitate," said Gotfred.

"Ha, you should just have had a go at Lars Dion," laughed Landrus. "I was sitting there waiting for it all the time, but it never happened, more's the pity."

Landrus gave him a slightly reproachful look.

"There were so many to have a go at," said Gotfred.

"But there's no one who deserves to be got at so much as Lars Dion," said Landrus, stroking his beard." He's a devil in human shape . . . God forgive me for saying that."

Young Gotfred went on talking to Landrus for a long time in the hope that Gregoria would come and sit with her parents. But she did not. Nor could he see her in the dance. He grew uneasy and got up.

Gregoria was nowhere to be seen. Gotfred became quite concerned. In the crush by the door of the dance hall someone caught his arm . . . It was Judika from the River House.

"Gotfred," she said plaintively. "Come and help me a bit, there's a dear."

"What's wrong?" asked Gotfred in surprise.

She took him round behind the barn. There was a male figure standing there, a lad from Holmvige, leaning against the wall.

"He's taken my ring," complained Judika.

Gotfred laughed and turned to the thief. "Give her that ring, Oluf."

"She can come and get it herself," said Oluf.

Gotfred caught him by the shoulders. "Give her that ring, do you understand?"

"What a nice person you are, Judika," said the other. "First you say I can have the ring, and then you fetch help to get it back again . . . but you needn't think I want it all that much."

He gives her the ring: "There you are, Judika; I'll not forget you for this . . ."

"Come on, Gotfred," says Judika, taking his arm. "I thought it'd help when you came. He's a cheeky blighter, that Oluf, don't you think?"

"Hey, where do you think we're going?" asks Gotfred.

"I don't know," says Judika with a smile. "Wherever you want."

Gotfred laughs and put his arm round her waist. Judika is a big, comely girl with pure white skin and golden curly hair. But it was Gregoria he was after. This is no good . . .

"I've got to go back to the dance hall," he says. "I'm in charge of the drinks, and I can't neglect my duties."

Judika feels insulted. "Oh, you're a funny one, too," she complains.

But Gregoria is still nowhere to be seen. Perhaps she's gone home.

Gotfred comes across Magnus and some other friends; they are flushed and hot from the dance and want to go outside now to cool down and have a drink together. They persuade him to go with them. The cognac bottle goes the rounds. Gotfred takes a great gulp. His pals all talk at once, and one of them starts singing dreamily:

> Invited to this wedding
> Were folk from far and wide
> There singing was and feasting
> And thousands danced with pride

Gotfred joins in, and they sing more verses . . . but then he thinks of Gregoria again and has to go off and continue his search.

In Kristoffer's sitting room he finds Morberg the solicitor. He is sitting all on his own by a table of empty and half-empty bottles and glasses.

"That's right," he shouts. "It's you I'm waiting for. Come here and sit down and I'll tell you the truth about everything. – You know, all these ballads, to Hell with them. They belong to the Middle Ages. They just hold us back . . . they're a dead weight we drag around as though it was a matter of life and death. We need to give pride of place to reason, not dreams. Cheers. We need rhymesters and people who can mock like you. People who can think!"

He leans back and lights a cigar stump.

"Just listen to all that over there . . . Bawling all about dreams. Homeless ghosts of Charlemagne and Sigurd the Dragon Slayer and Olav Trygvason! And things that are even worse still: trolls and giants and the little people. It's awful. And tomorrow they'll wake up worn out by dreams and deafened by their own yelling, and they'll slip back into their miserable peasant lives. They're satisfied with the wretched everyday life of the Middle Ages provided they can have the occasional pleasure of a colourful, sham Sunday. Cheers!"

The lawyer filled the glasses with a trembling hand. He was pale and much the worse for drink; his tongue refused to obey him when he spoke; his hair was dishevelled, but there was nothing wrong with his eyes – they were wakeful and unrelenting like the eyes of a bird.

"Perhaps it's the islander's fate," he went on thoughtfully, "living most intensely in dream! They experience so little in relation to what they miss . . . all the world out there around them. Unfortunately, I'm that type myself, I can hardly deny it. Cheers, young man, and keep well away from the mud and muck of dream. You see . . . no one has *dreamt* like I have. I've been one of those who've sold their good clothes for fool's gold and come home with a bag of mouldy bones."

The lawyer smiled and added confidentially: "Aye, I'm even one of those who have exchanged their fair and fine beloved for the subterranean spirits and been given a hundred troll maidens in exchange. Wild young troll lasses they are, seen in the moonlight with black hair. They're lovely. But at daybreak – oh hell."

Morberg got up and looked for a bottle from which to fill his glass, but all those he found were empty. He took one of them and smashed it against the others so the splinters flew and sang against the floor and the walls.

"Hey, behave yourself," Gotfred admonished him. He got up and twisted the bottle out of the solicitor's hand. "What sort of a learned man are you? I don't give a fig for all that twaddle or yours. You've sold your wife and got a hundred bitches instead, and now you sit there bellyaching about it . . . that's all."

"You're right," shouted the lawyer. "You spoke the naked truth. Come here; let me shake hands with you, young man."

"Yes, what have you done with that wife of yours? Where did you leave her in the lurch, you crazy devil?" shouted Gotfred. "If she's run off, it's because you've thoroughly deserved it."

"Oh, God help me," groaned the lawyer.

Gotfred took his arm, and they stumbled out of the room. Gregoria was standing outside beneath the window.

"Troll maidens," snarled Morberg. "No, bring Simona here, the bride.

Simona!" he shouted.

Gotfred let go of his arm and took hold of Gregoria. She timidly drew back from him.

"You're drunk," she said.

Through his haze, Gotfred sensed the tone of disappointment in her voice.

"Me? Drunk?" – He took out the abstinence badge and fixed it to his jersey. "At least I'm not drunk now," he laughed, but could hardly stand on his feet any longer." Those last shots must have been too much for him.

"You promised me not to drink," said Gregoria.

"I swear to you that I . . . that I've only drunk one glass," said Gotfred. He corrected himself: "Two glasses. Or three – four, five at the most, or six or seven. Eight, nine, ten eleven, twelve," he went on counting.

He almost fell over again. Gregoria quickly stepped over to him and took his arm.

"You'd better get to bed."

Gotfred made to put his arm round her neck, but she extricated herself.

"Troll girls," said Gotfred, laughing foolishly.

Gregoria managed to drag him over to the parish clerk's house.

"I'm not going in unless you come with me," shouted Gotfred holding his back up to the door.

"Of course I'm coming," said Gregoria.

She got him settled on a bench in the living room and took a blanket from an empty alcove and wrapped it around him.

Gotfred immediately fell asleep. Gregoria tiptoed out again and for a long time stood weeping outside the house.

XI

A breeze came in from the sea towards morning, dispersing the mist and the rain. The sun rose, naked and brick red, from

behind the horizon. There were still sounds of singing from the dance hall, but the chain of dancers was now quite small. Only a couple of dozen young men were holding out with the aim of singing the ballad of King Didrick and his warriors to the end.

They had no intention of going to bed. When they emerged from the dance hall and saw how magnificently the sun was shining, they began to play and frolic on the greensward outside. They performed somersaults and leapt about all over the place. A couple of them danced around alone, holding each other's arms and trying to tempt the others to make a ring and start a new ballad outside in the open:

> So early in the morning
> Splendid rose the sun from the waves
> Marita came from in the hall
> With maidens twelve in train.
> Let me rest in your arms,
> Sweet maiden.

"No, let's try wrestling instead," suggested Farmer Sverre. "Which of you dares to have a go with me?"

Magnus came forward and the wrestling match began. The others formed a circle around the wrestlers.

Sverre was a head shorter than Magnus and some ten years older, but he was as lithe as a cat and did not lose his balance even when he was lifted up and lost his foothold.

"That's right," the spectators shouted encouragement. "Just you go for him, Sverre ... remember David and Goliath."

The struggle became monotonous; the two opponents were each other's equals, and both refused to give in. Their veins stood out at their temples, and the sweat streamed down their faces. Frida Olsen and her kitchen staff appeared bleary-eyed in Kristoffer's doorway. Now Kristoffer and Farmer Rasmus showed themselves in the doorway. They followed the wrestling with uneasy looks on their faces.

"You can go on like that until midday," said Kristoffer. "You might just as well give up, and better now than later."

But neither of them would give in. They kept the struggle going for another quarter of an hour. The result was a muddy patch forming in the greensward under their feet.

"No, do stop, for God's sake," Kristoffer cautioned them. "You can do yourselves harm by going on like that. Are you listening?"

The wrestlers were breathing heavily. Magnus was pale, squeezing his eyes and mouth together with the supreme effort.

"Right, then we must separate them," said Rasmus. "Come on and give us a hand, lads."

To the sounds of laughter, the wrestlers were overpowered, dragged away from each other and laid out in the grass. There they lay groaning for a time. Magnus had blood in his nostrils.

"Leave them alone for a bit," said Kristoffer. "The rest of us can have a bit of breakfast while they catch their breath."

"That sort of thing *can* end badly," he went on when they had seated themselves around the table. "When two equals fight, they wear each other out."

After a while, Sverre and Magnus came in arm in arm like two brothers to the breakfast table.

"We'll get our own back on you all soon," said Sverre. "Magnus and I have agreed to avenge ourselves on you . . . Just you wait until after lunch, and then you'll all catch it."

But the threat was never carried out. When Sverre had eaten his fill, he went out into the field and lay down to sleep in the grass, and the others followed his example.

"Now you and I can have a quiet drink together," said Rasmus, winking to Kristoffer.

He leaned back and stretched. "Oh . . . being here at your house is just like being at home. But otherwise, times are changing . . . Those foreign dances are getting established in Storefjord, and they hardly dance anything else in Østervaag. Here in Kvandal at least we'll keep them out as long as I'm alive, I'll make sure of that."

Rasmus ran his fingers through his hair.

"And in general," he went on, "all the old ways are dying out . . . the old dignity, the good language. The new times have no respect for that kind of thing. But when we lose them, what have we left? . . . Oh well, the good old days are still alive and undisturbed on this island, thank God."

"Well, I don't know what to say to that," said Kristoffer. "I'm inclined to believe that we folk from Trymø are lagging behind all the others. We don't have a single motorboat between us, for instance: we have to row out to sea and back again when we go fishing, and that wastes both time and energy . . ."

"Aye, perhaps," said Rasmus thoughtfully. "There's more wealth in other places, but at the same time customs are being brutalised . . . the old values are being undermined, and what do we get in their place? You've got your old customs; you have faith in God; you sing hymns of thanksgiving when you come home with a catch; you bless the soil so it can bear fruit. The bigger places have their sectarian meeting houses and gramophones and ways . . . no! And the few folk who are able to adopt foreign customs cut the ground from under their feet and stand there rootless in their own country."

Rasmus had talked himself into quite an emotional state.

"Aye, I get irritated," he smiled. "And perhaps that's foolish of me. At least when I'm enjoying life and the spring weather on your lovely island. . . And besides, I'm getting old and no longer really understand how it all hangs together."

Other guests joined the lunch table. The farmer from Kvandal got up and went outside. There was already some strength in the sun, and the air was soft and clear after the dampness of the night. A haze rose from the earth, the stones, the roofs, indeed there was a fine haze rising even from Rasmus's own brown homespun jacket.

He lay down on the grass and breathed slowly and blissfully. He was surrounded by a host of budding daisies and tiny buttercups. A horse lay sunning itself down near the creek. It stretched out all its legs in the grass and settled down contentedly.

Suddenly and with almost painful clarity Rasmus

remembered what it had been like when he used to play in a flowering meadow as a little child. The flowers were big and warm to touch, indeed some of them could be eaten, and sucking the juice from them was like tasting the day and the sunshine.

The horse down by the shore had turned over on its back and lay there rolling happily in the grass, as though it, too, was intoxicated with spring and childhood memories.

Rasmus closed his eyes. There was a horse like that . . . now he suddenly remembered the old horse called Blanke that he pleaded for when it was to be shot. How happy he was that afternoon when his father had promised him that it would be allowed to live. It was a hazy summer's day; Blanke was down by the river drinking, filling itself thoughtfully and thoroughly with water. Then it went up along the river as though it had some special errand in mind. He followed to see what it intended doing. In a little hollow full of cotton grass and dandelions, Blanke lay down on its back and rolled in the grass . . . it was a remarkable sight. The great old horse grinned at him and snapped at the golden sun-like flowers in wanton abandon.

Rasmus smiled to himself and took a little book out of his inside pocket, a small, fat and shapeless notebook that he had made for himself. He wanted to see whether he could write a couple of verses about this old horse among the flowers . . .

XII

Young Gotfred woke up late in the morning. He had dreamt he was lying drinking from a brook . . . he drank and drank, but failed to quench his thirst. He pushed his head down into the water and then the upper part of his body, but he couldn't get enough.

Bit by bit the events of the previous day began to return to him, the rhymes at the table, the conversation with Landrus, Morberg . . . and how did it all end? Had he not also been together with Gregoria? And the abstainer badge, what had

become of that? It wasn't on his chest, and he couldn't find it in any of his pockets, either. So he must either have lost it, or perhaps Gregoria had taken it back.

He also felt ill and was beset by an uneasy feeling. Could Gregoria have given it to someone else?

"Oh, are you awake at last?" he heard his father's voice from the sitting room. "Everything in moderation," the old man continued in a reproachful voice. "You must learn to cope with drink if you want to be a decent respectable citizen."

Young Gotfred got up and quenched his thirst and washed the sleep from his eyes and hurried out. He had to go up to Landrus's shop and find Gregoria. The sky and the sea met in one great, gentle blue haze, and the clouds were clean and looked as though they were newly ironed. "Gregoria," he thought. It was as though his inside was nothing but a filthy, muddy track, full of footprints and puddles.

Landrus's shop window was half covered by a piece of cardboard on which was written in clumsy lettering:

FURTHER REDUCTIONS TODAY
On account of damage caused by a neighbour

Landrus was walking about inside the shop, shifty and round-eyed.

"Aye, that'll make them think," he said. "Now they can wriggle in the stocks a bit. Annette's already been here once and complained. They'll be sitting in there thinking of revenge now . . . I wonder what they'll cook up?"

Landrus was uneasy. He glanced up at the sign in the window.

"Well, what was I to do?" he went on. They who sow the wind shall reap the whirlwind, isn't that what it says?"

Some customers appeared.

"Gregoria," called Landrus.

Gregoria appeared. Her eyes were red and swollen. Gotfred felt it like a shaft through his heart . . . Could it be on account of him she had been weeping?

90

He asked for a bottle of beer, and as Gregoria handed it to him, he whispered, "Did you take the badge back, Gregoria?"

She nodded without looking up.

"Have you still got it on you?"

She nodded again.

"If you'll give it me once more, then . . . oh do give it me, Gregoria," he begged.

She merely shook her head.

"Gregoria," he whispered. "Please don't be so cruel . . . give the badge back to me. You know I'm leaving tomorrow . . ."

"Are you going already tomorrow?" she said and lapsed into thought.

"Gregoria," shouted Landrus.

She quickly took the badge from her apron pocket and handed it to Gotfred, still without looking at him, but with a tiny, almost invisible smile.

He fixed the badge to his jersey and whispered, "Can't we meet again this evening?"

She shook her head, but her tiny, closed mouth seemed to say something entirely different.

Gotfred emptied the glass of beer. He was happy and in high spirits again now that he had the blue badge on his chest.

In the doorway he met Torkel Timm, half drunk and grinning as he held his hand up to his nose.

"Are you going in to buy something?" asked Gotfred.

"No," said Torkel winking good-naturedly. "I've got a small matter to discuss with Landrus."

He stumbled into the shop. Gotfred remained at the door.

"Hey, Landrus," shouted Torkel. "What was all that about that man you murdered, you know – him from Nordvig?"

"Murdered?" said Landrus in horror. "Have I murdered someone? Oh, get out of here, you filthy drunkard."

"Ha, ha," grinned Torkel Timm. His beard was adorned with bread crumbs and the remains of other food. He was squirming with laughter: "You killed a man, Landrus. You're a murderer, so you are."

Landrus had turned pale.

"I know what you're getting at," he said with a quavering voice . . . "It was Ole the Valley who drowned in the stream the very evening we'd had a row in the shop here. But God in Heaven knows that I had nothing to do with his death."

Torkel leant himself comfortably against the counter and prepared happily for a lengthy argument.

"You wanted him dead," he said. "And you've got evil eyes."

Landrus smiled despondently. "Oh, mind your own business, Torkel . . . What was wrong with your mother Timothea? And in any case, how can you know anything at all about what happened that evening – you weren't there!"

"You wanted him dead," Torkel started to argue. "You did so, and that's why things went wrong for him. No sin can be kept hidden, you know, it'll emerge sooner or later, however much you try to hide it . . ."

Gotfred went over to Torkel and nudged him in the side: "How many drinks has Lars Dion promised you to make you come over here with this nonsense?"

Torkel realised he had been found out and tugged at his beard. Gotfred continued in a low tone: "Don't you let yourself be tempted, Torkel, for if the sheriff hears that you're going around accusing people of being murderers, it'll end with you yourself being punished as a murderer."

"Well, I've never known anything like it," said Landrus. He was scarlet. "And it's people like you, Torkel, that I provide for and make sure you can get your daily bread. Ugh."

"The sheriff," laughed Torkel and spat scornfully. "To Hell with him . . . did you see his wife yesterday, the way she'd decked herself out?"

"Now listen here, Torkel," said Gotfred. "You and I are going to go now. There's no point in hanging around here."

"Aye, if you'll stand me a drink, I'll go with you, Gotfred," said Torkel, clinging on to him.

Landrus shook his head. "It was strange, so it was," he said to himself. "But my conscience is clear."

Shortly afterwards, he went and removed the sign from the window.

Gotfred and Torkel went to Kristoffer's house. There was a crowd of visitors there who had come to have a final meal and to take leave of their hosts. Morberg was giving a speech for Simona.

"It's undoubtedly the greatest experience of my life," he said. "To have had the opportunity to see her as a bride. She's the sun around which everything revolves. The rest of us are dead moons circling around, cold and meaningless when she doesn't endow us with some of her warmth."

"Poor us," commented the sheriff.

Morberg turned to him and snarled, "Don't interrupt me, nonentity that you are." He continued, directly addressing Simona: "No, we fall to our knees before you, the woman over all women. You are the kindly Alma Mater, the fundamental principle of nature. We bow down in the dust before you. We kiss your feet."

Morberg fell to his knees and made to kiss Simona's shoe.

"No, Morberg." Simona gently pushed his head away, but he determinedly caught hold of her ankle and pressed his lips to it.

Sylverius laughed and shook his head ... that Johan Morberg had so many curious ideas. But the sheriff gave a shriek and then burst out laughing. Morberg got up and shouted, "Hey, what the devil are you laughing at?" But at that moment it was as though a sunbeam fell on his features, and he smiled: "But incidentally – you, too, deserve a word of praise. Just look at this really handsome face."

He drew in the air: "The fine line of the nose, the curved eyebrows, the jet black hair and these completely witless and brutish eyes."

"What did he say?" spluttered the sheriff.

"You are as fresh as sin, despite all outward affectation," Morberg continued. "There's something about you as though you've been abducted, something fascinatingly abducted as though you've been *carried away* ... You must derive from Turkish pirates; you simply don't belong here in this cold and foggy maritime clime. You are ... You are ..."

"Well, now we've heard enough, Morberg," the sheriff

interrupted him. "I don't think there's anything more to be said about that. You'd have been a wonderful speaker if you'd been a little less – addicted."

"Cheers," shouted Morberg. "Cheers to the little Turkish lady."

The sheriff's wife enthusiastically chinked her glass against his and gave her husband a mollifying wink. "Oh, we're not taking him seriously today."

"Brutish eyes!" whispered Torkel Timm. He squirmed and held his beard up to his mouth to stifle his laughter.

XIII

The sheriff's party took their leave and went aboard the motorboat from Storefjord, which had come to fetch them. Some other people from Kjovø made use of the opportunity to get home by this convenient means. During the late morning there was a general exodus of wedding guest; boats were floated and sails set. Only about fifty of the younger guests had no intention of leaving, and they gathered on the dance floor, where they danced to comic ballads until far into the night. . .

Young Gotfred went around looking for Gregoria. She was not in the dance hall, and the lights were out and the doors locked in Landrus's house. She had probably gone to bed. But neither had she expressly promised to meet him. Surely she had even said no. He had probably read her face wrongly. Perhaps she wasn't interested in him at all and had given him the badge back just to get rid of him.

Gotfred wandered around until midnight with a vague hope that she might come after all.

Down by the landing stage he happened to come across Judika.

"Oh, but you were drunk yesterday," she laughed, shaking her head. "Do you remember you helped me to get that ring back? . . . And then you went on drooling over poor Gregoria . . . You really must remember that you're a grown

man, and she's only a child. Between you and me, it didn't look good."

Gotfred made no reply. Judika went on, full of maternal admonishments. "You're too good to go around making a disgrace of yourself, Gotfred. And your sisters saw it . . . I can assure you they weren't pleased . . . Oh, sorry if I'm interfering."

"Since when have you been such a pious lamb?" laughed Gotfred.

"Oh, you needn't make fun of me," said Judika with a little sigh, adding in a broken voice, "And as for the ring . . . I lost it after all . . ."

"Oh, so who got it?" asked Gotfred.

Judika tapped his arm: "Got it? I'm telling you I lost it, it disappeared, I don't know how . . . and it was such a lovely ring, I got it from my brother for my confirmation."

"Was it real gold?" asked Gotfred.

"Perhaps not, but there was such a lovely blue stone in it, a genuine stone."

"Listen," said Gotfred, taking her hand. "You're a really nice girl, Judika, and I'll give you five kroner for a new ring."

"Oh, that's far too kind of you," she cried out in delight and threw her arms round him.

Gotfred took out his purse and gave her a five kroner note.

"And now, good night, Judika, and sleep well," he said and pressed her hand.

He drifted on, full of self-pity deep down inside . . . alas, he would perhaps never see little Gregoria again. Perhaps he had seen her troubled brown eyes today for the last time.

In the passageway behind the dance hall he came across Josva.

"What are you doing here?" said Gotfred. "I thought you were dancing."

Josva made no reply. He stood leaning against the wall.

"What on earth's wrong with you?" asked Gotfred, shaking him by the shoulder. "You're surely not standing out here crying?"

Josva turned towards him. He was dead drunk.

"Oh, it's like that, is it," said Gotfred. "You've left it rather late to start making merry."

"You see," explained Josva in a maundering voice. "It wasn't for my sake she came . . . but then it doesn't matter . . . and I'll guarantee I told her a few home truths, you see, 'cause I said that I could have fished him up, but I left him lying there like the stupid ass he is, and . . . and . . ."

Gotfred took his arm and got him home. He himself drifted around for some time longer, uneasy and tired. Only when the morning came again did he go to bed. A couple of hours later he was awakened by Magnus, who was already dressed and ready to leave. He quickly put on his seaman's clothes and downed his mother's hot coffee.

"I suppose you've remembered to take a Bible with you?" asked his father.

"A Bible? Yes, I've got one in my chest."

But there was something else he had forgotten in his hurry – the blue badge. He ran back into the bedroom and rummaged through his Sunday clothes.

"What's he looking for?" he heard his father ask. And his mother replied, "I think it's the blue badge he's been wearing for the past few days."

"Listen, Gotfred," his father said. "Why all this hypocrisy? Either you're an abstainer or you're not. You go there, decking yourself out with an abstinence badge, and yet everyone's seen how tipsy you were yesterday evening, to put it mildly."

Gotfred had found his badge and put it in his pocket. He didn't know what to answer, but his mother came to his aid: "Good Lord, we can all make a mistake. Provided the good intention's there, the rest will take care of itself."

Young Gotfred took leave of his parents and sisters before hoisting his seaman's chest on his shoulder. There was smoke issuing from Landrus's chimney. Gregoria was standing in the doorway of the shop.

"While I think of it, Gregoria," shouted Gotfred. "Can you let me have a box of matches?"

She fetched a box and handed it to him. He put the chest down and looked in his pocket for money.

"Well, goodbye, Gregoria," he said.

She made no reply. He glanced at her and saw she was on the point of tears.

"What's wrong, Gregoria?" he said. He wished he could take her in his arms and carry her off somewhere where they could be alone. But there was no chance of that.

"Gregoria," he said, taking the chest up again – "Will you be faithful until we see each other again?"

She nodded and helped him fix the chest on his shoulders, and he used the opportunity secretly to stroke her thin arm. There was no opportunity for other fond expressions.

"Well, goodbye," he said and hurried off in his heavy, clumsy seaman's boots.

"Let's hope he doesn't fall over," thought Gregoria half way between laughter and tears.

FALLING DEW IN
DISTANT VALLEYS

I

The last guests had left, and everyday life was returning to the
island. However, the weather remained just as splendid and
festive, with sunny days and mild, misty nights. The meadows
were beginning to ripen and turn red and feathery. Dan-
delions and camomile flowers were resplendent by the river
bank, and up on the mountain sides there hung whole gardens
of tender, pale green rose-root over the bare rocks. From early
morning when the sun broke through the mist to late evening
when it sank into the sea far to the north, the sound of the
happy and exuberant trills of the whimbrel could be heard.

People were also making the most of the good weather.
They slept as little as possible. Such a summer was a rare
occurrence, a gift from God, and not an hour must be wasted.
Peat cutting was in full swing; it was a golden time for the
children, who were allowed to go up into the mountains and
help to stack the peat. And many old people left their homes
and surrendered themselves to the long and difficult walk into
the mountains. By midday, blue peat smoke was rising into
the air far and wide from the hollows and the banks of streams
in the outfield.

Nor did Landrus take it easy. From morning to evening, his
wary voice could be heard down on the beach, where the
salted fish lay shining like spring snow. Sometimes he admon-
ished earnestly and emotionally, and sometimes he grumbled
and uttered terrible threats. It was not easy to please him. All
living things that approached the shore without some connec-
tion with his task of drying the fish were viewed with animos-
ity and met with warnings, and every cloud that appeared
behind the horizon was followed by plaintive, suffering eyes
until it was judged not to have any evil intent.

For several years, Landrus had dried fish for Niklas Næs, the merchant from Holmvige. Niklas had gone bankrupt now, but Landrus had gone on drying fish on his own account. In April he had bought a large quantity of salt fish from a small boat from Sandfjord; a lot of work had gone into it, and a great deal of money was at stake. Landrus spent his days on the drying grounds without taking a break. He had his meals while walking about and talking. Only after sunset, when he was behind the counter selling goods to the workers did he relax and utter a few encouraging and appreciative words.

"You've done well today," he could say. "And in time you might become quite cunning. For cunning's what's needed . . . you've got to tempt the sun and grovel for it, you see. But it's a really healthy job, is this . . . it does both your hearts and lungs good. The sun gets rid of any sign of illness, and not a single germ's left behind, not even the smallest germ's egg. Healthy young people. That's how it is."

II

About a week after the wedding, Kristoffer went to Sandfjord to fetch his sister Oluva, who had promised to come and keep house for him now that Simona had left.

Oluva had had a sad fate. Five years ago, her husband had been lost at sea, and scarcely a year later she had lost a nine-year-old boy, their only child. The last time Kristoffer had seen her, she had indeed seemed broken and aged. But a great and remarkable change had come over her now . . . She had joined the Adventist community in Storefjord and had been converted, as they called it. Kristoffer hardly recognised his sister. She looked years younger.

On the way back to Trymø, she told him how her conversion had come about. She'd been filled with grief and so low that she wished she were dead. She'd felt there was nothing else to live for. But then she'd gone along to an Adventist meeting and liked their singing and the things they said. And then suddenly, one evening, it had become clear to her that

life here on earth could only be seen as a preparation for the life to come. Judgement and eternity were close at hand . . . it was simply a matter of passing the test of life and winning salvation for eternity.

Kristoffer nodded.

"How right you are," he said seriously.

But then a strange little smile appeared on his sister's face.

"But as for salvation," she said quietly but with authority, "it must be *experienced*. You've got to undergo a conversion."

Kristoffer nodded thoughtfully. He sensed where she was going. These sectarians believed that the only ones to be redeemed were those who confessed to their own special faith.

But it was nevertheless remarkable to see how a conversion like this could change a person. Oluva had learned to cope with her loss and her eyes were brighter. As a child she had been of a cheerful but somewhat difficult disposition. She had been argumentative . . . Kristoffer remembered that she had once spent the better part of a day at an open window arguing with some friends outside. And rumour had it that life between her and her husband had not been without its problems.

But poor Oluva had had her time of trial, and it was good that she had now surfaced again after the hard blows that fate had dealt her.

III

Some time before Whitsuntide, Kristoffer went to Holmvige, partly to visit his daughter, and partly to look at a ship's motor that Sylverius had got hold of for him. Josva stayed behind on the island . . . he made the excuse that he hadn't time to go. Surely there was not such a rush with the peat cutting, his father thought, wondering once more at the curious change that had come over his son.

Josva never used to like hard work. As a boy there had been something almost lazy about him, but now he seemed all at

once to have been taken by a virtual work fever. He had undertaken to clear a piece of stony outfield up on Spirit Hill – an almost hopeless task that it was also difficult to see much point in, as there was such a thin layer of soil there that it would almost be impossible ever to turn it into a decent field. Although he said nothing, Kristoffer had been quietly surprised at this strange idea of Josva's. He had thought he would tire of it before he had got half way. But Josva had shown himself to be more determined than his father had imagined, and with every passing day he had cleared and trenched a new piece, and there was nothing to suggest that he was going to give up. For the last few days he had given this work a rest while he helped his father to cut peat, but he was going to start on it again after Whitsuntide.

. . .The big farmers had their peat grounds in Weaver's Valley, a hollow lying high above the western side of the island. One day, Josva went this way in the hope of catching a glimpse of Hilda. Harald and his people were busy collecting the peat and stacking it. Birita was there, too, sitting by a small fire and heating coffee for the workers. But of Hilda he saw no sign.

Josva went to his work. He took food with him and did not return to the village much before evening. He again went by way of Weaver's Valley. The folk from the farm had gone home. Up on the hillside, near the great stone standing red and warm in the sunset, the cattle had settled down for the night. There was nothing living to be seen in the valley apart from a little brook that was sparkling rapturously in the evening light.

But on his way home he met Hilda. She was with some milkmaids. Josva glanced at her. She was looking the other way and appeared not to notice him until she suddenly turned towards him, with smiling and almost closed eyes. He felt overwhelmed . . . never before had she looked at him like that!

As soon as the girls had disappeared beyond the crest of the hill, he hurried back, but taking a different, higher path so

that he was out of sight. He made his way carefully between boulders and heather-covered hillocks until he came to a place where he could lie hidden and look down into the valley.

It was not long before the girls came into view and started milking the cows. Trembling, Josva drank in the sight of Hilda . . . what a fine figure of a woman she was, and how dark her hair! And there was no misunderstanding the sign she had given him . . .

Her legs were bare like those of the other girls, and she was wearing a white woollen scarf over her shoulders. Every movement she made filled him with secret delight. And look, there she was going across to the great stone.

"Let's see whether Erla has any secrets to tell us this evening," she laughs.

"No, please don't," the other girls shouted in fright. "Don't touch the stone, Hilda!"

But Hilda puts her ear to the boulder and listens. Before long she shouts, "Hush, she's waking up in there . . . I can here her starting to move."

"Come back," the other girls shout, lifting their tubs on to their backs.

But Hilda puts her lips close to the stone and in a plaintive voice says, "Tell us something, dear Erla."

"If you don't come straight away we'll run off and leave you," shouts one of the girls.

Hilda waves reassuringly and pretends to listen.

"Wait a bit," she says. "I'm going to get Erla to tell me what the future holds for you."

The girls scream and start running down the slope so the milk splashes about in the tubs. The cows grow restless and start bellowing. But Hilda stands by the stone quite unconcerned.

"Hilda," shout the girls from down in the valley.

But Hilda stands there as though bound to the spot. Josva wishes the other girls would go home and leave her behind alone. But they probably daren't. The thought strikes him that Hilda might take it that he's not far away and will try to catch

her. He is trembling with excitement. Now she is climbing up on the stone.

Josva gets up in the heather so she can see him. For a long time she stares in the direction in which he is sitting. Then she gets down off the stone and starts running down the hillside and on through the mountain meadow.

"Hilda!" shout the horrified girls from down in the valley.

Josva gets up and runs to meet her. He finds her by the bank of a little brook, where she has sat down. She is out of breath, but waves: "Now they think the little people have got me."

Josva has a feeling he is dreaming. Here is Hilda . . . he is alone with her up in the wilds. "She's mine," he thinks in confusion. He would have put his arms round her and held her close, but he stops hesitantly a couple of steps away from her.

"You're teasing them all right," is the only thing he can think of to say.

"Oh, that'll do them good," she replies. "But I'd better hurry back, otherwise they'll only go home and say I've been taken by the fairies, and then Father will come looking for me . . . How are you otherwise, Josva?"

She gets up and gives him a kindly look.

"The sun's really caught you," she says.

"Yes, we've had sunshine every day for a long time now," replies Josva, blushing at his own awkwardness.

They are standing face to face. He feels that he ought to hold her tight now . . . but perhaps she would think it ridiculous if he behaved like that. She is looking at him quite differently now from what she did before when he met her together with the other girls . . . these secret, half-closed eyes. They are now open and look quite ordinary. And it strikes him that he used to think they were black, but now he can see they are pale green. And how pale she was, abnormally diaphanous skin, and a nose that was perhaps just a little too big for her face. Was this really Hilda standing there? He had dreamt about her fine, sad mouth – she had big, slightly cracked lips. And yet, yes it was she, her dark flowing hair and fine white arms.

"Hilda!" come the shouts from down in the valley. And the shout is echoed all around: Hilda . . . Hilda . . .

"No, I must go, otherwise I'll be found out," she says with a smile.

"Can't we meet . . . later . . . tomorrow?" asks Josva.

"Yes," Hilda thinks for a moment. "Tomorrow evening about this time . . . up here . . ."

"Hilda!" the shouts are closer now. The girls were obviously on their way up the hillside.

He kisses her forehead and her mouth.

"Yes, tomorrow . . . is that a promise then?"

She nods and smiles. And now it is again that hidden, magical smile. Then she runs off down the valley.

He follows her with his eyes until she is completely out of sight. He has no desire to go home. The sky is like a huge sea of red and gold, full of merry islands and skerries.

"She's in love . . . in love, so much she can hardly contain herself" – the words seem to sound gently in his ears. Well, it could have been pure imagination on the part of Daniel. She had probably not been in love with him, merely let him play with her a bit.

Josva feels both arrogant and cowed. Perhaps Hilda was one of those who liked to surrender to them all, as though in a game. He was not far from thinking that things had been too easy for him.

The dew was falling. There was a light, transfigured look to everything, and it all seemed lost in blissful thought.

IV

Josva had little sleep that night, and for all the following day he went round in a happy cloud. It was Whit Saturday. The church bells rang towards evening. There was a light covering of mist over the village, but up in the mountains the sun was shining.

"Tomorrow evening about this time," was what Hilda had said. But would she come alone or together with the milk-

maids like yesterday evening? And would she be with him for long, or just pop away for a brief moment while the other girls were waiting down in the valley? He was so hoping she would come alone.

Josva went up on to a ridge from where he had a view across Weaver's Valley and the little hollow with the brook where they had met the previous evening.

The cattle were down in the valley. A fine haze was rising from the peat bogs, dispersing in bluish wisps. The girls came towards sunset. Hilda was not among them. So she'll not come until the others have gone, he thought. Or perhaps she's gone another way.

The sun dipped into the sea. The mist down in Weaver's Valley slowly condensed into a sea of fog. He saw the girls emerge from the fog like a succession of sea people appearing near the beach and going ashore.

The sea of fog spread further and further. Now it was spreading out and sending arms south, as though it wanted to bring the girls back.

For a moment, Josva thought that Hilda might have hidden somewhere down in the valley to wait until the other girls had gone home and had perhaps got lost in the fog. He could go down and call out to her, of course. But she was probably far too familiar with the place to get lost. Besides, the fog was thinning now. It was spreading out in all directions and dissolving into a translucent mist. The valley gradually emerged and could clearly be seen. The cows had settled down there on some greensward dotted with cotton-grass.

Josva got up and looked around. No, Hilda couldn't be coming. She must have changed her mind. Perhaps her parents were keeping her at home. It was Whit Saturday . . . perhaps she hadn't remembered that yesterday evening. Or . . . she might also have regretted promising to come and so broken her word.

Josva began to feel disappointment gnawing at him. He seemed to become wide awake. The silent evening world started to have its own voices, and the sound of the babbling brook became unnaturally loud, as though a new spring had

suddenly issued from the ground. The sea, too, was moving, sighing heavily and hard like someone disturbed in sleep but not waking up.

No, whatever the reason, Hilda had not come.

Josva stretched out in the heather. There was a scent of thyme, summery and soothing. But suddenly he got up, cupped his hands and shouted "Hilda!"

The echo came back, first from somewhere close by and then further away.

"Hilda!" he shouted again, and the two echoes answered and carried the cry further out into the night. The last echo sounded faint and distant, as though coming from deep within the mountain.

He went down to the edge overlooking Weaver's Valley and loosened some stones and sent them rattling down. They tore long black streaks in the greensward, hitting other stones and creating a din that echoed around in the mountains. But then there was silence again, descending like deafness on his ears.

Josva went down to the Weaver's Valley stone. The great boulder looked alive now in the nocturnal light. The mountain sorrel at the top of it was moving quite gently in the weak breeze. As a child he had occasionally played by this stone together with other boys. They would place their ears against it and listen. To see whether they could hear the girl within. But you mustn't try to get her to talk to you. She had the power of prophecy and could look into the future, but she gained power over anyone to whom she told anything. As a child, Josva had sometimes dreamt of Erla the Raven and formed his own picture of her. She wore grey, silvery clothes and a necklace and bracelet of mat, misty silver. She sat staring ahead with sad eyes, and the sinister raven with the white head was her only companion. She was cold and filled with bitter longing in her chilly stone. But she was lost, and no one could free her from her evil fate.

Josva went across to the stone, leant against it and whispered, "Erla. Let me come into the stone to you."

He recalled the image of her: She was black and white, only

106

black and white . . . her eyes black, her cheeks and lips white, hair black, arms and legs white, the fine body as white as foam. Nothing in the world was as fine and delicate as Erla the Raven, the girl of the shadows, who sat in the stone and was eaten away by everlasting longing. She was full of tenderness and a need for caresses, but she was lost for ever.

A moth came and settled on his hand. It was silvery grey with black and white markings on its wings. "That's her greeting to me," thought Josva. The little creature's antennae were trembling and it was shivering as though it was cold. It soon flew away again.

It was long after midnight now. The grey sky was again beginning to swell with light in the north-east. Josva went slowly home. A golden plover followed him for part of the way, singing quietly and amicably. Before going down the mountain he turned round once more and looked across the high mountain landscape. It lay there completely silent and deserted . . . valley after valley, green and wet with dew. Further away he could see the blue mountain range on Husø, and behind that again other groups of mountains, distant islands that could only vaguely be distinguished. There, too, there must be green, untouched valleys where the dew was falling.

The line of a ballad came to mind:

> The dew falls in distant valleys . . .
> Gentle maiden,
> Shall we ride in the vale?

RAIN

I

The sea is not a friend of the sun. It envelops itself in murk and damp if the heat becomes too great; such is the nature of water.

From his drying grounds, Landrus kept watch on the unreliable sky with increasing bitterness. The sun remained mostly absent for some days, showing up only now and then as a colourless moon up in the grey heavens. And then one night it started to rain . . . a fine, dense drizzle. Landrus was wakened by the quiet, monotonous sound. There was no mistaking it . . . this would put a stop to his fish drying, and now he would be forced to sit and twiddle his thumbs along with half the village. He abandoned himself to sighing hopelessly.

Lars Dion woke and put his ear to the wall. He heard his neighbour complaining: "You say the rain's good for the soil? What does the soil concern us? Who benefits from the soil here on Trymø? Farmer Harald. And then Gotfred and Kristoffer to some extent – they've got a bit of land. And that's all. But prosperity in the village stands and falls with the trade monopoly. The monopoly buys the fishermen's fish and pays them for their work, and that brings money and wealth to the island. What would Redstones Ole and his wife and ten children have to live on if they hadn't got the monopoly to fall back on when everything else fails? And other poor people as well . . . Elias from the River House and *his* flock, or poor Torkel Timm, or Jakob the Granary? Oh well . . . I'm not just saying this in praise of myself, it's something God knows all about, so it's up to Him. But let's hope this is only a shower; then the soil will get what it needs, neither more nor less, and the rest of us won't go hungry because of it . . ."

But this was no modest shower. The following day it rained heavily and incessantly; the stream started to overflow its banks, and the inlet was coloured by brownish soil and gravel brought down by the swollen mountain torrents.

One dark rainy morning saw the arrival in Trymø of Balduin, Lars Dion's eldest son, to take over the post of teacher, which had been vacant for some months.

Balduin had attended the teacher training college in Østervaag for three years. He had changed a lot during that time. Each year he had come home on his summer holidays had shown a change in him. Before he left, he had been a strange, pale, long-haired youth who always went around alone and looked as though he was cold. Now he had filled out and was broad shouldered. He held his head high; he had lost most of his hair, and his forehead had become high and stern, but his eyes were curiously gentle and kind.

Lars Dion and Annette both felt a little unsure of themselves in relation to their son.

"You look so clever with those glasses," said Lars Dion. "You almost look like a parson."

Balduin smiled: "Don't say that, Father . . . If there's one thing I don't want to look like, it's a parson."

"Why not?" asked his mother.

Balduin hesitated: "Well . . . you know I'm not very fond of the clergy."

Lars Dion laughed: "No, by God. But you've not gone and become a pure heathen, have you?"

"Heathen," said Balduin, savouring the word. "No, not exactly that either."

He seemed to fall into deep thought, bent his head over backwards a little and relaxed his entire body.

"There, now he looks like he did as a little boy," laughed his mother.

Balduin straightened up. He gave his parents a benign look. But there was something unfamiliar about his eyes that they were unable to fathom.

"It doesn't matter," thought Lars Dion. "There's something of a parson about him whatever he says."

"It's a pity about that last teacher's poor widow," said Balduin. "She's lost her son now, too."

"Yes," sighed his mother. "And her daughter's in bed all the time . . . I suppose she's got the same."

Balduin put his hand to his forehead.

"It's terrible when misfortune afflicts people like that," he said.

"Yes," said Lars Dion. "That family's suffered a hard fate . . . a really hard fate."

He drummed his fingers on the table and audibly drew a deep breath. "But what about now you're moving into the teacher's house? It'll have to be thoroughly cleaned. And yet . . . when consumption's once taken a house over it's probably not easy to get rid of it again."

"I haven't thought of moving into the teacher's house," said Balduin. "I can find somewhere else to live. And besides . . . we can't just put those poor people in the street."

"As for that," argued Lars Dion "you've no duty to let them go on living there. Magdalena gets a widow's pension and can manage all right. – But of course it's up to you if you want to rent the house to her . . ."

Balduin nodded absent-mindedly.

"Now I come to think of it, it might be an idea to go up and have a talk to Magdalena," he said shortly afterwards.

II

Magdalena had been expecting a visit from Balduin and had tidied up the sitting room to make it comfortable. She had lit the stove to get rid of the clammy feeling resulting from the damp weather, and she had put a vase of fresh columbines on the table.

Balduin nevertheless felt slightly awkward when he had sat down on the little plush sofa and found himself facing an enlarged photograph of the late teacher. Three years ago, Ole Just had apparently been in the best of health. He was a tall, slightly shy man with almost feminine wrinkles around his

110

eyes. His son had nothing wrong with him then, either; he was one of the liveliest boys in the village. And now they had both gone. Their bodies had lain here in the sitting room. Balduin imagined the open coffins. And he thought of the drawn-out hymns that had filled the cramped room . . .

Magdalena came in with a tray of coffee and cakes. Grief had made her features hard and coarse; her smile was strangely out of place in her face.

"You're perhaps thinking I've come to take over the house?" said Balduin. "But it's not like that at all. I'm a bachelor and I don't need a whole house to live in. I've been thinking of furnishing a room in the attic above the school."

"We can't possibly ask you to take us so much into consideration," said Magdalena. "But to tell the truth . . . I've been wondering a lot where we could move to when you came, and I've been at my wits' end. If I'd been on my own, I could have found somewhere to go – for instance my sister in Kvandal or my brother in Sandefjord. But who wants to have a sick child in the house, especially when she's got such an infectious disease . . ."

"Perhaps you ought to send your daughter to the sanatorium in Østervaag," said Balduin.

Magdalena's face became twisted at the thought.

"Yes, Gotfred has advised that on several occasions. But what then . . . I can't go there myself, and I can't persuade myself to leave her entirely in the hands of others. I tend her and look after her as best I can in accordance with the doctor's instructions. No, if Jane and I can't be together, it will simply be awful . . ."

"Yes, but you could visit her in the sanatorium," suggested Balduin. "And besides . . . just think how happy you would be to get her home when she's well again."

Magdalena calmly shook her head and half closed her eyes. She leant over towards Balduin and whispered, "I don't think she can get better again. She's going to go the same way as the others."

Balduin felt a cold shiver run down the back of his head

111

and his back. He didn't know what to answer. Magdalena stared ahead with calm conviction in her eyes.

"But surely that's not certain," Balduin attempted to comfort Magdalena. "And, well, in any case . . . as far as I'm concerned you can live here as long as you want."

"Oh, I'll be so grateful if you'll let me rent the house for the time being," said Magdalena.

Balduin smiled: "Oh, as for rent . . . I'm not in need of the money."

"Oh, that's too much," said Magdalena with tears in her eyes. "I can't accept that."

"I'd have liked to say hello to Jane, too," said Balduin. "But . . . perhaps it's not convenient to her now?"

"Oh yes," said Magdalena elatedly. "She'd love it. She has so few visitors. But I didn't want to ask you to go in to her . . . some people are so frightened of the infection."

Jane lay in the other room in a scoured white bed over by the window. She gave a big, tired smile that lingered on her face for a long time. Three years ago, Jane was a fourteen-year-old girl who played hopscotch together with the other children in front of Landrus's shop. Now she was a young lady with the thin features of a grown woman, but her eyes were still full of childish spontaneity. As she lay there with her pale hair and bright face, there was something curiously, almost supernaturally beautiful about her. Balduin could scarcely believe his own eyes, and he didn't know what to say. They looked at each other for a long time, and again he felt this shiver down the back of his head and his back. Magdalena's whispered words of a moment ago still rang in his ears: "She's going to go the same way as the others."

He suddenly had an idea: "Do you like picture books, Jane? I've got some you could borrow."

Jane looked at her mother.

"Well," explained Magdalena. "The only thing is that books can carry infection . . ."

"I'm not frightened of that," said Balduin. "Besides, I've so many books that she's welcome to keep some of them."

"Thank you so much," said Jane, looking at him with her child-like, grey eyes.

"I'll come with them tomorrow," said Balduin. He pressed Jane's hand. "Goodbye."

"However shall I repay your kindness to us?" asked Magdalena as she went to the door with him.

Balduin shook his head: "Oh, it's nothing." He added, "And perhaps I've got some other things Jane would like to see . . ."

III

"Well, what did you decide on?" Lars Dion asked his son when he came back.

"Aye, Magdalena's going to live there for the time being," said Balduin.

Lars Dion nodded.

"I'm letting them live there rent free," said Balduin.

"I see . . . if you can afford to." Lars Dion shuffled uncomfortably. "Your mother and I were just saying how good it is that you've come back here and not got a job somewhere else . . . because if we're going to make ends meet we're going to have to rely on a bit of help from you."

"Yes, I've thought about that, too," said Balduin.

"Aye, for these are bad times for a poor smallholder," continued Lars Dion. "There's not much to be earned on the island here if you're not either a farmer or a shopkeeper . . . or have a rich man as your son-in-law like Kristoffer."

"Did you go in to see the sick girl?" Balduin's mother interrupted.

"Yes," said Balduin and gave her an enquiring look.

"You should take care not to catch it," said Lars Dion. "It's a nasty disease to catch."

Balduin stared ahead absent-mindedly. It had stopped raining for a moment. The inlet lay motionless like a black mirror.

Lars Dion glanced at his son and thought to himself, "This

is obviously *his* way of doing things. He's a man of few words."

He cleared his throat impatiently and said, "Quite a lot's happened since you were last here."

The parents now started telling him about this, that and the other . . . about the wedding, which had been pretty grand, although it had obviously been done purely on the basis of help from Sylverius; about conditions at the big farm, where the parents and their daughter were always at each other's throats; about Daniel, the farm servant, who had got Redstones Inga into trouble and then turned Hilda's head. Neither did they forget to tell him about Landrus and the outrageous notice he had had in the window.

"What do you think?" asked Lars Dion cautiously. "What should one do about that kind of thing?"

Balduin raised his eyebrows cautiously.

"You don't do anything, of course," he said.

Lars Dion laughed: "Ha, ha . . . when someone hits you on the left cheek, you're just to turn the right one? But you bet I got my own back . . . in a quiet and decent way of course, for I always do things decently."

He told his son how he had used Torkel Timm to persuade Landrus that he had been responsible for Ole's death merely because he had wanted it.

"Well, what's the point of that?" asked Balduin somewhat impatiently.

Lars Dion got up and tossed his head: "Do you think I ought to take all his insults and just sit back quietly? I'm simply not as easy-going as that. And I'd like to know if you would be if you were in my place."

Balduin looked out of the window and made no reply. This eternal bickering with his neighbour was ridiculous. He wouldn't put up with it. Besides, he had always considered Landrus to be a poor unintelligent creature that everyone went around mocking and whom one ought to feel deeply sorry for.

IV

Later that day, Balduin payed a visit to their neighbour.

"Hello, Landrus," he said amiably. "I see you've got some tobacco pouches in the window."

Landrus gave him an ambiguous look expressing both distrust and a desire to sell something.

"Tobacco pouches, yes."

He fetched a box containing four red rubber pouches.

"They're the sort that close themselves," he said.

Balduin noticed that the pouches had been patched.

"Yes, they've been torn," Landrus told him. "But I've mended them with a bit of fish glue, and now they're as good as new. And you can even have them for half price."

Balduin bought a pouch.

"Have you got any tobacco as well?" he asked.

Landrus fetched some small packets of tobacco and put them on the counter.

"They're reduced as well," he said.

"So what's wrong with them?" asked Balduin.

"Well the box they were in fell in the water while it was being unloaded. But the tobacco tastes better rather than worse for that. I'm always going to put a couple of grains of salt in the tobacco before I smoke it in future . . ."

Balduin bought a bag and also a long pipe with a flowered faience bowl.

"Aye, you're looking at the bowl," said Landrus. "It's been broken, but I've riveted it . . . Haven't I made a good job of it? You can have that pipe at a reduced price, too."

Landrus was grateful for the sale and said appreciatively, "Oh, so you're finished with your studies, Balduin, and you're going to pass your learning on to others. What does your father say to having such a learned man in the house?"

"Aye, can't you two make things up?" smiled Balduin, immediately touching on the sensitive spot.

"Make things up?" – Landrus drew back and his gaze darkened.

"Yes, it's such trivial things you're quarrelling about," continued Balduin in an amiable voice.

"Trivial things?" – Landrus opened his eyes wide. He had difficulty controlling himself, and his hands were trembling.

"No," he finally said. "They're not trivial things, Balduin. And I won't discuss them with you, you understand. I think and hope for your sake that you're different from your family. But make it up – never!"

Balduin felt that there was little he could do, at least for the present. The forces at play here were not to be tamed by a little kindness alone. He put his purchases in his pocket.

"We'll see, Landrus."

Landrus turned his back and made no reply.

On his way home, Balduin met Judika from the River House. She came across and shook hands with him and wished him welcome home.

"You're a really learned man now," she said with an admiring smile.

It was some time before Balduin recognised Judika, who had grown big and shapely. The familiarity with which she greeted him surprised him a little ... as far as he could remember he had never before exchanged a word with the girl from the River House.

"How are things at home?" he enquired in a kindly voice.

Judika shrugged her shoulders: "Same as always. And what about you, Balduin?" she added with a smile in her eyes. "You've not brought a wife or fiancée with you?"

"No, I'm neither married nor engaged," said Balduin.

"Then it's about time you were," said Judika. "You're getting on ... you must be thirty or more by now?"

"Thirty-two," said Balduin.

"Then you're almost old enough to be my father," laughed Judika. "Though perhaps not quite."

"Hardly," said Balduin. He blushed and felt a little uncomfortable at the thought. "Well, I'll look in and have a talk to your father one day," he hurried to add. . . . "Goodbye, Judika."

"Goodbye, Balduin."

Judika shook hands with him again, and held his hand in hers rather longer than was necessary.

V

Balduin set himself up in a room in the loft above the school. It was not big, but it would suffice. There was at any rate room for a desk, a bookcase and a bed. The window was to the south, with a view across the inlet and the sea. In the north end of the loft Balduin had also made a little box room. It was empty so far.

"What are you going to use that for?" asked Lars Dion, who had helped his son to arrange things.

"I want it to keep various things in," replied Balduin evasively.

That day, the mail boat came with some parcels and boxes for Balduin. They were put in the empty room.

"What's all that?" asked Lars Dion inquisitively.

"Oh, mostly books," said Balduin.

"There's liquid in one of the boxes," commented Lars Dion. "I can hear it sloshing around."

"Yes, it's ink for the school."

"Ink?" smiled Lars Dion suspiciously, but Balduin pretended not to hear.

For security he bought a padlock from Landrus and fixed it to the door to the little room. In the evening, he unpacked the books and arranged them on the bookcase. When that was done, he opened the window and let the wet breeze from the inlet fill the little room.

It was a grey, rainy evening with huge drifting clouds. Balduin went to bed early and lay listening to the sound of the sea. He had a feeling of sailing, the bed was sailing, the house was sailing, and the island was rocking gently as it moved forward, cleaving its way through the dark breakers.

TRADERS

I

Niklas Næs, the old Holmvige merchant had gone bankrupt. Soon after Whitsuntide the sheriff together with a lawyer from Østervaag arranged to value the estate and register it.

Niklas was a man of over seventy years of age and had been in business for more than a generation. It was a business of the old kind. Niklas had provided the farmers and small shop-keepers in Holmvige, Kvandal and other villages with flour, sugar, tea and coffee and then taken their wool and knitted jerseys. He also took on occasion small amounts of dried fish, which he then sent to Østervåg to be sold on. This produced a small, but assured income, and Niklas could still have been a wealthy man if he continued to keep his business within the modest, but safe framework of a general store.

But then it happened that Sylverius had settled down in Holmvige and started his fish business. He had been at sea for some years, first as a mate and then as a skipper, and he had earned good money. Fortune had continued to favour him; his purchases of ships were advantageous, and he started his business at a fortunate time, when there was a great demand for dried fish and fish prices were increasing. He did not at first run an ordinary general store; that came, so to speak, of its own accord as the fish business grew. Nor had he wanted to get in the way of Niklas with regard to the trade in wool. They could without great difficulty have thrived side by side if Niklas had not one day caught the fishing fever and put all his savings into a schooner which he had bought together with a skipper from Sandefjord. It was sadly an unfortunate purchase.

The schooner was handsome enough to look at, but even on its first spring voyage it turned out to be completely

unseaworthy and had to return with serious leaks after a couple of days. It was hauled up on the slipway in Storefjord and examined, but it had to be abandoned as hopeless . . . it was an old vessel that had been scrapped and was no use for anything but breaking up.

The disaster had brought Niklas close to despair. Sylverius had felt sorry for the ageing man and had in good faith even offered him a helping hand. But Niklas had taken it the wrong way and lost control of himself and hinted that Sylverius was the real cause of his misfortune. It was an unfair accusation. But on the other hand . . . it nevertheless had to be admitted that it was Sylverius' successful purchases of ships and his flourishing fish business that had led Niklas astray.

But that was how it was to be, and you could not sit and twiddle your thumbs because of that.

II

In fact, the firm bearing the name of Sylverius Eide was becoming more than Sylverius himself could cope with. His own work consisted mainly in ensuring that the ships were well maintained and that the fish was dealt with in the right way. In this area, he was a specialist, and nothing escaped his attention. But in everything concerning purchases and sales, he had to admit that his head clerk Bernhard Thomsen was more than a match for him. Bernhard was indispensable when it came to taking on the wily fish buyers, whether by word of mouth or in writing.

The spring fish was now ready but not yet sold. Prices had been quite good, but Bernhard was expecting a further increase, and Sylverius was one of those merchants who were in a sufficiently fortunate position to be able to afford to keep a quantity of fish back and see how things went.

Sylverius's dried fish was extremely well processed and so there was a demand for it – it was of first class quality. Buyers often came to see him. There were no fewer than three of

them in the hotel at the moment, a Spaniard, an Englishman and an Icelander.

"They're all three offering exactly the same," said Bernhard. "But they are each offering us advantageous conditions on the quiet. What shall we do?"

Bernhard laughed and stroked his nose.

"We must try to see through the wretches."

But this time it looked as though Bernhard would for once come off worst. The three agents had got together in a sort of partnership to force the price down. They represented large purchasing companies and were difficult to get around. After together explaining the new situation to Bernhard, they invited him to lunch in the hotel as a kind of further token of their unity and determination.

The three businessmen were all dressed in morning coats with flowers in their buttonholes. Otherwise they were very different in looks and character. The Spaniard was small, fair and well fed, not at all like a Southern European. However, there was something slightly greenish about his blond complexion, and his hair and eyes were of a strangely false and improbable colour. The Englishman was small in stature with a turned-up nose and short upper lip that always ensured that his well-tended teeth were visible. The Icelander was a giant with close-set brown eyes quietly expressive of honesty and kindness. All three spoke a kind of Norwegian.

Bernhard felt a little ill at ease at first. The table was well supplied, with beer and schnapps glasses at each setting, and Frida Olsen herself was serving, dressed in a dazzling white apron and with a hard, shiny face. But as soon as the first glass had been drunk, Bernhard felt on a level with the others. These gentlemen were making a mistake if they thought that he was less a man of the world than they . . . he had been to both Edinburgh and London and stayed in the big hotels there, and he could change into English if necessary. He had a flare for negotiations, and he came to life. He tried several times to turn the conversation on to business matters and fish prices, but he failed. The three businessmen seemed to be interested in anything but trade. They talked about motorcar

racing, music and the life of the creatures at the bottom of the great oceans.

But the conversation gradually slipped on to the subject of national politics. It began with the Icelander maintaining that the Faroese and Icelanders were brothers and ought to stick together, all the more so as both countries lived on fishing and so had the same business interests. This statement was obviously viewed as a breach of the arrangement. The Englishman commented with a smile that England, too, was a country with not inconsiderable fishing interests. The Spaniard calmly maintained that although it did not itself have a fishing industry of great significance, Spain formed a basis for all fishing and trade in fish in the north. If the Spanish stopped eating fish, both the English and the Icelanders might just as well scuttle their trawlers and cutters.

"You completely misunderstand me, gentlemen," said the Icelander excitedly. "I didn't mean that we Icelanders and Faroese should stick together and oppose other countries with regard to trade in fish. What I was talking about was purely political . . . In a political sense, the Faroes ought to stand together with Iceland instead of Denmark. Of course England is a much bigger fishing country than Iceland, and of course we couldn't possibly do without Spain as a customer . . . It would be ridiculous of me to argue in that way. No, I meant only that we Northerners . . ."

"All right," interrupted the Englishman. "But you Scandinavians easily forget that we British are Northerners as well. I've seen just as many fair-haired people in Scotland as I have seen in Iceland and the Faroe Islands. When it comes to the point, we are perhaps more Nordic than you are . . ."

"Yes," the Spaniard broke in. "And dark types are certainly not in the minority here in the Faroes either, on the contrary. I myself am fair and of Nordic extraction of course, as my mother was Norwegian, but I will nevertheless maintain that there is a lot of Southern blood in the Faroese, indeed *Spanish* blood, to put it bluntly. The Great Armada, when it was broken up . . . lots of Spaniards came to the Faroes on that occasion and settled here, or at least left offspring. Lots."

"My mother was Norwegian, too," said the Englishman.

The Icelander laughed indulgently and turned his kind eyes towards Bernhard: "It doesn't matter, we Icelanders *feel* that the Faroese are of the same blood as us. We are the same, in faults as well as in our good qualities. We are both small nations that probably can't measure up to the great nations of the world . . . but we have our own national characteristics just as much as anyone else does. And the Icelanders and Faroese . . . Well big brothers don't let little brothers down, but offer them a hand if necessary."

"All right," said the Englishman in a slightly waspish tone. "I think that what you've just said allows us to talk straight to each other. And I would like to ask Mr Gislason: Is it out of love for the Faroese that you buy their fine quality hand-caught fish and offer it at a lower price than your own third-rate trawler fish? Is it not rather to give the Spanish the impression that your own fish is the real top quality and the Faroese an inferior product that isn't worth bothering about?"

"Hey, hey, hey," said the Icelander in horror, holding up his knife and fork defensively. "No, hold your tongue, Mr Morris, or I'll hold you to account for what you say. What right has England at all to get mixed up in Faroese and Icelandic fishing? You should mind your own business. But you're trying to wheedle your way to an enormous commission, that's what it is."

The Spaniard gave a loud laugh and patted Bernhard on the shoulder. "There you can hear for yourself! Now these two gentlemen have both torn the masks off each other. But do we need more proof that the only right thing to do is to go straight to the consumer . . . to Spain?"

"You are not the consumer, Braga," the other two shouted with one voice, and the Icelander continued, "But it's your tactic . . . you are making the most of your surname. You're not even a Spaniard . . . You're a Norwegian mulatto, so you are."

"Aren't I Spanish? Of course I bloody am," Braga shouted out with a loud laugh. "And don't I represent major Spanish companies?"

He turned to Bernhard: "Haven't I bought fish from you before, and haven't you been well paid for it?"

"Oh yes," nodded Bernhard. He was feeling a little embarrassed on behalf of the others. His smile grew stiff around the wings of his nose.

"Yes, just you laugh," said Braga. "That sort of thing's only worth a cheap laugh."

But Gislason and Morris were not in the mood for laughing. After coffee, the Englishman rose, gave a wan smile and said, "Well after all this, I feel I must withdraw, at least as long as Mr Gislason is here."

"I won't get in the way," said the Icelander. His eyes were glazed, and he sought to catch Bernhard's attention.

"Well, I'm staying," laughed Braga, looking at his watch.

When the others had gone, he slapped Bernhard's shoulder: "Well sir, what do you say, a fifth of an øre more per kilo?"

"Well, thank you," said Bernhard. . . . "We'll think about it until tomorrow."

Braga caught hold of his sleeve: "My offer is only in confidence, so you mustn't consult the others."

"Hm . . . I'm afraid that's already been done," said Bernhard with a smile. Gislason also offered me a fifth of an øre more when he said good night."

Braga banged his fist on the table: Oh hell, then I'll give you half an øre more," he said. That amount of fish isn't going to break the bank."

"I'd also like to hear what Mr Morris offers," commented Bernhard with a smile.

III

Landrus had come to Holmvige to enquire about the price of fish and conditions of sale. He had Jakob the Granary with him in the boat. Out of habit they landed at Niklas Næs's wharf. Since Landrus had started trading he had been in touch with Niklas and had him as his middleman and adviser. It was sad now to see the closed shop.

Landrus went over and looked in through the window. Everything had always been clean and tidy in there, and so it still was. The counter, polished with use, was shining as though recently swept, and below one transverse beam there hung paper bags carefully arranged according to size.

Aye, Niklas had always been a tidy person. And a modest and reliable man whom you could trust without any hesitation. It was a great shame that things had gone so badly wrong for him . . .

Landrus would have to see about starting a link with Sylverius. But he wouldn't go past Niklas' door now that he was in Holmvige.

Niklas was sitting in his office sorting out various papers. He got up and gave Landrus an angry look.

"Are you here? Don't you know I've stopped trading?"

"Yes," said Landrus, warily stepping inside. "It's dreadful, the way things have gone for you, Niklas. You should never have bought that ship . . ."

"Yes, but I just can't see what that's got to do with *you*, Landrus," Niklas interrupted him impatiently. "I don't owe *you* anything, do I?"

Landrus looked inquisitively around in the little, unpainted office. Papers, papers, papers. They lay spread all over the table and the floor, and they hung in bundles on the wall. And there was an old calendar showing the date of 13 June. "That must be the unhappy day when it all came to an end," Landrus thought to himself. He sighed: "God help us, God help us, Niklas."

Niklas had flushed scarlet. He took a step towards Landrus and said in a rasping voice, "If you want to say something to me, then say it quickly, 'cause surely you can see you're interrupting my work?"

But Landrus ignored the fierce tone and looked at Niklas with genuine sympathy and again said, "God help us, Niklas, my old friend. So this is how it was to end for you. You weren't to have a better fate than this. And what will you do now? I suppose you won't be allowed to start trading again? And you're getting old, too, so you can't even

go out fishing. And you've no children. And your poor wife . . ."

"Listen, what are you getting at with all that chatter?" said Niklas angrily. "I tell you, I haven't time to stand here listening to you."

Landrus looked at him as one looks at a painting or some other inanimate object. Niklas, who had always been so well dressed . . . he was not wearing a collar, and his embroidered slippers were split at the seams. Aye, and it was as though he had lost height. "So that's what a broken man looks like," thought Landrus.

In an emotional voice he said, "You can send for me whenever you want, Niklas. I'll be neither worse nor better for that. But tell me honestly, haven't you got anything left? Have you let them take everything? Haven't you got anything, nothing put aside?"

This was too much for Niklas now.

"Oh, keep away from me with all your talk, you Trymø idiot," he said. "Out with you, I won't have you here any longer, so now you know."

"Oh well, as you wish," said Landrus patiently as he opened the door. "I just wanted to look in as I was here . . . I thought it was common courtesy."

Niklas refused to shake hands as Landrus left. Oh well, that must be up to him. Landrus couldn't see he had said anything to upset him. But of course, a ruined man could hardly be in the best of moods; that would be expecting too much.

Aye, the ways of fate were beyond understanding. A month ago, Niklas had still been a man who enjoyed everyone's respect. He was the farmers' agent, and virtually all the small shopkeepers in the surrounding villages had had him as their factor. Now he was nothing. He was so to speak dead in the eyes of the world. – Oh well, now it was simply a matter of making sure that the same didn't happen to oneself. The first thing was to get the fish sold at a good price. He had a good stock to offer; it was first-class fish that had cost him a lot of trouble to prepare . . . a relentless battle with the mischievous weather. Landrus flushed at the thought of what a low price

they would perhaps try to offer him. He would make sure of discussing it with Sylverius himself; that redhead Bernhard was probably rather a sly fox. Not to mention Egon, the new shop assistant, Lars Dion's son . . . he wouldn't as much as exchange a nod with that scum.

Sylverius gave Landrus a friendly reception and offered him beer and cigars.

"Yes, once we have your fish over here," he said, "we'll get it sold all right."

"But what shall I get for it?" asked Landrus staring out of the window with a worried expression in his eyes. He tentatively suggested a high price.

"We can't give as much as that," said Sylverius.

"Well, I can't sell it for less," said Landrus in a rather sorrowful tone. "It's first class fish, and it's cost me a lot in both money and effort."

Bernhard poked his head through the door.

"Is it fish you're wanting to sell?"

Landrus looked at him with an expression of profound distrust: "Yes, if I can get a decent price for it."

"Don't worry, old man," laughed Bernhard. "You'll get what it's worth all right."

Landrus managed a bitter smile: "You mean what you'll give . . ."

"Well, did you think you were going to dictate the price yourself?" asked Bernhard, winking to Sylverius. "By the way, you could go along first and have a talk to that Spaniard; I don't think he's left yet. Perhaps he might offer you a price to satisfy you."

"Spaniard?"

Landrus thought about it for a moment. Then he took his cap and got up. "Aye, that's perhaps not a bad idea."

"Well, go over to the hotel and ask for Braga," Bernhard encouraged him.

"Just let him get himself in a mess first," he added when Landrus had gone. "He's a difficult character, this old man from Trymø."

Braga was lying fully dressed on the bed, reading a book

in a bright yellow cover. The air in the little room was cold and full of cigarette smoke, and there was a glass of some restlessly bubbling liquid on a chair by the bed. The thick smoke made Landrus cough. He explained his errand in a stifled voice while staring at the Spaniard's short, reclining figure.

"Fine," said Braga, getting up from the bed. "Let's have a look at your fish straight away. I'm only killing time here while I wait for the steamer . . . and it's not coming until tomorrow."

"Yes, but I haven't got it all here yet," explained Landrus nervously. It's out on Trymø."

"Trymø?" Braga stretched and yawned. "Is it an island worth seeing? Lots of pretty girls and so on?"

"Pretty girls," Landrus considered, slightly taken aback. "Yes, I suppose so."

"Right then, we might just as well get out there straight away," suggested Braga. "And that will take care of this afternoon."

He emptied his glass and lit a fresh cigarette. Landrus felt uncertain of himself and to make absolutely sure, he asked, "Tell me, I hope I'm not mistaken . . . You are the Spanish fish buyer, aren't you?"

Braga nodded with a laugh and went over to the mirror.

"I don't think I've had a proper shave," he said. "But never mind."

He opened a suitcase and took out a couple of bottles wrapped in paper, which he placed in a leather briefcase.

"At least we shan't go thirsty," he said with a wink to Landrus.

"What's all that about?" laughed Landrus uneasily. This Braga and his bottles and his cigarettes scarcely filled him with confidence. But there was nothing else for it but to keep his eyes and ears open.

Jakob the Granary was asleep down in the boat.

"Up you get. Do you think you're going to sleep all day," Landrus complained, shaking Jakob violently.

A confused Jakob raised his head and looked around sleepily. Landrus continued to grumble at him while he raised the mast and prepared the sail: "I just thought you'd be asleep here, you stupid creature. You're nothing but an embarrassment and irritation. Why the devil did I give you a job, lazy and impolite as you are?

"Who's that man?" asked Braga, settling down in the stern. He had the leather briefcase and a small black travelling case on his lap.

"Oh, it's just a lad I have as a helper," said Landrus. "He's called Jakob. He's good at rowing, but he's no use at all otherwise. – There, Jakob, don't just sit there like a flounder looking at our visitor."

Jakob cowered subserviently.

"He's not quite all there," explained Landrus. "But he can actually be rather amusing, because he can sing . . ."

"Can he sing?" laughed Braga. "Let's have a song, Jakob."

Jakob blushed suddenly. He refused and complained happily for some time, but then he started singing one song after another.

> Up in the old oak tree
> There hangs a jug on high.
> Four nights before Christmas
> All the girls come to dance
> And Anna dances, on the grass
> She is such a bonny lass
> And Lars prances after her
> He'd so much like to catch her
> He'll nip her and nap her
> And kiss her and clap her
> He'd so much like to catch her.

Jakob roared with laughter and pulled awkwardly at the sleeves of his jersey.

Braga, too, had to laugh and reveal his gold teeth, and Landrus nodded approvingly at Jakob.

The boat moved forward quickly and smoothly over the

small waves. Braga opened his briefcase and took out a bottle.

"You must sing some more for us, Jakob," he said. "Then you can have a dram."

Jakob screwed up his eyes and rocked backwards and forwards while he thought.

"He only knows nursery rhymes," said Landrus. "You see, he's never really grown up even if he is grey and middle-aged."

Jakob had thought of a song now. He wriggled and apologised for a moment, but then it came:

> Down I went to the dark shore
> So many fish in the water,
> There I saw blue and gold fish,
> Good to fry and put a dish.
> I saw a black flounder
> And then I had found her
> And she bit at my legs
> So I fell off my pegs,
> Toothless, noseless,
> Headless and tail-less.

"What on earth is all that rubbish?" interrupted Landrus furiously. "You're making it all up!"

Jakob hid his face in his hands and chuckled quietly. Braga was shaking his head and smiling. He took a collapsible cup out of his case and rinsed it in the sea. Landrus swallowed the strong drink with distaste. Jacob refused to have anything to drink, but he started singing again and went on with his long and unstoppable nonsense songs, which he made up as he went along.

"Shut up, Jakob," shouted Landrus. "It's not funny any longer."

Jakob stopped suddenly and turned his back on the others, but he kept on shaking his head about as though he was singing silently to himself.

It caused quite a surprise when the boat landed at the jetty

with a strange man on board. Word soon got around that it was an important foreign fish importer who had come to the island to negotiate with Landrus.

Braga was in high spirits, greeting people all around and waving his arms: "Wonderful island. I wouldn't mind settling here. What do you say, Landrus . . . What about building a little château up in the mountains and having a dozen girls to wait on you, eh?"

There came an ecstatic look over Braga's face.

"Good Lord," he said. . . . "This reminds me of Norway. I was born on an island like this, with the blue sea all around and dried fish and all that sort of thing . . ."

Landrus drew Braga across to the warehouse cellar where the fish was stored. He was trembling with excitement.

"Yes, that fish looks all right," he thought. "Just get it ready and send it to Holmvige tomorrow morning, and then it can go with the steamer."

"And the price?" asked Landrus.

They bargained on the price for a while. Landrus was difficult to satisfy, but when Braga promised to give him a couple of percent above the day's market price, he agreed. He would receive the money as soon as the consignment had been inspected by the grader and taken on board. Braga always paid cash.

"Now we'll go home and have something to eat," suggested Landrus.

"You know, this shore is just right for drying fish," said Braga. "You could dry a lot of fish here. Why don't you buy yourself a boat or two?"

"Where am I going to get the money?" Landrus smiled glumly.

"Oh, that could probably be arranged." Braga sat thinking. "I suppose you've got a few thousand up in the attic . . . five or six thousand – that's always a start. And you can buy ships on credit over several years. A state mortgage or whatever it's called. And how do others manage? The profit . . . well, that doesn't come until later. You always start with a debt, you

know. I was a poor wretch myself until I started trading in fish."

He nudged Landrus: "The fish trade, you see, that's real trade, that's a world-wide trade. Playing around with flour and brown sugar will never get you anywhere."

The table was laid in Landrus' living room. Susanna had managed to fry some tasty plaice at short notice and she had put some tinned food and some beer on the white tablecloth.

Braga planted the brandy bottle in the middle of the table.

"What about this Peter or whatever you call him, isn't he going to join us?" he asked.

Who . . . Jakob the Granary? No, he is certainly not," said Landrus scornfully.

"I'd been looking forward to that otherwise," said Braga. "I thought he was a nice chap."

"Well, if you want him, that's a different matter of course."

Jakob took a lot of persuading, but at last he was seated at the table. He sat and filled his mouth with air and directed a sideways glance at Braga.

Braga took the bottle and made to pour a drink, but there were no glasses.

"Gregoria," shouted Landrus. "Bring us three small glasses."

For this festive occasion Gregoria was wearing her best clothes, a red skirt, a pale silk scarf over her shoulders and a small embroidered bonnet with pink ribbons tied in a big bow beneath her chin.

"Is this your daughter?" asked Braga, turning his chair away from the table. "What a beautiful porcelain doll. Good heavens, Landrus, is that really your work?"

Landrus rubbed his hand, both happy and nervous. Braga placed an arm round Gregoria's waist and took her on his knee.

"How old are you?" he asked. "Seventeen . . . but then you'll soon be a grown girl and too big to be taken on my knee."

He lifted her up in the air and put her down.

"You really must come to Spain and visit me . . . I've got

three wives and sixteen children. You could come and be my fourth wife, 'cause in Spain you're allowed to have as many as you want. What do you say to that?"

Gregoria blushed.

"That'd be rather a long journey for her," said Landrus. "She gets seasick if she only goes down to the shore and smells the water."

Gregoria disappeared with the tray. Braga filled the glasses. Jakob refused to drink anything. "Oh well, that doesn't matter," commented Braga. "'Cause he was born tipsy."

Braga ate a hearty meal.

"Listen, I know," he said suddenly. "I've just thought of something. We were talking about a ship just now . . . I've got a cutter you could have over in Løsund in Norway. It's almost new, and you can have it really cheap. Shall I reserve it for you when I get back there? 'Cause I'm going home that way . . . I've got some relatives in Løsund."

Landrus shuffled uncomfortably and had suddenly lost his appetite.

"A cutter," he said. "What would that cost?"

"Oh, about fifteen thousand kroner. And I'd let you have it on very favourable terms. Five thousand kroner deposit and the rest in instalments of two thousand, or just one thousand, a year."

Braga emptied his glass.

"The fact is," he added, "that I've got connections all over the place . . . all over the world."

He smiled contentedly. "Think about it and make up your mind."

Landrus put down his knife and fork. His head was spinning for a while. He could find five thousand all right, and then the ship would bring enough fish home to pay off the debt and leave a profit. He had a vision of Trymø as a real trading centre with quays and huge warehouses. Such a vision could quickly become reality, just think of Sylverius.

"And yet . . . remember Niklas Næs as well," Landrus went on to think. "Suppose the ship's a poor one or I had bad luck

132

in some other way. Fishing and shipping is a dangerous game to get mixed up in. There's less profit in a little village store, but it gives an assured income when you weigh every bit yourself by hand."

But on the other hand . . . he was already well into fish drying and had made a profit on it. And it looked as though this was still a time when things were improving.

Landrus moaned. Wracked by doubt, he looked at Braga, who was happy and eating a hearty meal. Was this his guardian angel sitting there? Or . . .

Suddenly, Jakob the Granary started to sing.

> Come and dance my mermaid fine,
> Your fishy tail it shall be mine.
> You fishy tail your shelly tum,
> Your shelly tum, your shelly breast
> Your shelly breast like the sun in the east
> Shall light and shine
> And the fish shall be mine

"Oh, shut up, you wretched creature," snarled Landrus, but Braga hushed him: "Oh, just let the daft lad sing. But what a strange song it is. By God, I've never in all my born days heard anything like it."

When the meal came to an end, Braga got up and went over to the window. The sun had gone, and it looked like rain.

"Hello, what's this?" he said. "It looks as though the good weather's coming to an end. So we'd better see about getting back to Holmvige, the sooner the better. I'd otherwise thought we might have had a bit of a dance."

"It's only a shower," said Landrus. "And by the way, the mail boat will be here in an hour or so, so you can go back on that if you want to be under cover."

"That's fine."

Braga took out his little travelling case and opened it . . . it turned out to contain a gramophone.

"Well," he said. "Where are the girls now that you talked about, Landrus? Off you go and find them."

Landrus laughed and shook his head. "Did I say anything about girls, I don't think so."

"Well, bring your daughter in at least," said Braga good-naturedly and started the gramophone.

Landrus got hold of Gregoria. She stood shyly up against the wall and stared with amazement at the little case that filled the sitting room with voices and music.

"Hasn't she heard one of those before?" asked Braga.

No, Gregoria hadn't.

"Good heavens," said Braga. His eyes took on an emotional look. "Aye, I was a little lad of fourteen myself before I heard a gramophone."

He drew heavily twice on his cigar.

"And then," he continued. "There was one like her on my island as well. She was called Viola and she went and dolled herself up with blue and red ribbons, too, and I should have had her, but she died while she was still quite young . . ."

He rose to wind up the gramophone again. Gregoria looked at his heaving back and was almost on the point of tears.

The gramophone was going again. This time it was no noisy dance music it was playing. It was a slow, moving song. To you, old mother dear . . . those were the last words in each verse.

Landrus went backwards and forwards on the floor, tormented by indecision. There was a moment when he decided to have confidence and place the matter in Braga's hands and ask him to buy the cutter. But then he hesitated again.

Braga chatted to Gregoria and patted her head. On the other side of the record it was the same voice singing another song, even more touching:

> His heart was near to breaking
> But no one knew its aching.

Jakob the Granary had moved his chair over to the gramophone and was sitting looking at the strange box from all sides with eyes open and nostrils dilated. A crowd of children had

134

gathered outside. They were listening to the song with earnest, rapt expressions on their faces.

Landrus scratched his head in great torment. He had as it were become tired of thinking . . . the various arguments in favour and against kept coming back to him, and the bright image of Sylverius' jetty with its warehouse gable and flag alternated constantly with the sombre picture of Niklas Næs's closed shop, with the paper bags hanging pale beneath the ceiling and twisting around to no purpose. He rose up on his toes and straightened his shoulders as though to shake off some nightmare.

It was suddenly as clear as daylight to Landrus that he would not embark on such a risky purchase of a ship. He smiled in relief . . . How on earth could he have been in any doubt?

Oh, it was like waking up after a bad dream.

"Well," said Braga. "Have you thought about it?"

"Yes," nodded Landrus and sat down. "I'm going to refuse the offer. For I can't afford it. No, we are poor people here on Trymø, and we have to dismiss that kind of splendid dream."

"Well, I won't try to persuade you to buy the ship," said Braga, who seemed to have lost interest in the matter. His thoughts were elsewhere.

Before long, the mail boat arrived. Braga said goodbye, and Landrus went on board with him. It had stopped raining, and the sea was moving in slow, easy breakers beneath a desolate afternoon sky. When he came home and stood in front of his low, blue-painted shop doorway, Landrus suddenly felt a strange sense of melancholy. But he dismissed it . . . this place was not exactly *big*, you could hardly say that, but on the other hand it was *safe*.

And yet, what was safe in this world?

The motorboat chugged out of the cove. Landrus watched it from his shop window until it disappeared in a new shower of rain.

But suddenly there was the sound of singing from the sitting room. What was that? Had Braga forgotten his gramophone? Landrus opened the door ajar. There was the

gramophone on the table, playing the sad song about the old mother, and Gregoria was sitting on a chair, staring at the turning record with tears in her eyes.

"Gregoria," scolded Landrus. "What on earth are you thinking of, playing with that machine?"

"He gave it to me," said Gregoria without looking up.

"Well, I must say! He gave it to you?"

Landrus went across and touched the wonderful machine and gently stroked the fine leather cover.

"That Braga must be incredibly well off, unimaginably rich . . . That was nice for you Gregoria."

But Gregoria was not happy. She listened to the man singing . . . it was almost too beautiful. It tore at her heart and it hurt her, and then afterwards, when the record had finished, everything in the room was so empty and sad.

She let the gramophone play the song once more and listened enchanted.

NEITHER SHALL YE USE ENCHANTMENT

I

The evenings had again begun to draw in. It was the hay-making season. At the big farm they were finding it difficult to get folk to work in the hay. One day, Harald turned up at Kristoffer's to ask Josva to come and help with the haymaking.

"It becomes more difficult every year to be a farmer," he said. "You can't get a farm servant nowadays even if you offer him twice the wage . . . Fishing's attracting all the young folk."

"Well, Josva must make up his own mind whether to come and help you," said Kristoffer. "But otherwise we were intending to see if we can catch some halibut . . . The Nordvig people are supposed to have had a good catch recently."

"I'll come tomorrow," Josva promised Harald.

"It was daft of you to promise that," said Kristoffer when the farmer had gone. "He'll not pay you much for haymaking, and our new boat could be here at any time. It would be far more fun to go out in it and see whether the engine's any good."

"Yes," said Josva. "It was perhaps foolish to give Harald a firm promise."

But he went up to the farm early the following morning.

The new boat came that same morning. It was an eight-oared vessel, tarred black and with a green bottom. The motor was a present from Sylverius. The entire village was down at the landing stage to see the new vessel. Kristoffer had already learned all about taking care of the motor while on his Whitsuntide visit to Holmvige. He took Gotfred and Landrus out on a trial outing.

"I don't like all that noise it makes," said Gotfred. "It's enough to make anyone deaf."

Kristoffer imagined it would be quite easy to get used to the noise. And think of all the time and trouble you save. The motor does the work of more than ten men . . . You get the fishing lines out in no time.

"If only there'd been some fish to catch," commented Landrus. "But those confounded English trawlers don't leave us as much as a sea scorpion. Damn them."

And Landrus spat overboard.

"And what about when the weather's bad?" he went on. "Won't the salt water damage the motor so the heavy machine drags the boat down to the bottom?"

Kristoffer smiled. "No the engine house is proof against the waves, and no sea water will get in. Besides, it's not as though the engine will stop straight away even if we do get a wave over us."

They sailed off at a great pace along the coast, and Gotfred had to hold on to his glasses.

"The old sailing boats were more stable in the water," he said.

"Yes, but then they could only sail when the wind was blowing . . . and blowing in the right direction," was Kristoffer's comment.

"It's almost a shame to waste all that oil just on a pleasure trip," murmured Landrus.

"Yes, so let's go back after the flounder line," proposed Kristoffer. "I've got it ready, and the current will change in half an hour, so it'll be a good thing to get out now."

It was decided to go fishing for flounder. The fishing gear, bait and food were taken aboard, as were both sail and oars, and they set out along the coast. The sea was calm, and there were some greenish blue gaps in the grey cloud cover betokening good weather.

"By the way," said Gotfred suddenly in his role as parish clerk. "This is this boat's first trip . . . it would be fitting to launch it with a hymn."

Kristoffer nodded. "That's true. We shouldn't forget."

"But no one can hear a thing through all that din," said Gotfred. "You'll have to stop it while we're singing."

He pointed imperiously at the vibrating engine house.

Kristoffer bent over the engine and turned it off. The gentle, soft sighing of the sea and the shore suddenly emerged in the silence now that the motor was stopped. Gotfred tried to think of a suitable hymn, and the three men uncovered their heads.

"Well, we could sing 'Thy grace is all I seek'," suggested Landrus.

"Aye, that's the usual one," said Gotfred. "But I know another text that would be more suitable for this special occasion."

He cleared his throat; two stern furrows appeared in his forehead, and with a commanding voice, he started:

> God's heavenly hand well knows
> Where fortune's wind now blows . . .

It was a long hymn, and while singing it they had drifted right in close to the coast. Kristoffer made to put out a couple of oars, but before he could free them from the flounder line that lay on them and weighed them down, the boat came so close to the shore that it became stuck in the seaweed.

Landrus, who had been sitting with his back to the shore, got up. As soon as the hymn was finished, he said, "That wasn't a good omen."

"What do you mean?" asked Kristoffer.

"Oh, you know," said Landrus.

Kristoffer exchanged a glance with Gotfred. Landrus was right in a way. When a fishing boat on its way out accidentally came so close to the shore that it stuck in the seaweed, it was considered a bad sign, and people would sometimes go back. But there was no enthusiasm for giving up this trip.

"Yes, Landrus," he said. "But as it was while we were singing a hymn that the boat got into the seaweed . . ."

"Oh, hold your tongue," shouted Landrus, quite beside himself

"What's come over you?" asked Kristoffer quietly. But just as he said this, he realised that he had referred to both the seaweed and the boat by name . . . and it was otherwise an old custom among people from Trymø that when they were on the water such things could only be referred to obliquely.

Gotfred had thought about this and said in a firm voice, "I agree with you, Kristoffer, that we don't show much trust in God if we take notice of chance happenings of that kind. We know perfectly well the boat came to drift in to the seaweed because we'd stopped the motor so as to sing a hymn."

"Aye, I don't think we need to worry," nodded Kristoffer.

"No," argued Landrus, looking bitterly and reluctantly at the others. "For the very reason that it happened while we were singing a hymn I see it as a sign from above. And I've experienced things like this twice before, and each time misfortune followed."

"But the weather's as fine as could be," argued Kristoffer persuasively.

"It's not only the weather and the waves that can do damage," said Landrus, looking suspiciously at the engine.

"If *that*'s what you're thinking of, I can reassure you," said Kristoffer. "There's nothing wrong with it."

He bent down and swung the starting handle.

"Hey! Wait!" shouted Landrus. "At least I demand to be put ashore."

"Then you can jump ashore now," said Kristoffer without looking up.

"And so I will," said Landrus.

"He took his lunch box and jumped over the edge of the boat on to the flat rock, where he remained standing for a while.

"I warn you," he shouted. "I can't do more than that. I wash my hands of it if things go wrong."

"Just you wash away," said Kristoffer with a smile.

He started the engine, and Gotfred turned the boat away from the shore.

II

Landrus went along the flat rocks of the foreshore until he found a place where it was easy to clamber up. He was feeling just a little embarrassed.

He was safe and sound on firm ground. And yet, suppose that what had happened was a warning of misfortune or accident, not on the sea, but on land That was to say for *him*? You could never know. There are dangers everywhere, and you were surrounded by a network of inexplicable happenings wherever you went. For instance, he had felt terribly shocked that day when Thorkel Timm had suddenly gone for him with all that talk about Ole.

Not that he took this crude and ridiculous accusation at all seriously. He had certainly not murdered or wanted to murder poor Ole. But how had Torkel Timm got to know anything about it at all? There were inexplicable forces at play, whatever they may be.

Landrus had on several occasions decided to question Torkel more closely about this, but he had hesitated so far. He would do it today. Now he was going to do it.

As soon as he was back in the village and had had a cup of coffee, he went over to the little house by the churchyard, where Torkel lived. He found him at home.

"Aye, I've come to have a word with you, Torkel," he said.

Torkel asked him to sit down. He himself was sitting on a bench under the alcove with his hands buried in his waistband and his legs stretched out in front. He was chewing tobacco; his beard was moving up and down, his watchful eyes were smiling beneath the red, half-closed eyelids, and his eyebrows were raised thoughtfully.

Landrus looked at him intensely and seriously. "Tell me, Torkel, the day after the wedding, when you were drunk, you came to me in the shop and said that I'd *murdered* Ole. What did you mean by that?"

"Did I say that?" asked Torkel, rubbing his eyes. "Did I really say that?"

"Yes, you did," Landrus went on. "And now you're going

to explain to me what you meant by it. 'Cause now you're going to be held responsible for it, let me tell you."

"Responsible?" said Torkel hesitantly.

Landrus stared straight at him. "Yes, you accused me of murder in the presence of witnesses, you understand."

Torkel was calm and said in a quiet voice: "You can't be held responsible for what you say when you're as drunk as a lord, can you?"

Landrus became incensed: "I'm an honest man, and I won't be accused of such a dreadful crime, so now you've got the choice of giving either me or the authorities an explanation, 'cause I'm not just going to drop this."

Torkel thought about it. He stroked his beard upwards to his nose and gave Landrus a strange look through eyes that were strangely veiled and overgrown.

"I'd very much like to give you an explanation," he said. "But there are things that simply can't be explained."

He sighed heavily and closed his eyes.

Landrus began to feel uncomfortable.

"What do you mean," he asked in an unsteady voice. "Did you have a dream or something?"

Torkel nodded.

Landrus went on: "Did this Ole come to you in a dream?"

Torkel nodded again.

"Did it happen only once or more times?"

"Three times." Torkel nodded without looking up.

"Strange, strange." Landrus shook his head. "So he's obviously your *familiar*. Why doesn't he come straight to me instead of going a roundabout way? I once thought I saw him in a vision, one winter it was . . . I woke up with some shining figure looking in through the window. It's the first time I've had that kind of experience, strangely enough. But perhaps it wasn't him after all. In any case, he didn't come again, which he's every reason to do if he really thinks that I . . ."

Landrus came to a halt. He sat staring for a moment, with a sad, petrified look in his eyes.

Torkel sighed.

Landrus glanced nervously at him and went on: "But I tell

142

you, Torkel, and you've got to believe me: I am not responsible for that man's death. I admit I met him the evening he drowned. And we had a row, I won't deny that either. He'd once had some stuff from me on credit, and the agreement was that he'd give me a couple of sheep in exchange, but he broke the agreement, went on promising and promising, but always found an excuse when I went for him and demanded what he owed me."

Landrus swallowed heavily and went on: "And it may well be that we said some harsh things to each other, but God knows that I neither wanted him dead nor caused his death. In fact I've even told his widow that I'll give up my claim on the two sheep."

"Is that right?" said Torkel.

"Yes, I've written to her so she's got it in black and white. And if Ole and I ever meet again, I'll explain it all to him, and then he'll see I've got clean hands. God's my witness. It was his own fault he died in the stream; he was just a tiny whipper-snapper of a man, and I think he had a limp, so he should never have tried to wade across the river, 'cause it must have been very full that evening . . ."

Landrus looked up at the ceiling and sighed heavily.

"No, I can understand," he said as he got up. "Evil forces have been at play here. This is the Devil's work, you see, Torkel, and whether you've intended to or not, you've been running Satan's errands for him. Remember the words of the scriptures: 'Neither shall ye use enchantment.' Pray and be zealous. That's my advice to you."

III

Josva worked all day together with Harald. They only spoke at meals, which were taken out to the field to them. Harald praised Josva for the way he went about things and for his stamina.

"As for stamina," he said, "I know no one who has demanded more of himself than my father. I can hardly

remember what he looked like when he was not doing something . . . he was always on the go, getting up before we children were awake and only going to bed again long after we had gone to sleep in the evening. Even on Sundays he was at it all the time, reading sermons and singing hymns all morning, and then during the afternoon telling the children and the farm servants stories and teaching them songs and ballads. Aye, those old people were willing to work . . ."

Harald told several things about his father's working life.

"And father died in the midst of his work," he concluded. "He collapsed one evening while getting the hay in. We found him under a pile of hay . . . he was on his knees, as though he's been trying to get up again, but he was dead."

Josva kept his eyes open for Hilda all day, but she was not among the women turning the hay. She was staying hidden indoors . . . perhaps she wasn't well. He hadn't seen anything of her since that evening when they had arranged to meet. But he had dreamt of her a couple of times. One night he had dreamt that he had gone past the Weaver's Valley stone and found it open − there was a fire inside and a female figure sitting rocking slowly to and fro; but it was not Erla, it was Hilda. She turned an anguished face imploringly towards him, but at that moment the stone closed. He had sensed a certain meaning in this dream. Hilda was not happy in the farm; she was imprisoned there like Erla in the stone. Her parents were strict with her, watching her every step. No wonder Daniel had made such a powerful impression on her. It was probably not he himself Hilda was in love with . . . he had simply awakened her longing for love and freedom.

At about eight in the evening, Harald put down his scythe.

"Come inside and have a bite," he said to Josva.

The harvesters were seated around a large table in the main room. Josva could only make them out with difficulty in the light from the peat fire. Old Jardes was there, as were the two old servant women Else and Sigrid. He also recognised the young girls who had helped turn the hay, Judika from the River House, Redstones Anna and Simon Peter's two daughters. But Hilda was not there.

144

Not many words were spoken during the meal. The kettle hung on its iron hook over the fire and boiled gently. The dogs wandered restlessly about and sniffed at the strangers. Josva could not help thinking of Daniel . . . he, too, had sat at this quiet, solemn table. And then afterwards, on the dark autumn evenings, he had had his trysts with Hilda. Or with Redstones Inga. Perhaps with both of them on the same evening.

When the meal was over, Harald took Josva aside to discuss wages and possible further help with him. Josva promised to come again the following day.

Outside, it was a quiet, starry August evening. There was a tangy smell in the air from the newly cut grass, and from the angelica patch on the farm there came a stale perfume of flowers and wet foliage, a curious, sweet scent. Josva felt his chest tighten with longing for Hilda. There stood the farm, silent and dark; the young girls had each gone home, and now there were only the farmer's family and the old folk left. And Hilda. He imagined her sitting on the bed in her lonely room, tired by a nagging longing for freedom, limp and sorrowful like a bird in a cage.

There was a figure standing down by the gate out to the lane leading to the village. It looked like an old woman, but Josva felt convinced it was Hilda. His heart suddenly started beating fiercely.

Yes, it was she.

"Hilda." He put his arm around her.

"No," she said. "We can't stay here; they'll find out."

"Well, let's sit in the grass a bit further away," Josva suggested.

"No . . . we'll tread the grass down, and they'll see the tracks tomorrow."

"Then what?"

"We can go down to the shore. That's the only place," said Hilda. "But you go first, and I'll come after you in a bit. People could easily see us together."

Josva went down to the shore. He was staggering as though tipsy. Now he suddenly had her again; it was almost like a happy but fleeting dream.

It was not long before Hilda came. They went out along the shore and sat down on the sand.

"Why didn't you come that Whit Saturday evening?" asked Josva.

Hilda hesitated then said: "I couldn't." And then she added, "Well I could have done, but I daren't."

"You daren't?" asked Josva. "Were you frightened of me?"

Hilda laughed and whispered, "Yes, I was frightened of you."

"And are you now?"

She moved a little away from him.

"Yes. You look at me in such a strange way."

Shortly afterwards, she added, "I dream about you sometimes, as well."

"What do you dream?"

It was some time before she replied: "I dream that you're looking at me . . . nothing else. You've got brown eyes, haven't you?" She leaned close to him and looked at his eyes: "Yes, you've got brown eyes."

"Yes, but aren't brown eyes as good as any others?" asked Josva.

"Of course, it was just something I said."

"I dream of you, too," said Josva. "I dream that you're Erla sitting up there in the stone."

Hilda laughed again. "Me – Erla? Yes, I can imagine that of you . . . the way you go round dreaming."

She smiled. "Do you know what you've got? You've got werewolf eyes. Do you have visions as well?"

But suddenly she got up.

"I've got to go now, they'll miss me at home."

Josva tried to grab her, but she dodged him.

"Hilda," he said. "Don't run away from me."

She laughed: "I'm not running away from you . . . See, here I am."

But just as he was about to take hold of her, she dodged away again.

"Now you mustn't run after me any more," she said.

"'Cause we're nearly at the road now, and people can see us."

But before they got there, he had caught hold of her and held her tight.

"No, Josva. Let go, do you hear," she begged. "I'm sure father's standing over by the gate."

"Well, then you must promise me to be here again tomorrow evening," said Josva. "Will you?"

"Yes, I'll come again tomorrow," she whispered.

Josva went home. The sweetness of Hilda's closeness clung blissfully to his face, his hands and his clothes. There was a curious musty smell to the woollen shawl she had been wearing; it smelt of age, darkness and smoke . . . the smell of the farm. But she herself was young and as fresh as the grass.

Frightened of him, she'd said. Josva smiled to himself. But what was the other thing she said Werewolf eyes? Did he really have werewolf eyes? He suddenly felt uneasy. What did she mean by those words?

His father had not yet returned from flounder fishing. Josva went down to the landing stage, there finding Landrus sitting on a boulder and staring out into the darkness.

"Landrus," he said in surprise. "I thought you were out flounder fishing."

"No," Landrus shook his head. "I should have been with them, but I had other things to do. But tell me, Josva, when do you expect your father home?"

Josva hesitated. "If they don't come by about ten o'clock, they mightn't be here until tomorrow morning. They might stay out until after the tide changes at midnight."

Landrus sighed: "Yes The weather's good of course."

He took out his watch and held it in front of him.

"Good Lord, it's past ten o'clock, almost half past."

He suddenly slapped his thigh and got up as though breaking out of some burdensome thoughts.

"I'd better tell you straight away," he said. "The point is that I'm a bit worried about your father and Gotfred."

He told Josva what had happened on the way out, and

added, "Signs like that – where do they come from if not from above? It's not wise to ignore them."

He walked to and fro on the rock for a moment, and then he stopped in front of Josva again.

"I warned them," he said. "I even said a quiet prayer for them. And I explained to them what seems completely obvious to me, that if the boat filled with water . . . and that can happen even in calm weather, for you must remember that there are strong currents in some of the waters they work in . . . well, that heavy engine would make the boat sink straight away. It'd be no good bailing out, either with ladles or food boxes or buckets . . ."

Landrus went up and down the rocky surface again and then came back. "Aye, I hope to God that they come back safe and sound. But if they've met with an accident, my hands are clean, for I did my best to warn them. Yes, I even risked making myself look a fool to them and to others."

"I can hear the motor now," said Josva.

"What?" Landrus listened open-mouthed. "My God, then it's bloody . . . Pardon my language."

He sighed. "Yes, I must say I've been worried, Josva, and I couldn't have gone to bed tonight if they hadn't come. At least I'd have had no sleep. But now God in His mercy's ignored their foolishness. But, let's see, they might have been unlucky in other ways . . . they mightn't have caught anything at all."

The boat came into view in the pale starlight, and before long it put in to the landing stage.

"Did you catch anything?" asked Landrus. His voice was trembling with excitement."

"We've caught four flounders weighing about two hundred pounds each," said Kristoffer.

"And has everything else gone well?" asked Landrus, standing open-mouthed as he waited for an answer.

"Aye, we can't complain," said Kristoffer. "I must admit we forgot to take any drinking water with us, but we got some over on Husø. A little excursion like that only takes a few minutes when we have that engine."

"Aye, you can thank God for that," said Landrus, immediately making off.

IV

Josva worked for Harald all the next day. A wind was blowing, but the sun was shining and white vaulted clouds moved across the horizon. Hilda helped turn the hay. She was wearing a white linen bonnet and had bare arms and legs. Josva worked quickly, as though filled with an abundance of joy. "She's not going to get away so easily this evening," he thought. "She's going to tell me what she meant by werewolf eyes."

Hilda was again by the gate after supper.

"I can only stay with you for a couple of minutes this evening," she said.

Her voice was broken, and she was on the verge of tears.

"What's wrong?" asked Josva, stroking her cheek.

"Let's go down to the shore like yesterday," said Hilda.

They sat down on the sand. She leant her head on his shoulder. He put his arm round her and lifted her up a little so she was sitting on his knee. She was weeping quietly.

"What on earth is the matter?" whispered Josva.

She made no reply, but continued to weep. He caressed her hands, and she clung to him.

"Josva," she said. "If I hadn't got you, I wouldn't have anyone . . ."

Josva was overcome by a thrill of happiness and held her tight. She put her cheek against his and they sat for a long time without speaking.

"She's mine now," thought Josva. "At last we've got as far as this."

He felt as though they were enveloped in a thick, gentle mist of happiness, a gentle spring mist that dissolved all their problems and was filled with the scent of grass and herbs.

But just as there can be a touch of cold even in the mildest summer mist, a touch of stealthy, merciless draught from the

149

sea or the mountains, the thought came to him that Hilda was not only this girl, this charming child who was now surrendering to him, but she was also Harald's and Birita's only daughter. And whoever wins her wins the farm along with her and ties himself to the island for life. And great demands will be made of him. Indeed, he'll have Birita's cold and watchful eyes on him all the time, and he'll have to be apprenticed to the punctilious and close-fisted farmer. And what about his travels abroad? He would have to give them up. – But well, that's as may be . . . there are plenty who would consider it a fantastic piece of good fortune to get a farm as a dowry.

He felt almost ashamed of these thoughts. They were unworthy of a grown man. But suddenly there was an image before him: the mountains that quiet summer night when he waited in vain for Hilda . . . peak after peak, fading into the blue distance. And the gentle, dewy solitude.

"Josva," said Hilda suddenly. "I've got to tell you something: I can't stand it any longer at home. You must help me to get away. You will, won't you?"

"Away?" asked Josva. "Where to?"

Hilda sat up. "It doesn't matter . . . just away from here."

Josva didn't know what to think.

"Do you intend to . . . escape from here?" he asked uneasily.

Hilda said, "I've got an aunt in Holmvige . . . I'd love to be with her, and she would like to have me as well, but mother won't let me go."

"But what do you want in Holmvige?" asked Josva, suddenly afraid. "And have you thought of going there for good? Not coming back to Trymø?"

"Oh, I don't know," said Hilda wearily. "But I must go there now, Josva."

She threw her arms round his neck and kissed him. "Do you hear? I'll have to go home now or else we'll be found out."

"Oh, it wouldn't matter all that much if someone saw us," said Josva. "But . . . let me talk to you . . . Do you really want

to get away from here, to leave the island, and to leave – me as well?"

"No," she said. And she added, a little uncertainly, "You're the only person I can confide in, you know."

She got up, and they walked together along the road leading to the village.

"Can we see each other again tomorrow evening?" asked Josva.

"Yes," said Hilda. "If I can."

And she disappeared into the darkness.

. . . "I suppose it's just Daniel she's after, if she wants to go to Holmvige," thought Josva. "I'm not sufficient consolation for her."

He felt divided and limp in spirit. The sound of Hilda's voice continued to pursue him: "It doesn't matter . . . just away from here."

He walked on along the shore. The water was sighing sleepily and as though ailing along the edge, as though there was someone down there in the seaweed giving vent to some great and inconsolable melancholy. But there was also pleasure in these sighs. The merman is always full of emotion, sometimes happy, sometimes sad, sometimes both, so he sighs and laughs at the same time

Josva stared out into the mild autumn darkness. "If only we could go away together, far away . . . just away."

THE INESCAPABLE

I

Frida Olsen had expanded her business during the summer. The little hotel had been extended with two outbuildings, one at either end of the house. She had set up a shop in one of them and a café in the other.

The shop had immediately been a success. Frida had provided it with the very things that Sylverius didn't sell: hat decorations, collars and trimmings and baubles of the kind that girls and women can't resist. And then there were picture frames, centrepieces and other things that could be used to decorate sitting rooms. It had so far been necessary to order that kind of thing to be sent cash on delivery from Østervaag, but now it was only a matter of going to the new shop and choosing whatever you needed. And as for payment, Frida was very easy-going. The fishermen's wives were given credit under their husbands' names, and Sylverius's people were always given an extension of credit until the next payday. The stock had been almost sold out within a couple of weeks, but new supplies were on their way. There was a book of "desiderata" on Frida Olsen's counter. If there was something people particularly wanted, they could note it in this book, and it would be ordered, even if it meant ordering it from Paris itself.

On the other hand, the café was not doing particularly well. Morberg, who was the only person staying in the hotel at the moment, was sometimes to be found there, walking up and down, gesturing and talking to himself or sitting looking apathetically out of the window. People had started laughing a little at the café. It was well furnished with green-painted tables and chairs, and there was room for a couple of dozen people. The walls were decorated with advertisements for

cigarettes and chocolates, and above the door outside there was a bright yellow notice on which was painted in red letters:

F. OLSEN
Hotel – Café

"You must do something to get people used to café life," said Morberg one day while having his lunch at one of the tables. "Try a barrel organ; that would start people off."

"Barrel organ," said Frida Olsen scornfully.

"Yes, or a gramophone," nodded Morberg sternly and imperiously. "One of the sort you have to put a coin in to play. Because this empty café's starting to get on people's nerves. When you move a chair in here it sounds as empty and desolate as a morgue. It's dreadful to hear."

Morberg got up and walked up and down in exasperation.

"You're smiling," he said. "But just come here and I'll show you."

He went across and opened the door to the café. It was gloomy inside, but the square windows were alive with the blue waves in the bay.

Morberg started chanting: "In the beginning God created the heaven and the earth. And the earth was without form, and void; and darkness was upon the face of the deep."

Frida's hard mouth adopted an expression almost of pain, and she quickly moved away. The lawyer sat down at table again. It was not long before Frida returned. She placed a bill by his plate.

"Perhaps you'd be so kind as to pay for the last two weeks," she said. "I can't have you living here on credit."

Morberg turned towards her and smiled. And Frida . . . she blushed like a young girl and retreated towards the kitchen.

"How beautiful you were at that moment," said Morberg. "You are full of fresh, hidden springs, Frida Olsen. I will wager you've stored up all your youth without using it. There's an ocean of longing in your blood. Why do you try to enclose it in the awkward, narrow soup tureen of your behaviour?"

Frida started humming to indicate that she was ignoring his speculations.

"You must have met something on your path one day," continued the lawyer. "Something that crushed and deadened you. For instance infidelity. Am I not right? Infidelity from someone from whom you had expected loyalty? It tore your soul apart, you shut yourself up and battled amidst tears and scruples, and when you had finally overcome the pain, you yourself had become as hard as glass . . . merciless and faithless."

Frida stopped humming. Suddenly, she laughed . . . a happy but cold laughter.

"What a splendid seer you are. That's what you yourself think, at least."

Morberg emptied his glass.

"Yes, just give me your hand," he said, opening his eyes wide. "I will undertake to interpret every line in it . . . I will raise the veil on your future just as easily as you raise the lid of your haybox."

He raised his voice prophetically: "You will be faced with grievous battles and crises . . ."

Frida slammed the door behind her and was gone. Out in the kitchen, the water was boiling and the lid on the kettle rattling cheerfully and chattily. Morberg took out his wallet and placed some notes on the tablecloth where he was sitting.

That afternoon some customers arrived in the café. They were the crew of an English trawler, happy, noisy sailors who drank large quantities of beer and filled the café with cigarette smoke and alien smells. In the course of the evening, someone fetched an accordion from the ship, and Frida was asked if she could find some ladies so they could have a dance.

She shook her head apologetically. She was afraid that was not possible. At least not on this occasion, but if they came back another day, then perhaps . . .

But they played the accordion and sang and made merry until far into the night. And they drank about fifty bottles of beer and bought large quantities of cigarettes.

Before the trawlermen left, they all wanted to shake hands with the hostess.

"You've got a good place here," one of them assured her. "And if we'd had any idea there was a pub here like this, we'd have come to Holmvige far more often."

"You ought to have a big painted sign put up," one of them suggested. "Then you'd be able to see there was an hotel here from right out at sea."

He asked for a piece of paper and a pencil and in large block lettering he wrote:

WELCOME HOTEL

"That's what you should have on the sign," he nodded encouragingly.

That evening, Frida Olsen was relieved and happy. The trawlermen had discovered her café now. It had admittedly not happened without her herself having had a finger in the pie . . . She had secretly sent Søren Smelt to the ship to point out to the foreign sailors that there was a pub in the village. For that had always been her plan with this café: it was to be a place of refuge for all the trawlers that put in to Holmvige during the year. These were people who paid cash and were not too fussy about how much they spent.

II

There were the strangest rumours circulating about the confessional congregation in Storefjord. Their numbers were growing steadily, and hardly a week passed but what there was a baptism in the meeting house. For these sectarians were anabaptists and did not believe in infant baptism.

Egon, Sylverius's shop assistant, had had an errand in Storefjord and could tell people what one of these baptisms was like. There was a dais at one end of the meeting house and a huge water tank had been set up there. To the accompaniment of singing and organ music, the newly converted were

155

led in from a room at the back of the hall, dressed only in a thin gauze garment and immersed in the water by a baptist wearing long rubber boots. It was the baptism of a young girl that he had seen. It had been strangely moving to hear her confess her sins. She had lived an immoral life, been a child of the Devil to whom no sin was alien, but now she felt that she had been purged and cleansed in the Blood of Christ.

Egon, who was otherwise known as a bit of a wag, was very serious indeed when telling people about this visit to the sectarians. In fact he was not far from being angry when Bernhard Thomsen asked whether the baptist had had a life-belt round his waist. "You've already started hanging your head a bit," laughed Bernhard. "That's what happens when you come from Trymø and see that kind of show for the first time. But if you'd been like me and been tanned and caulked in the evils of this world, you'd get less excited about that sort of thing."

Bernhard had lived in Edinburgh for a year and briefly been a member of a sectarian congregation. But he had soon had enough of it.

"People who stand up and confess their sins," he explained, "usually think that they're immediately and for all time raised above anything as low as sin. But they discover otherwise, and then things really go wrong for them, 'cause you can't go on being converted . . ."

Egon didn't agree.

"No one can deny that the world is a bed of sin," he said, looking away.

One evening soon after this, two of the sect's representatives arrived in Holmvige. They were Reinhold Vaag the preacher and his sister Tekla. They could be heard singing in the village that same evening. They had taken up a stand under the acetylene lamp hanging outside Sylverius' store. This lamp was usually taken down when the shop closed, but Sylverius allowed it to hang there so it should not look as though he were trying to exclude these people with their songs.

It was not long before a surprised group of listeners

gathered around these people from Storefjord. The tunes they sang were curiously cheerful, and if the word Jesus had not appeared so often in the text one might almost have doubted whether these were religious songs at all. The preacher had a clear, high-pitched voice, and words and music poured from his mouth naturally and easily. He was a slight figure with fair hair and kind, gentle eyes. But these eyes seemed not to be following what he was singing, but to be flitting around and observing on their own account.

As for his sister, on the other hand, her eyes did not leave the little booklet she was holding in her hand. She sang with a rather shrill voice . . . a stronger and more piercing voice, actually, that one would have credited her with, for she had a slender figure and gentle, childlike features.

When the last verse was finished she looked up for the first time, but her eyes were directed towards the heavens and did not seek the listeners; at the same time she folded her hands. The missionary said a brief prayer, and then he stepped closer to the group of spectators and started to speak.

Those closest to him drew back a little as though they were afraid of him getting too close to them.

Reinhold was one of the best speakers in the confessionist congregation. He did not labour to find his words, standing hesitantly like the Reverend Martens. He had an abundant gift of speech. His language was straightforward and full of everyday images, but at the same time there was something profoundly lamentational about it, something of a gloomy invocation.

There were many who took immediate exception to this tone. There were those who turned away in disgust . . . it was abhorrent to hear a grown man standing there moaning and on the point of tears. But others were carried away by his words, especially the womenfolk, at whom his message indeed appeared to be particularly aimed. They nodded quietly . . . of course, what he said was true: life was dangerous; sickness lurked everywhere; the sea was treacherous and merciless; the message about death hovered in the air above your heads, and you had to choose before it was too late. That was also what

the clergy and the Church said, but according to them you could repent and find grace quietly and comfortably, and in believing this they made a terrible mistake. For to a person who felt redeemed and remained silent about it, that redemption was as nothing. Step forth and confess your sins, bear witness to others and continue Jesus' work of redemption on earth. That was the way . . .

The listeners were also able to see how this confessing your sins was done. After the speech, the young girl, Tekla, stepped forward. With her arms hanging limp beside her and with her eyes turned down, she looked really troubled. Yes, she had been on the road to sin and error; she had lost her way in the dark and had gone far, far away from the ways of God. But she had met the Good Shepherd, whose heart bleeds for even the least and most miserable of His sheep, and He had taken her in His arms and carried her home.

The next day was a Sunday. Contrary to custom, the church was full to overflowing. It was as though the presence of the sectarians in the village had awakened the congregation to the need to stand together and be on guard.

An obvious change had taken place in the Reverend Martens over the three weeks that had passed since he last held a service here in Holmvige. He had become even more wretched to look at; his face had turned yellow and there was a feverish light in his eyes. He looked as though he had had been fighting profound religious scruples, or perhaps he was suffering from some wasting disease. And he spoke like someone who has been totally enervated and wearied, but who has determined to hang on to the very last. The slow sermon was unending. The pauses between sentences became longer and longer, sometimes so long that the congregation became restive . . . People had to pull themselves together and look at each other. Never before had they encountered such slowness.

Sigvard Hovgaard, the parish clerk, sat there unable to decide whether this slowness on the part of the Reverend Martens was due to a profundity unusual even for a clergyman, or simply an inability to express himself. There was

much to suggest that it was a mixture of the two. There was something moving about the priest's face and figure, something that made one think of certain biblical figures, Simon of Cyrene or Joseph of Arimathea. There could be no doubt that the Reverend Martens was a man fighting the good fight, a man whose faith was not superficial, but had grown from the depths of doubt and scruple. If only he had been able to express this profound and hard-earned faith to his congregation not only in his tone and his posture but also in words!

. . . Mr and Mrs Martens were staying with Sigvard. After the service, the minister wanted to rest for an hour or so. He lay down fully dressed on the bed.

"You'll crease your jacket," said his wife, pulling his sleeve gently.

"Oh, leave me alone," sighed the vicar.

Mrs Martens sat down on the edge of the bed. She, too, sighed. She took his hand and squeezed it, worried and pained as she was.

"Just you have a good rest," she whispered.

She felt dizzy for a moment; she had to close her eyes and sit down and collect her thoughts before she could regain her balance. It had been a demanding day in church today. But thank God, it had once more all gone well.

The minister had fallen into a deep sleep. The countless wrinkles in his face had been smoothed out, and there was a childlike look about his mouth.

Mrs Martens cautiously opened the door. She was going to make use of the opportunity to visit Simona from Trymø; she could allow herself at least that bit of relaxation.

Simona gave Mrs Martens a warm welcome. It had become something of a habit that Mrs Martens came and paid her a visit each time she was in Holmvige together with her husband. A plentiful table of hot chocolate and homemade cakes stood ready.

Mrs Martens loved hot chocolate.

It was wonderful to sit here in the bright new house adjacent to the merchant's store and to have her private

worries at a distance for a time. It brought back memories of her own youth, when she was newly married and without worries.

She started to tell Simona about those days. The result was a string of stories about merry evenings, excursions in carriages and boats, Christmas parties and midsummer festivals. Simona simply failed to imagine the solemn vicar as a happy young man, full of fun and games.

"No, it's difficult to imagine how he's changed," said Mrs Martens. "It simply happened . . . bit by bit."

And without having really intended to do so, Mrs Martens started to tell how this change in her husband had been revealed, how he had become increasingly eccentric and finally had decided to seek a lonely parish.

She felt a strange sense of liberation in being able to confide in someone about these things. Simona was so kind and understanding. It was like having a wearisome burden lifted from her shoulders and being quite free for a moment to gain her breath and stretch her limbs.

Mrs Martens took Simona's hand: "I will tell you something . . . and I know that you won't let it go any further, not even to your husband."

Simona nodded calmly.

"You see," Mrs Martens continued, though at that moment her eyes became strangely misty: "My husband is ill, not so much physically as spiritually. It's dreadful both for him and for me. He is convinced he is being pursued."

She hastily looked around.

"We are quite alone here?" she whispered and smiled immediately: "Yes, you know . . . one sometimes becomes a little nervous."

She went on: "You see . . . to begin with he just thought it was just a single man pursuing him, a Catholic priest. For you see, as a child and young boy, my husband was in a Jesuit college . . . the idea was that he should be a Catholic, but then he joined the ordinary church. And this Jesuit priest really *has* been after him; he has pestered him with letters and all kinds of persuasion . . ."

Mrs Martens hesitated for a moment and then closed her eyes tight.

"Here I am, talking all the time," she said. "But there's no harm in that, is there? . . . You know my husband has gradually persuaded himself that this Jesuit has started a vast apparatus to undermine him, to bring him down, as he says. Yes . . . it's difficult to explain . . . something about hypnosis and telepathy he says. But he sees traps everywhere and distrusts everyone – I simply can't describe how dreadful it is."

Simona sat open-mouthed. She didn't know what to say at all. For a moment she was inclined to believe that it was Mrs Martens herself who had gone off her head.

Mrs Martens sighed, and with a nervous little smile said, "No, you don't understand. And it's simply not possible to understand it either."

She got up and breathed out, relieved and refreshed, like a child that has played until it's tired and has flopped down on a bench. She had needed so much to get rid of this secret. And telling it to Simona was not letting her poor sick husband down, so there was no need at all for her to regret what she had done.

"Ah well," she said in conclusion. "It's all a trial sent to us by God, and so we know there's a loving intention behind it. And I suppose some more time will pass yet," she added with a sigh. "Perhaps a year, perhaps more. And one day the time of trial will be past, and then it will be good to rest after it . . ."

III

Autumn was approaching.

August had been mostly warm and damp with misty sunshine alternating with drizzle or fog. This calm weather lasted for some weeks into September, and then one night the wind changed to the north, bringing clouds and fog sweeping in the following day. The next day again both sky and sea

were moving southwards; the shadows of the clouds were constantly drifting across the countryside in its autumnal yellow, and the air was cool with a touch of frost. In the early hours of the morning dark veils of migrant birds could sometimes be seen standing out against the lightening sky.

The north wind was good for the returning fishing boats. Almost every day at this time one or more ships arrived in the Trymø Sound from the north.

Sylverius had received telegrams from his ships. They were all among the best with regard to profit. One of them, the Dumbarton had even achieved the record for the year. This was quickly rumoured in Holmvige and spread wider and wider throughout the country. The skipper of the Dumbarton had suddenly become a famous man, the fisherman of the year. His name was Guttorm. He was no more than twenty-five years old and had only recently qualified as a skipper, so he had made a singularly good start.

Morberg, the solicitor, paid a visit to Sylverius to congratulate him on the successful catch.

"It's as I foresaw," he said. "You're a King Midas, and everything succeeds for you. But . . . do you intend to accept all this cloying good fortune without sacrificing as much as a little glass of rum to the gods?"

Sylverius laughed and asked him to take a seat.

"Quite seriously," continued Morberg. "Don't you realise that you owe a sacrifice to the higher powers?"

"One might think you were a kind of high priest for the gods you're talking about," remarked Sylverius.

"Yes," said the lawyer seriously. "And that's completely right. As long as I live in Holmvige, I shall be the high priest of the gods. So, Sylverius, be a convert and take out that complacent bunch of keys and open the cupboard in which you hide the sacrificial bowl."

Sylverius did as he was told. Morberg closed his eyes.

"Omnia ad Dei gloriam," he chanted. "Thank you, favourite of the gods, and may you enjoy the favour of all higher powers now and to all eternity, Amen."

Morberg took the bottle and filled the glasses. "You're

smiling so strangely, it seems to me, Sylverius. And you don't look too pleased. Don't you sense the glory and grandeur of this moment? Just look out of the window . . . this midday sun surging over the sea. This golden wind bringing your fortunate ships to port."

He got up and went across to the window.

"Yes, that's just the point," he continued thoughtfully. "A wind of prosperity and success is blowing across the sea from the north. It carries with it a fine gold dust. Our poor black coasts are starting to glitter with fallen specks of gold."

He sat down at the table again, lit a cigar and leaned back in the sofa.

"In my childhood, the wind blew greyer and colder," he went on dreamily. "*I* was the only one it blew golden for. Poor teacher's son as I am, I was given a real place in the sun when I was 'discovered'. And my poor credulous father persuaded people to invest money in me."

He emptied his glass, filled it again and went on: "I'll never forget the admiring and adoring eyes I encountered when as a student I came home to this poor island of mine during the summer holidays. I was seen as a kind of hero. And finally I myself came to think I was. I well remember the heavy responsibility I felt each time I returned to my studies in Copenhagen. I so much wanted not to disappoint all those eyes watching me."

"No, times were different then," said Sylverius in an effort to turn the conversation in a different direction.

But Morberg interrupted him: "And you see, Sylverius, ever since then I've been unable to forget those eyes that I let down so shamefully. I ought never to have come back, you see, but one becomes shameless with the passing years . . ."

"It seems to me you're becoming rather glum," said Sylverius.

Morberg ignored him and went on, closing his eyes, "Aye, you understand, Sylverius . . . I was supposed to come back as a parson or a learned man or a rich man, not as a drunkard or the man 'whose wife ran off'. Or perhaps the truth is that I actually feel a certain satisfaction in going around showing

what a mistake they made . . . going around like a plucked angel shaking my goose-fleshed wings."

He gave a loud laugh.

"But this miserable show has lasted long enough, incidentally, and I'm leaving next week. Off into the unknown. Cheers."

He drained his glass and took a couple of powerful puffs at the cigar. "My poor old father . . . what was it he used to sing:

> What, o what, is that vile snare
> The world doth adorn with countenance fair?

. . . If he were still alive I would this moment have gone and sung that hymn with him again. – While I was little I always found it pretty dreary, but now I could genuinely apply it all to myself. Oh, but I don't know . . . tired of the world, perhaps, but not longing for heaven – no, I've not got as far as that yet."

"You're being pretty hard on yourself today," said Sylverius. "Now I think you ought to give *me* a going over to even things out a bit."

"No, I'll not do that," the solicitor smiled sadly. "For you could simply not have tolerated such a going over as that. You're not salted and cured enough. But perhaps you will be some day . . . All in good time."

Morberg smiled and raised his eyebrows.

"Although, Heaven alone knows. – Do you know what you really remind me of, Sylverius? You remind me of the plant called rhubarb. You are vigorous and juicy, and you're useful and you grow quickly, but you're *brittle*."

"Am I brittle?" laughed Sylverius.

"Yes you're brittle. You'll never grow to be a tree, you know. And for that matter neither will anyone else here in this treeless country. We never grow up, remember . . . We're all children, happy children, despairing children, poor naïve and hopeful children. But you're a big, brittle rhubarb, Sylverius; no one can take that away from you."

He got up and slapped Sylverius on the shoulder.

"Oh well, *allons*. For the time being I'll take this bottle and what's left in it, and then I'll tread my dark path. . . . out to flap my wings."

"Wouldn't you rather come and have supper with us?" suggested Sylverius.

"No." The lawyer wrinkled his nose. "I won't want to meet that wife of yours, the Madonna . . . those eyes, no!"

He put the bottle in his hip pocket and hurried out through the shop.

IV

The north wind developed into a gale during the week.

Out in the sound the tidal waters foamed white and green, and across the waters of the inlet the gusts swept ceaselessly and blew great flakes of foam up between the houses. All the windows were coated grey with sea salt. The sun disappeared in the clouds and only showed itself now and again in the shape of a brownish, drifting jellyfish up there. But the night was as black as the tomb; neither moon nor stars were to be seen, only the black cavern of the sky. The storm rang out and resounded in the mountains. It sounded like the doleful whine and roar of the wind in gigantic rigging.

Three of Sylverius' ships arrived in the midst of the gale. They had all been knocked about, but none of them had been seriously damaged. They anchored out in the cove, in the shelter of the small island out there.

But the gale seemed to intensify rather than blow itself out. There were fears for the two ships still at sea, the Isabella and the Dumbarton. They were certainly both new ships with powerful engines, but a hurricane such as was now sweeping the sea could be catastrophic even for large steamships.

Sylverius was uneasy, torn between fear and excitement. He spent most of his time fretting in his office and neglected to eat or sleep. For three days and nights, the barometer remained stubbornly down. Then it slowly began to rise; the gale subsided in the course of a day and the sun came out

again. During the evening, the inlet peacefully reflected the black mountains and the starry sky above. But through the silence the rumble could still be heard of breakers against the rocky coast of the sound, an everlasting, insatiable thundering.

During the night, Sylverius was awakened by the sound of an engine. He got up and went down to the wharf. There was already a throng of people, both men and women, milling about. They were crowded together in the light from an acetylene lamp and all talking feverishly at once. A boat had been lowered, and now the shouts cut through the darkness out on the sea:

Is it the Isabella? Is it the Dumbarton?

It was the Isabella. It had survived the storm with great difficulty. The mizzenmast had broken. One man had been struck by the mainsail boom and knocked overboard. Nothing had been seen of the Dumbarton.

At daybreak, the sad outlines of the single-masted Isabella emerged. Part of the gunwale had been smashed and splinters of wood lay scattered over the wet deck.

Everyone was discussing the fate of the Dumbarton. It was the general view that if the ship failed to arrive during the course of the day, it was unlikely to have survived the storm. Never before had the crew of the Isabella been out in a gale like this one.

Magnus and young Gotfred had gone up to have a talk to Simona. They sat in the kitchen drinking coffee, almost unrecognisable with their weathered and bearded faces and heavy jerseys and boots. Magnus had sprained his right wrist, which was swollen and bruised. He intended to take the mail boat to Storefjord that afternoon to ask the doctor there to see how badly he was hurt.

"Aye, Magnus almost went the same way as Daniel," said Young Gotfred. "But he got away with his wrist."

"Was it Daniel who was knocked overboard?" asked Simona.

Magnus nodded and started to tell about the unfortunate event. It had happened during the night, on the third day of their journey home. He had had the watch together with

166

Daniel; they had just been relieved and were on their way down to the forecastle to get some much-needed sleep. Magnus had gone on ahead. Daniel was standing giving instructions to the man who had replaced him. The storm was dreadful, and you had to be an experienced seaman to manage on deck.

"I ought to have waited for him, of course," said Magnus. "He always seemed to be stumbling over something. But I was dog-tired and, to be honest, I hardly gave him a thought. But then I suddenly heard a shout and rushed up on deck again . . . and I realised straight away that Daniel was in trouble. But before I had time to work out what was going on, I was knocked over by a huge wave and had difficulty holding on. You're both blind and deaf when you get all that water over you . . . and then I had the trouble with my hand; I really thought it had simply been cut off, that's what it felt like. But when I got myself pulled together and got up on my elbow again, I could see that Daniel had gone."

"Oh my God," exclaimed Simona. She stood holding her tightly clenched hands up to her chin.

"The watch had rushed up as well," continued Magnus. "They had heard the thwack he got from the boom. But there was nothing to be done. Aye, that's how it happened."

Magnus twisted his mouth: "That kind of thing's awful."

"Our Daniel was a bit clumsy on deck," commented Gotfred. "But well . . . even a trained sailor can be knocked overboard."

"But didn't you do anything to try to save him?" asked Simona.

"We turned the ship round, and that was a hell of a job, too," said Gotfred. "It was really for the sake of appearances, because it was simply hopeless."

"You could easily have been knocked overboard yourself, Magnus," said Simona. She added in a quavering voice: "What a terrible moment it must have been for him, poor lad."

"Yes, but he was presumably knocked right out by the blow he got, at least I hope so," said Magnus.

Simona sat huddled up as though she was cold.

"If Josva had gone with them," she said. "It might have been him who caught it."

. . . Sylverius had had a man standing looking out from the mountain from early in the morning. About midday he himself went up to take his place.

It was a clear day with bright skies and a black-blue sea. Up here on the mountainside there was a thin covering of snow. Sylverius opened his telescope and slowly examined the horizon, but there was not a ship to be seen, only the blue desolation of the sea.

How vast the sea was when seen from up here. And all the inlets he could see out there, which in daily life seemed to be a whole world . . . from up here they were like a couple of buckets of water. Near the opening to the inlet here were his buildings and ships, all looking like tiny toys. And the farms in the hollow around the bottom of it all looked like tiny hillocks and irregularities in the ground.

Sylverius had been to sea for a number of years, but never in all that time had he given a thought to how infinite the sea was, breathtakingly vast, from north to south, from west to east, boundless. The mountains stood out against the cold air in calm and unconcerned profile. Sylverius was overcome by an irrepressible melancholy. He felt weak; a cold sweat broke out on his forehead, and he was close to tears.

The Dumbarton – could that splendid ship really have gone down with its crew and its cargo, with that kind and brave Guttorm and his twenty-two fine men? Could that be God's will?

But hope had not entirely vanished yet.

Sylverius was just a little embarrassed at his own weakness. He thought of Morberg's comment that he was *brittle*. Was he really *brittle*?

He took a bright gold coin from his waistcoat pocket, an English guinea . . . it was his lucky coin, and many a time it had given him a useful hint when he was faced with a choice. Could it give him hope now?

It was worth a try.

He trod the snow down so a bit of firm ground appeared. Then he dropped the guinea. The first time . . . ah, the lucky side was up. Again . . . the coin glinted in the sunshine and fell to the ground, but this time it was the unlucky side up. He put the coin back in his pocket; it was not worth tempting fate.

And yet, as he had started, he might just as well go on to the end. He took the coin out again and threw it. The lucky side was up.

Sylverius involuntarily danced on the spot. Suddenly he noticed how the snow crystals were shining in the sun in fine rainbow colours. He felt filled with hope, indeed with certainty . . . the Dumbarton had not been wrecked. In some inexplicable way he felt that there was a connection between fate and his lucky coin, however that was to be explained. He was completely convinced of that.

V

But the days went by.

A week passed, and then two. The Dumbarton did not return.

Sylverius had not the heart to extinguish hope for those poor wives and girlfriends who came to the shop every day to hear whether there was any news of the ship.

Some sort of message must surely come from somewhere or other, they all thought – a letter or a telegram, even if it contained nothing except that the wreck or its name board had been found.

Sylverius tried to comfort them as best he could. It could do no harm, and it was perhaps better in spite of everything if hope ebbed out slowly than if the news of the catastrophe came suddenly like some implacable flash of lightning. And he himself was still not without a little hope. A ship *could* drift around for weeks, indeed months even, and yet come back. And even if the ship had sunk . . . the crew could still have got ashore somewhere or been picked up by another ship.

But this was a faint hope. It was like the glimmer from a tiny candle in a black, windy, tempestuous night.

Johanne, the skipper's wife, had not lost hope. She had lost a brother at sea, and on that occasion she had been visited by an apparition. If Guttorm had been lost, he would also have let her know by this occult means; she was convinced of that.

Johanne was a big, healthy woman, the mother of four, already stout although she was only twenty-one years old. She certainly did not look like a visionary. But not everyone was as calm as she. Elisabeth, Bernhard Thomsen's sister, whose fiancé was also on the Dumbarton, went about weeping and moaning openly to everyone; she was pitiful to behold. Their wedding was fixed for October, the house was built and furnished, the accessories had been bought . . . all that was missing were curtains in the best room; she had ordered the material for these curtains from Frida Olsen, but what was the use now?

Bernhard knew no way in which to comfort the girl in her despair. It was dreadful to see her struggling with her misfortune like a drowning girl in the water, and yet to be unanable to give her the least help.

One day, when Elisabeth came sobbing into the shop, Egon stepped over to her, took hold of her arm and said with a strange, alien ring to his voice: "Weep no more, Elisabeth. Remember that Jesus died for you."

The girl looked at him in amazement and shook her head.

"What was all that about?" asked Bernhard, going up to the shop assistant.

Egon blushed and looked down. But it was not long before he came and looked Bernhard straight in the eye.

"You ought to think about that as well," he said. "Jesus gave his life for us so we can be saved."

. . . Sylverius went up into the mountain with his telescope every day. It had become a habit with him, and it was as though he found some comfort in the time he spent up there alone. And he felt a constant and urgent need to think about his situation and to make up his mind about things.

One night as he lay unable to fall asleep, a thought had struck him: If he had not bought that ship, the Dumbarton, this misfortune would not have occurred. So properly speaking it was *he* who had the responsibility for the loss of these lives.

And yet, it was not right to look it in that light. In that case you might just as well never undertake anything at all and merely sit with your hands in your lap and shudder at what that happened of its own accord, what was inescapable . . .

★★★

But on the other hand, he could not dismiss the thought; it came back to him every time he had a moment of weakness. What power had moved him to expand his business and buy new ships? It had been done without any real hesitation . . . as something that was so much a matter of course that no one would have any second thoughts about it. But a painful reason for reflection had now been created. You could dismiss it as irrelevant, as nonsense. But it refused to go away, it simply lay in wait until there was an opportunity to reveal itself again. Just as he was falling asleep, it could suddenly be there and make him wide awake again. And then no reasoning was of any avail.

But for heaven's sake . . . must one abandon a business simply because there is danger associated with it? That would be a thought more appropriate to an old woman than to a man. And yet somewhere or other there were the words: "Take therefore no thought for the morrow, sufficient unto the day is the evil thereof." Perhaps he had been too concerned with the things of this world. First seek the Kingdom of God . . . Perhaps this misfortune was a lesson sent to him by God. But then what about the poor widows and orphans? What wrong had they done?

He saw them in his mind's eye sitting there in their homes, pale and spent by the constant waiting. Among them was an elderly widow, Sunneva, who had three unmarried sons on the Dumbarton. This Sunneva was now completely alone in

the world, for she had only the three children. That was how life could impoverish a human being.

Sylverius went past Sunneva's house every day and had several times thought of going in and talking to her. But what was he to say . . . how could he comfort the unhappy old woman? Nevertheless, he called on her one day. Sunneva was sitting in the kitchen reading a brand-new New Testament in pocket book format. She looked up in surprise when Sylverius came in and put the book down. But suddenly she got up and a wild look came into her eyes.

"Is there . . . news?" she asked.

Sylverius shook his head: "No, I've simply come to see how you are. You're having a difficult time."

Sunneva sighed.

"A dreadful time," she said. "Fancy an old woman like me having to experience this suffering. And I so pleaded with them not all to go off on the same ship, all three together. We all know what so often happens at sea."

She dried her eyes on a corner of her apron.

"But then it was God's will," she went on. "And if He's taken them in His mercy, the only thing to hope for is that He will shorten my life. I pray He will."

She shook her head and stared ahead.

"They all believed, so there must be mercy for them," she added. "The preacher thinks that, at any rate . . . He comes here every day, and now he's given me this lovely Bible. And just fancy, my eyes are still so good that I can read it without glasses even though the letters are so small."

She took the book and caressed its creaky leather binding.

"But what about me?" she said, abandoning herself to sad contemplation. "The preacher says that if I feel I have received grace, then it's my duty to stand up and tell everyone I am saved. My duty towards others so that they can be redeemed as well. And perhaps he's right. But I won't be baptised again. No, I won't do that . . ."

She made a dismissive gesture with her hand.

Sylverius felt it as a kind of consolation to discover how the old woman was supported by her faith. Perhaps the others

who had been affected by this tragedy were similarly feeling that they were being brought closer to God and that He was protecting them with His shield from the very worst pains of the disaster.

"But there's something else," said Sunneva dispiritedly. "The world will go on as it is as long as we're here, and I've got to think of what I'm to live on if my sons are no longer here."

She started to weep again. "They looked after me so well, all three of them. Just look at this shawl I'm wearing . . . they gave it to me when they came home from the spring fishing. And they had a lot of other things for me as well. Oh, God, they did really . . ."

"As for that," said Sylverius. "Just you come to the store and you can have whatever you need."

"Oh, thank you," said Sunneva, taking his hand. "I hope I'll only be a burden to you for a short time, a very short time . . ."

Sylverius left the old woman with a feeling that he himself had been consoled as well. Evening had come, and the people from the Storefjord Mission were outside singing hymns. He stood for a moment on the edge of the crowd.

The singing rang out. The preacher's sister stood looking down into her booklet. The light from the lamp caught her curly fair hair.

"Aye," thought Sylverius. "If these people can do even a little bit to comfort these wretched people struck by this misfortune, then theirs is a good cause."

DAY AND NIGHT

I

On Trymø, too, the news of the Dumbarton's fate had put a damper on people's spirits.

As they returned each evening, the fishermen gathered in Landrus' shop. Most of them had sailed on Sylverius' ships and experienced the great autumn gales. None of them held out any hope for the Dumbarton or its crew.

Landrus, on the other hand, had a different view of this matter as he did on so many others and went around nodding to himself as though possessing some dark secret. Now and then he would make some opaque comment: "We can think what we want, of course . . . I simply say that when two ships are out in the same gale and one comes back, why should the other be wrecked? Well, that's what I say . . . and I know a bit more about the world and human beings than you do, at least that's what I imagine."

No one really understood what Landrus meant. But one evening, when the conversation again turned on the fate of the Dumbarton, it emerged quite clearly what strange thoughts were going through his mind.

"I've been wondering quite a lot about how Sylverius will go about getting the insurance paid," he said. "Well . . . How can we know for certain that the ship's sunk? Doesn't the insurance company want proof?"

Landrus looked into the blue cloud of tobacco smoke hanging over the counter. He had a cunning look on his face: "For suppose in a case like this that the shipper's a cunning rogue and sails off and keeps both the ship and the catch . . . by agreement with the crew, of course. Or" – he laughed – "perhaps even by agreement with the ship's owner! I'm not thinking of this case in particular, but couldn't we imagine

that kind of thing in certain other cases? There can't be much doubt of that."

The seamen shook their heads. Some smiled. There was not much else you could do . . . Old Landrus was always saying peculiar things.

"It's a good job you're not a skipper yourself," said Martin, the shoemaker. " 'Cause then you'd just pinch the ship and be off to America to dig for gold and leave your wife and child in the lurch."

Landrus gave him a dismissive look. He took out a chest of tea and emptied its contents on the back counter.

"Ha, ha," he said aggressively, shaking the chest and sprinkling bits of tinfoil on the mound of tea.

"Aye, otherwise you'd be a pirate," continued Martin calmly, "lying in wait for the passenger boats or cutters coming home with the spring catch. You look just like a pirate when you're seen in the right light."

"You watch your tongue," said Landrus. "I really meant what I said just now. . . . We don't have to be told that things like that happen."

His eyes wandered over the group in the hope of finding support, but all he saw were eyes either looking down or mocking him.

"Aye, just you make fun of me," he said finally. "And cast doubt on my honesty and good will. Others have tried that before you, and it's done me no harm. But one thing I can tell you is that *I'm* capable of something none of you could do. You might one day get so far as to be skippers if your brains can cope with all you've got to learn, but I could buy myself a ship at any time I feel like it. I had what we might call an offer of one the other day. And who knows . . . I might accept it and get it ready for the spring."

"Good God," said Martin, sounding completely overwhelmed.

Landrus nodded and showed his teeth through his beard.

"You'll kill us all one day," commented Martin. "And that'll be the end of it."

Landrus laughed uncertainly and looked away. He took out

a roll of paper, sat down on a box and started to make small paper cones for the tea. His greying mane glittered in the lamplight with a sheen like hoarfrost.

"We'll see," he said reflectively. "Those who live longest will see most."

But suddenly Landrus sighed heavily. His heavy shoulders rose and sank.

"But good heavens," he said – "when you think of all the men and boys who might be lying on the bottom of the sea now."

This sigh came so unexpectedly . . . it was as though a cold wind had swept through the shop, and the conversation between the men at the counter came to a halt.

"Aye, no one knows what his fate's going to be," Landrus went on ponderously.

He left the tea and got up with a reflective look: "There's many a one among us going around with death's sting in him without knowing it. Like Daniel, that farmhand of Harald's that went round here with big ideas . . . Aye, we can't know the ways of fate – there was this Daniel who once nearly drowned near the quay in Holmvige. Magnus saved him that time. But then he was going to drown in any case. It was his fate. For God's account must always be rounded off . . ."

Landrus stood with his back to the light. It was as though darkness emanated from his broad figure, giving his mysterious words a remarkable weight. He stood there for a moment like an ominous priest and messenger of fate. Then he sighed again, turned around and resumed his task of making paper bags.

II

Josva had still not left. He had asked his brother-in-law to get him a job on some salt or fish transport as an ordinary seaman, stoker or anything at all, but nothing had come of it as yet. He still went around waiting and waiting.

The task of clearing the hillside was only going slowly – it

was an enormous job. Sometimes when he came home worn out after only managing to upend a single one of the huge, stubborn boulders out there in the course of a day, he felt terribly tempted to give it up. But the upshot was always that he set about it again. He had plans for getting some explosive and some drills; that would improve matters.

Kristoffer came out occasionally and gave his son a hand. He was quietly surprised at this idea of Josva's and sometimes could not help feeling a certain concern on account of his son. The boy had his peculiarities and must for heavens' sake be allowed to do what he wanted while waiting for a chance to get away. Kristoffer had also persuaded Magnus to say nothing about what he thought of his brother's undertaking up on the hillside.

Otherwise, Josva kept to himself and was not disposed to talk much to others. In the evenings, when he had gone to bed and lay listening to the desolate soughing from the darkness out in the bay, he could be overcome by a strange sense of despair. Half-forgotten snatches of ballads or refrains came to him, verses he had learned by heart as a child and only half understood, and which were still without a clear meaning for him. Yet they could contain so much worry or anguish that they carried him quite away. It relieved his depressed state of mind when he abandoned himself to these moods

Josva had felt strangely touched by the news of Daniel's death, and it was as though there was now an empty place in his mind. For – he realised now – he had been in such a state that he had feared, indeed almost hated this Daniel on account of Hilda. And now he felt shame and regret at the mere thought of it.

And as for Hilda . . . He wondered how she had taken the news of the tragedy. He imagined her completely crushed by it, like Margrethe in the Ballad of Benedict. Strange . . . he had had as it were a feeling that things would go like this for those two. And, although he had not wanted it, he himself had been a link in the chain of sad events . . . it was with his help that Daniel had left on the voyage from which he was not to return.

Josva wished from the bottom of his heart that he could comfort Hilda in her sorrow and loneliness. Though, after what had happened now, she could hardly do anything but despise him. Perhaps she actually hated him. Since that occasion during the harvest time he had not had the chance of meeting her, and he had had a bitter feeling that she was avoiding him. And was that really all that surprising? Of course, she had said that he went around dreaming . . . and had werewolf eyes, and he could not get those words out of his mind again. That was presumably what he was in her eyes, a strange lad who went around dreaming and having visions. Daniel – he'd probably been made of completely different stuff; he'd been one of those who go straight at things and achieve what they want. A real tough guy, as they said.

Josva became more dissatisfied with himself by the day and often abandoned himself to dark, strange thoughts. A longing to get away burned in his blood, but at the same time he dreaded the day when he would have to say goodbye to his native village. One night, when he was lying unable to get Daniel's at once sad and yet strangely compelling fate out of his mind, he remembered some verses from the ballad of the proud and cheerful Jon Rimaardsøn, who died at sea. What thoughts might Daniel have had when he saw death approaching? It must have been a dreadful moment . . . the dark night, the tempestuous sea and the hopelessness. And suddenly he was filled with profound sympathy for Daniel, whose life had ended out there in the dark just as when a poor defenceless candle is blown out by a mighty gust of wind:

> So sad it was, he crossed himself
> Above the waves so blue,
> And then he took the stormy path,
> To the deepest depths he flew.

III

Young Gotfred had not returned to Trymø together with the other seamen. He only appeared a week later. He had been attending to something in Østervaag. No one was told what this errand was.

He was hardly recognisable when he finally came; he had grown a reddish beard, and this had made him look several years older. In addition, he had exchanged his homely red cap for a black bowler hat.

His father examined him with obvious disapproval.

"You look more like a monkey than a respectable human being now," he said.

But Gotfred refused to be put out.

"The hat's fine," he replied. "Even if it's not intended to be worn out here in the Styx."

"It doesn't look too bad on you," his mother thought. "You look almost like a sheriff."

Looking flattered, young Gotfred sat down in his father's armchair and started opening his suitcase. His sisters hovered curiously about him.

"Off with you," he commanded. "You think it's presents for you, my little dears, but you can think again. It's only a hat for father, one like mine, and a pair of silk wristlets for mother . . ."

He turned the suitcase out on the floor. It was full of small packets, and on each packet had been carefully written in his best handwriting the name of the person it was intended for: to my dear Mother, to my tall sister Margrete, to my inquisitive sister Marianne and so on. There was a little thing for each of them. For his father a coloured bookmark portraying an interwoven cross, anchor and heart and inscribed in silver writing: "Faith, Hope and Charity". For his mother there was a pair of small gilded cups, for his sisters glass beads, brooches and hair ribbons, and for the inquisitive Marianne there was also a small box decorated with flowers, containing a long and very lively paper snake with a red head.

The gifts were received with cries of delight. The youngest

sisters fought to stand in front of the wall mirror and almost came to blows.

"Now, now," the parish clerk cleared his throat. "Behave yourselves and say thank you to your brother for the presents."

"There's not much to thank me for this time," said young Gotfred, pushing his hat high up on his forehead. "But when I come back next year as a skipper . . ."

"So you really intend to study for the home-trade master's certificate this winter?" asked his father.

Gotfred nodded: "Magnus and I have both signed up for it."

"Yes, that's the way to go," his father went on seriously. "But otherwise I can't help being a little concerned after hearing the sad news from the sea . . ."

"Oh, you mean the Dumbarton," said Gotfred. "Yes, that was sad, it certainly was. But Guttorm, the skipper, was not a good navigator."

"Wasn't he?" asked his father dubiously.

Gotfred took his hat off and drummed his fingers on its crown. His eyes assumed a thoughtful, worried look.

"Guttorm was a good chap, and he was usually fortunate with fishing, but when things got dangerous, he could easily lose his head. Why should he otherwise have lost a ship that was every bit as good as the Isabella . . .?"

"Yes, but it was touch and go for you, too," objected his father.

"That's not quite right." Gotfred sat up straight. "We had that trouble with the mizzen mast, but that was the fault of the confounded mast, and if it had been fixed properly it wouldn't have fallen . . ."

The parish clerk had to smile.

"But there are storms that overpower even the best ship," he commented.

"Yes, but . . . it's like that everywhere, not only at sea," his son objected. "I mean . . . you've always got to think that something *can* go wrong, of course. But with a good skipper on a good ship, things oughtn't to go wrong."

His father got up and went across to the window.

"Well, I can see that you've made your mind up to follow that course," he said. "But . . . you didn't need to. You've got a bit of land to fall back on even if it's not such a lot. But it's my view that there are plenty of lads who simply have to go to sea because there's nothing for them on land."

Young Gotfred made no reply. He stared thoughtfully down at his hat.

"Besides," continued his father. "You've got to think that I shall soon be getting old. And although the farm isn't all that big, the time's coming when it will be more than I can cope with. And you've no brothers to help me. I realised during the harvest that I'm no longer the man I was."

"But fishing produces far more money when you're lucky," said young Gotfred, getting up. "I mean . . . then you're not so dependent on what happens on land."

He felt that this remark was a bit clumsy and almost burst out laughing. And then it was strange that his father, who was anything but a coward when it came to travelling in a boat, should have this landlubber's fear of the water when it came to deep-sea fishing.

. . . Later that day, Young Gotfred went into Landrus's shop. His heart was beating hard when he opened the door. But Gregoria was not in the shop.

"Hello, nice to see you again," Landrus greeted him and shook hands across the counter. "You've grown up since I saw you last, with a beard and everything. By the way, how much did you give for that hat you're wearing?"

Gotfred told him, and Landrus nodded: "Not all that expensive, really. And I hear you've been fishing like a hero. But now, let me tell you something . . ."

They were alone in the shop. Landrus leant across the counter and lowered his voice: "Well, its old Lars Dion again, my neighbour . . . He's always been a devil, but now he's actually starting to outdo himself. You'll hardly believe me when I tell you he's planning to set up a shop. It's not generally known yet, but I've managed to find out. What do you think?"

There was a damp shine to Landrus's eyes.

"Just think . . . a shop in the same building as mine. He actually wants to do me out of my living."

"Where's he going to get his money from?" asked Gotfred.

"Aye, I've no idea," whispered Landrus. "Perhaps it's this eldest son of his, the teacher, who's agreed to support him. Although I must admit people say they don't get on well together, him and his father. Or perhaps it's Sylverius from Holmvige that's behind it. Of course, you know that one of Lars Dion's sons works for Sylverius as a shop assistant. And if that's what they're up to, *I* can just as well pack my things and go. Then *I'll* be ruined. I'll just slowly be finished off. If I'm not finished off already before that, for various reasons, because I think I'm ill . . . I've been having a lot of splitting headaches recently."

"I'll tell you what I think," Gotfred sought to console him. "Even if he got that shop going, it would soon collapse again, for Lars Dion's not a man to make anything pay if I know him rightly."

"Yes, but what about this son of his, Egon?" objected Landrus looking at Gotfred with a mixture of anxiety and confidence.

"Aye, but he's a bit of a wretch as well," said Gotfred.

"He was," nodded Landrus. "But they say he's now gone and been converted and saved . . ."

"Well, that certainly makes things worse. But I'll still bet you can put his nose out of joint in no time."

Landrus thrust his clenched fists down in his jacket pockets and bent forward: "Aye, if I could only . . . if I could only squeeze the living daylight out of him, venomous bit of vermin that he is! There wouldn't be a whole bone left in his body."

He started walking to and fro in grave agitation. But suddenly he once more sank down over the counter in complete despair,

"And do you know what's worst of all?" he started whispering to Gotfred again. "Aye, I made an enormous blunder during the summer soon after you left. There was a foreigner

who came to Trymø to see my fish, a Spanish fish merchant, and he offered me a ship, a good fishing cutter that wasn't all that dear either, according to what he said. And fool that I was, I refused it. 'Cause if I had a ship like that I could earn an enormous amount of money on fish and not bother about my little village store at all. Well not much."

"So you could imagine buying a ship?" asked Gotfred. And his eyes lit up.

A woman came into the shop to make some purchases. Landrus stood up.

"That's how it'll end," he nodded to Gotfred. "That's how it'll end. There's no other way. For that piece of vermin gets more and more meddlesome every day . . ."

A couple of other customers entered the shop.

"Gregoria," shouted Landrus. "There are people waiting to be served."

Gregoria appeared. She was blushing scarlet and screwed her eyes up as though she had been sitting in the pitch dark and could not get used to the daylight in the shop.

"Oh, can I have a bottle of beer," Gotfred called her over. "Give it to me, I can open it myself."

She handed him the bottle and bottle opener, and he stroked her hand as though by chance. He would have whispered something to her, but she was already away again.

Young Gotfred emptied the bottle.

"I say, Gregoria," he shouted. "You couldn't lend me a pencil and a piece of paper? There's something I need to write down before I forget."

"There's paper and pencil here," nodded Landrus, who was standing over by the scales.

He gave his daughter a thick pencil and a piece of wrapping paper. Gotfred took his knife and cut the paper in two. He stood writing for a long time, but the clumsy pencil refused to obey his hand.

"You can borrow a pen and ink if you like," said Landrus.

"No, I can manage," said Gotfred.

He folded the two pieces of paper carefully together.

"Thank you," he said and handed the pencil back to Gregoria. "And let me pay you for the beer straight away."

He took a two kroner piece from his pocket, secretly wrapped it up in one of his two notes and handed it to her. She looked at him with a little smile and understood.

IV

That evening, in the twilight, Young Gotfred sat down on the beach waiting for Gregoria. The moon was rising behind the island of Husø. It looked so alien against the veiled grey sky, big and shaggy, as though it were not the real moon, but a moon cub daring to come out of the safety of the nest for the first time.

Gotfred sat waiting for a long time. Down by the water's edge there was the gentle sobbing of the water, as though there were someone down there mocking him. But it was surely only the sea being forced in and out of holes on the water's edge by the waves. The moon gained more and more light. A seaweed-covered islet could be seen dark and motionless against the trembling streak of moonlight. There was a heron out there on the islet, quite motionless, with its neck bent down towards the water.

Gotfred started to feel worried. Could she intend to let him wait in vain this time as well? But suddenly she was there. She had tiptoed close to him so as to surprise him, but she had not dared when it came to the point, and now she was sitting only a short way off him. She looked like a stone among the other stones, for she sat with her head bent and her arms clasping her knees.

Gotfred went over to her, picked her up and carried her to a small depression among the boulders, where there was a little grass and some sea starwort.

"Now I've got you," he said in delight.

He took a small red box out of his jacket pocket: "Here, this is for you."

Gregoria opened the box. It contained a small medallion

on a long silver chain. Gotfred took it and hung it around her neck. The chain shone splendidly in the moonlight.

"Thank you so much," said Gregoria. "You shouldn't have . . ."

"I've still got more for you," said Gotfred. "But it depends on whether you want it . . . 'cause it's a ring. See."

He took another small red box out of his pocket.

But Gregoria's eyes had filled with tears. And suddenly he felt her cool arms round his neck and her warm forehead against his chin. She was choking with tears and gasping for breath.

"What on earth's the matter, Gregoria?" he asked in some confusion.

"You mustn't go around with that dreadful beard," she finally managed to say.

"No, then I'll shave it off," said Gotfred seriously.

They sat for a long time holding each other tight and without saying a word. The moon rose high in the sky and gradually turned into the old, shaven and fully grown moon. But that strange sobbing down on the shore — the sound of it became more and more incredible. Sometimes it rose to a little song, sometimes it dissolved into cold and fleeting laughter.

"I'm sure that's Jakob the Granary whistling down there," said Gotfred. "Wait here while I go down and have a look . . ."

He came back laughing.

"No, it's *only* the water being drawn in and out of a crack down there."

"Perhaps it's the merman," laughed Gregoria, embracing him and trembling with joy.

V

Early the following morning, Young Gotfred got up and shaved off his beard. He was rather sorry to do so, but nevertheless he felt relieved when it was done.

It was Sunday. The weather was grey and quiet. But there was a touch of frost over everything, the fields, the shore, the bay and the mountain sides . . . it all looked beautiful and as though recently swept clean.

Gotfred took out his best clothes and brushed them carefully, but otherwise went around all morning half dressed, humming and up to all kinds of tricks. He dressed the good-natured old cat in an apron, leaving its head and legs free and then he hung it up under the ceiling . . . and there it hung paddling with its legs up in the air like some strange water-fowl. He dressed himself in his mother's Sunday skirt, scarf and white leather shoes and danced a wild dance through the rooms downstairs so his sisters almost collapsed with laughter.

The parish clerk, who was dressing for the morning service, thumped on the floor: "Now then, can you make a bit less noise. Remember it's Sunday."

But when he came down from upstairs and saw his son wearing his mother's clothes, even he could not refrain from laughing. This boy Gotfred. He had no sense of propriety, he was and always would be a disrespectful young lad. And yet, whatever he was . . . it was good to have got him back alive.

After the service, young Gotfred went straight across to Landrus's house. Gregoria met him in the sitting room.

"No, not now," she asked. "Dad's in a dreadful mood."

Gotfred threw his arms round her and lifted her up in the air.

"I'll make sure of getting him in a better mood before I tell him about us two," he assured her.

Landrus was out in the shop, working over some account books. There was no denying he looked irritable and bad-tempered as he sat there over the back counter with his beard right down in his books. He raised his head and looked at Gotfred with eyes radiating annoyance, but suddenly it was as though his face lit up.

"Have you . . . heard any more about that matter?" he asked as he got up.

"You mean about Lars Dion's business plans?" asked

Gotfred. "No. I've come to talk to you about something entirely different, Landrus."

Gotfred jumped up and sat on the counter.

"I'd have told you yesterday, but somebody came and disturbed us . . . You see, I was in Østervaag the other day, and I had a quite specific aim in mind. I'd actually heard about a ship that was being compulsorily auctioned down there. And I thought it would be worth having a look at that ship and hearing a bit about it."

"Have *you* thought of buying a ship?" asked Landrus in a trembling voice.

"Wait a bit," said Gotfred. "You see, by all appearances it's a good ship, an eight-year-old cutter of eighty tons and with a good motor."

"What does it cost?" asked Landrus.

"Well, that depends on the auction."

Landrus started doodling on the counter with his blue pencil. He was breathing heavily, and his nostrils were dilating.

"But you know," Gotfred went on, "provided the price is reasonable, it would be fun to get hold of that cutter . . . I've got a plan, and that is that we men from Trymø – that's to say those who could come into consideration, of course – should get together and make an offer for the ship."

Landrus got up. Landrus was excited.

"Aye, but who might that be?" he asked in a hard voice.

"Well, I haven't got all that much myself, although I'm not entirely without savings," said Gotfred humbly. "And then there's Magnus – he's got a bit. And we could probably count on father and Kristoffer as well. And Harald . . . well, he'll probably say no, but it's worth trying him."

"Yes, you can be sure he'll refuse," laughed Landrus.

"All right . . . and then there are the people from Blackstream Farm, although they probably can't spare much . . . but then I could imagine that Magnus could get a bit of help from his brother-in-law in Holmvige."

Landrus chuckled bitterly in his beard.

"You're completely forgetting Lars Dion," he exclaimed.

"Don't you think he should have a bit of a share in this undertaking? And that hopeful, redeemed son of his?"

He was overcome by a great and melancholy attack of laughter.

"Well," Gotfred went on cautiously. "I've not mentioned the matter to anyone else but you, Landrus. Because you see"

"You can spare yourself your attempts to persuade me," Landrus interrupted him sharply. "Because I won't join with others. If I'm going to have a cutter, then I'm going it alone."

"That's exactly what I was thinking," nodded Gotfred. "You could buy the boat on your own, and so I just wanted quietly to let you know about this chance."

Landrus laughed, this time in a more mollified tone, and started walking to and fro.

"I don't know," he said. "Who's going to guarantee the whole thing's not based on cheating and double-dealing, might I ask? 'Cause you've never got your back covered. One day you have a competitor living under your own roof. Enemies on all sides, open and hidden . . . that's the only thing you can be sure of."

"I'm not your enemy," Gotfred tried to calm him down. "Do you think I'd have come to you first if I had been?"

Landrus went over to the window and stared out. Suddenly, he turned towards Gotfred: "I don't want to think evil of you because I've always thought of you as being a decent lad. But let me tell you that over time I've had so many disappointments that I've become *suspicious*, you understand. And in any case I won't go into any business in partnership with Sylverius and his family."

"No, but just think it over, Landrus, and we'll keep the others out of it for the time being," Gotfred suggested. "Now you've got your chance."

Landrus looked at him, more composed.

Gotfred slid down from the counter. He went on, without beating about the bush: "And then there was another matter I wanted to discuss with you, and that is that your daughter and I have got engaged."

Landrus remained sitting there, his mouth wide open.

"Gregoria," he said finally. "And . . you? But that's simply not possible for she's only a child."

"She's seventeen," said Gotfred.

And how old are you?" asked Landrus.

"Almost twenty-five."

"You must think it over ten times," said Landrus, getting up. "And in any case . . . the girl can't throw herself into the arms of the first man to come along. She must be allowed to choose when she's mature enough. She mustn't be forced to take the decisive step now, you understand. I won't have it."

Gotfred replied calmly and deliberately: "All right, Landrus. But it's the girl herself and not *you* who'll decide that."

"She does as *I* say," shouted Landrus.

He was furious. Bounding up, he took a couple of steps towards Gotfred and held a clenched fist in front of his face.

"Don't you dare take the girl away from me," he said. "You can look around for another girl, that you can."

Gotfred almost lost his temper and was on the point of replying to Landrus in kind. But he thought that Gregoria might be listening behind the door, and that calmed him down. He said with a little smile, "You're doing yourself a disservice, Landrus, by refusing to have me as your son-in-law. Just think it over on your own. I could have given you many a helping hand."

A glint of kindness appeared in Landrus's eyes, but he still doggedly shook his head.

"I'm leaving tomorrow," said Gotfred. "I'm going to Østervaag to study for my skipper's diploma. And now I'll ask you to think about these things, both of them. Because I want to know before I leave."

. . . It was no more than an hour before Landrus sent for young Gotfred.

"We've got to get this decided . . . It's nagging me," he said and asked Gotfred to sit down.

"The fact is," he continued, starting to walk up and down. "The fact is that I'm a lonely man. Who do I know? Who can I rely on as a friend? Life has taught me to rely on no one."

He gave Gotfred an anxious, hunted look and went on: "Well, so far I've managed, although forces both of this and the hidden world have been trying to catch me out. And I've done my best to upset as few people as possible. And I've spread a few blessings on my way, haven't I? Haven't I provided work for many hands and food for many mouths?"

Gotfred nodded.

"But you see, "Landrus continued, stopping in the middle of the room. "I'm faced with the prospect of tying another person to me. It's a terribly difficult step for a man like me. I won't do it until I've considered it carefully."

Gotfred shuffled uncomfortably.

"But I *have* considered it, you see," added Landrus. "And I hope and am sure that you won't let me down or bring shame on me in any way. I know you've got the best intentions, and I believe in your ability and in your future."

He held out his hand to Gotfred.

"Yes, then in God's name be my son-in-law. And as for the ship, we'll talk more about that, and in any case we can go to Østervaag together and attend the auction. Because it's beginning to look as though we must buy a ship and expand the business in that way. I'm becoming more convinced with every passing day."

"Gregoria," he shouted suddenly. "Come here. And ask your mother to come with you."

It was a solemn moment. Both Gregoria and her mother had tears in their eyes. Landrus asked the young couple to put their hand in each other's. And then he placed his hand on theirs.

"Aye, may God give His blessing to this," he prayed emotionally.

Looking up into the air, he added with a sigh, "For in this world it's so that those who can stay together ought to stay together. There are plenty who encounter each other with envy and evil, cunning and violence."

VI

That afternoon, the sun came out; the air felt quite summery again, and the sea was radiant over all its expanse.

Magnus and Josva were sitting by the window smoking their midday pipes.

"It would almost be worth rowing out to the Hell's Parlour cave today," said Josva.

"I can't imagine what you want to do there," laughed Magnus. "Unless you're wanting to catch seals."

"Well, just for the excitement," explained Josva. "I mean . . . we could row into the cave and take a lamp with us."

Magnus yawned.

"When the sun finally takes it into its head to show itself, why immediately run away from it," he murmured dismissively.

Josva persisted. "No one's ever tried to find out how far you can get into Hell's Parlour in a boat. It could be fun to be the first . . ."

"Well, I'm not going to risk my neck in the attempt," Magnus yawned again. "Besides, it's my last Sunday at home, so"

"Hey, do I sense you're really a bit . . . scared of the dark?" Josva asked suddenly.

Magnus smiled, a little sarcastically: "God knows which of us would be most scared if it came to that . . . eh, Josva?"

Josva's voice trembled a little.

"We'll see, Let's try."

"No, I'll be damned if I can be bothered."

"Then that's because you *daren't*," said Josva, looking him directly in the eye.

Magnus got up.

"Well, there's no reason why we shouldn't as far as I'm concerned," he said nonchalantly. "All right, let's get off straight away."

He added, "People would laugh their heads off if they

heard about this. We must keep it to ourselves for heaven's sake. Just you go on ahead and get the boat ready, and then you can pick me up at Blue Point."

"As you like," said Josva.

"Well, you see," added Magnus, "it'll not attract so much attention if you take a little Sunday trip out along the coast, because you're such a peculiar character in any case, but if people see us both in the boat, they'll immediately start wondering."

Josva was in a happy mood as he rowed out along the coast. He hadn't known such joy for a long time. Strange, really. He came to think of that lovely first trip of his in a boat as a child, together with his father . . . that extraordinary, giddy sensation on seeing the coast with its overhanging rocks and skerries passing by.

Magnus was out by Blue Point, right down by the water. Josva had felt a little twinge in his heart at Magnus's words earlier: you're such a peculiar character in any case, but he was prepared to forgive him for that now. He felt strangely superior for once.

Magnus sat down in the stern.

"Aye, you do the rowing yourself," he said, "because I'm not going to risk spraining my wrist again."

The cave opened before them. Josva slowed down. Cold air like that of a cellar met them, and the strokes of the oars produced a solemn, musical sound.

"I still think it's ridiculous changing day into night just for fun," commented Magnus.

The boat slid slowly in beneath the wet roof of the cave. The opening began to grow narrower as it receded. It began to look like a lonely moon on a dark night. New sounds were heard, a gurgling almost like laughter from a crack in the waterline, a deep snort from inside the darkness.

"Right, now we'll have to be careful," said Magnus. "Let's get the lantern lit."

The cave entrance gradually filled in. Magnus shone the lantern on the damp, naked walls. Here and there, there were great clusters of mussels down near the water.

"It's strange how bare it all is here," said Magnus, puffing away eagerly at his pipe, "Not a single plant or sign of moss. And see how worn everything is – its probably not much fun in here when the surf comes in . . ."

Josva rowed on.

"Careful," warned Magnus. "There can be hidden rocks here."

He positioned himself in the prow with the lamp. Josva rowed gently forward. The cave began to become narrower.

"We must soon be at the end," said Magnus. "So it's not true that this cave goes right through the island."

Josva shipped the oars for a moment and moved to his brother in the prow.

"I don't think it ends here," he said. "It's just a narrower part. The question now is whether we can get through it. I think we can just manage it . . ."

"We can just not manage it," thought Magnus.

Josva sat down and rowed a couple of strokes.

"Back," shouted Magnus. "The opening's too narrow."

Josva did not back. He shipped the oars and jumped over to the prow.

"You'll see, we'll just make it."

"Don't get up to any daft tricks," warned Magnus.

But the boat slipped easily through the narrow passage. They both stood and stared with bated breath. It was a moment or two before the beam from the lamp found the firm bottom.

"It's quite a pond, this," said Magnus.

There was the sound of a splash. They both started.

"A seal, of course," whispered Magnus. "There are probably lots of them in here. It was silly of us not to take a gun with us after all."

He searched with the lantern across the black surface of the water. It was heaving heavily. There was not a trace of life to be seen anywhere.

"It might have been a stone falling from the roof," said Josva.

He felt strangely enlivened, and his body was tingling with joyful anticipation.

Magnus cleared his throat. "Well then, we'll go on. But first let's get a fix on the place where we came in."

He held the lantern up in the air.

"See, it's that opening there, with the jutting rock at the bottom and the light patch on the right. Here . . . hold the lantern while I light my pipe, it's gone out."

Josva took the lantern and Magnus made a great show of lighting his pipe.

"Well, it's really quite nice here," he said. "So long as the roof doesn't decide to fall down. And provided some monster doesn't suddenly appear."

He blew the smoke away.

"Well, I suppose we're going on. You take the oars and I'll be look-out."

Josva felt dizzy with joy. The sound of the slurping, snuffing water and its ringing echo filled his ears like a feverish, breathless whisper from countless voices.

"Strange how deep the water seems to be in here," said Magnus. "I'm beginning to think the cave does go right through the island."

Shortly after this he added, "By the way . . . how long do you think the lantern will last?"

"Oh, there's nothing to worry about there," said Josva.

"There's another narrow passage here," shouted Magnus. "Can we manage it? There! You really must row more slowly now. We must be careful."

Josva sensed a certain nervousness in his voice.

"Back, for God's sake," shouted Magnus. "What do you think you're doing?"

"We're all right as far as I can see," said Josva.

The boat slipped easily through the new narrow stretch.

"There's no harm being a bit careful," mumbled Magnus. "We've got to remember where we are."

There was again the sound of a splash in the water, and then another one.

"What the hell!" hissed Magnus.

"Can you see anything?" asked Josva.

"No . . . but it must be seals," he added in a whisper. "We were a pair of fools not to bring a gun."

Josva felt the blood pulsing in his veins. They were right in below the island, deep inside the savage eternal night. Somewhere high above their heads the sun was shining on the grass and gravel of the mountains. The very thought filled him with a profound sense of rapture.

But what had come over Magnus? He suddenly appeared to be short of breath.

"What's wrong with you?" asked Josva.

"I don't think the air's good in here," said Magnus. His voice sounded hoarse and as though choking in smoke. And now Josva also felt as though the air was bad and thick to breathe. What on earth was this? He took a couple of deep breaths . . . no, it was only imagination, the air was cold and pure.

"We've got to get back," shouted Magnus suddenly. "Start rowing."

Josva hesitated for a moment, but now Magnus was completely beside himself: "Let's get out for God's sake. This is no place to be . . . we're suffocating in here."

And he really was gasping for air.

"You've really lost it," said Josva. "I assure you there's nothing at all wrong with the air in here."

"We've got to get out," roared Magnus.

He put the lantern down and sat down by the oars himself. "Come on, damn it."

They managed to turn the boat.

"It'd be better if you went to the prow again," said Josva.

Magnus got up and took the lantern. He was trembling all over, and sweat was pouring down his face. He fell silent and made himself as small as possible . . . it was as though the walls of the cave were encircling him like tentacles, as though he was a worm working its way through heavy, damp earth, or a child in its mother's womb. Out! Out! This was the word going through his head, and he clung on to that word.

The echo from the oar strokes told them that they slid first

through one narrow passage and then the other. And suddenly a greyish light of a quite different kind from that of the lantern fell on a wall of the cave. They glided on for some time through this smoke-grey half light. Then the light from the entrance appeared like a star. It grew bigger; it was as though it were falling at great speed from the heavens, but then it stood still and turned into a rising sun; the light dazzled their eyes so much that it hurt . . .

Before long they were outside the dark entrance to the grotto. There was a light breeze from the north, and the choppy seas were green and shot through with the sun.

Magnus leaned back and burst into relieved laughter.

"That was one hell of a nightmare," he said. "I got short of breath. Didn't you feel the air in there tightened your chest?"

"No, I honestly don't think it did," said Josva.

"Yes, well . . . I'm sure there was something in there that made it difficult to breathe," maintained Magnus. "Something bloody unhealthy. No, that sort of place is not for human beings."

"Perhaps," said Josva.

Magnus was much buoyed up.

"I didn't quite like it," he said. "I'll admit that. And I was the one to lose my courage. Well, to be honest, I was terrified. I've never been so scared in my life."

Magnus jumped ashore at Blue Point.

"Thanks for the trip," he laughed. "Next time you want to go down into Hell, I think you'd better take Jakob the Granary with you."

Josva rowed on along the coast that was now in the shadows cast by the afternoon sun. The waves sighed laboriously in the forests of seaweed. He felt limp and depressed, as though deep down inside he was filled with bitter disappointment. Not because the trip had had to be abandoned half way . . . that didn't really matter. The disappointment was of a different, more profound kind, and he couldn't explain what it was that had caused it.

But at all events it was a pity that Magnus, who was otherwise so brave, had suddenly panicked. It would have been an

enormous experience to come out at the other side of the island – that is if they had managed . . .

Josva could not fall asleep that evening. He lay listening to the waves whispering and whispering against the beach, an unending, melancholy story. They occasionally stopped for a time, but then they started all over again, with a new sentence:

And then

Now and then it was as though he could hear odd words in the sighing.

"Last time," they said.

"Thousands and thousands of years."

And then . . .

It gradually took the form of an enormously long and melancholy ballad.

"We who were wrecked . . ."

That was the refrain. These were the drowned men and women dancing on the waves, dressed in garments with flowing trains of foam. He himself now climbed down into a boat and rowed out on the white, whispering sea. The Hell's Parlour cave opened before him, and he was drawn into the darkness of the grotto. There were drips falling from the roof, heavy, warm drips . . . It was not water, it was blood. The cave was bleeding and racked with pain; the blood ran down his hair and cheeks, filled his eyes, penetrated into his nose and mouth and choked him . . .

Josva was awakened by concerned and angry voices. He could make out Harald's voice. Was this dream or reality? Now the door opened and Magnus burst in.

"Come with us, Josva. We've got to go over to Storefjord and fetch the doctor."

Josva sat up and was at once chillingly awake.

"What's wrong?" he asked. "Who's ill?"

"It's Harald's daughter; she's spitting blood."

Josva jumped out of bed. He hardly gave himself time to digest what he had heard, mumbling meaninglessly "She's spitting blood. Oh, so she's spitting blood."

He only managed to get half dressed, in his trousers and jersey. Down in the boathouse stood his father and brother,

Harald and a couple of other men. The boat had been put in the water, and the motor was running.

Day had begun to dawn. The air was mild, and the land stood outlined dark and wet against the grey sky. Magnus was at the rudder. There were only the two of them in the boat.

"You could have guessed she was ill," said Magnus. "She was in bed so often . . . and you don't do that if you're well."

"Do you think it's very serious?" asked Josva.

"Well, consumption's not something to joke about."

Josva thought to himself, "Consumption . . . That's something that tends to drag out. You don't often die suddenly from it."

There was contempt in Magnus's voice: "Those parents, who the hell'd feel sorry for them. Birita's an unfeeling scarecrow. And Harald, weakling that he is, says anything to agree with her. So if their daughter's sick in both mind and body . . ."

A little later, he added, "Aye, 'cause she's a bit peculiar, at least that's my impression. All that about Daniel, you know. But they got rid of him all right, and he's not going to bite any more."

Josva only half heard what his brother was mumbling. It was as though he had grown stiff inside and only had a single thought: "She'll not die yet. She'll not die this time."

It started to drizzle. Trymø disappeared in haze. Josva drank in the wet, fresh air and felt the damp in his nose and eyelids. He had to think of the night when he had met Hilda in the mist. It pained and hurt him to think of it now. How strange it seemed . . . like an event in one of the old ballads, something you sang about but never experienced. And yet, those things, too, had been reality just as much as this melancholy morning, this noisy boat with the dirty bilge water and the wet thwarts, these islands with their greyish yellow mountains and black shores, their threadbare villages with their smell of peat smoke and food and everyday, but this latter world was the stronger of the two. It always had the superior power. And it was harsh and implacable. It was always there, behind sleep and song . . . a cold and unsmiling

world that meant evil, that wanted to see blood and bring sorrow.

The rain stopped when they were half way across the sound. The sunrise was yellow and cold behind Trymø.

VII

Hilda's life was not in danger. But the doctor had said that she would have to be sent to the sanatorium in Østervaag and spend a year or so there.

The news spread quickly through the entire village. People heaved a sigh of relief. So the poor girl could be cured.

But consumption had once more made its mark on someone. And this time it had appeared in an entirely unexpected place. That's what it was like with that disease: it went its own inexplicable ways. Where could Hilda have got it from? She saw so little of other people.

Doctor Bonæs stayed on the island all morning. He went from house to house, talking to people and asking about their coughs, their appetites and whether anyone in the family was ill.

He also paid a visit to the teacher's widow and her daughter. Jane was half sitting up in bed, supported by some big pillows, twisting a thin gold bracelet with her elegant fingers.

"You're lying there like a little princess," the doctor said.

She smiled and fixed her big, dark grey eyes on him.

"Jane's always so happy," said her mother.

The doctor's grey and worn face opened in a kindly smile.

"Well, the most important thing is that she keeps her spirits up," he said.

"And Jane's not at all afraid any more," added her mother.

"Afraid . . . no?" the doctor exchanged a glance with Magdalena, apparently not quite understanding.

"No, she's looking forward," explained her mother. "She so often dreams of going to the Lord Jesus in Heaven."

The doctor nodded.

"Yes, I was there again last night," smiled Jane.

"What a lot of books you've got to read," said the doctor. "Are they your father's books?"

"No, they're actually some she's got from Balduin, the new teacher. He's so incredibly good to her," her mother could tell him.

The doctor nodded and pushed his lower lip forward. He patted Jane on the cheek.

"Well, I think I'd better be getting along," he smiled.

"Oh, God," sighed Magdalena once they were outside the sickroom. "I suppose it's not going to be long now?"

"Oh, you'll have her for some time yet. And she's getting the best care. Things can't be better in these circumstances. – Incidentally," he added, "the teacher oughtn't really to have those books back. But I suppose he realises that?"

"Yes, you can be sure I take care to keep the infection away from him," Magdalena assured him. "He is so incredibly kind. He comes almost every day. No, he doesn't want the books back at all; he's given them to her. And he's always bringing her new picture books that he has sent here . . ."

Landrus was standing outside his shop waiting for the doctor to go by. He had sent him a message inviting him to lunch.

"Well, what news, Landrus?" asked the doctor gaily as he shook hands with him.

Landrus looked away with worried, wrinkled brows.

"It's not so good, not so good," he said.

"Is anyone in the family ill?" asked the doctor.

Landrus nodded and pointed to his own chest.

"You're not ill . . . a big chap like you?" The doctor nudged him encouragingly.

Landrus opened the door and invited the doctor inside.

"Yes, I think I'm seriously ill," he said, and his voice grew weak. "There's hardly any part of my body that doesn't hurt sometimes . . . my head, my ears, my throat, chest, stomach, even the tips of my toes sometimes start twitching in a strange way."

"Well, well," said the doctor. "I think we'd better have a look."

The table was set for lunch in Landrus's living room. There

were all kinds of good food, cakes and cigars and a steaming jug of coffee.

"Do help yourself," said Landrus. He took a bottle of rum from the cupboard.

Dr Bonæs was hungry and did justice to the food. While eating, he asked Landrus about various matters and about how things were on the island.

"Harald's daughter didn't seem upset at the thought of having to go to the sanatorium," he said.

"No, I'm sure she wasn't," laughed Landrus. "That's just grist to her mill."

He related all the things that were being said about Hilda and her parents.

"It's that farming family pride." The doctor shook his head. "These old farming families that are dying out . . . Oh, I know. Birita, the wife, she's a strange, primitive person, as though she's been dug up from a time that's fortunately long past. This stubborn, hidebound attitude's never going to get her anywhere. No."

Dr Bonæs asked about conditions in the River House.

"I'd like to know what's really wrong with that man, Elias," he said. "He spends all his time in bed, but I can't really believe he's paralysed. But neither is there any reason to think he's putting it on. It must be some particularly nasty kind of imaginary illness. I think that if it were ever possible to get him up he'd suddenly stand on his own feet and be as fresh as a daisy."

"Get him up?" said Landrus. "How would we do that?"

Doctor Bonæs laughed: "Don't you know the story about the man who went out into the world to learn to shudder? He was finally cured when the princess poured a bucket of water full of live fish over his head."

Landrus laughed: "Live fish! Aye, if only I could be cured as easily as that!"

The doctor asked Landrus about his various symptoms.

"I'll give you something for rheumatism," he said.

"It surely can't all be rheumatism?" asked Landrus. There was a tone almost of disappointment in his voice.

"Well, I'm going to examine you now, don't worry."

He finished his coffee and got up. Landrus had to take his thick jersey and several layers of woollen underclothes off. The doctor took his time over the examination. Landrus groaned and had goose flesh all over.

"Oh dear, oh dear," he shivered. "Why do we poor human beings have to be tormented with all this illness? It's dreadful to think about. Even the best of doctors will never be able to get these epidemics under control. Germs are stronger than giants and cleverer than the wisest of men. The earth's full of them, and so is the sea, and even the air, or so I've read. It's no surprise that our poor weak bodies are full of them and eaten up by them."

Doctor Bonæs had finished his examination by now. He sat down and lit a cigar.

"Your chest and heart and all your innards are in splendid shape," he said. "You're as healthy and strong as a . . . well, what shall we say: as a walrus."

"Walrus?" laughed Landrus, mightily relieved.

He dressed quickly.

"Gregoria," he shouted. "Come in here and bring a corkscrew and two small glasses."

"Aye, 'cause we must have a drink on that," he said, nodding happily to the doctor.

HE MOVES UPON THE FACE
OF THE WATERS

I

Reinhold Vaag, the preacher, was on the go from morning to night. There was hardly a house in Holmvige he had not visited. He was quiet and polite in his manner, talking of this and that, about everyday matters, joking with the children and not too pushy with his cause. Only when he got up to go did he let a few words drop about the sinful age, the sorrow and misfortune that accompanied sin, and about how the door to grace was open for the repentant sinner, but closed to the self-righteous. But this little word *grace* had a special ring in Reinhold's mouth, which made people notice. Grace was no light matter, it was not something you achieved with your eyes closed. Grace was the most important thing of all, but also the most difficult to attain.

The preacher had gradually become a welcome guest in many homes, and he started to acquire a following.

The first person to join him was Egon, the shop assistant. He stood one evening singing together with the preacher's proselytes. Egon had a good voice, and it was wonderful to hear how his voice blended into the singing and he became one with the others as though things had never been any different. Then he stepped forward and spoke, confessed his sins and prayed that God might open the door to His glories for those who stood out in the dark longing for the light and warmth of His mercy.

Some time after this, Elisabeth, Bernhard Thomsen's sister, had also found a place beneath the lantern. The poor girl had for some time been completely beside herself with sorrow over the loss of her fiancé. She had locked herself away in her new house and had nothing to eat for two days. Bernhard had had to force her door open and carry the half unconscious girl

home to her parents. Here, she had lain as though at the point of death for two more days, and the doctor, who had been fetched from Storefjord, had feared for her reason. But then one afternoon, the preacher's sister had come and talked to her for a long time and sung for her, and there had been an improvement that very evening.

There were more young girls and wives who joined the preacher and his followers during the subsequent period. The evening meetings started earlier and lasted longer, as there were so many who wanted to come forward and confess.

When the weather was too cold or wet for the meetings to be held outdoors, they gathered in one of the homes. But there was not room for many there, and it happened that some of those listening had to stand outside in the rain. This could not go on in the long run. Reinhold decided to have a talk to Sylverius and ask him if they could use one of the warehouses.

He found Sylverius in his office together with Morberg. Sylverius invited him to take a seat. Morberg sat puffing away at a cigar. He was red in the face and breathing elatedly through his distended nostrils. There were two small glasses on the table.

"I'm sure you won't refuse a glass of extra fine rum, preacher?" asked the solicitor. With a nod in the direction of Sylverius he added: "Oh, I hope you'll excuse the liberty".

Reinhold looked cheerfully from one to the other: "I don't really drink alcohol . . . but the odd little glass can't do any harm."

"Bravo." Morberg took a glass from the cupboard and filled it.

"Cheers. Here's to . . . well, in general."

The preacher emptied the glass in a single draught.

"A cigar?" asked the solicitor.

"Please." Reinhold had nothing against a small cigar.

"You're a dangerous man," laughed the solicitor. "I'm actually beginning to feel a certain respect for you."

He lit a match and handed it to the preacher.

"You see," he went on, "if you went around with a super-cilious, censorious twist to your mouth, ha, ha . . . but you

know your job. You're a tactician, a man of the people through and through, really straightforward and seductively ordinary. While the minister turns up in black robes and with his head poking out above a ruff as though it were on a plate! Yes, you'll get somewhere."

The preacher lit his cigar. He looked at Morberg with cautious, searching eyes. "No, censorious . . . I can't think of anything more abhorrent than that. Judge not, that ye be not judged, says the Master."

The solicitor sat ruminating.

"I can't think who it is you remind me of," he said. "I think it's some lady I've known . . . oh, yes, I've got it now. It was a lady who was not entirely young and not entirely sinless, but with these beautiful, idealistic, fanatical eyes that can completely overwhelm a tired, self-ironic man."

"Yes, sin holds us all in its powerful grip," nodded the preacher. "The other thing you mentioned, the thing that sort of rises up above sin . . . Do you know what that is? It's the quiet and confident expectation of grace."

"Exactly," said the solicitor. "The lady I spoke about was a passionate stamp collector . . . and I happened to have a couple of rare stamps. She got them."

The preacher put his cigar down on the edge of the ashtray.

"We were talking about sin," he said quietly.

"Sin is a precondition for grace," commented the solicitor, adopting a patient expression.

The preacher nodded and went on: "Yes, but you must admit that sin for the sake of sin . . . is not worthy of a human being; it is degradation."

"Indeed," said Morberg, slapping him on the shoulder. "But, as I say, after sin comes repentance, and repentance is the path to salvation. So there *is* something good about sin after all."

The preacher looked at him benevolently: "Yes, but tell me . . . Do *you* never repent your sins?"

The solicitor smiled and put his hand up to his chin: "You're taking me round in circles like the charming demagogue you are. Oh yes, I probably repent my sins. But then . . .

you just sin again. And repent again. And when you've done that a few times, you get your account all mixed up, don't you."

"Exactly," said the preacher enthusiastically. "That's how things go until one day you experience grace. For we human beings are never raised above sin . . . but we do have access to grace."

"Ugh," said the solicitor. "But not everyone has access to grace. Some never achieve it. And God isn't so petty either. And there are always some figures to be carried that disappear in his sums."

He laughed.

"For instance, I'm one of those figures that got lost when it was carried. I slipped out of the divine sum, you understand. Cheers."

Morberg took the bottle, but the preacher held his hand over his glass: "No thank you . . . I have a lot of things to see to today."

He turned towards Sylverius and said in a warm voice, "Many thanks indeed for leaving the lantern lit in the evening so we have been able to hold our meetings in the light. It does great honour to you. But I suppose I can't expect you to go further still and help us with a temporary meeting hall? There isn't by any chance some room in your warehouses that isn't being used for anything else?"

"I'll have a look," said Sylverius. "You can pop in some time."

"Well, once more, many, many thanks."

The preacher took his cap. He turned towards Morberg, who was busy lighting another cigar: "No, God always gets His sums right; you can rely on that. Not even the smallest decimal is lost."

The solicitor blew out a cloud of smoke.

"Well, goodbye then," said the preacher. "And may God bless you. Perhaps we shall meet on another occasion."

"He's a dangerous man, that preacher," repeated Morberg. "He gets right into the hearts of ordinary people. He accepts a plug from the seaman; he drinks a cup of coffee with an old

woman, he talks about love to the young girls . . . he's probably an artist in his field. And then he's so delightfully calm and illogical. That's how they like it. I say . . . let's drink his health."

Sylverius shook his head: "I've got other things to do today."

"Oh well, then, for God's sake"

The solicitor poured his own glass and held the bottle up to the light. "There's still almost half a bottle left. I'm sure you'd love to give it to an old friend and co-sinner, wouldn't you?"

"No," said Sylverius, suddenly getting up.

Morberg looked at him in amazement.

"Oh, it's not out of meanness," said Sylverius in a rather uncertain voice. "But what's the point of all this drinking? It'll have to stop some time after all."

He was flushed in both cheeks.

The solicitor put down the bottle with a thump and pressed his lips together. But he soon burst out laughing: "Oh, so that's the way you're heading, my old friend. Well, I've wondered for a long time how things would go."

Sylverius looked down.

"Yes, and I've also wondered which way you'd be choosing," he commented quietly.

"Ah, but that's less complicated," laughed the solicitor. "Because it's the broad way that leadeth to destruction; we can easily agree on that."

He took his hat.

"So we've met half way, as it were . . . I'm on my way down, you're on your way up. But why the hell don't we drink each other's health before we lose sight of each other . . ."

"It'd be better if we made it our aim to become decent human beings," said Sylverius.

He took the bottle and put it in the cupboard.

II

Vitus had come to Holmvige with the mail boat. He had been far and wide, and now his endless wanderings had brought him back here once more.

A strange transformation had taken place in him; he had acquired an overcoat and hat, and instead of the old blue bundle he now carried a small canvas suitcase. He was hardly recognisable when he came ashore.

Vitus did not follow the usual road leading up through the village. He walked out along the shore until he came to a spot where he could be left entirely undisturbed. Here, he opened his suitcase and took out various things – small coloured packets and bags, tubes and sticks, carefully sorting them all out and putting them back in place. When he had done this, he took a brush and gave his broad-brimmed hat a thorough brushing. It was a splendid hat . . . every time he took it off and looked at it, he was filled with joy that it was really his.

Later in the morning, Vitus paid Simona a visit. He found her alone at home. She looked rather tired, as though she had lain awake or been weeping. The bright, carefree smile of earlier days . . . was quite gone. Oh well, she was married now and was perhaps expecting . . .

"Oh, how smart you are now," said Simona, unable to resist smiling a little.

Vitus smiled back politely. "Yes, it's the minister's wife that gave me these clothes. There's no one like her. I stayed in the parsonage for almost a fortnight . . . that's already a couple of months ago. And the minister was very kind to me as well. He's a great man . . . aye, God bless them both."

He sat down modestly on a chair by the door and looked around in amazement.

"You live like a queen here," he said. "But I must say that if anyone deserved to get on in the world, it was really you. And yet . . . the rich and fortunate have their cares as well – I'm thinking of the wreck of the Dumbarton. It was a terrible tragedy, not least for your husband; he must have lost a lot of money."

Vitus gave a deep sigh.

"Yes, the sea gives and the sea takes."

"Look, sit down here at the table, Vitus," said Simona, "and we'll have a cup of coffee together."

Vitus thanked her and shuffled modestly. "That's too great an honour for me . . . here in this fine sitting room. I could perfectly well sit in the kitchen."

Simona was uneasy, and her hand was trembling as she poured the coffee. Vitus sighed again and failed to find anything to say.

"I say, Vitus," said Simona suddenly in a low voice. "You spend a lot of time in Storefjord. . . . Do you know anything of this preacher Reinhold Vaag and his sister?"

"Yes." Vitus nodded. He knew them well. He emptied his mouth to speak: "Reinhold was a shop assistant in his youth, and then he travelled for a time as an agent. But then he set himself up as a preacher, first in Østervaag and then in Storefjord, and now he's paid a regular wage for going round organising meetings and converting people. And as for Tekla, she's been engaged, twice, once to a teacher, but she let him down. And then to a ship's mate, but he went away and she never saw him again. And after that she became rather strange, and so now she travels around with her brother . . ."

Simona asked him: "She let the teacher down, you say . . . but what did she do? Did she start going out with other men?"

Vitus considered a moment.

"Yes, she went off with the mate, I suppose, the man she got engaged to, the man who went away and didn't come back."

"But she's not been after anyone else?" asked Simona.

Vitus gave a worried smile: "You don't have to believe everything you hear. There was certainly talk at one time in Storefjord of something going on between her and the sheriff. But if was probably only the sheriff that was after her, 'cause I don't like to think ill of Tekla. She's probably not done any-thing she can't justify. And besides, the sheriff can't see a skirt without . . ."

Simona poured Vitus another cup of coffee. He noticed she was very pale.

"That Tekla's probably a hypocrite even so," remarked Simona. "You can almost see it in her face. I don't think she's as godly as she pretends to be."

Vitus considered a moment, and then he said, in a slightly embarrassed tone: "No, Simona dear, I think you're wrong. For as I said before . . ."

But Simona had got up and had suddenly gone into the other room. He thought he could hear her walking up and down in there as if agitated. He felt uncomfortable and left the coffee untouched.

Simona returned shortly afterwards. She was very flushed.

"Listen, Vitus," she whispered. "You can keep a secret for my sake, can't you? I can confide in you, can't I? You won't let me down?"

"God bless you, my dear . . . there's nothing on earth I'd rather do," said Vitus, blushing as well.

Simona took out a letter and handed it to him.

"Look, that's what I got yesterday."

Vitus opened the letter slowly and solemnly.

"Well, I'm afraid I've got a problem reading people's writing," he said. "Had they been printed letters, they'd have gone right into my soul, but fine handwriting . . ."

Simona took the letter and read it to him in a whisper. Her voice was trembling. 'Dear Madam, For your own sake I must inform you that things are not as they should be between your husband and the saintly T.V. Keep your eye on them. A well-wisher."

Simona folded the letter again and sat for a moment with her eyes closed.

"Well, this saintly T.V. can surely not be anyone but Tekla Vaag," she said.

"That letter's full of lies," said Vitus with great conviction "It was written by someone who wishes you ill."

"If it was someone who wished me ill," said Simona, "then she or he, whoever it may be, has got what they wanted."

Vitus sat stroking his beard. "What was it I was going to say . . . Do you still have the envelope?"

"The envelope? No, I've burnt it."

"That's a pity. You didn't notice the postmark by any chance?"

No, Simona had not given it a thought.

"Oh well, there's nothing to be done that way." Vitus sat for a moment staring ahead. "But," he continued slowly and ponderously, "I think even so I know who wrote that letter. There's only one person it could be. Yes, that's who it is."

"Who?" asked Simona, getting up.

Vitus was troubled by doubt and wriggled uncomfortably. "Well, let me not give an innocent person a bad reputation," he said. "There could be others as well, of course . . . but I know one person who *could* have done it, and that's the sheriff's wife from Storefjord. For that's what she's like."

"Could it be her?" asked Simona in amazement.

She sighed deeply.

"I didn't think I'd got any enemies otherwise. That's how foolish I've been."

"Enemies and enemies," said Vitus thoughtfully. "I suppose the good sheriff's wife is envious, because her life's no fun. He husband's unfaithful to her and she's unfaithful to him, and they're not well off. They've no children either, and they're always having rows."

"You might be right," said Simona more optimistically. "At any rate, Vitus, you've given me a bit of comfort, and I'm grateful for that. It's terrible to have to go around with this kind of suspicion . . ."

"There's nothing to thank me for," said Vitus. "But the more I think about it the more I'm convinced I'm not mistaken."

He got up.

"Well, goodbye and thank you for your kindness," he said. "I must go and take my case around. God bless."

"Your case?" asked Simona.

Vitus lifted his case up and said, not without a certain self-esteem, "Yes, this is my shop, and it's not bad at all. It was the

211

minister's wife who gave me the idea, God bless her. She really helped me to make a start."

He opened the suitcase: "Yes, just look here . . . they're all things you can't buy in the shops otherwise, so I'm not getting in the way of the shopkeepers. For instance, there's a cure for toothache. And here's a stick to remove stains from clothing. And what is there otherwise? – alum stone, dream books, corn rings, toothpaste, sofa cushion covers, glue . . ."

Simona smiled: "Well, let me see . . . there are really some things I might have use for. What about this stick to take stains out of clothing? I must really have one of those. And a dream book can also be useful to have around. And that embroidered sofa cushion cover . . ."

"Yes, the minister's wife embroidered it herself for me," said Vitus.

Simona made quite an inroad in the stock, and with a slightly apologetic smile Vitus put the money in a little skin bag.

"Well, I'll say thank you very much once more," he said and clicked the locks on the case shut.

"Come back tomorrow," nodded Simona. "And then I'll have a few things for you to sell, too . . ."

"God bless you. That's really too much, but thank you very much."

Vitus smiled humbly and took his big hat.

"And as I say," he said in conclusion. "As for the letter, you can be sure it's a packet of lies, and no sensible person can doubt that . . . and neither can anyone doubt who it's come from. I'm still sure about that. But that sort of thing rebounds sooner or later – there's some justice behind everything, however confused things may look sometimes, God be praised . . ."

Simona had to laugh.

Could it really be that the sheriff's wife had played this trick on her out of envy? It didn't actually sound unlikely.

There was no denying that Sylverius had recently been fairly preoccupied with the preacher and his followers. He had originally shrugged his shoulders at this curious couple who

were coming to convert Christians who had already been baptised. But nowadays he spoke warmly of them. The evening when it was rumoured that poor Elisabeth had joined them, he had sighed deeply and said, "Thank God, *she*'s managed it." And after that, a certain melancholy earnestness had come over him every time the subject was mentioned. Simona had noticed with some concern that he started to be *smitten*. She had had a feeling that it would distance them from each other if Sylverius joined the new community of believers, for this was somewhere where she would be unable to follow him. But then this letter had arrived and put the whole matter in a new and worrying light.

She had several times been on the point of showing the letter to Sylverius, but each time she had been overcome by an apprehension that had prevented her from acting. She was afraid of having her suspicions confirmed, afraid that he would give himself away by blushing or simply by some modulation in his voice or an averted eye.

But now she would do it. Vitus' assurance had given her the courage. She would get at the truth.

Simona sat down by the window, tired and uneasy, and looked out. It was not yet four o'clock, but twilight was already approaching. Semi-darkness reigned in November here among the high mountains of Holmvige.

It was starting to snow. The flakes fell heavy and grey, but they melted as soon as they touched the ground. Out in the bay the vague outlines of the ships could be seen, rocking there heavily and sleepily. Now a huge black shadow emerged from the grey mist – the regular steamer. It emitted a hoarse whistle and soon dropped anchor.

Brrrrr.

The noise cut through the silence and echoed in the mountains. Lights went on in the warehouse down by the water. A motorboat started chugging. But before long all the sounds combined to form a constant din. It was almost like hearing the mild and soothing sound of the dying surf at home in Trymø cove . . . a homely and communicative sound.

Simona suddenly started when there was a knock at the

door. She must have dozed off a bit, for she had not heard anyone come up the stairs. She got up and went across to the door. There was the figure of a small woman standing in the dark vestibule.

"Yes, don't worry . . . it's only me," came the sound of a voice speaking as though in confidence.

It was Mrs Skjoldhammer, the sheriff's wife.

Simona lit a lamp.

Mrs Skjoldhammer had her face hidden behind a veil. She was smiling and sighing at the same time: "Yes, I apologise for coming so late, but I have quite a special errand . . . I knew you were alone at home, because your husband's talking to the captain of the steamer. I could see that down on the quayside."

Simona invited her to take her coat off, but she shook her head energetically: "I'm just passing through . . . I've got to go on with the steamer to Østervaag, and it won't be here for long."

Mrs Skjoldhammer sat down on a chair near the door. She raised her veil. Her face was red and swollen from weeping.

"What on earth's wrong?" asked Simona.

"Oh . . . it's all over between him and me," said Mrs Skjoldhammer, averting her gaze. "I couldn't carry on with him any longer . . . I'm going on the steamer to Østervaag and perhaps further away."

Simona felt a little confused.

"But – do you have to go on this very evening?" she asked.

"I can't wait for a single moment." Mrs Skjoldhammer was weeping. "But the worst thing is that I've no money. Not a single coin. Could you possibly lend me a hundred kroner . . . or even fifty? Oh, you must do me that favour, or else I'm facing a catastrophe."

The sheriff's wife fixed her with a threatening look.

"Yes, but . . . I shall have to ask my husband for the money first," said Simona.

Mrs Skjoldhammer got up.

"Is that necessary?" she asked. "Haven't you as much as fifty kroner in the house? A fine lady like you?"

"No." Simona shook her head.

"Not even twenty-five?" Mrs Skjoldhammer continued.

Her pale features emerged, sharp and tense. Her dark eyes had a merciless, searching expression like those of a gull.

"I haven't got any money at all in the house," said Simona.

There came the sound of footsteps on the steps outside. Mrs Skjoldhammer gave a start: "That's him. You must hide me. You mustn't say I've been here."

She ran into the adjoining room to hide.

Simona had no idea what she should do if it really was the sheriff out there. She opened the door to the vestibule . . . no, it was only an errand boy delivering some goods from the shop.

Mrs Skjoldhammer came out again. She blew her nose in a small, embroidered handkerchief and looked at Simona with frightened, red-rimmed eyes.

"I thought it was him . . . I had a feeling all the time I was on board that there was a motorboat following us. Oh, I'm so unhappy."

She stood pulling at her gloves. Simona placed an arm around her.

"If I might give you a bit of advice," she said gently. "I would suggest you wait a little."

"There's nothing to wait for," said Mrs Skjoldhammer hoarsely, pushing Simona away.

But suddenly she threw herself sobbing on the floor.

"Oh, what's wrong now?" Simona knelt beside her and stroked her hair to calm her. "Get up. You can't lie on the floor like that. You'd better go upstairs and lie down on the bed. If my husband comes, I can just say you've been feeling unwell."

Mrs Skjoldhammer got up with a tired smile. She laid her head on Simona's shoulder.

"I won't forget your kindness to me," she said. "I haven't deserved it. I'm a sinful woman, a dreadful woman."

They went upstairs, and Mrs Skjoldhammer lay down on the bed in the guest room. She was weeping and pressed Simona's hand.

"Yes, I'm a dreadful person," she repeated. "And I've tried to make you unhappy."

"Do you mean . . . the letter?" asked Simona, trembling with excitement.

"The letter?" Mrs Skjoldhammer looked horrified. "Do you know . . . that it was me? Has anyone found out?"

"No, it was just an idea I had," said Simona. She breathed a sigh of relief.

Mrs Skjoldhammer shook her head for some time as though there were something she could not understand.

"Yes, it was terrible of me to behave in that way," she said with a strange, almost petrified voice. "I'm *evil*. I know. That's how I've become. It's his fault."

There was a pause, and then she added, "But you see, it wasn't really me who wrote the letter . . . not really. No, it's a letter someone or other sent to me last winter. And then, when I heard that Reinhold Vaag and his sister were in Holmvige, the Devil gave me the idea, and then one day I took the letter out . . . Oh, how could I do such a thing? I'll never forgive myself."

"Oh well, think no more about it," said Simona. "But now, you'll surely not be leaving this evening," she encouraged her.

"No, I think I'll do as you say and wait a while. If you'll have me here . . ."

"But your husband . . . He won't be able to understand what's become of you."

"Oh, never mind that."

Mrs Skjoldhammer lay staring ahead with a child-like expression in her eyes. She started to nod and then to laugh.

"Oh well . . . life," she said and sighed. "If only I could stay here as your guest and not have anything else to think about."

"Would you like a cup of tea?" asked Simona.

"Yes please."

Mrs Skjoldhammer's eyes took on an amused expression. Suddenly, she burst out laughing: "I'm a nice one! What must you think of me? But sometimes one becomes so unhappy and sorry. One simply longs for kind people . . ."

Simona took tea and cakes up to Mrs Skjoldhammer.

"By the way," said Mrs Skjoldhammer with her mouth full of cake. "Can we keep what's happened here this evening to ourselves?"

Simona nodded.

"Not even your husband must know. Will you promise me?"

"Yes."

"Thank you, my dear friend," said Mrs Skjoldhammer holding out her hand to Simona. "I hope you'll let me call you that."

She continued to look at Simona as she ate. "Oh, I'm so ashamed. And ashamed of that wretched husband of mine as well. Let him look for me for a bit. I can surely go away if I want. And then I could always ring him up . . ."

She pressed Simona's hand to her cheek.

"You're so fortunate," she said again, and tears came to her eyes. "And what a lovely place you have here, so clean and well looked after. And a good husband. And riches in plenty."

She closed her eyes.

"No, as for us," she said, "it can't go on any longer. But perhaps I can still be happy. We can get a divorce. And then I know there's someone else who'll support me . . . Yes, I can tell you that because I know you won't tell anyone. It's Kjovnæs, the fish grader. He's such a fine man. We were childhood sweethearts. And he's still a good-looking man. He's a gentleman, as they say. And fancy, he's never forgotten me and he's never wanted to marry anyone else . . . Isn't that touching?"

Mrs Skjoldhammer sighed and abandoned herself to her dreams. She soon fell into a deep sleep. Simona cautiously placed a blanket over her and extinguished the lamp.

III

During that day, Vitus had knocked on most doors in Holm-vige. And he had been fortunate. There would soon not be

anything left for sale in his case, but the little skin bag in which he kept his money had become noticeably heavier.

That evening, he booked a room in the hotel. It was a small basement room, the smallest available. There were great patches and bulges caused by damp on the wallpaper, and the rickety iron bedstead was pretty rusty and squeaked at the joints when you touched it. Despite this, Frida Olsen wanted payment in advance. But the room was pleasantly out of the way near the stairs leading up to the kitchen, so he could go in and out without disturbing anyone. And it was a strange feeling to be his own boss and for once not to be indebted to anyone. Except, of course, the minister's wife, who had helped him to get going, and then to Simona, who had promised him her support.

Vitus locked the door and went to bed. He was perfectly comfortable here, filled with a sense of wellbeing. The moon shone in on the floor. The room was paid for. He could stretch and yawn and sleep as long as he wanted. He could even live a life of luxury if he was that way inclined.

Besides, the hotel was an excellent place, full of fascinating secrets. Strange things were said to take place here. "Welcome Hotel" was painted on the end of the house facing the cove. That was to tempt English sailors ashore to drink and booze and perhaps even worse things. And this solicitor who hung around here and never got away, a man who had sunk dreadfully low . . . What was it that tied him to Holmvige and the hotel? Well, what else, presumably, apart from Frida Olsen herself, for she was surely an inordinately depraved and unrepentant person. He had heard all sorts of things about her in Storefjord. As a young woman she had worked for several years in an hotel in Østervaag, and there she was said to have got into trouble with a travelling salesman. Things had gone so far that it was impossible to be in any doubt as to her condition, but then she suddenly left. A few years later she turned up in Storefjord, and since then she had settled here in Holmvige. But the child – what had become of it? Had it ever been born? It was rumoured that she had killed it herself. And much in her behaviour and nature could suggest that she was

dogged by some ugly memory and was trying to numb her conscience with some kind of secret dissipation.

Even before coming to Holmvige, Vitus had heard stories about the foreign sailors' festive evenings in the hotel, behind drawn blinds and locked doors. What actually went on there was known only to the initiated, but there was no doubt at all that incredible things took place.

However, all was quiet in the hotel this evening. The only sound to be heard was the subdued noise of dragging footsteps in slippers. Someone was ceaselessly walking backwards and forwards on the floor. It was probably Morberg, that unfortunate man, unable to find peace with himself.

Vitus lay listening to the restless footsteps. Surely they would soon stop. How long can a person go up and down in that way?

Now there was the sound of someone whistling outside. The footsteps came to a halt, a window was opened and a few words were exchanged with someone out in the dark outside. Before long, the entrance door was opened, and someone came down the stairs. It was the solicitor. Someone carried on a whispered conversation immediately outside Vitus's door.

"How many?"

"Two."

"Wouldn't he let you have more?"

"No."

"How much?"

"Eight kroner each."

"That's a hell of a price for that. Here – there's two kroner for your trouble."

Vitus leapt up to see who it was the solicitor had been talking to. Fortunately, there was a little moonlight . . . yes, it was Søren from the train oil factory. So he had been somewhere getting hold of spirits for Morberg. Perhaps on board the steamer. In other words, this was a case of smuggling . . .

"Oh, that's how it's done," Vitus nodded to himself. "It's Søren Smelt who gets drink for him."

He crept back into bed. The solicitor crept up the stairs. A

219

door opened. Frida's voice. Ah . . . so they drank together, those two.

No, it was not that at all, for Frida Olsen was complaining now. Vitus couldn't hear distinctly what she was saying, but he caught a few words: shame, disgusting, ruining my business, won't have you living here any longer. Morberg answered in a subdued voice, calm and charming. But she was not to be placated, and suddenly there was a bump . . . She had knocked the bottles out of his hand, at least one of them, and it bounced down the stairs, and Frida shouted in a loud, embittered voice, "And then you can find somewhere else to live, 'cause you're finished here now."

She slammed the door. Morberg came downstairs again. He lit a couple of matches. Judging by the sound, the bottle had not broken. Morberg went back to his room, and before long all was quiet again.

But Vitus could not go to sleep. He lay thinking about what he had just overheard, trying to add to and subtract from it all. Perhaps this was only a feigned quarrel to give him the wrong impression. Morberg, who was usually so noisy and boisterous, had at all events been suspiciously calm. And perhaps they were both lying there now, drinking and abandoning themselves to indescribable things. Vitus failed to dismiss the thought; he lay listening with all his senses on edge and with a feeling of being close to a dangerous, consuming fire.

Yet perhaps he was mistaken. Perhaps Frida Olsen was not such a monster. Perhaps she was even upset by the solicitor's bibulous nature and had attempted to get the poor rake reformed to a more respectable life. You could do people a terrible injustice. And when it came to the point, he knew nothing for certain about Frida except that her parents both died early and that she had no relatives apart from a sister who was married and lived in Copenhagen. And that she was quick-tempered, but otherwise industrious. Perhaps a little too interested in money. And as for the English sailors . . . What did one know about that when it came to the point. Perhaps they just sat there perfectly respectably, drinking beer

and playing cards. And if that was the case, it was a pity people should speak so ill of them.

Vitus decided to do what he could to get to the bottom of things. In the name of truth and justice. That could only be pleasing to God. Indeed, he felt it as a kind of call that had been given to him. His mind fell quiet. He turned over on his side and abandoned himself to God and to sleep.

IV

The morning was far advanced before Vitus awoke. People were working, children playing and the sun rising above the highest mountain . . . it looked as though it was speared up there on the sharp peak. It was a melancholy wintry sun, and there was a carpet of frost over fields and roads, illumined pink where the sun shone, but icy blue in the shadow of the mountain.

He dressed and went up to the kitchen to have his breakfast . . . it had been paid for along with the room.

There was no one in the kitchen, and the lounges were empty. It almost looked as though no one was up. Although a kettle was singing on the stove, so Frida couldn't be far away. He found her in the shop, where she was busy helping one of the maids to break a packing case open.

"Take a seat down in the kitchen and wait for me there," she commanded. "I can't be everywhere at once, and I don't suppose you're in a hurry."

Vitus went back to the kitchen and sat by the stove. It was warm and clean there. The sun was reflected on the polished kitchen utensils on the wall. Two small doors . . . where could they lead to? He tiptoed cautiously over to find out. One led into a larder with lining paper with cut-out borders on all the shelves, the other to a small room where there was a made bed. Presumably Frida's own room. Nice and comfortable as well. No smell of spirits, no sign of debauchery. He felt almost ashamed. On the wall over the bed there was a small, framed photograph of a slim, smiling lady with a little child on her lap.

It might be Frida herself as a young woman. Oh, but it could also be her sister of course, the one who was married in Copenhagen.

And yet . . . *isn't* it Frida herself? Vitus feels that he is close to solving the riddle and is overcome with excitement. There is an open drawer in the chest of drawers; he dodges across and peeps into it. A little pile of letters. This is surely where Frida's secret lies buried.

He tiptoes back through the lounges to the shop and stands listening. She is still busy with that packing case. And there is obviously no one else up in the house . . . the solicitor is presumably not out of bed yet.

He tiptoes back and fishes the top letter out of the drawer. Pity that he is so bad at reading handwriting. He finds it difficult to interpret the letter. It's from her sister . . . "Your loving sister". And there are several references to Magda. Magda is all right. "Thank you very much for the money," are the words in another one. He cannot make the rest out. He goes over to the door and listens. Not a sound. Tiptoes back and takes the entire pile of letters out of the drawer, examines them, breathless with excitement. Here, a photograph . . . Magda, a little girl of six or seven, with Frida's features. And here another one of Magda stroking a small dog. And another one again where Magda is standing together with some other children, presumably her sister's; they don't much resemble her – they are dark, whereas she is fair.

Vitus knows now. He puts the letters carefully back in place, in the right order, and returns to sit by the stove, where the kettle lid is rattling as though it wants to tell tales. He lifts it off.

In other words, then, Magda is alive and well. She lives with her aunt, and Frida sends money. Good Lord. She has kept that well hidden otherwise. She might just as well have kept the child, actually, and then people could see she had not murdered her. But this wouldn't really be a suitable home for such a little girl. Of course not. Frida Olsen probably knew what she was doing.

The sound of the entrance door opening could be heard,

and someone was coming up the stairs, stepping hesitantly. Could it be Morberg coming home after a morning walk? No, it was the preacher. Vitus knew that straight away from the way in which he cleared his throat.

The preacher entered the lounge. He sniffed a little and stood there taking his bearings. What could he want here? Now he appeared in the kitchen doorway. Vitus stood up. "Good morning . . . Yes, I'm waiting for Frida Olsen. She's down in the shop, but she'll be coming soon."

"Good morning, Vitus," the preacher gave him a friendly nod. "So you're here in Holmvige as well? How are things going?"

"Not too bad, thank you."

"Well, I've actually come to have a talk to Morberg," the preacher said. "Perhaps he's not at home?"

Oh, Vitus thought he probably was.

Reinhold Vaag remained in the doorway. He crossed his arms and leant back against the doorpost.

"How old are you actually, Vitus?" he asked.

"Forty-six."

"Fancy. You look a lot younger. Not a trace of grey in your hair or beard. And yet you've had a life that's . . . not been entirely without problems, it must be said."

Vitus sighed, "Oh, I can't complain, thank God."

Reinhold looked at him enquiringly: "But then, you've kept your childhood faith, as they say."

"Yes, thank God. I've had that gift, otherwise I think things would have looked black many a time."

Reinhold stared up in the air as though searching for something: "You know the story of the rich man and Lazarus, don't you?"

Vitus smiled and thought to himself that that was some question.

"And I suppose you can't have avoided thinking – though not to literally – that – how shall we put it – you had more in common with Lazarus than with the rich man?"

Vitus nodded again and smiled sadly.

"And you were probably not mistaken in that," the

preacher went on. "You've had a difficult fate here on earth all in all, at least in the sense that you're poor and without relatives, though you're not without friends, and I don't think you've many enemies. But having to wander about like this and not having a place to lay your head, that is quite a cross to bear, of course."

"Yes, a cross it certainly is," Vitus agreed gratefully.

Reinhold went on, nodding his head thoughtfully: "But you've got the Bible's words promising you that whatever you suffer and go through here on earth will be repaid in the Kingdom of Heaven."

Vitus nodded and sighed deeply: "Yes, and God be mightily praised for that. Otherwise I would indeed be unhappy."

The preacher fixed him with his bright eyes. "But . . . is that really the right way to look at it. It's not enough simply to live through difficult things here on earth. Anyone who has wasted his life in sin and debauchery can find bliss, too, provided he is awakened to recognition of his sin, if he repents."

"Yes, of course," said Vitus uneasily. "Otherwise the outlook would be bleak."

"Yes," Reinhold went on. "And on the other hand, a man can suffer all the torments of Hell even here on earth . . . but that only benefits his soul if he repents. And I believe that it is unfortunately so that the underprivileged in life will often find that their ability to repent is limited. They are as it were too sure beforehand that they have found grace."

Vitus drew his breath slowly in through his beard. He was perfectly well aware of where the preacher was leading him. But these thoughts were not foreign to him at all. He was not self-righteous; he was a sinner, a great sinner, and he was racked by regrets as much as anyone was. For instance, had he not just now given in to the temptation of delving into Frida's secrets? It was a shameful thing to do, and he had felt that all along and known that he would come to regret it bitterly.

Meeting the preacher's self-assured eye, he said, "No, I suppose it's not everyone who goes around convinced they have found redemption really *have* found it."

"Exactly," said the preacher.

So they were agreed. That was to say that they were by no means agreed. "I don't respect you, Reinhold Vaag," thought Vitus in the back of his mind, and he started to look out of the window. And yet he did not feel at all at ease. It was as though he had been wounded in his soul, quite a small wound that was scarcely any wound at all. But there it was nevertheless . . . like a tiny pain.

The preacher said, as though in conclusion, "And it's not enough even if you think you've found grace. That feeling's not worth much if you don't at the same time feel a powerful desire to show your faith in deeds and to share it with others."

Vitus felt more deeply wounded.

Now Frida Olsen emerged from the shop.

"It was your breakfast, Vitus," she said. "I'll be there in a moment But what's this, we've got another visitor."

"Yes, it's me," said Reinhold. He held out his hand: "Good morning, Frida . . . Do you think it might be possible for me to have a talk to Morberg?"

"He's not up yet," Frida replied. "I don't think he's really very well. You'd better come back this afternoon or tomorrow."

She took the tin of coffee down from the shelf.

"Oh well . . . then I'll look in another time," said the preacher with a nod. "Are you all right otherwise? Business going well? You're not wishing you were back in Storefjord? No, I suppose one place can be as good as another . . ."

Frida stood straining the coffee. She had her back to him and answered none of his questions.

"Your coffee smells good," Reinhold went on. "I think I'll have a cup . . . you do run a hostelry here, don't you?"

"Would you like to go and take a seat in the lounge," said Frida politely.

Vitus took his time with his coffee. He was curious to see what would happen next. The preacher was obviously trying to get Frida to talk. They were on informal terms, perhaps knew each other of old, and in any case they both came from the same village.

Reinhold drank his coffee very slowly indeed. He sat thoughtfully doodling with his fingers on the table.

"How's your sister, Johanne?" he asked. "She stayed out there. Wasn't she married to a ship's mate?"

"Yes," said Frida.

"You were very different, you two sisters," Reinhold continued. "She was dark and you were fair; she was short and plump and you are tall . . . and, well, I suppose you're not slender any longer, but you were as a young woman."

He took another mouthful of coffee and went on: "And she was quiet by nature, and you were . . . enterprising, always doing something, always busy. So in a way you were like Martha and Mary if I can put it that way. And you are still restless, the one who's always busy. You've got quite a big business going here."

Frida put some peat on the fire. She was obviously trying to look as expressionless as possible.

The preacher remained silent for a moment. Then he started a different tack: "Aye, and now I've come to Holmvige as well, and I suppose I'll stay here for a while. I wonder how our work will progress here? I'm glad to have Tekla with me, she's a tireless creature. As for me, I am perhaps inclined to look too pessimistically at things . . ."

He took another sip of his coffee.

"Aye, I worry quite a lot. We're living in sombre times. There's so much illness and need, misfortune and sorrow around us. In the old days, before the deep-sea fishing really got going, it was as though you could better see yourself and your fellow human beings. The boats were rarely away fishing for long at a time, and they were in any case in local waters. People were not so scattered and they didn't get so far from each other as they do now. Life was more secure. Now there's a spirit of insecurity, a spirit of everlasting uncertainty and anxiety. And that makes its mark on us; we become nervous, we are searching for something. We have to have something to hold on to . . . a hope beyond death, much more powerful than this tendency to accept that things will probably be all right because God is merciful."

The preacher was now sitting up straight and talking as though speaking to a large gathering.

"For even though God is merciful, even though He is generous with His grace . . . it is of no benefit to us if we do not accept it with all our hearts. And we only do that if we repent. So God has called on those who have sinned and found themselves overcome with the worries and scruples that accompany repentance. If we feel the slightest dissatisfaction with ourselves, with all our doings, that is because Jesus stands at the door to our hearts, knocking gently and urgently. And then we know no peace before we have let Him in and thrown ourselves into His arms and wet His coat with our tears of repentance . . ."

He emptied his cup and pushed it away.

He stood up.

"But what was I going to say? Perhaps we'll meet again, Frida? You are always heartily welcome at our meetings."

Frida made no reply. She stood chewing and looking out of the window.

"How much do I owe you for the coffee?" asked Reinhold.

"Twenty-five."

Frida took the payment, which the preacher counted out in copper coins.

"Well, then, I'll come again this afternoon or tomorrow to see the solicitor," Reinhold smiled as he took his leave.

Frida disappeared into her room.

While the preacher had been talking to her, Vitus had been cautiously watching her, but there had been no reaction to be seen in her face. She was as cold and unbending as a knife. Or what was she really like? What was she doing now in her room? Was she sitting writing on the edge of her bed? With a tiny, but merciless wound in her soul?

No, she was humming a tune. From inside the little room he could hear a gentle, merry sound of humming, as though it was someone thinking about pleasant things.

V

Reinhold Vaag felt unusually inspired today. The words burst upon him with overwhelming power; he could not keep all this exuberance to himself.

First, he would talk to Sylverius. Perhaps he would have come to a decision regarding a meeting room.

Bernhard Thomsen was standing in the shop doorway sharpening a pencil.

"No, Sylverius has gone home for lunch," he said without looking up. "Come back again this afternoon if it's important."

"I would really like to speak to him now," said the preacher. "So I think I'll go and see him at home."

"Yes, just you go up . . . and have a bite of food with him," said Bernhard, still without looking up. "But make sure you don't eat the host along with the food," he added.

The preacher cleared his throat: "My dear friend, what's the point of those pernicious words? Are you and I enemies for some reason?"

"Oh, I simply don't approve of cannibalism," said Bernhard.

He shut his knife and put it in his pocket.

The preacher blinked calmly. "Yes, but you see, what you call cannibalism . . ."

"Isn't cannibalism at all," Bernhard cut him off. And he continued in a sombre preaching voice: "On the contrary, it is salvation from the all-consuming cannibalism of the world, for, dear friends, worldly cannibalism is the true cannibalism, that is the cannibalism we fight against with all our souls by surrendering ourselves to the cannibalism of Divine grace. And so on. As you can see, the world has lost a preacher in me."

Reinhold stood slightly taken aback for a moment. But only for a moment, and then a kind of smile emerged in the corners of his eyes.

"Well If you really have something on your mind, then step forward and say it to the congregation. I'm inviting you

to do so, although I know you only seek to make me look ridiculous. Just you come and wrestle with me, and we'll see who is the stronger."

"Oh, you've already turned the minds of the entire village," snarled Bernhard. He was unable to hide his irascibility and contempt. "You ought to be horsewhipped as much as your back could take."

But now Reinhold really had to laugh. It was a gentle, infinitely gentle and tolerant laughter, and he now looked at Bernhard as one looks at a child.

"Oh, I think we'll come to some sort of agreement sooner or later, without spilling any blood of any kind," he said.

Bernhard turned away in disgust.

. . . A rather hot-tempered man, that Bernhard Thomsen. Of course, it was all the business about his sister's conversion that had upset him.

Reinhold had himself been a little dubious about Elisabeth's sudden conversion. There were certain things that indicated that the poor girl was one of the spiritually weak. This passionate devotion, this convulsive submission to the faith often only lasted for a short time and could turn into indifference, indeed into defiance and antagonism. It was not unusual to see that kind of person lapsing and turning into difficult and unscrupulous opponents. From what he had heard, Bernhard had himself once been deeply religious, and now he seemed to be filled with hatred and scorn.

No, the steadfast were more often to be found among the hesitant and the slow. The fire rarely burst into flame in them, but they glowed constantly, and habit did not cool them.

There was something that told him that Sylverius was one of this latter kind. He thought he had detected signs of a certain receptivity in him, something in his look and movements that could scarcely be explained otherwise. It would be an enormous victory for the cause of the Kingdom of God in Holmvige if Sylverius could be counted among his followers. The wealthy ship owners and captains in Storefjord almost all belonged to the persuasion; they were its mainstays, its unfailing salt. The farmers were more difficult everywhere, they

held on more to the old forms and were suspicious of the new. Well, one day it would be seen . . .

Sylverius gave the preacher a friendly reception. Yes, he had thought about his request and had decided to make a room available to them. It was a big room above one of the warehouses that was otherwise used as a sail loft . . . but perhaps it didn't matter that there were some sails hanging on the walls and if it smelt a bit of bark and rope. Perhaps they could manage with that for the time being.

"Yes, we're grateful if only we can have a roof over our heads," said Reinhold. "I shan't forget your kindness."

He adopted an emotional look. "You know, we are often met with suspicion . . . as though we were seeking to break down, not to build up. And yet I believe that, especially at this difficult time, we are honestly seeking to carry out an important task, that is to say to spread a little light and blessing, the peace and warmth of faith to those who are suffering or insecure and those who are groping their way forward. Perhaps the odd word will strike root and grow. That's my hope."

Sylverius nodded.

The spirit was moving Reinhold. He smiled: "Yes, isn't it strange . . . we are often accused of undermining and breaking down worldly society. It's especially certain members of the clergy who warn against us for that reason. And yet it would be nearer the truth if they said the exact opposite. For we don't seek a new social order, we only want to spread God's light over the social order already existing. We fight to make human beings active not only in a secular sense but also in a spiritual sense. For a sluggish faith, a half faith, a doubting faith or a habitual and lethargic relationship to God paralyses everything. People fear the instability in all things. You ask yourself what the point is of it all when we are soon to die in any case. Or when you can't explain the distressing, meaningless events around us . . . indeed we might sometimes almost think that God is unjust. But once you have experienced the glory of faith, the gospel of grace, you are at peace with yourself. Then death holds no fear. Indeed, if you once feel the living grace in your being, you gain courage, and a light falls

on all things, that is to say the light from the life to come. For without it, the world is a vale of tears. – Oh, here I am as usual getting lost in my own thoughts . . . it comes from habit . . . and one likes talking about those things that occupy one, it's difficult not to."

The preacher rose.

"May God reward you for your kindness to us," he said, pressing Sylverius' hand. "We shall not forget it."

VI

Reinhold Vaag had a busy day, a zealous day.

During the afternoon he visited Morberg again.

He found him sitting in the café, dressed in his overcoat and cap. He was unshaven and had red, baggy eyes, but otherwise looked perfectly clear in his head.

"Come in," he waved cheerfully. "Sit down in this vacant hall."

He repeated triumphantly, "Yes, isn't it *vacant* here? Magnificently vacant. And darkness was upon the face of the deep. And the spirit of God moved upon the face of the waters."

The preacher sat down.

"I wanted to have a few words with you," he said. "I have something I want to say. That is if my company is not a burden to you."

The solicitor smiled elatedly and slapped his shoulder: "There's nothing I would rather have than a chat with you. I believe in your cause, as you know. I think you're the right man. You have both courage and experience. But . . . What was I going to say: Are you married?"

"No, I'm a bachelor," said the preacher.

"An ascetic then," nodded the solicitor giving him a searching look.

But suddenly Morberg banged the table: "No! I'm not going to have that one. You're something of a sly old fox. Aren't you . . . Good God, man! That face. Oh well, but that

231

doesn't make you any less in my eyes. I think of you as a politician."

Reinhold held his head on one side and started doodling on the table top with his finger: "As I was going to say . . . we talked the other day about God's arithmetic . . ."

"No, I don't remember," the solicitor interrupted him. "God's arithmetic? Do you think God sits working everything out? Do you really think He's so calculating? That's a pretty ignoble thought, I must say. It's actually shameful to attribute ordinary human qualities to God. He's God after all and must be allowed to have certain things to Himself. You misunderstand His nature. He . . . He moves upon the face of the waters and darkness was upon the face of the deep. He's a lord in majesty, you see."

The solicitor sat up straight and stared grimly into the air.

"Yes, but He loves the world and all creation . . . He loves mankind," the preacher interrupted timidly.

"Yes," – the solicitor thoughtfully rubbed his bristly chin and considered this observation. "He loves His creation, that's obvious."

"And creation suffers," said the preacher.

"Yes, but why does He let it suffer? He could prevent it," objected the solicitor. "That's to say . . . He simply can't. For life is suffering. It's twofold, self-contradictory, incomprehensible like God Himself . . . it only exists by virtue of that incomprehensibility. Otherwise it's not life, but stagnation and death . . ."

"Suffering came into the world with sin," said the preacher. "God takes pity on mankind."

Morberg had been absorbed in his own thoughts, but now he awoke again. "Oh yes, He takes pity . . . that's not surprising either. But He's powerless, we agreed on that."

"No, He is not powerless." The preacher strained his neck and turned towards the solicitor and looked him straight in the eye: He has a *miraculous* power . . . a power that neither you nor I understand. He can redeem us through the Blood of His Son."

The solicitor shook his head. "Yes, that's all a mystery."

"It's a mystery, yes it is," the preacher agreed. "It's a great sacred mystery that transcends human understanding. It cannot be understood, it must be experienced. And then, don't you feel deep down inside you a gaping void, a burning thirst, a longing for the only thing to ensure salvation? Don't you long to surrender with all your soul to a . . . a great and all-embracing love beyond all understanding? If you feel this longing, then it's *God* coming to life in you. Through dearth and pain He gives you part in His grace. For He is the heart of all hearts."

"Splendid," commented the solicitor. "If I put myself in the position of a repentant sinner . . . oh, I'll straight away be suffocated under the avalanche of your message. But I am *not* a repentant sinner. There's no salvation for me. And what then?"

The preacher gave him an anxious look. "Does that mean that you think everything's fine as it is? Wouldn't you like to see life different?"

The solicitor shrugged his shoulders: "I feel a certain satisfaction in noting, quite soberly, that life is as it is."

"No," argued the preacher ponderously and earnestly. "You are *not* satisfied with life as it is. Otherwise you wouldn't . . . drink."

The solicitor stroked his sharp, arched nose.

"You didn't answer my question before," he said impatiently. "I asked what would become of me if I didn't feel like a repentant sinner."

"You'd simply go on being unhappy," said the preacher.

"Also . . . after death?"

The preacher nodded.

"Be tormented in Hell to all eternity?"

The preacher nodded again.

The solicitor breathed a sigh of relief: "There, I caught you! There we got to the bottom of your goodness . . . and your God's goodness. You can't bluff me any more, you understand. Behind all your philosophy of goodness and love there is still unbounded evil. Why do you tiptoe round it in your general preaching? Come on, put your cards on the table.

Let's have your Hell and that great vindictiveness. Væ victis! Eternal torment to the opponent."

The preacher moved uncomfortably and swallowed a couple of times. "My task is precisely to do what I can to save people from eternal suffering. But . . . I am not willing to threaten them or frighten them to ensure their conversion. Conversion must take place in love . . ."

"As you like," said Morberg and was calm again. "But listen to me: Here you are, sitting face to face with a sinner who won't repent, and who doesn't think he has any need of conversion. A hard-baked and unrepentant soul, you understand. There's nothing you can do about him, he goes straight to Hell, to the eternal torment that's waiting for him there."

The solicitor's worn face was hard and implacable.

The preacher bowed his head: "Is there nothing, nothing at all, you repent?"

"Nothing!"

The solicitor stood up and started to go backwards and forwards. Twilight was falling. The preacher remained sitting hunched up by the table. Out in the cove the lights could be seen of a trawler approaching.

Now the preacher stood up.

"I have prayed for you," he said. "And we will all pray for your soul. You will come to a different view, believe me. He stands at the door knocking, He who is the love of all the world . . ."

"But there's no door to come in through," laughed the solicitor coldly. "No, there's only one way for me. It's been clearly laid out for me. There's no mistaking it."

"May I come again?" asked the preacher humbly.

"You'll be very welcome, but it won't do you any good." Morberg's tone was dark and solemn: "I am sliding down, down, down . . . I'm beyond redemption."

The preacher whispered something that sounded like an exorcism. Shortly afterwards, he disappeared.

Morberg laughed to himself, "That gave him something to think about. I don't think he's had to face a case like this

before. A sinner who simply recognises and accepts his own eternal damnation."

He was not far from feeling a little sympathy for the poor preacher. He went on: "How this fear of judgement and torment has plagued humanity over the centuries! This threat of being shut in the earth's cellar for ever. And this fear still drives its plough through the human mind and perhaps will do so in one form or another as long as there are human beings in existence."

The wind was getting up. The gusts drew their fleeting islands on the surface of the cove. How he knew these windy, supple figures and their sound as though they were licking the water. And all this raw and healthy winter twilight with frost in the air and glowing Northern Lights.

Oh well, it would probably be best to have a bite of supper. Morberg rubbed his hands and shivered. It was really cold in the café here. But now the trawler had arrived Frida would probably light up.

There she was already.

"That's right, Miss Olsen," he said merrily. "Light and warmth, music and festivity!"

But it was not Frida. It was the preacher who had returned, this time accompanied by his sister and another woman.

"I hope you'll not be angry," said Reinhold plaintively. "We would so much like to show you that we mean something by what we say . . ."

The solicitor started: "What on earth . . .?"

Through the half light he could dimly make out the features of the two women in their black dresses. He seemed to remember something about the women in the Bible, Mary Magdalene and whatever they were called, these humble and quiet young women who followed the Saviour. But what did these people want? They threw themselves on their knees at his feet. The preacher raised his voice and started to pray.

Morberg was torn between fascination and fury. This was an ambush, a spiritual assault. There they were, kneeling and praying for his soul . . . two young girls at that!

The preacher's prayer was quite brief, but then one of the

girls started in an indescribable voice . . . it was impossible to decide whether it was ugly or beautiful. It went right through him. He was filled with a sense of cruelty, and he felt an urge to push these innocent creatures away, to hit them, to kick them out of the café. It was disgusting to stand there and have them weep for him. It was degrading. If only he had had any idea that his little joke of a few moments ago would have this consequence.

But he remained standing there, as though nailed to the floor. An unpleasant, caressing warmth emanated from the little group of praying figures, and it made him think of heretics being burned at the stake. No, this was intolerable to him. He felt almost an urge to scream, for this was torture. Good God . . . it was like being baptised or buried against your will. Or married! Yes, precisely, it was like being married . . .

And suddenly Morberg burst into tears. He tried to stop it, but it was impossible for him to keep the tears at bay. "A ridiculous psychosis", he thought to himself. Thank God, the show now looked as though it was at an end. The three figures got up.

Morberg turned away in order to hide his tears.

"You mustn't think badly of us," he heard the preacher say.

And then he was alone again. And now the long-suppressed fury broke out. He regretted bitterly that he had not thrown that snake of a preacher out. It was indecent to come here with hysterical women and put on a show like that. Shameless. He understood now that he had wept with suppressed fury.

He rushed up the stairs and shouted, "Why in the devil's name did you let those hyenas lose on me, Miss Olsen? Aren't you ashamed?"

But Frida Olsen was nowhere to be seen.

"Where the hell have you got to?" he shouted. "Haven't you noticed a trawler's arrived?"

"She's probably been standing watching somewhere or other," he thought to himself. "She's been a witness to the entire performance."

A small figure was sitting hunched up on the bench near the stove in the dark kitchen. It was Vitus.

Morberg lit a match.

"What the devil are you sitting here for?"

"I'm . . . just sitting here," said Vitus in a pleading voice.

He held up his hand defensively. Great tears were glistening on his cheeks and beard.

"What the hell are you blubbering for?" shouted the solicitor furiously. "You've been listening. I'll . . . I'll . . .! Oh no, this is just too crazy."

He threw himself down on a bench and laughed, abandoning himself completely to laughter.

VII

Vitus was profoundly shocked by what had taken place in the twilit café. He had heard voices in there and thought it was Morberg and Frida making things up after their nocturnal row. But then it was a prayer meeting. They were praying for the solicitor's soul. That was such a strange thought.

"Perhaps those prayers would bear fruit," he thought. "Perhaps God would take pity on Morberg and make him less intransigent. But what about me? There's probably no one who will pray for me . . ."

Vitus could not forget the preacher's word about the underprivileged who had lost the ability to repent. He had tried to dismiss the thought, but he couldn't escape it. For suppose you didn't repent enough and so were excluded from grace. Here he was, going around in this cold and windy forecourt, impatient for the gates to be opened to the secure and blessed eternal dwellings. But what if that gate led to the blackness of damnation instead . . .?

These thoughts had pursued him all day. He had wandered around in a fog of despondency and vague fear. During the evening, while he was sitting in his room, he heard the singing from the mission folk's meeting, and he had to go out and listen; he simply could not resist, although he had been looking forward to going to bed and getting some sleep.

It was a bitterly cold evening. The wind was blowing, and

the Northern Lights were illuminating the skies. The preacher was dressed in a solid leather wind jacket, so there was no need for him to be cold. In general . . . Vitus could not help thinking that this Reinhold Vaag was in every respect a man who had ensured he was all right. As for worldly things, he had his regular income, and it then went without saying that he was well off in a spiritual respect, too, he whose work solely consisted in easing people's path to grace and redemption. But he wondered how things were with his awareness of sin and with his repentance? Did he have anything to repent? If not, then he couldn't have much benefit from all the rest.

But Reinhold was really a repentant sinner . . . that, too, in addition to everything else. He confessed it personally, in so many words, to the assembly listening to him. His address was about the terrible power of sin, which it was difficult to combat even for one who was closest to the door leading to grace. There was no heart so pure that some sinful thought could not make its way in. Indeed, even when you thought you had eliminated sin from your soul, torn it up by the roots, there it still was, in the shape of self-justification and arrogance. It was a serpent with a thousand heads that no weapon could destroy. Except for one: repentance. For repentance made you humble. Jesus would only recognise a repentant sinner.

Vitus felt a little ashamed for having doubted the preacher's awareness of his own sin. Yes indeed . . . only repentance could save you from damnation. That was an eternally true statement, whether it was uttered by a minister or a preacher – it was the Bible's own words. And now he also realised that what was worrying him and making him uneasy was precisely the question of repentance. He regretted having looked at Frida's letters and getting to know something that she was going to some trouble to hide. And he regretted having stood at the top of the stairs leading to the café, listening when they were praying for Morberg. And when he thought things over, he had to admit to himself that his entire life was so to speak larded with those kinds of sins. It was all the result of his curiosity, this mania of his. He stood with his arms full of borrowed and stolen secrets and wished he could return these

stolen goods. But nothing could be changed. Repentance was the only course . . .

The preacher finished his address by announcing that the next meeting would be held indoors, thanks to the great generosity of the merchant Sylverius Eide. Then they sang a hymn. Tekla raised her face; her pure, powerful voice penetrated all the way into his soul in some strange way:

> Brother, now list to the call of the voice,
> Resounding and counting the cost
> Your Saviour calls out and commands you rejoice
> His grace is too great to be lost.
> Grasp it and keep it
> And tend it and reap it
> And never be lost to your God

Never be lost to your God. The words entered Vitus' mind like freezing flakes of snow. He felt cold in both body and soul. An insufferable cold. And he was not the only one to be cold. The light from the lantern flickered on nothing but pale blue expressionless faces. It was like taking part in a gathering of the dead.

And now Elisabeth stepped forward, she, too, pale and corpse-like. She closed her eyes and threw her head back. A few dishevelled wisps of her fair hair appeared beneath her bonnet; she looked neglected and hounded.

"No, never be lost to God," she began. Those were the words of the hymn, and if anyone could demonstrate the truth of these words, it was she. She had walked in the dark, preoccupied with all kinds of sinful thoughts and things of this world and had not paid attention to the calling voice and the one thing that was necessary. But then God had given her a more urgent call . . . terrifyingly urgent and with a force that left her powerless. And then she understood the power of His love. Sorrow had opened her eyes.

Remarkable to hear how little Elisabeth was able to formulate herself; it was almost as though she had been trained in the ministry. But her voice was weak and constricted, breaking

and becoming hoarse when she became too fervent. Nevertheless, she went on doggedly, interrupted by coughing and huskiness, until it was as though she had no more breath in her breast. It was pitiful, and yet . . . it gripped your heart. Some of the listeners had to dry their eyes.

. . . When Vitus returned to the hotel, there were lights on in the café. The trawlermen! Should he go in and buy a cup of coffee? He was bitterly cold, and a cup of hot coffee would do him good. And he could afford it. But there was a voice inside him, warning him not to give in to his curiosity. And he dully obeyed it.

It was bitterly cold in the little basement room. He crept into bed and lay there a long time, surrendering himself to the vapid chattering of his teeth. The sound of merry voices and accordion music reached him from the café.

Vitus gradually warmed up a little and lay listening. He had to interpret every sound he heard. Tramping. Singing. A table being moved. Morberg's voice. These English animals . . . they would surely not be content to sit and fill themselves with beer and schnapps; they were fooling around, shouting and singing indecent songs – at least that was what it sounded like. And the solicitor, for whose soul prayers were being said only a couple of hours ago . . . in the same room!

Now the seamen were singing a chorus together. It didn't sound bad. And Morberg shouted bravo. More accordion music and rhythmical tramping. Yes, they were dancing now, there was no mistaking that. But who were they dancing with? Frida Olsen presumably. In his mind's eye he could see her waltzing around, red and excited, brazen and shameless. And perhaps there were other women there as well, the one who helped Frida in the house and the other one who helped her in the shop, and Søren Smelt's daughters Sara and Roberta . . .

Vitus could not but form an image of the dissolute party. He lay there and broke into a sweat over it. Horrifying scenes appeared to his inner eye . . . a sultry, horrific, depraved world. It was almost intolerable to think of it. It would be better to get up and escape from this glowing temple of sin, to take a

240

walk in the bitterly cold night to strengthen and harden his soul . . .

And yet, suppose he was doing these people a deep injustice? Suppose it was not Morberg's voice he had heard at all, and suppose Frida was not taking part in the fun, but sitting weary and sad in the kitchen, thinking of Magda. In that case all that ugly suspicion would rebound on himself. In that case he was harbouring injustice and sin in his heart. So if he were to do the right thing, he would get up and go over and sit in the café and let truth receive the justice that it deserved. And besides, no one would be surprised that he went. He was staying in the hotel and paying for it. And anyway, Vitus was used to a bit of everything.

No, you're simply giving in to your confounded curiosity, pronounced the voice of his conscience deep inside him. And it would probably be best to stay where he was. He could get down under the duvet and shut out all that racy din down in the café. Or – and that would probably be best when it came to the point – he could get up and go for a walk. That would be the least pleasant solution, but on the other hand he would find peace in his soul and feel clean and happy like a man who has vanquished Satan in himself . . .

And he jumped out of bed and quickly dressed. Strangely enough . . . it did not take much to overcome his reluctance. He was not terribly cold, and on the other hand he felt a wonderful, buzzing sense of wellbeing. That must surely be his conscience that was settling down within him, relaxing, liberated, in his soul.

He put on his coat and hat and went out into the night. The wind had turned to the south; the sky was full of great clouds, and the air was no longer biting, but filled with that watery perfume the southerly wind brings with it. The illuminated windows from the café were the only light to be seen in the night. For a moment he felt tempted to tiptoe across and see whether the blinds were a tight fit, but he dismissed the idea with disgust.

A black shadow could be seen against one of the windows. Morberg's profile. But no, the shadow picture took up

another position . . . it was not the solicitor. But who was it then? Now it looked exactly like the preacher. Could he be in there? Yes, it was the preacher, there could be no doubt about that. But suddenly Vitus discovers that this shadow does not derive from anyone inside the café, but that it is someone standing there looking in through the window. And it is indeed the preacher, Reinhold Vaag.

Vitus approaches closer. He is careful to move silently. Yes, it is the preacher. He is standing looking in, or trying to look in, open-mouthed . . .

Vitus coughs.

Reinhold Vaag gives a start: "In the name of Christ . . . Is it you, Vitus. How you frightened me. Yes, here am I standing wondering whether it's worth interfering. You live in the hotel, so you could perhaps tell me what's going on in there. I can't see anything since the roller blinds fit so tight. But one can imagine all sorts of things. And perhaps there might be the odd soul in there who could be saved from sin and put on the path to redemption . . .? Are there not women in there, poor, ignorant women who are at the mercy of these unprincipled sea dogs?"

Vitus replied coolly: "I don't know. I thought about taking a look myself, but Jesus be praised, my conscience held me back, and I decided instead to get out of the house and find some lonely place where I could pray for the poor people who are perhaps being led astray in there . . ."

And with a bitter smile, he turned away from the preacher and disappeared in the darkness.

WINTER DARKNESS

I

Kristoffer wakes each morning on the dot of half past four and has to get up and go out whatever the weather is like. It is an old habit of his. During his childhood, he suffered from shortness of breath. It came on him early in the morning, and then he had to go out.

If it is during the fishing season and the weather is suitable, he wakens the other members of his crew. Otherwise he finds some job that needs doing, sees to his boat and tools or makes something or other out of wood here and there. But he is only really himself at sea, and an enforced indoor life makes him sleepy and morose.

Since the great autumn storm when the Dumbarton was lost, the weather has on the whole been calm and mild. The fishing boats from Trymø have been out almost every day, and the fish caught on line to the north of the island have been splendid. Not until a week into November did the winter weather really arrive; it started with a dry frost and north wind, clear skies and biting cold, but then one evening the barometer suddenly fell, the wind turned to the south east and grew to a gale during the night. And the following morning the storm had hit the island.

Kristoffer wakens up at his usual time and goes down to the boat shed. There is a tumultuous surf, the landing stage is white with foam and froth, and the merciless wind is resounding and howling up in the mountains.

The eider ducks are riding it out on the great breakers, as they are accustomed, and when the crest of a wave breaks, they dive down under it as easily as one moves a foot in a dance. They feel at home in the deafening white breakers.

And there are other winged creatures on the move in the

dark morning. The heron is out looking for a catch. Kristoffer can hear its rusty cry through the roar of the storm . . . it must have strong nerves since it risks going out in this weather. And a little further away something is squeaking timorously and piteously . . . it is surely some unhappy creature, perhaps some weakling that should have flown south with the others, but hasn't had the strength to go with them.

The gale persists for days. The heavy, wet snowflakes settle like great eiderdowns on the western slopes of the mountains and congregate in granulated accumulations on the west ends of the houses and on everything else facing west. It is a languid, difficult snow, clinging to everything, piling up, forming impassable drifts between the houses.

A huge snowdrift had formed just outside the entrance to Landrus' shop. Landrus managed to shovel it away at the cost of half an hour's work. But a couple of hours later it had once more grown enough to be in the way. An impatient Landrus re-emerged with his shovel and moved it again, carefully and deliberately. But there was something strange about all this. There were no drifts in front of other people's doors as far as he could see.

And there were other curious little happenings as well. One morning when his wife had gone down into the kitchen to light the fire, she heard a muffled cry from the stove. She called Landrus. They opened stove door, and out fell a crow. A big, heavy crow with a drop of blood on its beak. It shook itself to get rid of the soot and snow and started to nod, looking around all over the kitchen, blinking eyes that seemed to recognise its surroundings. It was not like a natural crow . . . perhaps it was a shape changer. Landrus put down some food for it, but it didn't appear to be hungry. So it was allowed to stay in the kitchen. However, it started to become restless during the day, and Landrus thought it best to let it go. He opened the door, and the sombre guest hopped out and disappeared in the drifting snow to the accompaniment of a series of loud and rather unpleasant cries.

Aye, there was much to suggest that unfriendly powers

were at play. For two nights running, Landrus had dreamt about his father. He had seen him crouching by a crossroads, busy sharpening his axe. That sort of thing was hardly a good omen. He would have given a great deal to discover *what* it meant. Certain people, of course, had the ability to interpret dreams and see into the hidden world. Such ability was a strange gift from God. Landrus' grandfather had had that gift. But he had certainly had to pay for this privilege with bad health. And he had certainly become neither particularly rich nor happy. On the other hand, he had known a rare peace of mind. Nothing could surprise him, because he knew everything beforehand . . .

But now there was every reason for Landrus to be happy. The purchase of the ship was in order, and the payment conditions had been good into the bargain. No major down payment in cash had been necessary; it was mainly a matter of taking some loans and making sure of paying interest and instalments on time. He had admittedly had to mortgage his house and all his possessions. But the ship was first class; experienced men had assured him of that. Aye, young Gotfred had a fine sense for that kind of thing, and he had a good head in general. Landrus actually missed him.

But for the moment, all this was strangely distant and unreal. Did he really possess a ship? Was he really a ship owner? Did he have a bright, clever son-in-law? It was almost too much to believe. But it was true. And there was even more he could feel pleased about. Egon, Lars Dion's son, had left Sylverius . . . he had suddenly had the idea that he was destined to something better than standing in a shop, and now he wanted to be a missionary to the heathen.

Aye, in God's name . . . Landrus hoped from the bottom of his heart that he would do well out there in foreign lands, among cannibals and wild animals.

And perhaps he ought to put all his worries and presentiments aside and put his faith in God. That crow . . . it *could* of course have been a natural crow that had got stuck in the chimney. And even if it was a shape changer . . . who was to say that it came to warn him of evil? But those dreams about

his father sitting sharpening his axe, dark and unapproachable on that desolate road . . .

And yet there was some old saying that if you wanted to be rich you should go out by night to a crossroads and sit there and sharpen an axe. And suppose now that the dream meant wealth . . . that he could look forward to good luck and to making a fortune. Landrus felt encouraged by the thought. For fun, he would go and have a talk to Torkel Timm. He was quite good on that kind of thing. His mother, Tomotea, had been something of a fortune-teller, and the son was like her both in looks and character.

Landrus took an account book and opened it at Torkel's account. He owed him some money, did Torkel. But that could be arranged during the spring, of course, for there would be no lack of work now if things went as he and young Gotfred had foreseen.

Torkel's little living room was full of smoke, part peat smoke from the fire and part tobacco smoke. Torkel himself was lying in a dark alcove, half dressed and with sleepy eyes.

"Are you ill Torkel?" asked Landrus.

"I'm not so good." Torkel cleared his throat through his beard and clouds of smoke. "This weather's awful as well."

"I've got a little packet of tobacco for you," said Landrus, sitting down on a bench by the fire. "What was it I was going to say? – This Ole's not turned up again since I saw you last, has he?"

"No," Torkel hesitated, quite amenable to discussing the subject. "He's not shown himself to me again. Not much at any rate . . ."

Landrus nodded in relief and satisfaction. "I can imagine that. For you see, not only have I, as I told you, cancelled his widow's debt to me, but I've let her have a sack of rye flour and five pounds of sugar on credit. Jovine's quite a character; she's asked to be allowed to come and help with work on the fish in spring. And neither does she think anyone can say that I'm in any way responsible for her husband's sad fate. But as I was about to say . . . you know perfectly well, Torkel, that it's only granted to very few people to have a guardian spirit. But

what about you? You could discover a lot of things if you really set about it, couldn't you? Or . . ."

Torkel looked wearily up at the ceiling: "Well, you know, it perhaps sounds a bit peculiar to say so, but the fact is, Landrus, that I'm not allowed to talk to you about such things."

"Not allowed?"

Landrus shuffled rather awkwardly.

Torkel adopted an apologetic look: "Aye, you mustn't misunderstand me, but the fact is . . . that I'm not allowed to give other people an insight into these matters. But I'm willing to help you as far as I can."

Landrus looked at him and tried to read his face. He became none the wiser for that.

Torkel repeated, "As I say, I'll do anything I can for you, Landrus. I know you're a good and honest man. And I can tell you so much, that there are good things awaiting you, fortune and riches, enormous riches."

There came a rather coy look over Landrus. "Do you really mean that, Torkel? Well, since we're talking about that sort of thing . . . I've had a strange dream for two nights running, and I'm wondering what it might mean."

He now gave an emotional description of the curious dream.

Torkel nodded and wrinkled his brow attentively. "I can interpret that dream for you, but I must have time to think about it."

Landrus got up and gave a little laugh, at once optimistic and suspicious. Torkel Timm was a difficult man to see through.

"I'll be seeing you, Torkel. Come round to my place when you've worked the dream out."

It was snowing heavily and intensely. That intolerable drift was building up again outside the shop doorway. There were sounds of music from the sitting room. It was Gregoria playing her gramophone. Landrus couldn't stand that music box. He opened the door to the sitting room and looked in with a harassed face. "How often do I have to tell you that I won't have that screeching? I forbid you to touch that box, you

understand. I'll have it sold as soon as I can, so we can get some peace from it."

Gregoria stopped the record. She had just been sitting here in the twilight enjoying the music. She could never tire of that lovely sad song. Every time her father was out, she slipped in to hear it. In a way it was unfair to young Gotfred, for it was not only the song that affected her, but the voice singing. And there was more . . . for she was able to imagine the singer. She had formed an image of him. He reminded her a bit of the Spaniard, Braga, but he was younger, pale and dark and with a tender, melancholy line around his mouth. And he was strangely faithful, too, for he never tired of singing for her. Each time equally filled with longing and tenderness:

> And right to the last her thoughts were with him
> And his vision stayed with her as her eyes grew dim.

It was so sad she could weep over it. For they were never to see each other again. But that was a good job after all, for she was engaged to Gotfred. And he, too, was kind and sweet in his way, although he was more ordinary and couldn't work magic and seduce her with his singing.

Gregoria closed the lid and pushed the lovely black box under the chest of drawers.

II

Quite gradually and unnoticeably, the snowstorm turns into a rainstorm. In the course of a single night, the island is almost entirely cleared of snow and transformed into one vast water-fall with countless branches. At the steep rock face the wind forces the cascading waters back up, and they stand out against the sky like smoke and fluttering ribbons. The angry, murky water everywhere groans and froths and seeks to drown the sound of the waves in the earth-brown cove.

Josva awakes one deep black rainy night and lies listening to the insatiable sound of the waters. He can sense the gentle,

fresh scent of water and earth even in his bed. It makes him think of spring, and suddenly he is wide awake and painfully constricted in his soul with sorrow and longing. He feels homeless, superfluous. The thought comes to him as something totally matter of fact that until now he has simply avoided acknowledging that he is weak and cowardly . . . a werewolf, as Hilda called him. It is as though he is now beginning to understand what that word means.

A werewolf . . . something that sneaks around. It's like a human being, but in reality it is only a shadow, an empty skin. It can't feel sorrow or anger or love as human beings can, and it has neither the bravery nor the will of a man. It sneaks around furtively, bearing with it its sorrows and its sickly longing.

Josva slips into a state of sleepy indifference. He falls asleep again and dreams now that he is walking around naked on the island, wading in gushing, lukewarm water and quite alone in the world. He is strong and mighty, pushing his knee against rocks weighing many tons and making them rock and roll down the mountain slopes. Everything has to yield to his power; he releases the water from dammed-up lakes and amuses himself by watching the tiny houses in the valley being flooded by it. He is a giant, and the island is entirely in his power. He shakes it until it splits and subterranean passages and grottoes appear. He wades out into the sea to shake the other islands and see what they contain. They wriggle beneath his hands like gigantic human bodies, frolicking joyously and yet in his power.

He wakes again, restless and sweating. Outside, the water continues to seethe and roar. And those thoughts overwhelm him and torment him again. He forces them away, pushes his head down in the pillow and tries to make himself sleep again.

A strangely long and laborious night. Once more he dreams: It has been summer with red, sunlit nights and dancing up in the mountain pastures, but then winter comes to the island and the air is full of icy needles. A boat sails away . . . it's the mail boat that is to take Hilda to the sanatorium in Østervaag. She sits on deck, pale and wrapped in shawls and

249

scarves that flap in the wind and rise from her back like wings. Her mother is behind her, she, too, pale and with great eye sockets. There are no eyes in these sockets. Hilda's face also lacks eyes . . . this is a bony death's head; it's all skeletons. The man at the tiller has white bony hands. And the boat is drifting away, soundless and black, disappearing in the distance.

He sees how the vision dissolves and vanishes. Everything around him is blown away in mist and unreality, and a voice is heard: "You have werewolf eyes . . . don't you have visions as well?

But then he is wide awake again. And soberly and with icy calm he remembers that afternoon a couple of months ago when Hilda left together with her mother. It was a grey, misty day. Hilda looked quite ordinary; there was no emotion to be seen in her face. She was bareheaded, walking with a pale headscarf over her arm, and when she had gone on board she waved to those who had come to the landing stage with her. And Josva, who was standing down there among some other young men, also received a little nod, friendly, but without any special significance. And the boat set off; Hilda put on her woollen scarf and looked like any other village girl going on a journey and just a little concerned at the thought of being seasick.

. . . The incessant rain streams down on windows and walls. But the wind is dropping. In the living room the clock strikes three. So the greater part of the night is yet to come.

The enforced indoor life during these days of storm devours the mind and makes sleep impossible.

Josva can't go back to sleep. He gets up and dresses. His oilskins are down in the boathouse; he puts them on and thus protected from the rain walks off along the shore. There is no break to be seen in the sky; there is black night everywhere.

The wind gradually drops, and the rain is less heavy. Josva sits down on a stone bench on the shore and feels crushed and overpowered by some indefinable and boundless sorrow. He sits there for a long time; he has as it were come to a standstill inside and is unable to think a single thought.

III

For some days, Landrus has excitedly been looking forward to Torkel Timm's visit. But Torkel does not hurry, whatever the reason might be.

The dark winter months are a dead time for trade. They eat into the stocks, but instead of money in the till, they provide figures on paper, long rows of figures that will only be turned into money some time in the summer when the fish has been dried and sold. Landrus takes great care to ensure that credit is kept within a reasonable limit; he only supplies things that are absolutely necessary and he does so to the accompaniment of admonishments and warnings. Some of those he employs to prepare his fish have already almost overdrawn their account . . . the main one is Redstones Ole, and it will soon be necessary to go and have a word with him. He is a difficult man and he has a difficult family to deal with. And there are the people from the River House. And then there is Torkel Timm himself; Landrus has been a little over-generous with him, and now he will have to hold back. It is considerably more difficult with Torkel and he must be treated with care, for he is a bit different from the others. His soul has a window into the future and into things that are hidden from Man.

But viewed as an ordinary mortal, Torkel is not much good. In many ways it's difficult to understand that the powers should have chosen him as their tool. Not only is he a drunkard when *that* comes over him, but he is also burdened with the vice of laziness. More than half of the wool with which Landrus had supplied him to spin and knit as far back as September is still lying untouched in the corner. People of Torkel's kind prefer to lie in bed and smoke instead of doing an honest day's work.

Landrus decides to go round and talk to Torkel about a couple of things.

Torkel is sitting by the fire, frying something in a frying pan and completely surrounded by the smell emanating from it.

Landrus tries a gentle reproach. "You're not doing much with the wool. I hope it's not lying about in the corner getting all moth-eaten."

Torkel scratches his beard: "No, I know, but I think better times are coming . . . I mean times with fewer complaints, you know."

"What complaints?" asks Landrus.

Torkel ignores his question and goes on as if lost in thought, "Aye, things have been bad recently, you see."

Landrus sits down ready to listen, but Torkel says no more. The expression on his face suggests to Landrus that it is all about something he cannot explain.

Landrus makes an impatient and impotent gesture with both hands.

"Yes, but you could surely knit those jerseys you've promised to knit for me," he says plaintively. "And . . . the dream, Torkel. Haven't you done anything about that either?"

Torkel puts more fat on the frying pan. He bends over towards Landrus and says in a low voice, suddenly opening his eyes wide, "I'll come round to you this evening . . . I've something important to tell you."

Landrus spends the rest of the day in a state of tense excitement. By the time Torkel comes in the evening, he is quite limp from agitation and expectation.

"Have you . . . have you had a visit from your prophet?" he whispers.

Torkel plays hard to get: "You mustn't question me, Landrus, you know that. It only makes it more difficult for me to talk to you."

"No, of course," says Landrus, compliant and polite.

Torkel looks tense. He says quickly, "You want to know your fate in the future, Landrus? You must walk round the church three times one night by moonlight . . . then you must stare at the moon, and your future will be revealed to you. But . . . it's not without danger, I'm telling you this before-hand, and now you do as you like. This is the message I've been given for you, and I can't explain any more."

"Does it matter what night it is?" asks Landrus.

"Yes . . . only when there's a clear moon," Torkel nods and puts his hand on the door handle.

"Well, how can it be dangerous?" Landrus persists.

"You'll discover that," replies Torkel, bowing his head. "Well, goodbye and good luck."

There is something about Torkel's words and the whole of his behaviour that makes Landrus suspicious. What is all this about forbidding him to ask any questions? And this about staring at the moon and its not being without its danger . . . it sounds like something Torkel himself might have thought up.

Landrus has a painful feeling that he has been made a fool of. He was not going to have any of this walking round the church and staring at the moon while Torkel was perhaps sitting at his window laughing at him. And besides . . . Landrus had never actually wanted to see his entire future all at one go. He had wanted an interpretation of his dream, no more. And in addition . . . if it was as dangerous as Torkel said, it was also his duty to give him a hint of what the danger was.

But suppose it was all a lie, and that's what it probably was. Here he was letting himself be made into a source of amusement for lazy, cunning rascals.

Landrus began to feel furious. "I'm too kind," he thought to himself, "ridiculously kind, looking after the worst rabble in the village until I get what's coming to me."

He had to go outside to get some fresh air and cool his anger. Should he go straight over to Torkel and give him a well-deserved ticking off? He was itching to wipe the floor with the cunning wretch. But . . . no, Landrus couldn't bring himself to set foot over his threshold after all. He would instead go up to Redstones this evening and teach Ole and his family a lesson they needed.

The family at Redstones had just finished their supper. There was not much on the table, a little bread and dried fish. But on the wall above the kitchen table there was a paraffin lamp turned right up . . . It did not look as though they were doing much to economise after all. And Ole was lighting his pipe; he smoked all the time did Ole. Landrus always limited himself to smoking within reason.

"Nice light in here," he remarked, nodding towards the lamp.

Ole looked scared and put his pipe down.

"No, just you go on smoking," said Landrus. "You'll pick your pipe up when I've gone in any case. Tobacco . . . it's both food and drink, it's so nourishing and it's not to be done without, is it?"

"I don't smoke all that much," objected Ole, scratching his thin nose.

Landrus went on scornfully: "And what about the two lads, Ansgar and Jeser . . . I suppose it's you who've taught them to smoke, too? Everyone in the village knows how they lie down by the shore smoking like chimneys . . ."

"Ansgar and Jeser?" says Ole at a loss for words.

"Yes, isn't it dreadful," his wife interrupted in a plaintive voice. "I've preached to them and threatened them, but they're so stubborn they don't take any notice of what their mother says to them . . . and as for their father, they don't take any more notice of him, more's the pity. And just imagine, they got hold of the tea caddy the other day and were going to put tea in their pipes . . . Have you ever heard the like?"

"How old are the lads?" asked Landrus. He turned towards the boys, who were sitting there, staring at the floor. "How old are you, you two rascals?"

"Ten," whined Jeser pressing back against the wall.

"And you?" asked Landrus.

Ansgar sat up straight and adopted a stubborn look.

"Aren't you going to answer?" laughed Landrus ominously.

"Answer, child," said his worried mother.

Ansgar kept his mouth tight shut.

"He'll soon be fourteen," explained his mother.

"And the pipes?" Landrus went on. "Where did they get them from? I've not seen any sign of them on your account. Answer me, boy: Where did you get the pipes? Let me see them."

Jeser started to cry.

"Out with those pipes," thundered Landrus.

"Well, let Landrus see your pipes," their mother implored.

Jeser fumbled under his jersey and took out a pipe. It was a funny, homemade pipe consisting of a hollowed cork with a goose quill stuck in it.

"And yours?" Landrus went closer to Ansgar with a threatening look on his face. "Come on. Out with it."

But Ansgar did not stir. He stared straight up in the air, pale and with a hard look on his freckled face.

"All right, as you like, nodded Landrus. "I won't forget this."

He turned back to Ole. "I must say, you give your children a fine upbringing. You ought to be thoroughly ashamed. And . . . how many of these sweet little infants have you got really? It can't be under ten. You really are a sensible chap, Ole, bringing so many children into the world, a man like you who can so well afford such things. Couldn't you have been satisfied with a few less? But that's how it always is, the poorest and most wretched people, the ones who can't even provide for a wife . . ."

Ole sat rocking to and fro and rubbing his eyes and trying to smile: "As for that . . . the children – they don't really come unless it's God's will . . ."

"Aye, it's like you to give God the blame," said Landrus. "Surely we're all responsible for the children we have. You ought to have prayed to God, you ungrateful wretch, and pulled yourself together before it was too late."

He looked round the room and caught sight of Inga, who was sitting in a corner darning a jersey.

"And There are obviously more on the way," he went on. "It looks as if you can't get enough. The offspring start out where the parents left off! Aye, what a charming way to live."

Inga bent her head and held the jersey up to her face.

"Yes, the poor girl," the mother interrupted, weeping. "She . . . she . . ."

"Perhaps she blames God as well," snorted Landrus.

Ole sighed and winced plaintively, "Yes, I know. It's terrible, we know that . . . Poverty and shame often go together, Landrus, that's a sad truth."

"Poverty and . . . a filthy conscience," Landrus corrected

him. "But I suppose you don't really need to care. It's worse for the one that has to carry the whole load, the one who has to feed all these ungrateful mouths. If you got what you deserve, you'd be left to your own devices, and then how would things look?"

"No, I know," admitted Ole contritely. "We've got a lot to thank you for, Landrus, and we'll do what we can . . ."

"Well, don't go feeling too safe," said Landrus as he turned away. "One day I'll say stop. Understand?"

He opened the door, but turned around once more and glared at the lamp: "For heavens sake turn that lamp down. What do you need all that light for? Other people sleep in the evening, but you just sit and bathe yourselves in light . . . with other people's money."

Ole got up and showed Landrus out. They stood outside for a moment exchanging a few more words. His wife went across and turned the light down.

"You should be ashamed of yourself, Ansgar," she wept. "It was your fault he got so mad."

Ansgar made no reply. He took his jersey off and swung himself up into his alcove. Soon afterwards, Jeser crept up after him; he was still trembling with fear.

. . . Landrus goes past the River House on his way home. He is glad that he gave Redstones Ole a ticking off. If he did the right thing he would go in to see the River House folk now while he was in the mood. They could do with a bit of a reminder.

There was a light in the window, but the door is closed. Landrus knocks, three heavy thuds. The door is opened cautiously . . . Landrus flings it wide open and walks in.

It is Judika who has opened the door. She backs in fright: "Jesus, but you scared me, Landrus."

"Good evening, Elias," says Landrus, going over to the bed where the owner of the River House is lying staring with great, uneasy eyes. "Well, how are you?"

"Oh, I mustn't complain," says Elias. "As long as it doesn't get any worse I must be grateful."

Elias speaks in a deep, resonant voice . . . a voice that sounds

like that of a healthy man. And neither does he look like a weakling as he lies there in an abundance of curly fair hair and beard. Landrus remembers what Doctor Bonæs once said about Elias's illness perhaps being some kind of imagination.

"Do you never . . . well, try to get up a bit, Elias?" he asks, making encouraging gestures. "You know, trying to pull yourself together?"

Elias has to smile: "What would be the good of me trying?"

"Just have a go now and then," Landrus continues. "Then you'd gradually get your limbs used to it. You'd so to say make them respect you more. It's just a matter of willpower. Willpower!"

He bends his arms and clenches his fists making them tremble: "Like that. Understand? Force them. Say: I *must* get well. I *will* not lie here any longer and be a burden on other people; I'm too good for that."

Looking round the living room, he says, "But you haven't got enough willpower, Elias, that's the sad thing about it. You might well think you're all right – you're far too grateful for having been able to keep a healthy body. In which case you don't need to do anything, that's one advantage. And you've got a good appetite . . . you like good things, I believe. Or are the sardines in olive oil that your wife buys not for you?"

"Sardines in olive oil?" asks Elias. "What on earth are you talking about?"

"Sardines in olive oil?" echoes Elias's wife, Oline, sitting awkwardly and humbly on the edge of the foot of the bed.

"Well, there are a couple of tins of sardines in olive oil on your account," explains Landrus.

Oline turns towards Judika, who is sitting over by the table in the midst of a group of siblings and with a younger brother on her lap.

"Is it you who has been buying these things in olive oil, Judika?"

Judika shakes her head.

The mother gets up: "Is it you, Hans?"

"No."

"Is it you, Emanuel?"

257

"No."

She turns to the old grandmother, who is sitting knitting by the window. "Well, it's not you, mother, is it?"

"Sweet Jesus, no," the old woman shakes her head vigorously.

"Well, then it's none of us," says Oline resignedly.

Landrus looks up. "What do you mean by that? Are you saying you've not bought those tins of sardines? Eh? All right, out with it. Do you think I'm trying to cheat you?"

"God help me," whispers Oline. "I've never thought that."

"I've never heard anything like this," laughs Landrus. "So I suppose you're going to deny getting other things on credit, eh? Deny the whole lot . . . you perhaps think you can get away with that. But you're mistaken. I've got it in black and white."

Fuming, he goes over to the door. "Disgusting. So that's what you'll do. You take so much on credit that your account almost fills the book, and then you deny you've had anything. And there you lie, Elias, and don't even care that you can't get up. Disgusting, I say."

"Don't I care?" Elias tries to object.

But Landrus interrupts him: "Denying having any sardines! That's about the worst thing I've ever come across in my life. Gregoria knows who bought those sardines. I'll get at the truth."

"He flings the door open and mumbles as he goes out into the dark, "But I'll remember you. You'll find out who it is you're trying to cheat, I'll make sure of that."

. . . Ansgar lies chewing his fingers. He can't go to asleep . . . Landrus's voice keeps ringing in his ears. The lamp is extinguished. He hears his parents lying there whispering to each other. His mother is weeping and sighing, "Oh, my God and Saviour . . . he surely doesn't mean it as bad as that. It's his habit to use strong language."

Jeser has fallen asleep. He lies there clinging on to his brother. Ansgar feels a damp patch from tears on his back. Night comes; the darkness is filled with slumber and breath-

ing. But Ansgar remains awake. He regrets not taking the lamp and throwing it in Landrus's face so he could have oil all over his beard and burn it off . . . that's the sort of treatment he deserves.

Now there is a slight movement over in the corner, where Inga is lying. He hears her get up and put her feet down on the floor. Before long she tiptoes over to the door. Ansgar raises his head and listens. She opens the door quietly and slips out.

Ansgar cautiously frees himself from Jeser's arm and creeps out of the alcove. It is pitch dark. He opens the door . . . the wind is blowing, and it is cold. The sky is closed like a clam, and there is not a star to be seen. Bit by bit, his eyes grow accustomed to the dark; he can see the road and the outline of the cove and the mountains.

Where can Inga have gone? He feels anxious. What is she playing at, going out into the night like this?

"Inga," he whispers out into the darkness.

And suddenly he is overcome by a great fear.

"Inga," he whispers again.

No reply. He thinks for a moment It is not easy to know what direction she has taken. Should he go in and wake his father? He thinks he can hear footsteps down on the road and hurries in the direction of the sound. "Inga," he shouts.

Now he catches sight of his sister. She is walking slowly and calmly down on the road with her head bent like a sleepwalker.

"Inga," he said. "Where are you going? It's the middle of the night. Are you mad?"

He grasps her arm. She stops and sways.

"What on earth's wrong with you?" he asks in his confusion.

"Nothing," she says, but at that moment collapses and falls over backwards. He just manages to save her falling with his arms and knees.

"Leave me alone," groans Inga.

He pulls her across to the edge of the road so she at least doesn't have to lie down in all the mud.

"You're crazy," he grumbles. "Now, up you get again, you can't stay here."

"No," says Inga. She gets up with difficulty. He puts his arm around her and seeks to help her.

"Oh no," his sister complains. "I can manage. Come on, just let me hold on to you a bit and I'll be all right."

She places an icily cold, wet arm round his neck . . .he has to make a great effort to hold her up. But they go home, step by step. Ansgar opens the door carefully and gets his sister back to bed.

Their mother wakes up: "What is it Ansgar? Are you getting up already?"

"I've been out feeding the ram," replies Ansgar. "It was making such a din in the stall."

He creeps down into the alcove again. Soon all is quiet. But he can't fall asleep. He lies thinking about Landrus . . . if only he could one day get the chance to get his own back on him. He remembers a time when a bull from the farm was to be sent to Kirkevaag. It was led down to the beach and forced out into the water . . . it had to swim out to the boat while some men sat in a dinghy holding its head above water. It was a big, vicious bull, but it was thoroughly tamed by this process, groaning and puffing as though asking for mercy. He would like to give Landrus a going over like that . . .

IV

The mail boat came to Trymø the next day.

Landrus went on board together with Jakob the Granary to fetch the post and a consignment of goods.

"It's a long time since you bothered coming out here," he said, looking reproachfully at the captain. "It's not good enough neglecting us for weeks on end like this. There's not a lump of sugar nor a coffee bean left on the island."

"Well, it's a miserable island to live on," replied the captain, winking to the engineer. "A really lousy island."

"Hey, watch what you're saying," replied Landrus

threatening him with a clenched fist. "I'll complain about you to the post office, you'll see if I don't. We can't have a man who's afraid of a bit of snow. The man who did the job before you, Sivert, was a different type. He hardly ever let us down even though he had to manage with no more than a sail and some oars."

"If I was you, I'd still get away from the island," the skipper answered unruffled. "'Cause this is not a place fit for human beings to live. Good God, there are almost twenty better islands to choose from, so why the devil do you have to hang on to the smallest and worst of them?"

He added with a grin, "You get to feel so little and spiteful when you live on a little island like this, let me tell you, Landrus."

"It's not the smallest island," growled Landrus. "It's the fifth smallest. And as for that, there's no more awful place in the country than Storefjord, where you come from . . . It's always raining, and it's full of confessionists."

He went on grumbling and complaining while helping Jakob the Granary to pile the bags of sugar on his back. "A lot of yellow bellies you are, I'm ashamed on behalf of the post office . . . a big, strong boat and you have to stay at home as soon as there's a bit of a breeze."

Apart from the goods for Landrus, there was a box and two parcels for Balduin, the teacher. He came on board personally to fetch them. Lars Dion stood at his window, watching his son. What could these secret consignments be? They could hardly all be books, especially when there was the obvious sound of liquid in the boxes.

Lars Dion had spent sleepless nights wondering what Balduin was hiding in the little closet in the school loft. He had guessed at all kinds of strange things. Could it be that his son was threatened by some kind of disease and had to take medicine to stop it developing? That kind of thing was not unknown. In addition, it was striking how little Balduin ate; he had a poor appetite and simply fiddled with his food and could not get it down.

Lars Dion actually intended going to Holmvige on the

boat himself today. He wanted to talk to Sylverius. He wanted to suggest to him that they should together set up a branch of Sylverius's store on Trymø. He would provide the premises and undertake to sell the goods, and Sylverius should keep the shop supplied.

It wouldn't be too difficult to set up the shop. It only meant removing the partition wall between the two living rooms and making a counter and some shelves with the timber from it. If Sylverius weren't interested in his plan, he would try on his own. Balduin would have to provide the working capital. He had a good salary as a teacher and no one else to support apart from his old parents.

Starting a shop was originally Egon's idea, and it was because of this that he had applied for the job as Sylverius's shop assistant. But now things had taken a different and quite unexpected turn with him. The letters he had recently sent to his parents were both to laugh and weep at and be furious over . . . He was on the way to being even crazier than his brother.

Aye, they were a curious couple of sons. They were by no means unintelligent, but they were interested in everything except reality. He could understand Egon at a pinch; he had come under the influence of the Storefjord mission; the preacher had completely turned the poor lad's head. But that was happening to a lot of people at the moment. Balduin, on the other hand was neither a member of the mission nor an Adventist. He was not easy to come to grips with because he gave no indication of what mad ideas he was hatching.

Otherwise, Balduin didn't keep himself to himself. He went about and talked to people in his gentle, thoughtful way. And he was fundamentally well liked everywhere, although most people found him a little strange. He would often ask the most amazing questions. Nor was it easy to explain how he could have long conversations with Jakob the Granary or Torkel Timm, men whom people in general only smiled at.

Balduin could often be seen in the mountains on his way to or from Nordvig, where there were also some children to be taught. But he rarely followed the path. Especially when the

weather was good, he could be met in the strangest places in the outfield. People out fetching peat had seen him sitting up on steep rock faces, right at the edge, sometimes with a book in his hand.

One Sunday afternoon, when Josva had gone for a walk up in the mountains without any definite object in mind, he saw someone lying stretched out on the ground down in Weaver's Valley, near the great stone. It was Balduin. He had a handkerchief pressed to his face. Josva thought he had had an accident and with a beating heart he ran down the slope.

"No, there's nothing wrong with me," Balduin shook his head and smiled. "I've just had a slight nosebleed . . . it happens sometimes. But I think it's stopped now."

He cautiously removed the handkerchief, but it had not stopped. Blood was pouring from his nose.

"I could fetch a little water in my cap," said Josva. "It might cool you down a bit . . ."

He fetched some water, and Balduin dipped his hand-kerchief in it.

"Thank you, that's nice and cool," he said. "But this just has to take its time."

The bleeding finally stopped. Balduin got up cautiously.

"Well, we've all got something to put up with," he said, half in jest. And in the same jovial tone, he added, "I'd actually come up here to get closer to heaven. It's such a beautiful day . . . just like on the moon."

Unaccustomed to that kind of talk, Josva felt slightly embarrassed. Simply in order to say something, he commented, "Aye, it must be beautiful up there."

"Yes, don't you think so?" Balduin went on. "To walk around on your own, completely free of all earthly ties. A wonderful life."

"Yes, but . . . don't you think it would be very cold?" Josva asked hesitantly.

"Of course," Balduin laughed to himself. "Nothing can live up there on the moon. There's not a blade of grass, you know. No moss. Not even the tiniest bit of lichen."

They started moving back towards the village.

Balduin went on: "So the Earth's preferable if you want to live. Although . . . earthly life has some pretty awful aspects to it, and you can sometimes wish you were on the moon."

He nodded thoughtfully.

"Don't you think . . . I can sometimes get quite worked up about it. Here we human beings go taking ourselves and life seriously. And we want it to take us seriously, too. And then even so it often looks as though we're having the wool pulled delightfully over our eyes. And we aren't quite in the mood to find that amusing. No, we are shaken to our foundations, that's all . . ."

Josva failed to understand what he meant. There were strange words.

Balduin went on, virtually talking to himself, "And if only that could make us better, I mean the fact that we are shaken. But, if possible, it simply makes us worse because it makes us suspicious of everything . . ."

Balduin's expression became serious. His high forehead and projecting lower lip gave him a severe look. He looked like a priest standing and thinking while delivering a sermon.

But suddenly he stopped: "Oh, but that probably doesn't interest you, Josva. I'm talking rubbish. You're a living being; you don't just stand still and consider the world and yourself. You are pure youth and activity . . . there's nothing eating at your mind, no secret burden."

"Secret burden!" Josva tightened his mouth and felt a cold shiver down his spine. But he had no desire to talk to Balduin about his own problems. Perhaps, had they been of an age. But the teacher was a man of over thirty, well read and full of knowledge and authority. And yet . . . his ability didn't make him arrogant; there was something open about him, something that inspired confidence, something almost comradely in his manner.

"Well, I don't really know," Josva hesitated and started to blush. "I don't think there's anyone at all who doesn't have some kind of secret burden . . ."

Balduin looked at him inquisitively. Josva's face was uneasy and emotional, at once childlike and brooding. His eyes were

a little torpid beneath the joined eyebrows, but this was obviously not the result of lethargy or emptiness.

And once more Balduin surrenders to his speculations and is carried away: "Yes, life's a strange thing when you start to think about it. There's not a blade of grass on your path, not a speck of dust on your shoe that shouldn't awaken your sense of wonderment once you notice it. A drop of water is a world inhabited by millions of living beings. Every star in the sky, even if it's as tiny as the point of a needle, is a sun so vast that it makes the mind boggle . . ." Josva listens to this crazy talk and is filled with confusion. It strikes him that Balduin is perhaps just a little mad.

Evening is approaching. The air is filled with calm and a frosty haze. There is a gentle, melancholy silver sheen over the mountains. They are approaching the village.

"And as for people," Balduin goes on, "they congregate in villages and towns; they can't do without each other and yet they can't refrain from waging war and hating each other. Even here on our little island. They go to church and profess the doctrine of love for their neighbour, but who lives according to that doctrine? Not one of them. They live in two worlds, a Sunday world and an everyday world, and if someone or other tries to reconcile these two worlds to each other . . . he immediately gets himself bogged down in self-contradictions. But there is a superior wisdom . . . it stands like a mountain above human life, and when you climb that mountain you see how all things are related to each other."

Josva listens and feels as though he is in church or at some religious convention. His Adventist Aunt Oluva at home can go on talking like this when the spirit takes her. And then it ends in prayers, invocations and hymns. But Balduin doesn't otherwise seem to belong to any religious movement; that's the strange thing about it. He is rather against that sort of thing. He is simply beyond understanding.

"This mountain of wisdom," he goes on. "The only trouble is that it is so difficult to climb. It takes not only a single life but many lives. I myself have only recently begun slowly to understand this."

Balduin looks at Josva with a little smile: "Yes, that's the sort of thing I go tormenting myself with. By the way . . . do you like reading books, Josva?"

"I hardly know any books," says Josva and does not really know what to answer. He has never bothered very much with reading. All they have at home is a book of homilies, the hymnbook and Oluva's Adventist tracts.

"Come up to my room," suggests Balduin.

They stop outside the school. Josva feels quite solemn. Balduin takes out a key, opens the door and strikes a match. There is a clean, newly washed smell in here. The floor and walls are scrubbed white. They go up a narrow staircase and enter Balduin's room. He lights the lamp. Bookshelves and pictures . . . a long row of pictures has been fixed to the sloping wall, all round the room, all of them serious faces.

Balduin disappears for a moment and then comes back with some kindling. Before long the little stove is crackling and sending up smoke. Josva has a feeling of being in some foreign place, far away from the island, in some village or big city.

"We were talking about the moon before," says Balduin. "Let me show you a map of the moon."

He takes a book out and leafs through it and explains. "The moon is a kind of round sphere floating in space like the Earth and it has day and night. But it's dead. It is a silent, ossified land of death. A land of the dead. And there are other planets floating in space, hundreds of times bigger than both the moon and the Earth, which are also dead. Just imagine . . . worlds that are many times as big as the whole of the Earth, with mountains and plains, clouds and seas, but dead . . . not a worm in the ground, not a mussel on the shore."

Balduin turns over more pages and continues: "But then here's a world that is not so far away from us, a planet called Mars . . . They think it might also be inhabited. See here, they've dug canals and built towns up there. But it's a dying world, a sick world that will soon be extinct. The living creatures up there fight a heroic but hopeless battle against cold and drought."

Balduin draws the curtain aside and looks out of the window: "I wonder whether we can't see that planet from here. Yes, there it is."

He points to a big reddish star up above the island of Husø. Josva senses a slight shudder.

"Yes, but it shines as though it was pure fire," he protests.

"It's only reflected light from the sun," Balduin explains seriously. "It throws the sunshine back like a mirror."

And Balduin loses himself in strange, dark thoughts. "Earth will also die one day. In millions of years. And the sun will be extinguished. Everything will die and turn into darkness . . . only the human soul is immortal. It will only come to the end of its long journey when it has climbed the great mountain I spoke of before. But alas, when shall we progress so far, poor, benighted, abased creatures that we are?"

Josva thinks to himself, "So he's some sort of sectarian after all."

Balduin sits staring ahead with kind, thoughtful eyes.

"Ah well," he says, straightening up. "It's no good speculating on such matters all the time. We've got to stop some time and think of other things."

"I say, by the way, what about a little glass of gin?" he asks suddenly.

"Yes please," replies Josva in surprise. He feels quite confused at this unexpected suggestion and cannot refrain from smiling.

Balduin disappears and returns with a tall yellowish brown bottle of Dutch gin. He has the same preoccupied look on his face and appears to be far away in his thoughts while he fills the glasses.

"Cheers," he says and looks at Josva with an infinitely sad smile.

Josva swallows the yellow liquid. He is reminded of the wedding last spring . . . the mist, the scent of wet hedgerows, Hilda. And his soul contracts.

"Are you hungry?" asks Balduin. And without waiting for an answer, he goes and fetches a loaf and various kinds of food.

"We must have something to give us strength," he smiles and looks appreciatively at the food. He adds as an explanation, "I prepare a lot of my food myself, because then I'm less tied . . ."

The food Balduin produces is good, real town food. Josva cannot hide his amazement. Does Balduin really live like this every day? A meal like this would be thought of as sheer gluttony at home.

Balduin fills the glasses. They eat in silence and their cheeks become flushed. The lamp gives a strong, festive light, which is thrown back harshly from the scrubbed sloping walls; it is quite unusually light in here. And outside there is a starry, cold evening and the dark village. And space and dead worlds.

Balduin puts a kettle on the roaring stove. Josva has to laugh to himself at this lovely, secret feast on an ordinary Sunday evening.

Balduin nods, "Eat and drink. It does you good occasionally to get out of your normal habits. Mankind has always had this urge to celebrate. If we didn't have these simple good things, we'd feel twice as oppressed."

. . . After the meal, they took out their pipes. Josva was full of admiration and liking for Balduin, and he felt the urge to confide in him. It would all have to come out, and he would hide nothing . . . all those lonely thoughts, the werewolf thoughts would all be revealed.

But he could not get them out. They tore at his soul every time he made to grasp his secrets. He could not get Hilda's name over his lips. He got no further than vague hints. But Balduin listens and nods and needs only quite a small amount before he understands.

"Believe me, I know it," he says, and his voice breaks. "It's what you call unhappy love."

There follows a pause. They both sit staring out into the smoke-filled air. Balduin fills the glasses and rocks his chair backwards and forwards uneasily. He, too, has something in his heart that it is difficult to tell.

But it emerges nevertheless, first in scattered thoughts and then in a dull and smothered confession. He has an expression

in his eyes like that of an old man looking back on his youth. He, too, knows love. Aye, things can take a strange turn. Woman . . . She is an entire world on her own, difficult to comprehend. The principle's daughter from the teacher training college in Østervaag . . . he had been in love with her and written letters to her. And she written long letters in reply. He had kept these letters because they were so wise and beautiful. But they never spoke to each other, he and she; things never got that far before it was too late. One day she had gone abroad. He obtained her address and wrote to her, and they continued writing to each other for six months or so. Then she came back home. But by then she was engaged and had her fiancé with her.

Balduin gave a hollow laugh.

"Just imagine, she had her fiancé with her. And silly fool that I was, I was expected to act as though nothing had happened. But I was in love with her, and one evening I went to see her and acted like a complete idiot. I was quite beside myself and reproached her for having made me unhappy for the rest of my life and so on. And that's when she said to me, 'It's not your outer self, but your inner self I have been fond of Balduin, for you have a great soul.' And there I stood with my tears and my great soul. And shortly after that she was married. And now she's recently had twins."

Balduin laughed again, but immediately became serious: "It might sound foolish, but I ask myself now who got the better bargain after all, I, who loved her soul to soul, or the other one . . . the twins' father."

He straightened his back and looked along the row of portraits on the wall: "Aye, life's often ridiculous, and yet it's sad and serious enough. But others have lived great and beautiful lives Why shouldn't we try as well?"

He pointed to one of the pictures in the row: "This one was called Heinrich Heine, and he was also deeply and unhappily in love . . ."

Balduin filled the glasses again and went on in a quiet, intimate voice, "But you see, there *is* the other sort of love, spiritual love, and that's the real thing. I've felt that since. This

shock to the soul, without any sign of physical desire. It's something infinitely finer than the coarse bestiality that most people are content with."

Balduin closes his eyes and repeats: "I've felt it since, this indescribable trembling."

And he goes on to tell about poor Jane, of his meeting her again this summer and the strange feelings that possessed him on that occasion. It was pity, indescribable pity with the mortally sick girl. But then this feeling grew and became something more than pity; it turned into a profound infatuation with her. Or whatever it was to be called, for he could hardly explain it. It was rather a love of a pure spiritual sort, strangely all-embracing for in a way it was suffering humanity itself he loved in the shape of this sick person. It was very strange.

He stroked his forehead and shook his head.

"Well . . . can one explain that kind of thing? I've thought a lot about it and I've recently found a kind of explanation . . .you see it's the Logos principle, or the Christ principle as it's also called; it's that principle that has come to life in me."

Josva listened open-mouthed to Balduin's strange words. And through the warmth of intoxication he felt a tiny, insidious shiver of cold. It was as though he was standing out on the farthest edge of a promontory, looking down into the depths, the cold and solemn world of the blue-green breakers.

"Oh, I think it's getting late," he said and got up.

Balduin sat him down again.

"Tonight's a wake, as the ballad has it," he said, raising his glass. "Cheers."

And he started to hum the ballad on young Signelil who steals away to the dance:

> A wake it is this night tonight
> – Bow down my love –
> And many there come to the dance so bright
> And so to the dance I long to go
> With young Lord Eric

Josva joins in. They sing the sad ballad to the end. And now Josva takes up the ballad of Jon Rimaardsøn. They sit each on their own chair rocking to and fro and moving their shoulders up and down in an imaginary dance, their eyes hazy and transported by the words of the ballad.

It is difficult to stop again now. Balduin wants to hear the Ballad of Benedict. Josva closes his eyes to remember, and the array of verses passes before him, slowly and sadly. And while he sings, he sees in his inner eye as it were a vast chain of dancing people. And there Hilda dances past him with her pale face. And Daniel is dancing in another place, even paler and with sand and seaweed in his wet hair. And ever new faces come into sight, pale, young faces, and the chain twists in and out between hills and mountains, and there is no end to it.

V

Magdalena, the teacher's widow, awakens one dark morning shivering with cold. She is kneeling by her daughter's bed and holding her hand in her own. She has wakened like this a few times before during the night, and she has felt the hand to be warm and living, and then she has again succumbed to her weariness. But now this hand is cold, icily, helplessly cold. And here she has sat and slept.

The lamp has burned out. She gets up; her teeth are chattering; it goes black before her eyes; she has to bend down again to return completely to consciousness, struggling with the darkness for a fearful, agonising moment. But then it is past. She pulls herself together and manages to light a candle. That thing that had to happen has happened. Jane has gone, to her father and brother. God has willed it thus.

Magdalena nods slowly in calm recognition. She has had time to come to terms with this, and it comes as no surprise. She knows that the girl died happy, in the gentle expectation of waking up in a new world and with fresh strength.

And Magdalena herself has become familiar with a human being's lot in this life. She has experienced happiness and then

sorrow, and now loneliness is all that is left. She will surely come through that, too, she simply prays that the wait may not be long.

Morning slowly dawns. The night has left a little snow on the mountains, but it is otherwise clammy weather with low clouds and a westerly wind. Oh yes, the world is itself; life is immutable; only people change, are born, grow, smile and weep for a time and then gradually become small again, small and helpless when their course draws to an end and death comes.

. . . Everyone has known that Jane could not live long. And yet the news of her death spreads through the village and paralyses it. Adults and children all bow their heads, all talk is subdued, all work slows down. A human being is no more! And in this case a special awfulness is linked to it: Jane is the third corpse to be carried out of the teacher's home, the third in only two years. It is more than death, it is annihilation. And people know of cases in which bigger families than the teacher's have been annihilated within a few years. And the old people can tell of times when Death's harvest was even more terrible, when epidemics throughout the country destroyed entire villages. You can't imagine it . . . hearts contract in fear and pity.

. . . Balduin stood by Jane's bed for the last time. She was not much changed; it almost looked as though she was just asleep and far away in a dream. Her dark eyebrows drew their elegant curves. But the small, closed mouth had a despondent expression that sent a shock of pain through him.

Magdalena was standing with a book under her arm.

"See, this illustrated Bible that you gave her; she was particularly fond of it. And there was especially one picture she never tired of looking at."

Magdalena leafed through the book and found the picture.

"Yes, here it is . . . it shows Paradise. Jane often dreamt of this picture. And on one of the last days when she lay looking at it, she said that it reminded her of the day of Simona's wedding. She lay here and heard the singing from the church, and it was a day of such lovely sunshine."

Balduin noticed the picture, the Adoration of the Lamb. Hubert and Jan van Eyck c. 1400 it said beneath it. A strange picture. And yet . . . he suddenly understood why Jane had been fond of this picture: there was something so homely and summery about it. Except that all these homely things appeared in a transfigured and elevated form . . . the flowering meadow was more luxuriant, the common sorrel and angelica bushes bore beautiful flowers, the domed hills of the outfield had been replaced with forest; the mountain slopes in the background had dissolved into the magnificent pinnacles of temples. And the people moving there were dressed in royal crowns and costly garments. A radiant bird sang up in the air and filled the entire landscape with song, with the clear, summery song of the curlew and the Lamb in the midst of the picture . . . it was just like one of the light and innocent sheep that used to graze on the infield in the spring months. It was all neat and tidy, freshly ironed and untouched like some costume reserved for a special occasion. This was just how a young and undefiled girl's soul would imagine Paradise.

"Yes, and then there's something I would like to ask you," said Magdalena. "But it's probably asking too much, for it's an expensive book. But I would so much like to let it go into the grave with her . . ."

Balduin nodded. He was unable to speak for emotion. He bent down and caressed the hands of the dead girl. How thin and cold they were, these poor hands.

. . . Balduin goes about for the rest of the day in a stupor. When twilight comes, he lights the lamp and takes "The Ocean of Theosophy" from the shelf and settles down to really engross himself in this comforting work. But then he is disturbed by the barking of a dog . . . a low, distressed bark, almost a sob, that gradually changes into a hollow howl. He looks out of the window and catches sight of the dog . . . it is standing outside the teacher's house.

Balduin gets up, tired and despondent. The dog's howling goes right through him. What could it be that makes such an animal howl? Memories of a previous existence? A previous higher existence perhaps . . .

Harald comes and calls the dog. It stops howling and lies down at his feet with its head buried in its front paws. He pats it gently, takes it by the scruff of its neck and drags it along home.

Balduin makes a fresh attempt to concentrate on his reading. But he keeps hearing the dog's howling. And suddenly a chasm of dread opens in his mind . . . dread of *Karma*, the implacable law of causation that has forced all living things to accept its rule and made its stern and cold demand on them.

THE DREAMER

I

Josva stands up on Spirit Hill battling with a huge boulder that must be cleared. It is a stubborn and obstinate beast. He has been on the point of giving it up as hopeless. But now he has got so far with it that he is able to rock it with the help of a lever. He sits down for a moment to gather his strength. Sweat is pouring from him and there is not a dry stitch on his body; steam is rising from his jersey and swollen hands. He sits and looks at the boulder, furious and vengeful. He has spent a whole day battling with this troll. But now he has it in his power . . . In a few moments he will have forced it to do as he wants. Using his pickaxe, he has chopped away the ground on which it has been standing, and now all that is left is to have a final go at it and get it tipped down the slope, down to the other stones in the crevasse.

It is growing dusk. The stars are emerging in the greenish sky. Josva gets up again. He exerts all his force on the lever . . . and he manages to force the boulder a little bit out of the slope, but then it falls back into place with a stubborn grunt, and he is not far from getting his foot trapped. He lies down on his back and with all his strength pushes his feet against the stone; he is filled with implacable hatred of it and a blood-thirsty desire to get rid of it. And now the brute finally yields and moves. It performs a few hesitant, reluctant somersaults and then goes off with the heavy, crushing tread of a troll, down the hillside, hissing and coughing fire and smoke until with a piteous crash it ends in the crevasse among the other vanquished stone trolls that have been exiled down there.

Josva throws himself to the ground in exhaustion. The din echoes in his ears for a long time and is finally lost in a distant ringing. The lever had been lost in the process, slipping in

beneath the overturning stone and cracking. There it lies now, broken in two, dead on the field of battle like a brave warrior.

So now he will have to get himself a new lever.

Josva lies staring up at the vaulted evening sky. The stars are twinkling and changing colour up there, moving slowly, slowly. They are infinitely far away and there are infinitely many of them.

Pity about that lever, though . . . It has been a loyal helper. He must have a new one. Supposing he went to Østervaag and bought one. That would be an outing.

The stars continue to increase in numbers. He pictures them even when he closes his eyes. They are shining on all the world's extensive gardens. And now it is as though he were standing in the prow of a smoothly sailing ship. The darkening night water foams at the bow. Silent streams of stars move across the heavens. There is no world any longer, only this endless ocean of stars and this blissful voyage through them. And it is not water he is crossing, but the clear air. Far below, as though at the bottom of a well, lies the earth, dark and cold . . . an assemblage of houses around a cove. Beneath the wind-swept turf roofs human beings lie sleeping, and the dead lie beneath the mounds in the churchyard. And now he is descending . . . he will soon be down there himself. Black clouds glide forth and hide the stars from him, and a cold, damp wind is blowing.

Josva gets up and walks towards home. Yes, he will go to Østervaag. He feels exhilarated at the thought. Perhaps he will go on, perhaps never come back . . .

At all events he will think of an errand in Østervaag. He has a shotgun that has long needed to be repaired. It is useless as it is now. Admittedly, his brother has said he can use his, but there are some other little things that he might as well attend to at the same time. And the mail boat comes tomorrow. It couldn't be better.

His father is having supper in the kitchen at home.

"I've been wondering if it wouldn't be a good thing to go to Østervaag tomorrow," says Josva. "There are a few things I ought to see to."

Yes, Kristoffer also thinks that doesn't sound like a bad idea. "And you can take my watch to the watchmaker; it needs cleaning – it's losing almost five minutes a day."

Oluva, too, has a watch that needs repairing, and there are various other things she would like to ask him to do.

"But make sure you take the watches to Enoksen," she instructs him. "He's the best watchmaker in Østervaag, and he's such a nice, kind person as well."

She places the steaming teacups on the table and cuts a few slices of bread for Josva.

"You don't need to be frightened of having a chat with Enoksen," she goes on. "He's both wise and amusing, and you can learn a lot from him . . ."

"And then you might ask about the prices of oilskins, because I think that Landrus is a bit on the expensive side. And in any case it would be nice to know what you have to give for that sort of thing elsewhere. And then enquire about the price of fishing lines and string. And powder and shot."

"And see if you can find some cheap grey cloth and buy three metres for me," says Oluva. "And go to the bookshop and buy a roll of the sort of shelving paper used on larder shelves; it looks so nice and it doesn't cost much."

"And see if you can get hold of some good cheap tobacco," adds Kristoffer.

Josva nods and promises to remember it all.

"And give our love to the boys," says Kristoffer. "And ask if they're coming home for Christmas. And then you ought to go and see poor Hilda; I don't think it's much fun for her being out there in the sanatorium."

II

Josva wakes to the sound of his father moving about in the kitchen. The weather is good, and the old man is going fishing. Josva gets up and goes with his father down to the landing stage, where young Martin and Redstones Ole's brother, Simon Peter, are waiting. He feels heavy at heart . . . this might

be the last time he will see his father. For it *could* be that he would go off further than Østervaag and perhaps never come back.

"Oh, so you're off to Østervaag today," says young Martin merrily. "I suppose you'll be going out dancing and having fun with Magnus and Gotfred. For believe me, they . . ."

Simon Peter comes close to Josva and stares sadly into his eye. He waits politely until Martin has finished, and then he says in a low voice:

"Since you're going to Østervaag, Josva, would you buy a small packet of Christmas candles for me?"

The boat is pushed into the water.

"Aye, goodbye and God bless," says Kristoffer.

The engine is started, and before long the boat is out of sight in the dark half-light.

Josva is left behind on the landing stage. The day slowly begins to dawn. In the east above Husø a calm, grey bank of clouds shuts out the sunrise, a vast dome with a thread-like golden outline. The glowing edge turns into a curved bridge of celestial fire, and there is life and activity on this bridge, tiny sparks push their way forward, wander, meet and part as in some kind of ecstatic, blissful game until finally, the watery, clear, dazzling sun itself comes into sight. There is no wind. The sea spreads out in sand-grey patches, with channels of glittering, shining water in between. The cove glimmers with countless needle-sharp tiny flashes of light.

It is a long time since the morning sun came into view. There is something spring-like about this light, in spite of the frosty weather. And Josva suddenly feels disquiet . . . suppose something or other were to prevent him from leaving. Suppose he should be taken ill and die . . . oh, ridiculous idea.

But his strange feeling of disquiet becomes more intense. He feels a tingling all over, as though there is something wanting to keep him back, to hold on to him and weigh him down, refusing to let him leave.

A group of eider ducks comes into sight behind a patch of seaweed, tiny black dots in the flickering water. He counts them . . . if the number is uneven that means that he won't get

away . . . oh, luckily there are exactly ten. Or are there only nine? He counts them again; no there are ten. He feels relieved.

Oluva is at home in the kitchen, writing a letter.

"See here," she said. "First of all, I've made a list of the things you're to remember. And now I'm writing a letter to Enoksen . . . Would you please give him this letter?"

Josva takes a small wooden box out of a cupboard. It contains a little over four hundred kroner. They are his savings. Best to take them with him to be on the safe side.

The low sun is shining in through the windows and filling the house with light. The brass pendulum on the striking clock is flickering and flashing. An image springs to mind: It is a late morning in winter many many years ago, and he is in bed with a temperature. The sun is shining just as it is now, and the pendulum is flashing, and out in the kitchen, which is still half-dark, his mother is busy taking some loaves out of the oven. He can sense the smell of these loaves, floating in from the dark kitchen. And now his mother comes into the living room, blinking at the light, and stands there uncommonly gentle, with sunshine in her reddish fair hair. "What lovely sunshine," she says merrily. "And now spring will soon be here and you'll be well again."

And other memories of his mother appear to him. He was only five years old when she died, and he remembers her only vaguely, not as one person among others, but as a being . . . something light and warm and beyond description.

He stands for a long time filled with strange childhood memories. They flow towards him from all directions, like invisible, benevolent spirits, and they flock about him, seeking to persuade him not to leave, but to stay. They call to him from near and far, from the shore, from the fields, from all the thousand places of his childhood . . . a chorus of gentle voices, woven together by the whispering of the cove, the babbling of the mountain streams and the bird-song of summer. He is carried away by dark and inexpressible memories, by a sweetness that transcends everything, dreamt and real experiences mingled together. He sees the

moon low over the darkening ridge. There is a smell of thyme; late birds are busy and tempting him with deep, tremulous song, and beneath the greensward the springs are bubbling in reply. He is not alone . . . there are several children together, playing among big, silent boulders. But suddenly they stop playing and stand excited and frightened and look at the moon. They take each other's hand and start making for home. On the way they come past a tiny round lake, black and shining in the shadow of a mound. It looks like a huge horse's eye. And here something strange happens . . . There is a tiny splash in the water, and fine, golden rings emerge on the dark surface. Nothing else happens, but he can never forget that little pond and the golden rings . . .

He remembers another evening, or perhaps it was an early morning. He is standing at the window watching something sail past in the dark sound . . . a long row of lights looking almost like a whole village that has got loose and drifted out to sea. It is a big ship, a steamship, his father tells him. No, no ship can be as big as that, he thinks to himself and simply can't believe his father's explanation. It's more like a church, a sea church. And from now on, this floating sea church haunts him in his dreams . . . a huge church, a mighty church, full of light and glory like a piece of heaven. It's the church of the dead . . . his mother is there, too, sitting looking ahead as though in silent bliss.

"Oh well . . ." He pushes all these dreams away.

Oluva comes with his packed lunch and the letter to Enoksen. He packs all his things in a small sealskin case. There is a little pocket in the lining, and there he puts his money. Then there is the shotgun . . .he has to pack that in its canvas cover and carry it over his shoulder. The cove and the sound are shining in the sun out there. And there . . . a black dot in the midst of all this glittering splendour, is the mail boat.

Landrus and Jakob the Granary are down on the landing stage surrounded by some large bales of wool.

"Good morning, Josva," says Landrus. "Hmm, you almost

look as though you're going off on a long journey. You're not emigrating, are you? Where are you off to? Østervaag?"

"That's the idea," nods Josva.

"Good," says Landrus merrily. "'Cause then you can keep an eye on this wool. That's where it's going, too."

He places a hand gently on one of the bales.

"Aye, 'cause these motormen tend not to care a damn about that sort of thing, especially when it's me sending it. My man in Østervaag has often complained that my bales of wool were wet. And that's something that's happened on the way, for everything's in perfect order when it leaves me. You know perfectly well, Josva, that my things are always in order. But if you'd be so kind as to stay near these bales and perhaps have a word with the men on my behalf if they don't look after them . . ."

Josva promises to keep an eye on the bales.

Landrus is full of gratitude: "Thank you very much. I know you're a fine lad . . . I can rely on you and entrust things to you. And give my best wishes to my son–in–law, Gotfred, and ask him to get home for Christmas if he possibly can, because I need to talk to him."

Josva promises.

The motorboat is approaching. Landrus nudges Jakob the Granary who has stretched out on his stomach on one of the bales and lies there smelling at it with a look of disgust on his face.

"Up you get, lazybones. You're sniffing at things like a dog. Isn't it good clean wool?"

"Sheep always smell filthy," replies Jakob and spits.

The boat comes alongside. Oluf, the skipper, shouts from the wheelhouse, "What's that you've got there, Landrus? There's not an inch left in the hold. It'll have to go as deck cargo."

"And get wet through," fumed Landrus.

He turns to Josva: "What did I say? Thank God you're there to take care of it."

"Then I want it at a cheaper rate," he shouts back. "And I want tarpaulins over the bales. So there."

"That's not necessary in this weather," replies the skipper. "And as for the price, you'll have to talk to the boat's owners. I can't decide that for you."

He yawns. Then a glint of laughter lights up his watery eyes: "By the way, Landrus . . . your son-in-law sends his best wishes. He was sober this morning."

"Sober?" Landrus pricks up his ears. "What do you mean by that?"

"It's the opposite of drunk," Oluf informs him.

"Yes, but is he usually drunk . . . you know, more than people usually are?"

Oluf gives a hefty nod. "Yes, I'll say he is. He goes around blind drunk all day long together with this chap called Magnus, you know. And as for that old ship you bought, it's sprung a leak."

Landrus's face turns dark red.

"It's breaking in two," Oluf continues. "It's splitting into two pieces, you understand. Like this . . ."

He makes a movement with his hand to show how.

"Come on, get on with it," commands Landrus, furiously nudging Jakob in the side. "What the hell are you standing looking at? Have you never seen a monkey like that before?"

But Jakob is secretly so amused he is incapable of doing anything.

"Your ship's broken in two," he chuckles with his eyes shut and the stumps of his teeth bared.

Landrus gets hold of one of the biggest bales and drags it down to the boat on his own. Then he fetches the next. He struggles with the heavy bales as though they were no more than ordinary pillows in an attempt to show what a tough guy he is. Jakob gradually recovers from his amusement and offers to help, but Landrus pushes him away with a snort, determined in all his fury to show he can manage on his own. He takes the last of the bales, which is a little smaller than the others, but still heavy, and throws it up in the boat with such force that the men have to jump aside to avoid being knocked over.

"That's enough, Landrus," says Oluf to calm him down. "Surely you understand a joke?"

No, Landrus doesn't understand a joke. He stands groaning and looking irate and baleful. Oluf is quite concerned and has to go down and pat him on the shoulder and explain things to him. "It was all meant as a joke, Landrus. You know, that's the kind of thing we're always saying here on board. Remember, we don't have much fun otherwise."

"Oh, so there's nothing at all *in it* either," asks Landrus, beginning to pull himself together.

"Nothing at all," says Oluf in relief. "Your son–in–law's a good lad through and through, and as for the ship . . . aye, you've made quite a coup there, a real coup let me tell you. And I gather he's got another name for it as well."

"Another name?" asks Landrus suspiciously. "I told him to keep the old one, *General Gordon*, because it's asking for trouble to give a ship another name. What's it called now?"

"Aye, what is it called?" Oluf considers. "It's a woman's name, but I can't think of what it is. Virginia or Patronia or something like that . . ."

"What is it this ship from Trymø's called?" he turns to one of his crew.

"Gregoria!"

"Aye, that's it, Gregoria," nods Oluf.

"Gregoria!" Landrus smiles and is reconciled. "So the ship's called the Gregoria. Aye, aye. Well that's a good name."

"Aye, I suppose it's after your daughter?" says Oluf, giving him a slap on the shoulder at the same time. "Oh well, I suppose we'd bloody better see about getting a move on. Goodbye, Landrus."

The boat puts out.

Josva stands and looks towards land. There is smoke rising from the pale roofs. A dog barks. The sun catches a window. The mountains are all frost-grey and solemn. They tower up towards the sky, grow, stand out more and more strongly. Before long, these mountains are all that is to be seen; the village and the inlet disappear in mist. Other islands and

mountains glide into view. Trymø is now only a blue mountain top among the other tops.

He leans back against one of Landrus's bales of wool and closes his eyes. Now he can see the village again before him . . . the kindly houses, the bluish smoke from the chimneys, the church, the cove, Spirit Hill. And in his thoughts he is up in the mountains, in Weaver's Valley, where the great stone stands alone and cold in the frost. Everything is icy and desolate up there in the place where he and Hilda met one summer evening as the dew was falling.

Strange to think of this. Now they have both left the island. And he has a feeling as if they have both fallen out of the island's favour . . .

The blue peaks of Trymø have quite disappeared now. Other mountains glide into view . . . these are the big islands appearing in front of him, Kjovø and Hærmandsø. An ocean of blue peaks and long, straight mountain crests. He feels refreshed at the sight. To travel and travel and to see the world appear and change . . . ever new shapes and profiles.

That is why he has left. And that is how he will go on. This is the only thing that can satisfy him. Just to travel and travel for ever.

No . . . that's not it. He has something akin to an empty feeling within him. He has had a quite specific aim, and there is no use hiding it from himself. He feels it like an under-current beneath everything, or like firm ground beneath all those other things that are changing around him. This journey is about Hilda, her and nothing else. All this indeterminate longing to get away . . . it is a longing for her. He senses that now, a sudden, warm feeling.

The motor chugs along beside a gently sloping mountainous coast, full of irregular outcrops that look like huge steps. A chasm appears here and there, filled with bluish, frozen darkness. Out on the sound there are vast areas of choppy seas glittering in the sun, but here near the coast the water is dark and transparent. A few jellyfish drift past, milky blue and elusive in the green water. Landrus's bales of wool smell homely and good. At this moment, Josva has no greater wish than to

go back home to Trymø together with Hilda. Home to the spring fields, to the good and gentle grassy world where they have both grown up. He imagines the smoke rising in fine columns from all the roofs, while the sun is glittering on the wet mountainsides. It is spring; little white lambs are gambolling among mossy stones, the curlew sings its long, hearty trills ending in a blissful peal of bells. He gathers his entire soul in a desire to win Hilda back and take her home. Everything shall be as before, as on that mild and joyous autumn evening when they sat on the shore and she told him she had no one else to turn to. For she did say that; he could still hear the sound of her voice as she spoke those words.

And yet, what has not happened since? And what can't still happen. The worst can happen. Painful thoughts emerge in his mind . . . the world is full of deceit, of crushing winter darkness, of sorrow and longing and terrible things. Perhaps she is incurably ill. Perhaps she's going to die like poor Jane.

Perhaps he will find her pale and weak, marked by death. Perhaps she is lying in bed with bewildered eyes, everything irrevocably past . . .

The pale midwinter sun has started to sink again. In a couple of hours it will be twilight once more. New mountains and tongues of land appear. The boat makes its way into a broad sound furrowed by the current. It is like a huge, rough road. In the middle of the sound there is an islet surrounded by black skerries. The current seethes and foams around these skerries. It is blowing out here, a winter wind as sharp as a knife. And the sun becomes darker and darker, finally slipping completely out of sight behind a bank of cloud.

Josva seeks to rid himself of the melancholy mental visions, but it is impossible; they become ever clearer and ever more heart-breaking. He thinks about the dream he had about Hilda's departure on the boat full of skeletons. He imagines her, lying dreaming, with her feverish eyes full of expectation . . . she is thinking of Daniel – soon she will be treading that same wild path. The werewolf remains behind on earth among the living, but is himself neither living nor dead . . .

"Well, my friend from Trymø!" the skipper suddenly

285

shouts from the wheelhouse. "What's your errand in Østervaag? Are you going to find yourself a girl? Or are you simply going to have a tooth pulled out? Come up here and let's have a chat."

III

It is twilight, and snow is falling gently.

At the long quayside in Østervaag, a steamship is taking on coal. It is a huge steamer, as tall as a house, indeed like a mountain. It is full of lights and noise and steaming warmth. And further along there is another steamship with a smoking funnel and lighted windows and portholes. Wagons and people are milling about on the wharf, and it is quite difficult to find a way through the crowd. Josva looks for a way of getting around this turmoil and strays in between some warehouses and timber sheds. It is quiet here. The snow is falling sadly from the grey sky, and behind a single lighted window there is a man with a cap pushed back and his coat collar turned up around his ears. He is busy writing or adding up and has a stern, sullen expression on his face.

A dog comes across and sniffs at Josva. It gives a friendly wag of its tail as though it knows him, and he pats its damp coat. Now one of the steamers is sounding its horn, echoing somewhere or other far away in the darkness.

Josva stands looking at the lighted window. He feels a curiously attractive torment at the thought of being alone in a strange place. He had thought of looking up Magnus and Gotfred, but he has changed his mind. There's no hurry. He'll be alone all this evening and night; he'll see about finding a room in some hostelry or other and enjoy being entirely on his own, a complete stranger. He'll act as though he is someone quite different. It's really fun, a grand joke. For this Josva, this lad from Trymø, has come to town to buy a lever, get a shotgun and some watches repaired and to visit a girl, and to . . . well, because it's not only these errands – it's something else, something incredibly great he has gone away for. Apart

from anything else, he's also thought of not going back to Trymø. Perhaps nothing will come of that. But never mind . . . the possibility is there. He has not tied himself to anything definite. And this evening he'll take the liberty of being free, of being outside it all.

He secretly enjoys this idea and feels intoxicated by his freedom. Everyone else is tied, tied hand and foot, they take themselves dreadfully seriously, and only he has been so inventive as to escape from his usual self. It is breathtakingly wonderful. Just see that man up there in the window, sitting there in his heavy coat and slaving away at being himself, although it doesn't look as though it's particularly attractive, judging by his morose expression.

Josva goes on, drifting about here and there.

A long street opens up, with lamps and illuminated windows. The snow is falling heavily. People hurry along, bent forward and looking as though they are offended by the snow. A shop window has a pile of oranges on display. That is an unaccustomed sight for someone from Trymø . . . He has to go over and take a closer look at this golden abundance. Twenty øre each, it says on a ticket. He goes in and buys two oranges and watches delightedly as they are wrapped up for him. They are going to be his own, these two strange, golden suns. He takes them and puts them carefully in his pocket.

The street ends in a steep hill, at the top of which stands a big white building, lit up from cellar to loft. Behind this building there is a garden of white trees. But the town does not end here; there are new streets, new rows of lamps, new big houses, and people hurrying through the driving snow. Two girls are standing at one door, talking happily together; but they are obviously cold as they dance about in their shiny rubber boots. He catches a few words as he passes by: "I assure you, never in all my born days have I seen anything like it." And the other: "You'll drive me mad . . ."

At one place in a broad street, there are coats and garments hanging in a window. What if he went in and bought a coat and a hat – he'd be completely unrecognisable then. For a

moment he feels very tempted. But he has only just about enough money, and he needs it for more useful things.

Again the steamer sounds its horn down by the harbour, one long and three short blasts. Heaven knows where *it* is bound for now . . . perhaps England, perhaps Spain. If only he were on board, sailing off through the drifting snow away to places where perhaps no snow ever fell, to sun-drenched shores where glorious shiny oranges hang on the trees.

Josva has reached a darker, narrower street now. Some small boys come running down it as if their lives depended on it, and a man appears in a door threatening them: "You just watch out, you little devils." Josva has to laugh at the angry man standing here in the midst of everything and giving expression to his irritation. He is a small man, broad and plump. Now he screws his eyes up in the face of the snow and fumes: "Confound it."

There is a smithy at the end of the road. Din and flickering lights pour out of the open door. Two men covered in black grime are standing at the anvil working on an iron bar. One of them has a dark full beard. Sparks buzz like flies around the glowing iron . . . it's hard to understand how this smith doesn't get his beard burnt. Perhaps that happens now and again, but he doesn't take much notice of it, merely ruffles his beard a bit and brushes the sparks away . . .

Josva goes on. He comes to think of an old story about Saint Peter, wandering around on earth disguised as a poor man. The snow is stopping now, and the clear starry sky comes into view. Smoke is rising from all the chimneys. Now he is actually outside the town. The houses are more scattered. Suddenly the church bells begin to ring. He turns round and automatically makes for the sound. Then the church comes into view, with flickering lights in all its windows. He stands for a moment listening to the happy sound of bells that are full of promise. . . . It is obviously a wedding they are ringing for. The town is celebrating a wedding this evening! It is as though he has all the time felt there was something unusual and festive in prospect.

Genezareth Seamen's Hostel it says on a sign above the

entrance to a big stone-built house. He'll go in here and have a cup of coffee and something to eat and perhaps find lodgings for the night. He hesitates for a moment . . . he doesn't by any chance risk meeting Magnus or Gotfred in this seamen's hostel? No, why should they be here, they've got their own lodgings elsewhere in town.

He opens the door. This is rather a splendid place, with a stone floor and big windows in the doors. Dining Room it says on one of the doors. It's a large room with pictures and biblical texts on the walls and a multitude of tables and chairs. But there are not many customers. There are four men over in a corner drinking coffee. One of them gets up and comes towards him . . . a short, fat man wearing glasses and with his hair brushed back. He's Hugo Poulsen, the manager of the seamen's hostel. He shakes hands with Josva and asks him to take a seat, and he shall have some supper.

"Who are you, by the way, young man?" he asks kindly, looking over his glasses.

Josva had not really imagined it was necessary to say who he was. But there is nothing else for it . . . he gives his name.

"Oh, so you're a son of David from Kalvø?" Poulsen says encouragingly and looks at him as though recognising him.

Josva nods. Just let him believe that, he thinks.

The manager goes on: "I know David well. And your brother Ole — he's stayed here several times. But . . . isn't it you who are engaged to Susanna, the teacher's daughter from Frodenæs, the one studying at the training college?"

Josva nods again, rather embarrassed. This may be a slippery slope he's got himself on. But at the same time it's just something to suit him. Yes, he's engaged to Susanna and now he's come to visit her.

The manager smiles and is quite emotional. "Yes, Susanna and I know each other well. From work for the Mission, you see. She's a splendid girl, so kind and understanding. I can guarantee you'll have a happy life with her."

Josva blushes and is most inclined to get the mistake corrected. But it's too late now. But it's a nice mess he has got

himself into. Suppose this Susanna hears her fiancé is in town living in the seamen's hostel.

But suddenly the manager says, "You've come to visit her! But surely . . . didn't she go home for Christmas the day before yesterday? She came in here to say goodbye at least."

"Oh dear . . . then I shan't manage to see her." Josva sits up straight and can scarcely hide his relief.

The manager has to smile: "No, my friend, she's certainly left . . . quite a cold reception for a suitor, isn't it? You're obviously very carefully avoiding each other, you two."

"But let me show you something – it might be a bit of consolation to you. Wait a moment."

He gets up and disappears through a door at the other end of the room. Josva feels humiliated through his lying. This is bound to go wrong. Suppose it's a sister or another of Susanna's relatives the manager's going to surprise him with! He wonders if he wouldn't do best to get out while Poulsen's away. But there he is back already. And thank Heavens, he's alone. The surprise turns out to be a large photograph of a dozen people sitting around a large table.

"Yes, that's our Mission committee," Poulsen informs him, pointing. "Can you find the young lady who's run away from you?"

Josva has to pretend that he can find her and forces himself to smile in recognition. There are at least three or four young-ish women in the picture.

"Well, you won't know the others," explains the manager, pointing, but this is me, and then there's Mrs Reuter and Mr Simonsen the preacher, and Ferdinansen the carpenter . . . Oh, but the names don't matter, because you don't know any of them in any case . . ."

A waitress arrives with coffee and sandwiches on a tray. Josva turns to the food in relief.

"Yes, help yourself," says Poulsen. "I must say I'm really pleased to have met you, even if I'm sorry you've come in vain. I can't help repeating that Susanna's a girl I respect and am fond of. And that applies to all of us in our circle. She's as good and honest as she's beautiful. And she really is a beauty,

that I must say. Her soul radiates from her eyes, and then this fine fair hair . . ."

Josva nods dreamily. He glances at the photograph lying on the table. The fair-haired girl . . . oh, so that must be her. Yes, she's not bad looking . . .

The manager goes on talking to Josva for a little longer, trusting and unwavering, as though to one with whom he had a faith and activities in common.

Josva is tired and sleepy. He calmly slips into his new way of life. There is an incredible rest and sweetness in it.

"Oh well, goodnight, and may God bless you and give you His grace," concludes Poulsen at long last. "I'll show you to your room."

Josva goes straight to bed and puts out the light. The picture of Susanna continues to haunt him. She has kindly, tender eyes, but he isn't the one she's looking at. And gradually her eyes change expression. They become anxious and plaintive . . . "What do you want with me? Leave me in peace, your ways and mine are not the same," they say. And now they change again, growing tired and scornful. Werewolf, they say. Josva turns away in shame. It is snowing heavily and silently, there are lights in all windows. People are hurrying through the snow, steamers are hooting, wedding bells chiming. And in a smoky smithy, a man stands brushing his black beard so that the sparks fly. But there comes Hilda, with bare legs and a white woollen scarf over her shoulders. She is smiling secretly and surrenders to his gaze, and he holds her tight. At last, at last! If I didn't have you, I wouldn't have anyone . . .

It is Hilda . . . and yet not her. It is someone else whom he knows well but never met, Erla. She smiles and takes him with her into the stone where she lives. And weeping and shivering she lays her head on his chest. He kisses her hair, which is damp from the drizzle, and around them it is night, misty and sweet-smelling spring night . . .

IV

There is nothing to be seen but mist, a white, light-intoxicated mist wrapping itself gently and summery around all things. Josva lies staring out into this mist. He has lain there for a long time, blissfully unaware of everything around him. But he gradually wakes sufficiently to start thinking . . . He is in a bed, and it is light around him. But this mist? Is he ill, or perhaps even dead? He starts up; the mist suddenly disappears and something falls to the floor and is shattered with a plaintive sound. It is a lampshade. He must have pushed it in some way so it has fallen on the floor. He can't understand that. The rest of the lamp is on a small chest of drawers over by the window. Has he been sleepwalking? Or are there ghosts in the place?

He looks around in the little room. Dirty, grey light is entering through the curtain. Outside, it is pouring with rain. Over by the wall there is a wardrobe, painted grey, but worn in places so that the grainy wood can be seen through. On the wall above this cupboard there is a framed biblical text. Blessed is he that shall eat bread in the kingdom of God . . .

But what on earth can the connection be between that and the lampshade? He must have had it in bed with him, for it fell out of the bed on to the floor. He sits for a moment quite confused. Perhaps he's still dreaming. Yes, that's what it must be. For now there's a sound of movement in the cupboard; someone is moaning in there, and he can hear sniffing and stifled groans. And there is someone moaning under the bed as well. What's going on? Has he gone mad? He sits up and is about to jump out of bed. But now the cupboard door flies open and, and . . . young Gotfred emerges, scarlet-faced with suppressed laughter. And Magnus is under the bed, laughing helplessly

Josva alternates for a moment between fury and laughter. He could have rushed at Gotfred and banged his grinning face against the wall. But laughter got the better of him . . . he gives in and shares in the fun.

"Oh, it was you, you wretches."

But suddenly he becomes serious again. "Hey, by the way, how did you get to know I was here?"

Young Gotfred explains. They had met Oluf, the skipper, and he had told them that Josva had come. And they had gone all over town to find him and finally worked out that he must be here.

"Worked out?" asks Josva. "But how?"

"Well, it wasn't so difficult," says Magnus. "We asked around as one usually does. But what did you do yesterday evening? Why didn't you come up to us? It couldn't have been all that difficult to find out where we lived."

"Aye, and what's all this about you going around pulling the wool over people's eyes?" interrupts Gotfred. "You'd better confess, you wretch."

"Confess?" Josva is blushing and confused.

"Yes," threatens Gotfred. "You can't get away with it."

He bends down over Josva and says in a low voice, "What's this tale you've been telling old Poulsen?"

"Oh, that," says Josva in an uncertain voice. "Well, you see, it was a bit of a mistake that I couldn't be bothered correcting, because it doesn't matter to him where I come from, does it?"

Gotfred laughs sceptically.

"Yes, but there's something behind all this, and if you won't say what it is, I'll tell you what I think: You've come to town to spy on us. Have you arranged it with Landrus?"

"To spy?" Josva doesn't know what he's talking about.

"Yes, you see," explained Magnus with a laugh, "It was Oluf who put us on your track."

"Aye, and that explains everything," adds Gotfred. "I suppose Landrus is having all kinds of crazy ideas."

"No, it wasn't *that*, I swear," says Josva seriously.

He tells them about his various errands. But he can feel that his words fail to convince them. And he really has to admit to himself that they are all only empty excuses. He sounds disheartened and is most inclined to go along with their idea that he has come to spy on them . . . there would be more point in that after all.

He adds: "And besides, perhaps you need someone to come and see what you're getting up to."

"There you are," Gotfred winks contentedly. "We got it out of you after all. So you've been planning things with the old folks, wily bird that you are."

Josva feels deeply upset at that accusation. But he ignores it for the want of a better explanation. But then he suddenly thinks of something else, something that immediately justifies him.

Sitting up in bed and stretching, he says, "By the way, I don't really intend going back to Trymø."

Magnus and Gotfred look questioningly at him. "Not go home again? What do you mean by that?"

"Well, I intend going abroad," smiles Josva. "I'll see if I can get a job on some ship or other, a steamship . . ."

"Are you serious?" asks Gotfred.

Josva nods.

Gotfred exchanges a glance with Magnus and looks very thoughtful.

"You'd do better to come fishing with us this spring . . . on our own ship. That'd be better than working on a steamer as a miserable stoker and being pushed from pillar to post, eh?"

"Perhaps so," says Josva, adding in a very determined voice, "but all the same, I intend getting away now and going abroad. I've made up my mind."

"Well, if you tried just a single trip . . . that would leave you free to come back if you don't like it," suggests Magnus.

Gotfred goes across to the window, pulls the curtain aside and looks out.

"You're a strange, crazy chap, Josva," he says. "A real clown. But . . . if you really intend to leave, you've got a chance now. And you can get away as early as tomorrow."

"How?" asks Josva in surprise.

Gotfred nods and explains. "Well, it's quite straightforward. Have you noticed the big steamer out there on the quayside? Well, yesterday two stokers from that ship were arrested and put in clink for stealing on board. So there's probably a chance for you if you want to take their place. Magnus and I were

talking about it just now because one of our friends over there in the school's grown tired of life as well and wants to sign up on some foreign ship and go to warmer lands, or where the hell he wants to go, daft as he is . . . He's had trouble with his girlfriend and that's what's made him want to go."

Josva has a tingling sensation all over. He pictures the great steamship lying there at the quayside yesterday evening, with the sooty funnel pointing up through the driving snow. He feels almost breathless at the thought of the hot, greasy smoke rising from inside it. It was not his intention to rush headlong off . . . he had thought of hanging around a couple of days and getting used to the idea. But already tomorrow! And what about Hilda . . . he must go and visit her first. That is his most important errand, his real errand.

"Well, what about getting up and dressing?" asks Magnus.

"That story about me and the manager's a nice one," says Josva with a laugh. "Did you tell him I'd been spinning him a pack of lies?"

Gotfred laughs: "No, we didn't know what to make of it. And we'd actually have gone off again if Magnus hadn't happened to see your shotgun. You'd left it in the corridor, of course, and I ought to know that gun," said Magnus. "For I was the one who made the cover for it."

Josva laughs with relief.

"Well, the fact is that he took me for someone entirely different, and as I say, I didn't think it was worth the trouble of giving him the real explanation, because I was tired and . . ."

"Aye, you're a charming sleepwalker," says Gotfred pulling at his duvet. "Come on, up you get, braggart."

He shakes his head: "Come to see your fiancée, a student in the training college. I've never heard anything so outrageous in my life . . ."

"And the lampshade?" says Josva.

"Well, you'll have to pay for that yourself," laughs Gotfred. "It was well worth it, seeing you lying there with it on your head . . . you looked just like the Pope in Rome."

V

A gentle drizzle is falling. The long, muddy streets of Østervaag are all lost in a grey mist. Josva goes around attending to his errands. He is very careful not to forget a single one. He gets to know the price of oilskins and canvas and ropes, he even goes to several shops to see where he can get them most cheaply. As for Oluva's grey cloth, he arranges for it to be sent by post, and he pays the postage so she will get it all without having to pay anything. And he includes a roll of shelving paper for the larder, and also the Christmas candles for Simon Peter.

Finally, everything has been taken care of except the watches and the letter to this watchmaker called Enoksen. He would like to know what there is in that letter. The point is that Enoksen is an Adventist. He is probably a man with some skill as a preacher . . . perhaps he is one of those threatening people with hellfire. Josva has no desire to have to confront him just now. On the other hand, he would also like to get this task behind him. He could of course simply not deliver the letter and content himself with giving him the watches. Or he can take out the letter at the last moment, just before leaving. Yes, that's what he will do. He will say goodbye and go over to the door and suddenly remember the letter . . . Oh, by the way, I've got a letter for you as well from a lady on Trymø. And before Enoksen can manage to open the letter, he will have gone.

Enoksen lives down near the mouth of the river, in a pretty little white-painted house. The river runs past, yellowish and covered with dirty foam. As Josva opens the door, an electric doorbell rings . . . a piercing sound that goes right through him. There is a sweetish smell as of leather in the warm little shop, and from the many clocks arrayed on walls and tables there is a remarkable polyphonous din . . . a web of sound imprisoning the customer. In a gold frame above the entrance there is a sign in blue lettering against a silver background: Prepare to meet thy God.

It is a long time before anyone comes. Josva takes out the

pocket watches and places them on the counter. This counter is made of glass, through which you can look down into an array of valuables, rings and jewellery, shining stones, gold crosses, fine slender chains, so thin that it must require a magician to get the individual links fitted together. Josva is quite overwhelmed as he stares down into this display of valuables. Enoksen must really be a wealthy man. And not only does he sell watches, clocks and jewellery; he also deals in shoes, sewing machines and glass . . . Indeed, if Josva looks more closely there is hardly anything Enoksen doesn't have to sell: brushes, suitcases, children's coats and chocolate. There is a whole row of Bibles in shiny black bindings standing on a small bookcase.

The clocks tick. Now one of them strikes twelve. Several others join in . . . Each clock has its own voice, one of them plays a little tune; it is almost as though the air is overflowing with harmonious sounds. Josva comes to think of the old clock at home, the poor, rusty sound when it strikes. Perhaps he will never hear that again. And yet it will stay hanging there for many years yet and strike the hour in the same way as in his childhood. It has survived his mother and will presumably also survive his father, and even himself and his siblings. Perhaps it will end in other hands in time and be moved to a different place but still happily strike the hour. Strange, all these dead things to which human beings have imparted something of their own lives.

He has a feeling as if this watchmaker's shop is the centre of the world, the only place there was in the world at that moment. Everything else fades into unreality . . . the misty streets, the big steamer at the quayside, the sailors' hostel. And far, far away, right out in the airy, windy blue, the island of Trymø like a floating cloud among other clouds.

He drums on the counter with his nails. No Enoksen. Then he is lost in thought again. Will he see Hilda again today? It seems so unreasonable to him. Is he to leave tomorrow, to go abroad perhaps never to come back again? Even more ridiculous and unreasonable. Only one thing remains fixed, and that is that he is standing here in Enoksen's shop looking down on

a display of small wonders and with his ears filled with the sound of ticking clocks . . .

He goes across and opens the door to see if the ringing of the bell might bring Enoksen into the shop. Now there is the sound of movement. A little lady dressed in black appears. She is as small and fragile as a twelve-year-old girl, but her face is old and lined, with puffy red eyes and sunken cheeks.

Josva explains his errand. He has two watches that he would like Enoksen to repair.

But the little woman shakes her head: "I'm afraid that's not possible, for Enoksen isn't here."

Josva fails to understand her properly: "He's not here?"

"No," replies the woman. "He's not here any more at all, for he passed away on Wednesday. He went to meet his God and Saviour on Wednesday."

Josva bows his head and puts the watches in his pocket again. Oh, so Enoksen is dead. All right, then he will have to find another watchmaker. And the letter . . . it doesn't matter about that any more.

The clocks tick. Enoksen is dead. Prepare to meet thy Lord. Josva nods in solemn farewell. The bell rings.

It is half past twelve. Visiting time in the sanatorium is not until three o'clock. Magnus and Gotfred are at the college, and he has agreed to meet them about five o'clock. The steamer is out by the quay, and the cranes are moving back and forth loading it. The steam winches are rattling and producing tiny clouds of steam. He ought to have been on board already to ask about a job, but that will have to wait. He will see to the other thing first, the visit to the sanatorium . . . that's far more important and urgent.

But now he has a couple of hours to spare, a couple of golden hours. Nothing decisive has happened yet. He can still relax in the thought that he is only here in Østervaag on a short visit and is going home tomorrow after undertaking various small errands. He will take the watches to another watchmaker. There are plenty of them in Østervaag. For

298

instance, there is one almost opposite Enoksen's. *Dam*, watchmaker and instrument maker it says in white lettering on the shop window. Josva opens the door . . . there is no need to wait here – the watchmaker is standing at the counter reading a newspaper. He takes the watches, nods politely, writes down the address and nods again . . . yes, he will start the repairs that very afternoon.

So that is taken care of. Josva goes back to the seamen's hostel to have a bite of lunch. It has stopped raining. A reddish light has emerged in the south. It gradually extends over the whole sky. Everything takes on a reddish hue. It is as though the grey, dripping world was opening its face in a smile.

"There's been a young man asking for you," says Poulsen, coming across to Josva in the dining room. "He said he'll be back in half an hour."

"That must have been Gotfred or Magnus," thinks Josva.

The manager is dressed in black and has a solemn look behind his glasses.

"I'm waiting for my wife," he says. "We are going to bury my old friend Enoksen. . . ."

"Enoksen the watchmaker?"

"Yes. Did you know him? He died suddenly, a heart attack, I think. We were childhood friends . . . but then we went our separate ways, as he joined the Adventists while I stayed in the National Church. But he was a good man, was Enoksen, honest and loyal. Perhaps a little too zealous in his special faith. And he was supposed to be a wealthy man. He doesn't appear to have reflected too much on the text warning against gathering treasures upon earth which moth and rust corrupt . . . I once said that to him, half in jest, for we would have quite a friendly chat now and again. And do you know what he replied?"

A melancholy little smile emerged in Poulsen's eyes: "He actually said, 'We have quite good ways these days of keeping moths and rust at bay.' Yes, that's what he was like. Oh well, we were actually both agreed that Christianity needs revising and modernising. We were simply not agreed as to the best way of doing it. But now he's in that place where you discover

for certain whether you've been right or wrong. Aye, aye, God comfort us all."

There is a knock on the door, and a young man comes in.

"Oh, here he is again, the young man who was looking for you. Well, carry on and have your little chat. As I say, I have to be off."

The stranger quickly nods goodbye to him and sits down at Josva's table.

"Have you been out there?" he asks without any introduction, and Josva immediately understands that this is the young man from the navigation school that Gotfred mentioned, the man who simply wants to get away as quickly as possible.

"Out to the steamer?" asks Josva. "No, I thought . . ."

"I've got a job there," the other interrupts. "And you can as well if you want. They're not too bothered . . . We can always manage the signing on, says the mate. Yes, I told him there were two of us, you understand . . ."

Josva nods.

"Well see each other again this evening," the other says as he gets up . . . "I shall be there with your brother and Gotfred. See you later, then."

"So it's as easy as this to get away," thinks Josva. "All you need is to go on board. Otherwise, you can simply stay way. They're not too bothered about a couple of stokers . . ."

VI

The sanatorium is a little way south of the town, near a small bay. It is a big, bright building with a garden around and a large number of outhouses. No castle could be bigger, thinks Josva. The garden is surrounded by a drystone wall. A full stream flows close to this wall. It is crossed by a humped stone bridge with solid iron railings on either side. Josva stops on this bridge for a moment and looks down into the fast flowing water. His heart is pounding, and his hands are trembling.

The weather is brightening up, and as he opens the heavy iron gate to the garden the sun comes out and casts a reddish

light on the grey tiled roof of the sanatorium. The garden is full of people walking around in twos or in groups, chatting and humming and apparently perfectly happy. Josva has always imagined a sanatorium to be a sombre place where folk lie in bed coughing. It looks here as though life is good. In an open area in the middle of the garden there are some young men armed with wooden clubs, playing some sort of game with balls that they knock backwards and forwards by hitting them gently with the clubs. Josva does not know who to ask where he can find Hilda. It's probably best to go up to the house and ask there. But suddenly he sees her in front of him . . . she has discovered him and is coming towards him.

"Hello, Josva." She laughs happily and takes his hand in surprise.

"Hello, Hilda."

"Is it me you've come to visit?" she asks. "That was nice of you, Josva. How are they all back on Trymø?"

She asks various questions, and Josva is able to answer them all. He speaks as though half dreaming. He finds it difficult to believe that this really is Hilda he is talking to. She is so changed. It is only a few months since he last saw her, but she has altered so much that several years might have passed. Her voice is no different, and neither is her manner. And yet something has happened to change her . . . it is difficult to explain what it is.

"Come on, let's walk on a little," suggests Hilda.

She talks of this and that. Things have gone well since she came to Østervaag. She was in bed to begin with, but it turned out that her case was not a particularly serious one, and she can be completely cured. And it's nice here in the sanatorium, lots of people with things happening. One day all the younger patients were over in town and saw moving pictures . . .

"And you're not missing home?" asks Josva.

"No, God knows I'm not," she assures him. "And neither am I going back when I'm well again in the spring. Except for a very short visit."

Hilda laughs.

"Oh, I was pretty stupid in those days at home . . . wasn't I? But what can you expect of a person, a mere child, who has never seen anything apart from Trymø, old Jardes, Jakob the Granary and whatever all those curious people on Trymø are called."

"No," Josva has to agree with her. "Trymø's a strange, godforsaken, out-of-the-way place."

And it suddenly dawns on him that he, too, has probably been pretty stupid. And he, too, is on his way to becoming someone else. He thinks back with a kind of sympathy to the poor people at home, trotting about spellbound in their funny little world and not getting anything else out of life. Life could have been like that for him, too. But now, thank God . . . now he has torn himself away. And he tells her why he has come to Østervaag. He intends to go abroad, has got a job on a steamer and is leaving tomorrow . . .

"You're doing the right thing, Josva," says Hilda approvingly. "We young people simply have to get out, otherwise we'll never grow up properly."

Josva feels strangely enlivened. He has a feeling as though a window has been opened into his innermost self, and the fresh air is streaming in, soothing and cool. Here he is, talking freely and openly to Hilda; they are sensible and clear thinking, both of them; they understand each other and are happy on each other's behalf. And he is leaving tomorrow. There is nothing tying him any longer, no homesickness, no unhealthy, suppressed infatuation. For this Hilda walking beside him is a different Hilda from the one he has been dreaming of. He has all of a sudden become awake and aware.

They have reached the edge of the garden. Here, Hilda stops and leans against a boulder. She is breathing deeply and smiling as she looks at Josva. It's a sisterly or motherly smile . . . but neither does Josva wish for anything else. Hilda comes from his village, and she is a friend of his, a pretty, bright girl, nothing more.

"But what are you going to do when you are cured and don't need to be here any longer?" asks Josva.

Hilda smiles. "Well, that's a secret . . ."

He asks her, a little impatiently, "A secret?"

"No, I don't mind telling you ... otherwise I hadn't intended it to come out yet."

She smiles again and lowers her voice. "Well, I'm half engaged, you see."

Josva feels a little sting in his heart. But it passes quickly. Hilda engaged ... Why not? It's a good thing for her if she's not going back to Trymø in any case.

And she goes on, a frank and close friend: "Yes, I'm engaged ... What do you think? To the son of a merchant here in Østervaag. We were together in the sanatorium for the first couple of weeks."

"Well, I suppose I must congratulate you," says Josva, pressing her hand.

Strangely enough, it is as though he has all the time sensed something like this, that Hilda was engaged. She is engaged. And the world does not collapse as a result. On the contrary, it's so obviously good and natural that Hilda should have got engaged.

"Incidentally, my fiancé comes to see me every day," she says happily.

"So perhaps he'll be coming today as well?" asks Josva.

"He's probably already here looking for me," smiles Hilda.

They go back the way they have come. The sun is sinking; the air is damp and mild. Thin lines of smoke are rising from the sanatorium chimneys.

"By the way," says Josva. "There was something I wanted to ask you. Back in the autumn when you heard that Daniel had drowned ... Were you very upset?"

"Was I upset?" Hilda hesitates. "I felt sorry, of course. And in those days I was feeling strangely lonely and ..."

She looks at him and adds, "Yes, of course I was upset."

Josva thinks to himself, "No, she wasn't terribly upset." And he goes on to ask, cannot refrain from asking, or at least does not want to: "Listen, Hilda, tell me one thing more. When I ... when we used to meet at home, you remember ... Were you always thinking of Daniel?"

"Was I always thinking of him?" repeats Hilda. "No."

She gives a laugh. "Fundamentally, I didn't think about anything but how I could get away."

Josva laughs with her.

"Yes, we were both a little . . . strange then," he says in conclusion and asks no more questions. It is as though there were not months, but years, between then and now.

He leaves before long. Hilda holds his hand in both hers and says in the voice of a good friend, "Goodbye, Josva. All the best. And come back as a man of importance, a wealthy man."

It has begun to grow dark. Josva stops for a moment on the bridge outside and stares down into the stream. Now *that*'s been seen to, he thinks – this important errand. He has seen Hilda again.

And yet, it was not she, not his Hilda. This Hilda he had been talking to now was not really any great concern of his. She was not *his* Hilda. His Hilda was enigmatic; she was one you could weep over, worship or dream about. She was faithful. Faithful to . . . poor dead Daniel.

He leans over the railings, closes his eyes, clenches his fists and murmurs to the rapidly flowing water foaming as it flows past down there: "Strangely, incredibly, impossibly faithful. Her likes are not to be found. Not on earth."

And he imagines her in his thoughts, the fine and sorrowful girl.

> The maiden walks in the gloom of the church
> With sorrow she is filled and with rue.
> My prayers go to God to grant me the joy
> Of dying this day here with you.

No, Hilda from Trymø, the daughter of Harald and Birita, was not like that. He had completely mistaken her. It was all so obvious and straightforward. She was a decent girl, a sweet and kindly girl; there was no need to feel resentment towards her for anything. But heavens above, how mistaken one could be.

Josva walks slowly back to the town. He stops occasionally and smiles to himself . . . cannot help it. He has a feeling as though he were a reel that the line had been unwound from.

Soon the reel would be free and able to breathe really deeply. He feels how liberated forces awaken in him. He feels a desire to turn cartwheels all the way back, or fly . . . fly quite quietly and gently. The darkening sky is reddish brown and full of golden wisps of cloud. The stones on the road begin to be dry and white. Everything is so strangely alive. The world is open like some mighty gateway, opened as wide as it would go. He was approaching this gateway, full of eagerness and impatience.

NOW IS MY SOUL TROUBLED

I

A strange change had come over Johan Morberg, the solicitor. He was regularly to be seen in the company of the preacher – it appeared the two had become good friends. And judging by what Reinhold himself said, the solicitor was in the process of turning his back on his old self and opening his soul to the great truths about salvation and grace.

Sylverius had difficulty believing that this was really the case. If it were so, it must be said to be something of a miracle. He had been round to see Morberg a couple of times to have the rumours confirmed, but each time he had found him drunk and unapproachable. Poor man . . . alcohol still had him in its vicious grasp at least. He was probably in the midst of a relentless struggle with himself; good and evil forces were fighting for control of his soul.

One evening when Sylverius was sitting alone in his office, Morberg entered quite unexpectedly. Sylverius could see from his eyes that he was drunk, but at the same time there was a heavy, weary look of solemnity in his eyes.

"I hope I'm not disturbing you," he said, sitting down on the sofa. "But I saw there was a light on and thought . . . perhaps I'm not entirely unwelcome, although, if I may put it this way, circumstances have recently kept us a little apart from each other."

"No, I'm delighted to see you," said Sylverius with feeling. "But what do you mean with circumstances keeping us apart, as you put it?"

The solicitor frowned and subjected Sylverius to a stern, searching look for a moment.

"Just give me a single glass of rum," he said dully.

Sylverius got up automatically.

"Rum?" he said in surprise. "Yes, but . . ."

"Do as I say," commanded the solicitor. "You know how things are with me. I must have a drink; otherwise I'll crack up. Do you appreciate your responsibility?"

Sylverius took a bottle and a glass out of the cupboard.

"Of course you can have a pick-me-up if you're in that state," he said anxiously.

Gratified, the solicitor stared into the glass, but left it untouched. He went across and took a box of cigars from the shelf above the stove and handed it to Sylverius.

"There. Offer me a cigar," he said and sat down in the sofa again.

"Oh, do have one," said Sylverius in some confusion, opening the box.

Morberg lit the cigar and leant back, buried in his own thoughts.

"Oh . . . so this is where you spend your time," he said nodding thoughtfully. "The rich man. With a store of riches here on earth. Cheers."

"Cheers," said Sylverius moving as though he, too, were raising a glass.

"What's all this nonsense?" the solicitor bounced up. "You haven't got a glass. Get hold of one this minute, otherwise . . ."

Sylverius got up, but remained standing.

"I . . . don't drink," he said.

Morberg got up as well. He took the bottle and poured a fresh glass, but at the same time he bent towards Sylverius and whispered, "Pharisee. Ph-a-ri-see!"

"Am I . . . a Pharisee?" asked Sylverius, attempting a smile.

"Sit down," commanded the solicitor. He went on, in a slightly gentler voice, "Yes, my friend, you are a real, genuine Pharisee. You are one of those pitiable folk who have never committed a sin and who are therefore excluded from redemption. Yes, let me not beat about the bush – Cheers! – You are one of the seventy times seven just men who are in no need of conversion. While I . . . I'm like the publican and sinner who strikes his breast. I don't need to do anything else,

you understand, only beat my breast, and then there'll be endless rejoicing in heaven. Angels will bear me to Abraham's bosom without further formalities. Whereas you . . . you who dress in purple and the finest linen! Have you ever considered what a poor set of cards you have in your hand, Sylverius?"

The solicitor enveloped himself in thick clouds of smoke. Sylverius sat with his arms crossed and his head bowed. His body was rocking gently backwards and forwards.

"I suppose I'm a sinner, too," he objected mildly.

The solicitor laughed. "Yes, just you imagine that. How have you sinned? You've never uttered an improper word, never allowed room for an evil or base thought, never drunk schnapps except out of politeness to the person you were together with. And you knew no woman before you got married. No, indeed, you are pure, you are just. And you have received a plentiful reward . . . the reward given by this world. You have been followed by good fortune wherever you have turned, whether you've deserved it or not . . ."

Morberg poured himself another glass.

"For we can easily agree that . . . all right, you've been a good skipper, but you aren't really a businessman . . . your speculations in ships and fish have been childish, foolhardy, indeed sometimes simply crazy, and you would soon have been finished if fortune hadn't favoured you to an unreasonable, even ridiculous extent. Oh yes, you enjoy a generous measure of the favours of this world, Sylverius. And recently fate has even sent you first a wife who is as beautiful as she is faithful to you, and second a companion who is as tough and sharp as you are careless and soft."

Sylverius was starting to flush . . . anger was beginning to surface in him. He wondered whether he ought to remain silent in the face of all these insinuations or whether he ought to counter them. For it was not difficult to say disagreeable things about Morberg. Oh, but the man was drunk . . . better to leave him in peace and only listen to his nonsense with half an ear. He didn't deserve any better.

The solicitor got up, banged the cork back in the bottle and put it in his back pocket.

"You'd better leave the bottle," said Sylverius. "You can't stand much more this evening"

The solicitor pushed him away.

"I'm on my way to Abraham's bosom now," he said. "Fare thee well, my wealthy friend. We shall perhaps see each other again later . . . when we are sitting each on his own side of the abyss!"

Sylverius could not help but feel a little confused when Morberg had gone. Our good Johan Morberg was obviously in his most vicious mood this evening. Oh, but it was foolish to take much notice of that drunken talk.

Though . . . there was naturally a grain of truth in it. The rich man and Lazarus. And that bit about fortune favouring him, often to an unreasonable extent. But . . . at least one misfortune had struck him: the Dumbarton. And yet one could talk of misfortunes and misfortunes.

"You with your store of riches and property on earth," the solicitor's voice rang still in his ears.

But now he heard the sounds of an engine, presumably the mail boat from Storefjord. That was what he had been waiting for, for there was probably a letter for him from Bernhard. Bernhard had gone off a couple of days ago on a business trip to Østervaag and Storefjord, so perhaps he might even be coming back himself this evening.

" . . . And Lazarus died, and was carried by the angels into Abraham's bosom: the rich man also died, and was buried; but when he opened his eyes . . ."

Sylverius failed to get Morberg's biting words out of his mind. Another text came to him, and he was immediately filled with a sense of cold and darkness inside him: "It is easier for a camel to go through the eye of a needle, than for a rich man to enter into the kingdom of God." That was what it said. He remembered this text from the time he was going to confirmation classes, and he could remember as well that in those days he had felt relief at the thought that his father was not what one could call a rich man.

But the words should probably not be taken too literally. Besides, there is rich and rich.

There was a knock on the door. Bernhard entered. He was wearing a new dark green suit and carrying a light-coloured grainy raincoat over his arm.

"Good evening. Yes, I'm back. I thought I might just as well take the mail boat this evening. The weather's so good and I didn't want to spend the night among all those sectarians in Storefjord."

Bernhard sat down. Morberg's empty glass was still on the table.

"Yes, I've just had Morberg here on a visit," explained Sylverius.

"Morberg?" laughed Bernhard. "I thought that he'd turned his back on the world and all its good things."

"I don't really know what's going on inside him," said Sylverius pensively.

Bernhard was full of good news. The price of dried fish was rising. It was fortunate that they had had the autumn fish dried in Justinus Forberg's drying plant in Storefjord. Now it was all ready there and going up in value. If it had been sold freshly salted in the autumn they would hardly have got half as much for it as they now had in prospect.

He had also been negotiating with the insurance agent concerning compensation for the Dumbarton and had the promise that the insurance for the ship and its catch would be paid at the beginning of January. And that was good money.

Bernhard lit a cigarette.

"Incidentally, it's a pity we don't have a drying plant our-selves," he said. "It would soon pay for itself, and there's no point in sending the fish to others to have it dried."

Sylverius nodded absent-mindedly. Bernhard looked at him impatiently. Sylverius didn't seem particularly excited at the news. He just sat looking ahead, languid and evasive. Bernhard was irritated to find him so uninterested. Though he suspected he knew the reason.

"Oh well, I'd better go home and get some sleep."

Bernhard rose and brusquely wished Sylverius goodnight.

At home, Elisabeth was saying evening prayers together

with her parents. She was already making good progress in turning the old people's heads. Bernhard did not want to go into the room where they were sitting and listen to their prayers and confessions. He was tired after his journey and went straight to bed. But it was a long time before he could fall asleep. His sister started to sing downstairs; it was heartbreaking to listen to ... oh, this sectarian movement was spreading like an epidemic. Which reminded him that he had greetings from Justinus Forberg to Sylverius, but had deliberately not passed them on: Justinus intended coming to Holmvige together with some of the other members of the Storefjord Mission to hold a public meeting. "If only the Devil would turn up in person to disrupt that meeting," thinks Bernhard to himself, clenching his teeth.

Oh well, there was nothing for it for the time being but to put a good face on things. And otherwise hope that the night would bring a change for the worse as far as the weather was concerned.

It is late in the morning before Bernhard awakens. It is Sunday, the last Sunday before Christmas. He gets up and dresses. Out in the sound a white dot has come into view amidst all the grey. It is obviously a motorboat. He takes out his telescope. Yes, it's a motorboat . . . Justinus Forberg's big one. It's full of people in their Sunday best. Now he can distinguish the individual passengers. There is Justinus Forberg himself, and his wife and daughters. And there is Johannes Nordbo, the merchant . . . John the Baptist, as they call him over in Østervaag. And Gunnar Kjovnæs, the fish grader, and Klein the building berth superintendent, and Peter Hammer the baker. Yes, they are all there, all those sanctimonious nobs from Storefjord.

And now the boat is coming alongside Sylverius's quay. There stand the preacher, his sister and Egon and some others of the converted . . . Elisabeth in the front row, of course. And indeed, there comes Sylverius as well, bareheaded and waving hospitably.

Bernhard turns away. He sits for a long time staring at his hands, filled with disgust and contempt.

. . . Sylverius greets Justinus Forberg and his wife and daughters. Justinus is an elderly man, thickset and with large, coarse features. He is wearing dark glasses.

"Yes, here we are," he says gaily. "We thought the weather was so good today, so we decided we would have this little trip."

He takes off his glasses and rubs his small red eyes.

"I don't see too well," he explains. "Can't stand the light . . ."

"You know you mustn't rub your eyes," his wife warns him anxiously.

Sylverius turns to the preacher: "Wouldn't it be a good idea for the visitors to have a little snack first?"

Reinhold thanks him: "Yes, that would be lovely. The idea was actually to go to the hotel, but . . ."

He clears his throat and then informs them in the voice of a preacher: "Sylverius Ejde, the man who has provided us with premises in which to hold our meetings, invites you all to his home for a cup of coffee before we begin."

The people from Storefjord nod and look gratefully in the direction of Sylverius. These are quiet, serious people, well dressed and restrained. Nordbø's wife, who is English, has a flag-like checked shawl draped across her shoulders. She is dark and has smiling black eyes.

"A lovely place, Holmvige," she says in her semi-English and nods to Sylverius.

Simona receives the guests in the entrance hall. She is blushing with embarrassment and making small involuntary movements with her head.

Sylverius introduces Justinus Forberg to her . . . "This is the man who has dried our autumn fish."

"Yes, and if you are thinking of selling it now," Justinus interrupts him, "I can offer you a good price. I'm sending a consignment to Spain in a fortnight. But perhaps you've made other arrangements."

Sylverius hesitates a little: "Well . . . Bernhard Thomsen has just started negotiations with Kleivland and Braga, so I don't really know. But we can come back to that."

Justinus nods amiably. "No, I was just asking. But I'd better warn you not to wait much longer before you sell, 'cause the Icelandic trawlers are not far away, and once the new fish come on the market . . ."

The guests take seats in the living room. Mrs Nordbø has hung her shawl up. She is dressed in foreign clothes and radiates a sweet and expensive perfume. She sits in the middle of the sofa, and the other women have grouped themselves around her.

"No, if only we had sunshine throughout the winter," smiles Justinus Forberg, continuing the discussion on fish. "Just enough sun and dry weather, then no one could compete with us. Artificially dried fish might be good enough, but it's not as good as the real thing . . ."

"But it's the future," remarks Klein. "The country has already earned hundreds of thousands of kroner since we started the drying plant and no longer needed to salt the autumn fish before selling it. But of course, it requires capital, for a ship owner without capital is unfortunately still forced to sell straight away in order to have something to stave off his creditors."

"Aye, you need capital," confirmed Nordbø. "And, as we all know, that goes up and down. One year you can be lucky and make good money, and the next you can be unlucky and find yourself on the rocks again. No, what we need is a bank for the fishing industry that could regulate the flow of capital. But I suppose there'll be one sooner or later, because we *need* one."

He nods to Sylverius. "You must help us to organise one; you'll not regret it. Forberg's in on it, and so are a lot of other good men, both in Storefjord and Østervaag."

He throws his head back and looks up in the air. "For everyone here's interested in the fishing industry. It's life and death to us all. Healthy fishing means a healthy country. Ship owners need better conditions."

"Yes, and so does the fisherman," adds Peter Hammer, the baker, looking eagerly around the group. "For he's the one who has the hardest work."

"Oh, that'll take care of itself provided the overall profit is good," argues Klein.

"It will *not* take care of itself," maintains the baker stubbornly in an increasingly acrimonious voice. He goes on, nodding and gesticulating. "What's the point in the skipper going off with all the profit? He's paid a lordly wage, often up to about ten thousand, while an ordinary fisherman has to be content with a few hundred for working like a slave. It's so blatantly unjust that an honest man can only be infuriated by it even if he's not a fisherman himself or has children or relatives that are."

Justinus Forberg smiles soberly beneath his greying moustache. "Well what should one say? I've been both a fisherman and a skipper. And as a fisherman I didn't dream of anything except becoming a skipper, and when I was a skipper I dreamt of becoming a ship owner. So the fact is that a good fisherman always has the chance of becoming a skipper. And if he's good, the skipper can perfectly well become a ship owner."

"Yes, there's no doubt about that whatever," says Kjovnæs, glancing admiringly at Forberg.

"Aye, for inequality between rich and poor is something we'll never solve in this world," adds Johannes Nordbø. "There are always those who can't be bothered to do anything. And they're not always the ones who have been born poor. On the contrary, those who've been born poor are often the ones who do best."

The table is laid for coffee and the conversation continues. The various markets are discussed, Spain, Italy, Portugal, Brazil. Sylverius sits silently, listening and learning a good deal about things of which he has hitherto been ignorant. He is simply amazed. Is it possible that these clever and percipient businessmen who apparently have their feet so firmly planted on the ground really are the fanatical sectarians from Storefjord?

Justinus Forberg tells of a deal he once made with a young fish buyer who was quite new to the game and amazingly badly informed on market prices. He offered a price that was far too high.

"But as he had good connections with his bank, I agreed the price," laughs Forberg, taking off spectacles. "Not that it was such a big consignment."

He adds hastily, "Oh well . . . In a way it wasn't a nice thing to do to take advantage of his foolishness and lack of experience. And I regretted it and went and suggested some alterations in the contract, in his favour. But there the young man turned out to be difficult. He was furious and asserted that I had been perfectly aware I was cheating him. He called me all sorts of names, and I've not seen anything of him since. Hm . . . that sort of thing doesn't happen often, 'cause fish buyers usually know what they're talking about."

"Even so, you were cheating him," remarks the baker with some weight, raising his thin face. "That wasn't a nice thing to do, Justinus Forberg. It was disgraceful."

Justinus puts on his glasses again.

"I don't need you to tell me that," he replies calmly. "I'm perfectly well aware of it. And I've not tried to make myself look better than I am. In any case, I sent him a cheque for the difference later, if you really must know. That was the most I could do."

"Oh, did you really do that, Justinus?" says the placated baker.

Justinus Forberg nods and bows his head at the same time. He strokes his beard and without looking up adds: "But the check was returned."

The fish grader closes his eyes and laughs and hides his head with his shoulders.

"Well, what was I to do?" continues Justinus. "You can't force someone to take compensation he refuses to accept."

"I know what I would have done in your place," says the baker emphatically.

"And so I did, too," replies Forberg gently.

"Well, what did you do?" asks the baker a little uncertainly, as though he felt he was being made a fool of.

"Go on, guess," teases Justinus.

"Guess?" repeats the baker, looking around suspiciously.

"Well, what could a Christian do but give this . . . dirty money to the poor or to the congregation?"

But now, Johannes Nordbø intervenes. He turns to the baker and speaks pedantically, as though to a child: "Now listen, Peter, do you really doubt that Justinus would neglect any opportunity to perform a charitable act? Do you think you have any right to doubt it?"

And the baker is silent, slightly embarrassed, but with shining, argumentative eyes.

Sylverius looks at Justinus Forberg and feels both attracted and repelled by his manner. Forberg is a powerful, raw-boned man, obviously a man used to hard work, and his face is coarse and battered. And yet there is something strangely appealing about this face . . . something extremely experienced and yet shy and humble, almost child-like.

The visitors sit down around the table. For a moment they all sit silent, with bowed heads and closed eyes. Sylverius, too, bows his head. He feels awkward in the total silence that has arisen. The ticking of the clock is the only sound for some minutes. But suddenly the silence is broken by a deep and emotional voice:

"We thank thee, Lord Jesus Christ, for the food we are about to receive. Bless our visit to Holmvige and let it bear fruit. Bless and preserve the people who live in this village. Bless our host and his wife, and guide them on the path to redemption through Thy great and wondrous grace. Amen."

It was Justinus Forberg who spoke. Now he raises his head and strokes his whiskers. And the conversation resumes and covers the old ground. Klein has recently returned from a visit to Munkø and can tell them about the large-scale trawler purchases the merchants down there have embarked on. A dubious speculation, he thinks. Trawlers are expensive to buy and expensive to maintain, and trawled fish can never be as good as real quality fish.

"Oh, trawlers are very good," asserts Mrs Nordbø. "Hand line fishing is too slow."

"Oh well, we can at least benefit from these Munkø owners' experiences," is the opinion of Klein. "And in gen-

eral . . . there's no denying that they are ahead of us in many ways down there."

"Well, in what way?" asks the baker.

"Well, for instance, the drying is done much more quickly down there," says Klein slowly. "They really know how to get people working. . ."

The baker shakes his head: "Yes, I've heard about the way they treat them like slaves down there. That's nothing to sing their praises for. And then they've got what they call a club where these fine folk sit drinking and playing cards every Saturday evening and right on to Sunday morning."

The baker's voice adopts an uneasy tone as though he is on the point of weeping. He has presumably heard how it went when the wealthy merchant Johnny Finsen died of a heart attack in the summer. It was after a riotous drinking session . . . they had been drinking in competition with some fish merchants . . . this Braga was one of them. But then someone was suddenly heard shouting from outside: "Come on Johnny. I'm here now." That was in the morning, Sunday morning. "Yes, I'm coming," Finsen replies and turns terribly pale, and at that very moment he fell down dead. But there was no one to be seen outside. No one had called. And who do you think it was calling, my dear Johan Klein? Tell me that."

Klein nods heavily. "Aye, it was a terrible, sad event. I spoke to a man down there who was there when it happened . . . He said it was Johnny Finsen's wife who had been calling."

"Wife," shouts the baker triumphantly. "Yes, my friend, but Finsen's wife died years ago."

Klein nods: "I see."

The baker looks around with a smile: "I see? I see – that's all he has to say. Tell me, Klein, is there something wrong with you, my friend? I'm telling you that that wife of his died years ago."

"Yes, yes, yes," says Nordbø dogmatically. "She still called . . . from the beyond, then."

"Oh, like that," says a subdued baker, taking up his cup of coffee. He adds, "Yes, if it was a woman's voice that might explain it. But otherwise . . ."

317

"No, I'm well aware that they can be pretty rough down there," Klein goes on, turning towards Reinhold Vaag. "Perhaps that's a field we might work in."

"Yes, I have thought about it," says the preacher. "And Tekla has talked about it, too. Perhaps we can manage that as well, God willing. We'll see."

II

As the weather was unusually mild, the people from Storefjord held their meeting outdoors, in the open space in front of Sylverius's store. Never had there been so many participants as on this occasion.

The preacher opened the meeting with a prayer. Then they sang hymns. Johannes Nordbø's English wife and Justinus Forberg's daughters played the mandolin, and in the midst of the group the baker sat at a small portable organ. Voices and melodies cascaded into the air and were countered by an echo from the mountains. It was a rare and captivating experience for the people of Holmvige. Small as this organ was, it was many times more powerful and beautiful than the organ in the church. The baker played using all his fingers, not just two, as Esmar the schoolmaster did when he played in church.

After the hymns, Justinus Forberg stepped forward. It was strange to hear the wealthy old merchant from Storefjord tell of his conversion. It had come quite suddenly one Sunday afternoon when he was on board his ship the Geoffrey Twyde, which was anchored out in the roads. He had rowed out there, all on his own, without any particular errand, just to take a look at the good old ship that he himself had skippered in his youth, and which he knew in and out. He walks to and fro on the deck, engrossed in old memories. So much had happened since he had skippered this old vessel. He had become a rich man in the eyes of the world, the owner of ten ships, a whole fleet, the owner of a building berth, of warehouses and goods and a store. And yet there was a curious emptiness about it all on this dark Sunday afternoon. He felt depressed and without

firm ground to stand on, for he had not found grace and only knew transient earthly pleasures. He goes down the ladders to the forecastle and into what used to be his own cabin. In the plank above his bunk he had once carved his own initials: "J.N.R.J., Justinus Nikolaj Rasmus Jacobsen . . . that was before he took the name of Forberg. It suddenly strikes him that these were the letters above the Saviour's Cross. The thought had never struck him before, although he had throughout his life been a member of the ordinary Christian church. Now he suddenly feels affected by it.

He sits down on the edge of the bunk and rests for a moment. There are some papers on a little shelf in the locker belonging to the bunk. He takes them out. They are some English tracts, probably brought back from a visit to England, and the skipper has put them aside here and forgotten them. He opens one of these pamphlets and his eyes light on a text written in italics: "Now is my soul troubled. And what shall I say? Father, save me from this hour: but for this cause came I into this hour . . ."

And as he sat there in the narrow cabin, he suddenly, in some inexplicable way, felt that God had spoken to him. He felt filled with a strangely new and unknown joy. It was as though he awoke from a sleep lasting many years, and he sat there for a long time in the darkening cabin, sometimes heavy at heart, sometimes bursting with joy. For it was God who was with him, Jesus, the lettering from whose Cross he had once, by chance, carved out above his bunk.

That was how his conversion had started. A few months later he had joined the Mission . . . He felt that of all the paths this was the only one leading to salvation and grace.

The people from Storefjord were skilled preachers. Their addresses were brief and pithy, not long-winded like church sermons. They all stepped forward, each of them with a personal testimony to proclaim. They spoke of the need for conversion and described the shattering and wonderful experience when God's presence is felt and the certainty of redemption permeates the soul.

Klein had had this experience for the first time one day when he was reading a book about the marvels of technology. It was a secular book that said not a word about God's presence in nature, and yet reading about electricity, which is invisibly present in all things, had moved him in a religious sense. And as he sat reading there by the window, the sun suddenly came out and dazzled him. He got up to draw a curtain across the window, but just as he did so he happened to stare at the sun and became aware of the cross, the dazzling cross there is in the sun and which is incidentally present in all light – never before had he given that a thought. And at the same time it was as though he heard a voice within him saying: "Do not shut me out of your mind."

Since then, he had chosen the Cross, the mighty Cross in the sun that is raised over the whole of nature as a sign of Jesus Christ's victory over death, and as an admonishment not to exclude redemption and grace from your mind.

Johannes Nordbø had originally been an opponent of the Mission. He had been a member of the evangelical wing of the State Church and had been a witness to how so-called Christians of that kind hate and persecute other denominations. But he had been converted in the English city of Hull, where he had arrived in his ship, the Merry Wave, to sell a consignment of washed and pressed fish. He had ended up in bad company one evening and had gone on a binge in various dockland pubs together with a young fish merchant and some poor fallen women. He had drunk himself out of his mind and immersed himself in the muddy, sulphurous waters of sin. When he woke up again, he was lying on a bench in a small inn, and some women wearing uniforms came and gave him powders and warm milk. He felt dreadfully ashamed and hardly dared look up. But then they had come across to him, knelt beside him and prayed for his soul. And that had not been in vain. He had been filled with fresh courage; he had regretted his sin with all his heart and felt that redemption had undeservedly been granted to him, and he thanked God who through humiliation and shame had guided him to the light of His grace.

Kjovnæs, the fish grader, had been converted recently . . . no more than a month ago. It was Forberg's words that had caused him to reflect. To begin with he had felt deeply unhappy because he doubted whether he had received the gift of grace and felt crushed by the burden of his sin. But one dark and stormy evening, when he had come home from a meeting in Bethel, he had had a feeling as though someone was following him . . . it was not a human being, and yet it was something strangely alive, like a warm current of air. And this inexplicable thing had filled his soul, and at a stroke he had become seeing and was now a believer. There in the dark, he had met his Lord and Redeemer.

The last speaker was Peter Hammer, the baker. He looked stern and uncompromising, and his voice trembled with accusations and reproaches.

"Today, we have heard so much about the gospel of redemption," he said. "I for my part must say that I do not know whether I am redeemed. I have experienced Jesus, but since then He has often slipped away from me. For grace is a bird in flight. It is nothing permanent, not a jewel you can hang round your neck and not a sum of money you can pay into your bank account. No, it is rather like a lamp that goes out if you fail to pour fresh oil into it. The humble oil of repentance. Blind eyes still think the lamp is burning, but that is no more than an illusion. Only he who every day and every hour in the day ensures there is oil in his lamp can keep it alight. It costs trouble and effort. But life is an incessant battle against the dark, choking waters of sin. You and I are both in the midst of this struggle, and we must fight until our hands bleed and a bloody sweat runs down our foreheads and our hearts turn to ice. Every morning you must awaken and arm yourself for this struggle, for your day is filled with sin, full of resentment and desire and unclean thoughts. If you have battled throughout the day, you can perhaps fall asleep in the evening with the taste of grace on your tongue. But I believe rather that you fall asleep with the rancid taste of sin on your palate."

The baker's words are cast over his listeners like gusts of

biting wind. His eyes shine black and sharp like bodkins in his thin, pale face. This baker is no ordinary character. A short while ago he was playing the organ quite competently, and now he is speaking like thunder and lightning.

"You must fight," he goes on. "Fight every hour of the day. Do not believe too blindly in grace, for you might easily be disappointed. Turn unto the Lord, but do something to retain the faith you have achieved. It will soon be too late; soon all doors will be shut to you and you will sink lonely and deserted to the bottom of the pit, like a weight that is fixed to no line."

The baker bows his head. His features relax and he looks as though he is on the point of weeping. He says a brief prayer: "Strengthen us in our daily struggle, Lord. Heal our wounds and fill our miserable souls with the balm of consolation. Amen."

Then he sits down at the organ again.

Sigvard Hovgaard, the parish clerk, has stepped out from the congregation during this last address and stands there now with his head uncovered. He strokes his beard uneasily and coughs as though he is going to speak, but nothing comes of it. The organ begins to play, and the singing starts.

Sigvard puts his cap on, turns half way towards the group of listeners and raises his elbow as though to defend himself. During the singing, he stands there talking aloud to himself, and as soon as the last note has grown silent he again steps forwards and in a voice that is half unrecognisable on account of emotion, he says, "I warn you, you people of the Mission. In the sacred name of the church I warn you against coming here and creating dissent and sowing your tares among the wheat."

He turns his back on the visitors from Storefjord and goes on, addressing the congregation, which is becoming uneasy: "And I warn you, members of our church community, against putting your faith in what these rebels here proclaim. Here I stand . . . God in Heaven knows I condemn no one. But . . . but . . . may Jesus our Saviour help us against the diabolical powers seeking to spread confusion in our minds and poison

322

them with false and brazen words. Yes, that is my prayer. Amen."

Again he pulls his black velvet cap down over his head and with firm, determined steps moves back to his place among the congregation.

The preacher steps forward . . . all eyes are turned towards him in the expectation that he will now give Sigvard a sharp reply, a crushing rejoinder. But that is not to be. He folds his hands, looks up and prays in a gentle, conciliatory voice: "Be with us, O Lord. Strengthen us all, guide the good will to victory and bend recalcitrant minds to Thy Will, You who Yourself said 'Forgive them for they know not what they do.'"

He goes on in conclusion, "Today we have heard the witnesses of several converted Christians, happy and grateful as well as concerned and admonitory. But they all have in common the scruples they reveal, the profound shock to the soul that is the sign of the converted and those who thirst for redemption and grace. This shock will come to every honestly seeking soul sooner or later . . . even to the man who today in his blindness persecutes us. And that will be Jesus knocking on our door and asking to be let in. Let Him not knock in vain, my friends."

Dusk is starting to fall. The tops of the mountains adopt a warm and melancholy colour from the rusty yellow sunset sky in the south west. The meeting is finished, and the people from Storefjord talk together as they walk slowly down towards the quay, where the motorboat lies chugging and expelling blue rings of petrol fumes.

Sylverius walks alongside Justinus Forberg.

"Aye," sighs Justinus. "This is lovely summery weather in the middle of winter."

He adds in a quiet voice, with a slight smile: "That parish clerk must be a rather acrimonious sort of person?"

Sylverius nods.

Justinus goes on: "Oh, the baker's no less acrimonious in his way. But . . . you ought to become better acquainted with him. He's really a fine man. But when you only know him

superficially it's easy to get him wrong. He's always got to contradict everyone else. It's an urge he has, a sort of feeling of superiority you might say. But he always repents of it afterwards, and he's really such a nice, good man . . . we're all very fond of him."

And Justinus suddenly changes the subject: "It's a nice place, Holmvige . . . These big drying grounds for fish, are they all yours?"

"Yes. I recently bought Niklas Næs's ground over on the other side; it's a fine drying ground. You know, he was unfortunate, poor old Niklas, and he had to give up."

"Aye, poor man." Justinus shrugs his shoulders. "What does he live on now, by the way?"

"He's got the post," Sylverius informs him. "We arranged for him to have the post when Stefanius, the old postman, died. So he's really all right."

"By the way," says Justinus. "When we were at your house we were discussing a bank for the fishing industry. That's something we're planning. I don't remember whether you promised to support us . . . but would you be interested in taking part? Think about it. It's men of your calibre we need."

Sylverius promised to think about it.

"And do you know what I thought of before?" Justinus went on. "You ought to set up an indoor drying plant here in Holmvige. I recommend it to you even though there's no denying I make more out of it if you send your autumn fish over to me to be dried. But you understand, one's only a businessman within certain limits. Beyond that you don't any longer feel like a businessman, but as a . . . brother, if I may put it that way. A drying plant isn't all that expensive if you go about it in a sensible way, and it soon pays for itself. That's my experience."

"Yes, perhaps I should think about that as well," says Sylverius.

"You could come over and see my plant . . . some time when you have the time. You can learn something from my experience and in that way get it going more cheaply."

"Thank you," says Sylverius.

III

The Storefjord boat slid out into the twilight. The sound of the motor slowly disappeared. Sylverius stood at his office window staring out over the darkening bay.

He felt strangely agitated and troubled in his mind.

A drying plant . . . yes, of course it was a good idea to build his own plant here in Holmvige. That was what Bernhard was keen to do. But how these folk from Storefjord, how Justinus Forberg, who had given such a moving account of his conversion . . . how he could also have worldly things on his mind and even be so concerned with them, was something he failed to understand.

Can you be a follower of Jesus and an ordinary, down-to-earth person at one and the same time? Was there not something about its being easier for a camel to go through the eye of a needle than for a rich man to enter heaven? He had recently been struggling with such thoughts. Yesterday evening he had lain reading the Bible and had come to the place about the rich young man whom Jesus tells to sell his possessions and divide the money among the poor. You wouldn't think it was possible to get round these words. The meaning was clear enough: you have to pay something, you have to sacrifice, if your soul is to be saved.

To build a drying plant might of course be practical enough for its purpose. But . . . he had to smile. Here he had gone around thinking he was a kind person. But then one fine day he discovered that he had misunderstood the way the world worked. Or has he not looked deeply enough and only concerned himself with the surface in the way of an everyday Christian?

You buy ships and you build houses . . . and one day you are no more. You yourself are like a ship, well caulked and equipped with a motor, sails, compass and sextant. And provisions for some time. But one fine day, the waves have hemmed you in. And if only that were the end once and for all. But that is where life really begins . . . eternal life, in comparison with which earthly life is only like a single

glittering herring scale sinking in an ocean of millions and millions of fish.

Sylverius felt sick and ill at ease and at the same time strangely alive in all his senses. A tap was dripping out in the shop, quite gently, almost inaudibly . . . a carefree little melody in the silence. And there was an all-pervading warm, sweetish smell of shop, spices, tobacco and paraffin coming in through the open office door.

What shall I do that I may inherit eternal life? Those words resounded throughout his mind.

Suddenly, there was someone knocking at the door, several hard, uneasy knocks. He went across and opened the door. It was Simona. She came in quickly and taking him firmly by the arm and with tears in her voice, said, "Why are you out here alone? Why don't you come home?"

He put his arms round her and stroked her cheek to calm her: "I'm coming. But what on earth's the matter with *you*? What are you crying for?"

"Oh, these sectarians, these folk from Storefjord, and the preacher and the whole lot of them," exploded Simona. "I can't stand them. I won't allow you to go and let yourself be baptised by them. Do you hear? I won't."

She pressed her forehead hard against his shoulder and held his arm tight.

"Yes, but . . . what have you got so much against them?" asked Sylverius gently. "They are good, decent people."

"Yes, that may be," said Simona. "But what's all this talk about rejecting infant baptism and getting up and confessing and all that?"

She stopped weeping.

"Oh, it goes right through me when I hear them confessing and singing," she said quietly. "I can't explain what it is I feel . . . but it's almost as though they were forcing each other to take all their clothes off."

"I know what you mean," said Sylverius quietly. "I must admit I've felt the same. But that's only at first. You're quite right when you say it's like undressing . . . spiritually speaking, that is. That's exactly what they do. As for us, we go and hide

326

ourselves in . . . in self-deception. We are so very much afraid that anyone might see our naked souls."

"Yes, but it's not only *that*," Simona objects. "I mean, it's not only spiritual . . ."

"Not only spiritual?" asks Sylverius in confusion.

"No, perhaps I'm just talking nonsense." Simona feels slightly embarrassed. She smiles: "But come home at any rate. We're not going to stand here all evening."

The table is set for supper at home in the dining room. Simona begins to calm down again.

"Perhaps I was only talking rubbish before," she smiles. "But I can't help it . . . when all is said and done, that's what I'm like."

Sylverius sits down at the table with a serious look on his face and says thoughtfully while buttering a slice of bread, "No, you see, Simona, what you were saying was not silly, quite the contrary. But this reticence about approaching God and truth and about letting others participate in the joy we feel in so doing . . . that's something you and I will have to try to get over."

"Yes, but I don't understand why they can't leave infant baptism alone," sighs Simona.

"Baptism, aye."

Sylverius sights and stares ahead with a troubled look in his eyes.

"I don't really like Mrs Forberg," Simona continues. "She looks so nice. And so do her daughters. And the other woman, Nordbø's wife . . . she's a curious, mixed-up creature, don't you think?"

Sylverius sits lost in other thoughts. "Ehh . . . Nordbø's wife. Oh, the Englishwoman? Well, she's . . . English."

"English? Yes, but she's a dreadful woman. Don't you think? Or do you find her charming just because she's English?"

And suddenly, Simona pushes her plate across the table and leans forward with her face hidden in her arms.

"Oh, what's wrong now?" says Sylverius. He is quite shocked and gets up. "What's wrong, Simona?"

"Oh, I can't stand that woman," Simona sobs. "She sat looking at you all the time . . . you know she couldn't take her eyes off you."

Sylverius has to smile.

"No. Listen, my love. That can't be right. At least I never noticed it. No, I'm sure you're wrong. It's something you're imagining."

Simona is angry and there is a stubborn ring to her voice. "I am *not* mistaken, I tell you. And that's what they're all like, all these sectarians. The sheriff's wife's told me, and she knows all right. Oh, you should just know what goes on among them."

"That can't possibly be right," says Sylverius. "And the sheriff's wife's not a person to be relied on if what I hear is correct. No, evil tongues have probably been wagging, Simona. You can never get away from them."

"Well, you might be right about that," Simona admits.

They sit for a while, staring ahead, lost in thought.

After the meal, Sylverius fills his pipe and sits down in an easy chair by the stove. He does not light the pipe, however, but sits absent-mindedly weighing it in his hand.

"I don't think we should attach too much importance to what the sheriff's wife has told you," he says slowly. "But there's something quite different, as well . . . Can you understand that these people who call themselves saved and are so sure of being God's children . . . can you understand their worldliness? It says in the Bible that no one can serve two masters. I just don't understand it . . ."

He gets up and takes out the Bible.

"Yes, here it says quite explicitly: 'No man can serve two masters: for either he will hate the one, and love the other; or else he will hold to the one, and despise the other. Ye cannot serve God and mammon.'"

He turned some more pages.

"And here . . . just as clearly: 'And he that taketh not his cross, and followeth after me, is not worthy of me.'"

"No, that must be right," says Simona quietly.

Sylverius puts the Bible down open on the table and walks uneasily to and fro. He is soon engrossed in the text again.

Simona is reluctant to disturb him; she takes out some needlework and sits down over by the lamp.

"Yes, just listen," says Sylverius in a low voice: "'If thou wilt be perfect, go and sell that thou hast, and give to the poor, and thou shalt have treasure in heaven: and come and follow me.'"

IV

Sylverius does not have much sleep that night.

He ponders and ponders until everything goes round for him, and he has to abandon himself to this painful vertigo. No, he has probably not been called to be an interpreter of the Word of God; these words in the Bible are beyond his ability to comprehend. Only one thing remains, that no one can serve both God and mammon. That is a straightforward message, and there is no misunderstanding it.

"Go and sell that thou hast, and give to the poor, and thou shalt have treasure in heaven." That is the Saviour's message to anyone who possesses something, to the merchant and ship owner, the wealthy farmer, all those possessing worldly wealth. Only when these worldly ties have been cut, when you have made your sacrifice, only then are you ready to follow Jesus.

I see – but supposing I did that.

Sylverius imagines selling all his property, ships, houses, motorboats, quays . . . freeing himself from all these ties. It might perhaps be difficult to find a buyer he could rely on. But suppose the sale goes through. Then you divide your money out among the poor . . . naturally in such a way as not to attract attention. And then, at last, there you are, free from all ties. You can then start from the beginning again, as a fisherman, or as a skipper, for your qualifications as a skipper can't be sold after all. Life would become strangely easy all at once. You would no longer take earthly things seriously; you'd have your treasure in heaven.

"But you're not going to do that," a voice whispers inside him. "You know the path to salvation, but you're not going to take it."

For the first time in his life, Sylverius felt what was meant by being a weak and sinful person. And he thought with horror of how many people there were of his kind, and how few possessed the strength and courage to take up their crosses and follow the Saviour on the bitter path of suffering . . .

It was almost morning before he fell asleep. But even then he only dozed restlessly for a couple of hours.

He woke bathed in sweat, and had all the time dreamt about lying and fighting to free himself from a pile of nets, heavy, dark red herring nets, wet and sticky, that had been piled over him by some evil power. He had some idea about Satan's snares. And suddenly he was struck by the depressing thoughts of the previous day and night, and they started all over again.

. . . Sylverius sat throughout that day lost in the Bible. It was a windless, heavy day with an overcast grey sky. At midday a thunderstorm came on. It started with quite small flashes of lightning that were followed by a distant rumble, but it quickly came closer. Simona came into the living room smiling nervously. She drew the curtains and lit the lamp. But she could not muffle the thunder, and the peals became stronger and stronger, and they were ominously echoed by the mountains. Finally the thunder merged with its echoes; there was an unbroken noise; the house shook, and big hailstones as hard as pebbles started rattling now against the roof and windows.

Simona stood with her hands pressed to her ears. But Sylverius sat with a strangely animated expression in his eyes. He had put the Bible down on the table and sat staring and listening with a look that reflected an almost boyish merriment.

For the moment, Sylverius had really forgotten his worries. He thought of an occasion when he had been in his first ship, the Lizzie, close to the English coast and an enormous thunderstorm had come on. The cook, an older man whom they all respected, had been beside himself with fear; he swore he had seen a ball of fire in the shape of a little sausage neatly roll down the main mast and some way along the deck and finally disappear into a small provisions shed. And when the storm was over he emerged with a piece of salt meat that he main-

tained had been struck by the lightning . . . it had in any case of its own accord jumped out of a barrel of brine and was warm and a blackish blue when he found it.

"It's passing over now," said Simona.

The rumbles became more scattered now. There were a few more claps of thunder, but then there was nothing but the rattling of hailstones.

Sylverius told his wife about the salt meat that the lightning had struck. No one on board would believe the cook's explanation, and they subsequently nicknamed him Thunder Sausage. And in a curious way that suited his appearance, for he was small, round and swarthy.

"I actually stood up for him," Sylverius went on. "For it wasn't always much fun on board for poor Thunder Sausage. But he paid me back in a peculiar way. It was about a year later, close to Iceland. I was taken ill and had to stay in my bunk for several days. And Thunder Sausage looked after me as best he could. But at the same time he gave me to understand that my last hour had come. He had dreamt it and seen various omens. Among other things he had met the grey dog that was supposed to turn up on board when a death was expected. And you can imagine I was rather worried about it for a time. But I recovered, and Thunder Sausage had to eat his prophecies."

Sylverius stretched and rubbed his eyes. The thunderstorm and the memories of his time at sea had brightened him up and for a time put all heavy thoughts to flight.

He remembers another cook, Sigurd the Blacksmith. He was entirely different from Thunder Sausage, for he was a huge chap and not afraid of anything. But he couldn't cook.

Sylverius is about to tell his wife how Sigurd the Smith once made a dessert soup from fish heads, but there comes a knock on the door.

It is the preacher.

Sylverius invites him in and asks him to take a seat, but Reinhold shakes his head. He doesn't want to disturb. He just wants to ask Sylverius a single question: "What's this about the warehouse loft?"

"Warehouse loft?" Sylverius doesn't know what he means.

"So perhaps it is without your knowledge that we have been denied access to it this evening," says Reinhold.

No, Sylverius knows nothing about that. It must be a misunderstanding.

"Yes, I thought it must be," says the preacher with a look of relief. "No, you see, Bernhard Thomsen came over a short while ago and asked for the key to the warehouse. He said that we couldn't have any more meetings in the sailmakers' workshop, as people would be working up there both day and night. And so I gave him the key . . ."

"Come with me. We'll go across and have a talk to him," suggests Sylverius. "This is something he's thought up for himself."

"And he said something about our having to stop holding meetings here in Holmvige," Reinhold adds quietly. "He said we've caused enough trouble."

"But of course," the preacher goes on co-operatively, "if the sailmakers' workshop is to be used both day and night now that the ships will soon have to be rigged . . ."

"No," Sylverius shakes his head. "That's not the case."

They meet Bernhard in the door to his house. He is just going out.

"You've got . . . the warehouse key?" asks Sylverius.

Bernhard takes the big key out of his overcoat pocket. "Of course I've got it, Here you are."

His voice is trembling.

Neither Sylverius nor the preacher takes the proffered key.

"Here you are, here's the key," says Bernhard again impatiently.

And suddenly he loses control of himself: "What the hell . . . I said here's the bloody key."

Reinhold ducks involuntarily as though receiving a blow. "Yes, but as I say . . . if that's the way things are, we can hold our meetings somewhere else."

"Aye, you can hold you meetings with the Devil in Hell, so you can," Bernhard snarls in his face. "Or with the Devil's grandmother if you'd rather."

"Watch your tongue, Bernhard," says Sylverius.

He takes the key and hands it to the preacher. "You can hold your meetings in the warehouse loft just as before, Reinhold Vaag. I'm the one to decide."

"Thank you," says the preacher with feeling. "I won't forget your kindness."

"Phony," Bernhard snarls after him.

Sylverius shakes his head. It is a little while before Bernhard pulls himself together after his furious outburst.

"Oh well," he finally says in a rather embarrassed voice. "Perhaps I went a little too far. But I couldn't resist it. And now you can take it as you like."

"But by the way," he adds. "I'd like to have a serious talk with you, for there's something I want to know."

"Fine," says Sylverius. "I'm ready at any time. Let's talk things through, that's the best thing. We can go across to the office straight away."

"All right."

Bernhard lights a cigarette. His temper has completely subsided. He feels the need to explain both to Sylverius and himself why he had behaved as he did to the preacher. It was not nice of him. He admits that his gall has been rising for some time, and now things had suddenly become too much. But there was nothing to be done about that; what was done was done. And neither can he deny that he still despises and loathes this preacher and all his co-religionists in Storefjord.

"Aye, of course they have their faults," admits Sylverius.

"To my mind, they're either enormous hypocrites or completely stupid," says Bernhard.

"They're certainly not stupid. A man like Justinus Forberg . . ."

"Well then they're a crowd of hypocrites," Bernhard cuts him off.

"So you don't think . . . they live according to their own teachings?" asks Sylverius with interest.

"Oh, I don't know. I think it's their teachings themselves that are hypocritical. Or whatever you like to call it."

Sylverius opens the door to the shop. Bernhard continues

eagerly: "I do know something about it, for I can say in all modesty that I once lived for almost six months among sectarians of this kind. But that cured me. Every evening in their meetings you had your ears filled with their stories about their conversions, and in the end you were pretty well prepared and simply went expecting to be converted yourself, waiting excitedly for the moment when God's spirit would come and take up its residence in you, as they put it."

"Oh," says Sylverius, lighting a match.

Bernhard shakes his head wearily.

"Yes, and then one fine day it happens. That's to say you simply go nearly out of your head, and the others come and say that now it's happened, this wonderful thing, and you're redeemed."

"Yes . . . but perhaps they are right," suggests Sylverius.

"Well, that I can't say," says Bernhard. "For I never got to that stage myself. Because then something happened that nearly made me sick. You see it turned out that one of the keenest of these preachers the place was full of – that in his private life he was an arch scoundrel who went around seducing the young ladies in the sect."

Sylverius lights the office lamp. Bernhard has taken a seat and sits staring out in the air with his mouth twisted with disgust.

"Yes, that's how it all ended – as far as I was concerned."

"Yes, but surely they weren't all like that?"

Bernhard lights a fresh cigarette and blows out the smoke scornfully. "I couldn't be bothered finding out. I simply left without creating a fuss . . ."

Sylverius sits down pensively on the chair at the writing desk and remains there lost in thought for a while.

"Well, this story . . . does it really mean anything except that you've come up against a preacher who was a scoundrel?" he asks finally. "I suppose there must be a few of them, perhaps a lot. But this actual proclamation of eternal life, of sin and redemption and grace, the actual Holy Gospel . . ."

"Well, that will always be a principle that it's impossible to live up to," says Bernhard with conviction. "Just look at these

334

sectarians. Just look at Justinus Forberg himself. Doesn't it say in the Bible that it's easier for a camel to go through the eye of a needle, than for a rich man to enter into the kingdom of God?"

Sylverius suddenly turns pale.

"Yes, it does say that," he says quietly.

"Yes, and who is more interested in wealth and Mammon than the sectarians?" Bernhard continued. "There's hardly a rich man in the country who isn't a member either of the sect or the evangelical wing of the church. They mix God and Mammon up in one glorious hotchpotch."

Bernhard looks searchingly at Sylverius and adds, "Well, isn't that right?"

Sylverius nods.

"It's strange . . . that's exactly what I've been asking myself recently."

"Aye, and that's how any reasonably human being must think," says Bernhard in a more relaxed voice. He laughs quietly: "Justinus . . . a full-blooded heathen when you peel the skin off him. He's one of those who have made their way by haggling and fishing."

"Aye," says Sylverius reflectively. After a pause, he continues: "But you see, if you want to do as the Bible commands . . . what then? You'll have to give up trading, bargaining and selling, gathering earthly treasures as it is called. What do you think about all that?"

Bernhard's eyes become watchful. He thinks for a time before answering. Sylverius is breathing deeply. He sits in thought, twisting a small ruler of metal and rubber.

"You can do it without being hypocritical," says Bernhard finally.

Sylverius bows his head and looks away as he asks, "What do you mean? I understand it as saying that you have to choose . . . either God or Mammon. Either Jesus or the rulers of this world. Either this life or eternal life. And then what weighs most on the scales, Bernhard?"

Bernhard gets up and coughs to gain time. He has a nagging feeling that it is his own clumsiness that has turned the

conversation in this direction. It's as though he has got stuck now. He must either give a direct answer and say, as is true, that we know extremely little about eternity . . . he only thinks of heaven and hell as misty, figurative ideas that don't have to be taken seriously. Or else he must give in in order to put Sylverius off and keep wondering and meanwhile try to move him in a sensible direction. That would really be hypocrisy, but so be it.

"Well," he replies. "If there really is any question of such a choice, then naturally . . ."

"That's what I think," says Sylverius.

Bernhard gets up, leans his shoulder against the doorframe and scratches his nose thoughtfully.

"But listen," he says. "You talk of Mammon and earthly treasures as though you were a pure . . . yes, a pure Justinus Forberg. But how much do you really possess when it comes to the point? You should give that question some consideration."

Sylverius puts down the ruler and looks at Bernhard with a dubious little smile. "No, properly speaking, of course . . ."

"Mammon," Bernhard goes on. "That must be secure possessions that you've put aside and are sitting around and drawing interest on. That's the kind of thing you call Mammon and earthly treasure. But what do you really possess that you can with certainty call your own? Your fortune's on the water, my good friend. It's expensive to have ships, and nothing is more risky than the fishing industry. You are running a business that certainly looks as though it's going fine at the moment, but it can produce a loss in the autumn and could completely ruin you within a few years."

Sylverius gets up and runs his hand over his forehead.

"Yes, but . . . suppose I sold it all now?" he says in a low voice.

Bernhard gives a start. "Sold? . . . All right, yes, if you sold it at a good price you might perhaps have enough to let you retire and live on the interest. Or . . . give the money to the poor if you preferred."

He looks at Sylverius intently.

"Then I'd at least have my conscience clear," says Sylverius seriously.

"Yes, but what about your business here?" Bernhard protests. "It provides a lot of people with their livelihood."

"Others would take it up after me."

"Aye, but suppose these others also went and sold it and gave the profit to the poor?"

"Then the Kingdom of God would be at hand," replies Sylverius. And he adds in a quiet and slightly embarrassed voice: "'My kingdom is not of this world', it says in the Bible.

Bernhard glances at Sylverius. Can he really be serious about this? Is he really thinking of selling and realising all his possessions — for religious reasons?

He asks — not without a certain emotion in his voice: "Could you really imagine . . . sacrificing everything?"

It is some time before Sylverius replies. His cheeks are flushed, and his eyes hot and troubled.

"We must both seek to choose the right thing, Bernhard," he finally says. "I can't see any other way. We must pray to God, and perhaps He will give us the strength to choose the difficult way . . ."

Bernhard feels something in the nature of a tiny inner tremor.

So Sylverius' religious mania is a fact. Well then it's no good arguing any more. There's nothing for it but to let him ride out the storm.

V

Sylverius stays behind alone in the office. He is again surrounded by silence. Outside, he can hear the rain splashing on the paving stones, and inside in the shop the tap is dripping. He has a feeling as of God' presence and is uneasy, almost afraid. Perhaps the moment has come when God wants to speak to him.

He kneels before the office chair and folds his hands, shuddering with a dreadful expectation. And he is carried away . . . it is as though he feels his soul being dissolved and flowing out and becoming one with God; it is as though in some wondrous way he feels the boundless goodness emanating from on high and permeating the world, just as the warmth from a beating heart streams out in the body with all its thousands of currents of blood. He is trembling with emotion and presses his folded hands together so as to hold tight on to this great moment.

But suddenly, it is as though his eyes grow dark, and he feels a pinprick deep in his soul: "You are unclean, a lost sinner, you are not worthy of the crucified Christ."

And again: "You know the path to salvation, but you do not tread it."

He gets up again, filled with torment. It is some time before he can compose himself. There on the writing desk stands the lamp, its red flame seen mistily through the bluish white shade. And there is the calendar showing it to be the 19th of December. The green safe, the bookshelf with its files, the map of Europe over the sofa . . . All these things gradually emerge into sight, and the world becomes itself. The rain is falling and the tap singing its song.

How was it . . . he had almost felt himself lifted up into the presence of God, permeated with the warmth of the spirit. Perhaps what he had felt was a call. But he hadn't had the strength to follow this call; he had been too weak in spirit, too irresolute . . . so far.

Sylverius sits for a while rocking to and fro on the office chair, a victim of doubt and fear. Perhaps it would be best if he tried to pray. He kneels again. But he cannot collect himself to pray; he fails to get a word across his lips. It is as though God refuses to hear him.

There is a knock on the shop door. Sylverius gets up, broken and sick in spirit. He looks at his watch . . . It is almost eight o'clock. This must be Simona coming to fetch him to supper. He opens the door. But it is not Simona standing outside; it is Reinhold Vaag.

"Am I perhaps disturbing you?" the preacher asks politely. "I saw there was a light . . ."

Sylverius asks him in. He is not disturbing him, quite the contrary.

Reinhold had come to the conclusion that it was perhaps best they had another talk about the warehouse loft. It was asking too much to suggest that Sylverius should make it available to them for the entire winter free of charge. Justinus Forberg had also talked about it . . . Of course Sylverius Eide was not to do this free of charge, he had said. And besides, the intention was for them to build a small meeting house here in Holmvige. Forberg had asked him to get hold of a plot of land. Perhaps Sylverius could give them some advice as regards to a suitable spot.

"I'm sure that can be done," said Sylverius. He asks the preacher to take a seat in the sofa, but Reinhold hardly has time: he is on his way to the meeting . . . he had only decided to look in because he saw the light, to justify himself, as it were, for the row with Bernhard Thomsen had upset him deeply.

"No, Bernhard doesn't like the sect," says Sylverius.

He feels a certain satisfaction in speaking plainly to the preacher: "Bernhard says you are a bunch of hypocrites."

The look of suffering suddenly disappears from Reinhold's eyes. He sits up and looks earnestly at Sylverius, as though greatly and honestly amazed.

"Hypocrites?"

"Yes, he doesn't believe you follow the Bible's words about choosing between God and Mammon."

Sylverius flushes and continues in an emotional voice: "Yes, as it says, no man can serve two masters . . ."

Reinhold nods and interrupts him. "No that's true enough; that's what it says: 'No servant can serve two masters: for either he will hate the one, and love the other; or else he will hold to the one, and despise the other. Ye cannot serve God and mammon'."

Sylverius looks down, dazzled by the preacher's certainty and calm.

"So he thinks we are too interested in Mammon," Reinhold goes on. "Well, but look . . . it depends on how we do it, doesn't it? Anyone who has received the gift of redemption and grace – for him worldly things don't have an importance overshadowing everything else as they do for those who are not saved. It's to be seen in an entirely different light, a light from above you might say. It's not his world, of course, and not God's world. But he has once and for all been put in this world and must live its life."

Sylverius interrupts a little shyly: "Yes, but Jesus said to the rich youth . . ."

"'If thou wilt be perfect, go and sell that thou hast, and give to the poor, and thou shalt have treasure in heaven.'"

"Exactly."

"Yes . . . 'if thou wilt be *perfect*', it says." The preacher looks up. "Notice that. And who is perfect? No one is perfect but God alone, Jesus says elsewhere."

"No, but . . . then it says somewhere else that it's easier for a camel . . ."

"Yes, so it does," Reinhold interrupts him. "But what more does it say: 'With men this is impossible, but with God all things are possible'."

"Oh yes, I suppose it does," Sylverius remembers.

However, at the same time he comes to think of another text: "He that loveth his life shall lose it; and he that hateth his life in this world shall keep it unto life eternal." How is that to be understood? Can you live a worldly life and at the same time hate your life in this world?

"Perfectly well," replies the preacher without hesitation. "You don't for that reason need to become a child of this world. God doesn't demand of us that we should stop working for this world."

He goes on to explain: "We simply mustn't believe that it is *everything*. It is so little, so minute, measured with God's yardstick. And the man who has been saved doesn't bother with these things. He knows a greater wisdom than that of the world. But on the other hand he doesn't want to be a stumbling block for the society in which he has been placed. He

would like to help it, to improve its conditions, and he prays to Jesus for the means to do this. But at the same time he doesn't forget for a moment that it's all only a loan that is entrusted to him, a pound he must seek to multiply and not bury in the ground. 'But seek ye first the kingdom of God, it says, and his righteousness; and all these things shall be added unto you'."

"Yes, but . . . How can we know when we have achieved salvation?" Sylverius asks anxiously.

"You feel it . . . well, it can't be described; it has to be experienced."

Reinhold suddenly looks intently at Sylverius and adds: "You will experience that, Sylverius Eide, if you have not *already* experienced it. For I can feel that God wants to speak to you."

. . . Sylverius felt at once confused and uplifted by the preacher's words. It was some time before he could collect his thoughts; he remained at his desk, filled with silent wonder. He had again to admit that he was not good at interpreting the words of the Bible, and it saddened him that he had been able in his mind to be unjust to the preacher and the other sectarians.

He had got them wrong in a way that did little honour to him. He ought to have been able to say to himself that people who could pray and speak as they did took their relationship with God seriously enough. It was simply a credit to them that at the same time they gave the world what it could demand as long as they lived there and did not become a burden on their fellows. They gave unto Caesar what was Caesar's and unto God what was God's, as Jesus himself had commanded. But conversion was the be all and end all for them.

Conversion, indeed.

Sylverius puts out the lamp and goes and opens the window. It has stopped raining. The cove lies shining in hazy moonlight . . . it is just possible to distinguish the outlines of the ships lying tied up out there. It is some time before he discovers the moon . . . it has risen remarkably high in the heavens, almost in the zenith, and looks almost ridiculously small through the veil of floating clouds.

There is a slight breeze from the north east. Sylverius breathes in the fresh sea air a couple of times, closes his eyes and relishes the taste. He thinks of the preacher's words: "God wants to talk to you." And he has a blissful feeling that these are true words.

The moon emerges from a gap in the cloud cover. It is reflected in a skylight on one of the ships – the French schooner, the Yvonne. He suddenly feels an urge to pull a dinghy into the water and row out there. But Simona is at home waiting with supper. Of course, he could fetch her and take her out there with him as the weather is so beautiful . . .

Sylverius closes the window. The moonlight falls on the desk. The calendar on the wall shows the 19th of December. Sylverius feels boundless inner joy streaming through him. He feels that he will never forget this date, the 19th of December. This has been a day of significance to him.

. . . Simona is a little surprised at Sylverius's idea of rowing out to the Yvonne. But she happily agrees to go.

"The weather is so lovely now, after the thunderstorm," says Sylverius.

There are a couple of small dinghies at the end of the warehouse. He drags one of them down into the water and helps Simona on board. They glide out on the calm cove. The water is dark and shiny, here and there with ripples of silver from the moon. All it completely still. The only sound is that of the oars.

Sylverius ties up at the side of the ship and clambers up the gunwale, secures the painter and lowers the ladder. Then he helps Simona on board.

They stand for a moment looking in towards the shore, where the quay and the houses are bathed in hazy moonlight.

"Fancy . . . it was pouring with hail only two hours ago," says Simona in wonderment.

Sylverius takes her arm and leads her to the prow, where the lonely bowsprit is pointing to the cloudy sky.

Simona feels quite giddy out here.

"Just imagine being here when it's really blowing and rocking," she says.

Sylverius stands looking at the moon.

"Just look," he says. "When you squeeze your eyes tight, it turns into a cross. What Klein said yesterday about there being a cross in all light is true."

And, full of emotion, he adds, "And I've started to understand that, Simona. For, you see, the Kingdom of God is raised far above all these things."

Simona shakes her head, fascinated and afraid.

Sylverius goes on in a mild and caring voice: "That's why redemption is such an important thing. You remember the saying 'For what shall it profit a man, if he shall gain the whole world, and lose his own soul?'"

Simona sighs anxiously and holds his arm tighter.

CHRISTMAS

I

Ansgar and Jeser were standing down on the shore with their fishing rods. The clear, brownish golden water was swarming with fry, quite small fish with a copper sheen, that were too tiny to bite on the hook, but they milled around the bait and picked at it. When you pushed the tip of the rod down in the water, they fled like a shower of arrows, but they were there again immediately afterwards and started to play ball with the yellow snail bait.

The two boys had stood here most of one afternoon without catching anything but a couple of miserable coalies.

"I'm going home to get something to eat now," said Ansgar. "Coming?"

"No," replied Jeser without looking up. He had caught sight of a large Norway haddock close to the water's edge, half hidden by seaweed. He would quietly try to catch it . . . it would be a real surprise for Ansgar.

He fixed a tempting new piece of bait on the hook. The red fish moved hesitantly, sniffed indifferently at the choice morsel and slipped away, arrogant and unhurried. But then it came back again, obviously having changed its mind. And before long Jeser had a bite and delightedly pulled the heavy fish ashore. He started examining it more closely. It was no ordinary Norway haddock . . . it looked curious, copper coloured and full of thorns and knobs, and there were two tiny tubes sticking out of its snout. It seemed to him that it was glaring vengefully at him. It flapped its tail energetically a couple of times, slid a little way down towards the water again, but then lay there stretched out with dead, milky eyes.

Jeser felt relieved to see that it was really dead. It looked otherwise as though it were a fish you would be best advised

to be careful of. Perhaps it would be best not to touch it. He would wait to take it off the hook until his brother came back. Perhaps he could say what sort of fish it was.

Jeser sat down to wait. The fish lay there with its belly up . . . it was a curious colour, that stomach, whitish blue-red, like a human hand that was numb with cold.

It was not long before Ansgar returned. He took a long and serious look at the fish, lifted the line and shook his head dubiously.

"Do you think that sort of fish can be eaten," asked Jeser with disappointment in his voice. "It's big and fat enough."

Ansgar sighed.

"No, I'm afraid it can't be eaten," he said sombrely. "I'm afraid it's a dead man fish."

Jeser shuddered. "Why do you think that?"

"It's so peculiar. It's not like an ordinary fish . . . there's a soul in it, a drowned man's soul."

They stood looking at the fish for a moment. The shine had gone, and the colours were growing dull.

"We could throw it back into the water," suggested Jeser.

Ansgar shook his head and pursed his lips.

"Well, what shall we do with it then?" asked Jeser at a loss.

He stared at the fish with horror in his eyes. His whitish hair was blowing in the wind.

"If it's a dead man fish," explained Ansgar, "It must be buried in the churchyard at midnight. Then the soul in it will find peace."

"Yes, but we daren't do that. Besides it's Christmas Eve tonight."

Ansgar's eyes took on a distant look. And suddenly he says, "No, what I said about it being a dead man fish was a lie. It's a lumpfish, a really good, fat lumpfish. We can get a good dinner out of it this evening."

"Was what you told me a lie?" asked Jeser reproachfully and was both relieved and disappointed.

He went across and took the fish off the hook.

"We can't be bothered fishing any more this evening," said Ansgar. "Come on and I'll show you something awful."

"Something awful?" asked Jeser excitedly.

Ansgar ran off over the flat rocks along the shore, followed by an excited Jeser. Ansgar only stops right out by Highpoint. There is a cave at the foot of the slope; it is only accessible at low tide, but now it's just low enough for them to reach it without getting their feet wet. Ansgar dodges into the dark cave, Jeser follows and can hear his brother laughing and making a noise inside.

"Just you look what I've got hidden here," says Ansgar.

He holds a bottle in front of Jeser's nose. "Do you know what it is? Brandy. We're going to get properly drunk this evening, 'cause it's Christmas."

"I don't want any," says Jeser.

"Cissy," laughs Ansgar.

He puts the bottle to his lips.

"If you get drunk, you'll fall over in the water and drown," warns Jeser, whose mouth is turning down as though he is going to cry.

"You should just have a taste," says Ansgar. "It makes you go all queer and see things."

"What can you see?" asks a frightened Jeser.

Ansgar puts the bottle to his mouth. "Oh, what is that I can see? There's a merman in here watching us. Come and have a drink and you'll see him as well."

"No, I don't want to see him." Jeser looks at his brother in excitement and pain.

"I'm blind drunk now," laughs Ansgar. He starts to sing:

> Let me now come and join the dance
> While roses and lilies grow fair

"What do you think Mum will say when you come home drunk?"

"Oh, I don't care," replies Ansgar in a rough voice. "Now I'm as drunk as a lord. I could murder you as you stand there."

Jeser starts to cry.

"No, it's all lies," shouts Ansgar. "There's only water in the bottle."

A large, dark bird flies slowly down and settles on the slab of rock near the entrance to the cave. The boys sit still as mice watching it. Twilight is approaching. The heron settles cautiously right on the water's edge, standing motionless with a bent neck and staring down into the water. And whoosh. Suddenly it has a small fish in its beak.

"Ooh, look." Jeser can't refrain from shouting. The bird quickly unfolds its wings and disappears with a harsh cry.

"It's as intelligent as a human being," explains Ansgar. "If you could tame a heron you could have as much fish as you could eat."

Ansgar and Jeser drift along by the shore until it is completely dark, and then they take their fishing rods and the three fish and go home.

Their father is dressed in his Sunday best. He is sitting with his newly-pressed blue cap in his hand and seems strangely unfamiliar with it, almost showing respect to it even though it is his own.

"You'd better get yourselves tidied up," he says to the boys. "And then come over to the church with me . . . we've got to help Gotfred to light the candles."

Jeser dances and excitedly claps his hands in delight. "Are we going to light the candles? Do you hear, Ansgar, we're going to help to light the candles."

"We do that every Christmas," comments Ansgar dryly.

"Yes, you have, but not Jeser. It's the first time for him."

Ole is a kind of assistant to Gotfred in the church. He helps the parish clerk at weddings and funerals and on other special occasions.

There is a little box of candles in the entrance to the church, long, slender church candles. Ole takes out a bundle of them and goes in and starts fixing them in the candlesticks. Ansgar and Jeser have been given matches and tiptoe around the dark church in awe.

"It smells so holy," whispers Jeser.

"Rubbish. I know what it smells of," says Ansgar.

He goes up to his brother and whispers in his ear: "It smells of dead bodies."

Jeser suddenly looks serious and says no more. His father lights a large altar candle with a flame that is no bigger than a coffee bean at first. . . It looks as though the candle is miles away. But bit by bit it grows and starts to flicker. Jeser tiptoes up to touch the altar cloth . . . it is clammy and feels peculiar. It's almost as though the altar was sweating. The pulpit shines as white as chalk in the light from the candles; it's as white as anything white can be, and the gate to it has a little cut glass handle. Jeser has an irresistible urge to touch that handle, but he daren't. He looks at his finger and is afraid of dirtying the sacred glass. But then he has an idea. He tiptoes up the little steps to the pulpit and feels the fine handle with his mouth . . . with his lips closed – that can't hurt.

"Come down . . . What are you doing up there?" his father grumbles.

The wind is getting up. It is howling in the church tower. Simon Peter, the sexton, is up there ready to start ringing as soon as the parish clerk gives the sign. He knows the tower and is sitting up there in pitch darkness. Ansgar has dared to go right up to him, but Jeser only risks going up a couple of the steps leading into the tower. Close to where he is standing, the wind is whistling through a crack, plaintive and timorous. It is almost as though there was someone living up here in the dark and suffering from cold and hunger and having a miserable time. Someone's coming up the steps now . . . It's Gotfred, telling Simon Peter he can start now. A couple of thumps can be heard as the bells starts moving and swinging . . . the entire tower shudders. Jeser's ears are filled with the paralysing din and he hurries down the steps again with his heart thumping in his chest.

People have not started coming yet. Ole is outside attending to something or other, and the parish clerk is not to be seen anywhere. Jeser goes around in the illuminated church alone . . . there's so much to look at and examine. He must have a look at the font. He probably mustn't touch it, but he sniffs at it. There's no smell. There's a door behind the altar where the minister goes in and out when he is there for the service. He'd better not open that door, of course, but he can

hardly refrain. He touches it, kneels in front of it and puts his nose up to the chink . . . a curious mouldy smell. What can be inside? Suddenly he has the dreadful idea that Lazarus might be lying in there, the man Jesus awoke from the dead. Trembling, he turns away and runs back to the porch, where he feels a little more secure.

His father comes with a candle in either hand.

"What's that brown box?"

It's the poor box.

Jeser has to go across and look at the poor box. It's old and worn, and the lid is fitted with a big padlock. Jeser sticks his hand down into the slit . . . it can just be done with a bit of fiddling.

"Hey, what are you doing?" shouts his father in horror. "Is there anything in it? For heavens' sake keep your fingers away from that box, boy."

"No, it's empty."

The ringing ceases. Simon Peter and Ansgar come down from the tower and screw up their eyes when confronted with all the light in the nave. And now people are beginning to stream into the church . . . two old women from Blackwater Farm are the first, the raindrops sparkling in their newly ironed shawls. They stand for a long time and look devoutly into the church, where the rows of candles are as radiant as heaven itself.

Before long, Landrus and his family arrive. Young Gotfred is with them, dressed in foreign clothes, a double-breasted blue jacket and stiff collar. In his hand he is holding a cap with a polished peak. Ansgar follows every one of his movements with profound admiration. Gotfred's going to skipper his own ship in the spring. If only he could go with him on a trip like that. Pity that he's not a bit bigger for his age. Gotfred disappears behind the back of a pew in the church, and Ansgar is ready to cry with irritation at not being older and able to go on the spring fishing. There come his mother and siblings . . . he is just a little ashamed of them – they are so poorly dressed; his little brothers and sisters have walked on the wet road in their light shoes. They stand open-mouthed and chilled as

they look at the candles and hold firmly on to their mother's skirt. Fortunately, Inga is not with them. Ansgar thinks scornfully of his sister who has bought shame on the home. But even so, it's a pity she couldn't be here this evening to see the candles. She's at home in the dark, for there's nothing left in the lamp, and Landrus has refused to let them have any more paraffin or candles.

More and more people arrive, and the church is almost full. The very last to come are Harald and his wife. Harald is in national dress, with silver buttons shining on his jersey and at the knees of his trousers.

And now Gotfred starts the singing:

A child is born in Bethlehem

The candles blink like good, peaceful eyes. Jeser can't help all the time thinking that he has helped to light these candles. He has been close to them, touched them and breathed on them, all these holy candles. He's had a real good look around the church – the pulpit handle, the font, the altar cloth, the secret room where Lazarus perhaps lies.

While the parish clerk reads the Christmas story, Redstones Ole sits thinking about a candle he has in his pocket. It is one that had broken in the middle; it couldn't be used in any case, and a candle like that is too good to throw away. Besides, these candles belong to the church, to the parish, and so he has a right to a share in them. And in any case, he can look on this candle as a kind of payment for the trouble he's had fixing and lighting the other candles . . . Admittedly, it's not been any great trouble to him, in fact it's really been quite a pleasure, especially as the boys were allowed to help. But surely the church can afford to let him have a single candle.

After the service, Ole stands for a while out in the porch reflecting. He can still manage to put the candle back in the box, which is in a cupboard under the steps. But no, he finally decides to take it home.

But no sooner has he got outside than he regrets the theft. He goes back to the church. Gotfred is just locking the door.

"What is it, Ole? Have you forgotten something in there?" he asks.

Ole smiles and shakes his head. "I've got a candle in my pocket . . . a broken candle. It couldn't be used to put in a candle stick, so I put it in my pocket."

"He hands the candle to Gotfred, who takes hold of it absent-mindedly.

"Oh, a candle . . . oh, just you take it home with you. You can always find a use for one."

He hands the candle back to Ole.

"Happy Christmas," he says. "And thank you for your help."

"The same to you, and many thanks," replies Ole in relief.

He goes home and lights the candle.

Inga is sitting near the stove with the baby on her lap.

"So we've got some light after all," she smiles. "And we've got some food for Christmas as well . . . Kristoffer was here a moment ago with meat and potatoes.

Her mother immediately sets about frying the meat. The living room is filled with warmth and the festive scent of food. Ansgar and Jeser have each been given a coloured Christmas candle by Simon Peter. They are both a little disappointed with the big candle father has brought. They'd been looking forward to being the ones who had saved the family from a dark Christmas Eve.

II

On this occasion, young Gotfred is not so boisterous and boyish as he usually is. He goes about frowning and saying little.

During the afternoon of Christmas Day he has a row with Landrus. Gregoria is standing listening and trembling behind the door of the sitting room. It is about money, more money.

"You don't give a thought to the fact that I'm a man with a mortgage," she hears her father complain. "You've put me in

this position . . . I soon shan't have anything I can call my own."

Gotfred's voice is hard.

"Do you want us to go to sea without oil?" he asks irritably. "In that case, we might just as well not have bought the ship and equipped it in the first place."

"I've been done for every penny I've got, I tell you," moans Landrus. "This is going to be the end of us, it is. I wish I'd never . . ."

Gotfred interrupts him: "Besides, I tell you that this isn't about cash. You don't have to commit violence on your coffers . . . all I'm asking you to do is write your name on a bill of exchange together with my father."

The result is that Landrus finally gives in.

Gotfred's humour improves. That evening he sits playing cards with the old folks. There could of course be no question of dancing this Christmas so soon after Jane's death, all the more so as the minister had not yet been on the island to perform the funeral ceremony.

Kristoffer calls. He has become even more taciturn than before. He can't really understand all this about Josva. Young Gotfred has brought him greetings from his sons . . . Magnus had to stay in Østervaag to see to various things about the ship; he had to have everything in order so that nothing should prevent them from being among the first to leave for the spring fishing. And Josva . . . well, he wanted to go off and try his hand on his own. And it was probably the best thing for him to get away a bit and really see what life was all about.

"I still can't understand it," says Kristoffer, staring ahead. "At least it wasn't his intention when he left. He was going to buy a new lever and some other things; that was all."

"Yes, but even so, he's been thinking for a long time about going abroad," says Gotfred.

"Aye . . . but who thought he really meant it?"

And there is something else as well that's worrying Kristoffer. There is a rumour that Sylverius and Simona are going to join the mission. He doesn't think personally that's anything to bother about – they're not actually going to become worse

for that reason. But both Gotfred and Landrus are upset at the thought. They have several times encouraged Kristoffer to go to Holmvige and put his daughter to rights before it's too late. Indeed, they have even threatened to do it themselves. And with the same intention they have recently started getting at Oluva to persuade her to return to the church and give up her Adventism. Gotfred, the parish clerk, would be all right, for he was a sensible man who knew how to fashion his phrases. But Landrus, that powder keg, had gone for Oluva one evening, using such coarse language that Kristoffer had had to defend her in the name of fairness even though he was actually in agreement with Gotfred and Landrus.

. . . On Boxing Day, young Gotfred went out to find a crew for the spring fishing. It was not so easy as he had expected. People were not all that happy to have Landrus as the ship owner; they were afraid there might be difficulties about payment. It was safer to be on one of Sylverius's ships.

Despite all this, Gotfred managed to find eight men from Trymø. Most of them were young friends of his, who had confidence in his ability and luck at fishing. Gotfred wrote their names down in a little notebook. Landrus ran through the list, wrinkling his nose at some of the names and nodding approvingly at others.

"It wouldn't have hurt you to learn to write better," he remarked peevishly.

The name at the bottom of the list was *T. Simonsen*.

"That's surely not Torkel Timm?" asked Landrus, horrified.

"Yes, it's Torkel," nodded Gotfred.

"I won't have him," said Landrus and handed the book back. "Things go wrong whenever he's around."

Landrus got up, flushing deeply, and started walking backwards and forwards. "You're not going to have him, Gotfred. Besides, he's a lazy blighter. You'll never get him out of his bunk even if you whip him with a rope's end."

Gotfred had had great trouble in persuading Torkel to go. He had almost been forced to threaten him. But he had made up his mind that Torkel should go to sea . . . he lay in

353

bed at home doing nothing, and what bit of money he earned was spent on brandy. Gotfred wanted to put an end to that.

"Torkel *is* coming."

"Then it's *your* responsibility," said Landrus furiously. "I've warned you."

And he added in a broken voice: "And in general . . . your behaviour's been such that I've started to regret everything, let me tell you. You're a stubborn lad, you know, young as you are. Here I could have been left in peace and quiet and been a rich man. Now I don't know where I am . . . I might be ruined before I know it."

"As for the responsibility," said Gotfred. "I'll obviously accept that."

He smiled, a little scornfully: "Do you know what I'd like to do as well, Landrus? I'd like to take you yourself on the trip, because it'd do you good to get out a bit. Sitting around here just makes you spend all your time complaining. A few splashes of salt water in your beard wouldn't do you any harm."

Landrus sits down and breathes out helplessly.

Gotfred continues, "I've never known the like . . . here I go and actually have to put up with being grumbled at when I'm trying to help you. When I've even made your problem my own. Even helped you up out of the ditch."

"Out of the ditch?"

Landrus gets up again and goes towards his son-in-law with a threatening expression, but contents himself with sighing heavily and at length.

Gotfred again begins to talk in gentle and amenable tones. "Just you wait till we really get going . . . until the money starts flowing in. For you surely know I keep what I promise."

"He raises a clenched fist in the air and laughs. "Yes, 'cause I bloody well know what I'm doing, let me tell you. I'm not going to let you down."

Landrus sits again. His nostrils are dilated, and he remains there for a while breathing heavily. At last he allows himself to be infected with Gotfred's enthusiasm.

"Well, never mind," he says. "We've burned our bridges, as they say. Now we'll have to hope for the best, there's nothing else for it."

"There is a knock in the porch. Gregoria comes in and says there's someone who wants to talk to Gotfred.

"Ask him to come in," says Landrus.

It is Ansgar from Redstones. He stands up against the wall and hardly dares to look up. He is screwing up his cap in his thin, weather-beaten boy's hands. Well . . . he's coming to ask if there couldn't be room on board for a cabin boy, a cook's helper or something like that.

Landrus lets out a roar of laughter. "No, sunny boy, this isn't a ship for children. We can't have kids running around and getting under our feet. Tell that to your father."

Ansgard looks down and blushes.

"How old are you?" asks Gotfred.

"Nearly fourteen," stammers Ansgar, humiliated.

"Are you a bright lad? Can you manage life at sea?"

"Of course he can't manage life at sea," Landrus says dismissively. "Those folks up there at Redstones, miserable paupers they are . . . How can you expect them to manage it. No, my lad, just you wait for three or four more years, and then come again."

"Does your father know you want to come to sea with us?" asks Gotfred.

Ansgar shakes his head.

"Do you think he'll let you?"

"I don't know."

Gotfred goes across and ruffles his hair. "Do you really think it's much fun being on board a ship?"

"Yes," says Ansgar, looking up for the first time, trustingly, with hope in his eyes.

"Then you shall damned well be allowed to come," laughs Gotfred. "I think you're a fine lad. I like you. I'll have a talk to your father."

"You don't really intend taking that kid with you?" asks Landrus. "You should think carefully about that . . . He's a real bad'un, he smokes and . . ."

"He might be a bit on the young side," Gotfred admits. "But on the other hand . . . they could do with getting a bit more fresh air into their nest. And a time at sea will put a bit of marrow in his bones and flesh on his body."

Young Gotfred has to go back to Østervaag the following day. The weather is stormy with snow showers and squally winds blowing down from the mountains.

Gotfred wants to take Gregoria on a trip to Østervaag, but Landrus will not hear of it, and so Gotfred gives way this time for the sake of peace and quiet.

Gregoria goes on board the mail boat together with her fiancé. She is trembling a bit from the cold and her own emotion. Gotfred takes her down into a small cabin and sits her on his knee. There is someone else down there in the dark room, an old man from Holmvige. Gregoria feels terribly embarrassed.

"It's only my girl friend," explains Gotfred. "So you don't have to worry, Thomas. She ought to have been coming with me today, but she wasn't allowed . . . You have to give in to the old folk, you know."

"No, and the weather's not all that good," nods the man from Holmvige. "It's no weather for women today."

The floor is rocking. There is a stuffy smell of mould and paraffin. Gregoria is not far from being seasick.

Gotfred gives her a kiss and goes on, addressing the old man: "Isn't she nice? A bit thin yet . . . but come and see her in a couple of years when we're married and see what a thumping great wife she'll be, a real skipper's wife with cheeks hanging down and four chins. Eh, Gregoria?"

"Gregoria," shouts Landrus from the top of the steps leading down to the cabin.

"Take it easy," replies Gotfred. "I've not thought of smuggling her on board."

Gregoria frees herself from his arms and doesn't know whether to laugh or cry. Before long, she is standing on the landing stage beside her father watching the motorboat disappear in a shower of rain. She is both embarrassed and proud

and stands smiling to herself with half dried tears on her cheeks.

Landrus cannot forget that Gotfred has taken Torkel Timm on for the spring expedition. It can sometimes be annoying enough to have a man like Torkel living on the island, but there is not much you can do about that. But to take him on a ship voluntarily, that was too big a risk. With the dangerous powers that he surely possessed, he would be able to spoil both the weather and the fishing. Especially if he were not treated with care and in the right spirit . . . of which, of course, there would be no question with young Gotfred in charge.

Landrus pays Torkel a visit towards evening.

Torkel has been out in the meadow gathering rushes for his oil lamp. He is peeling the long rushes and pulling the wick out.

"Well?" he asks and looks curiously at Landrus. "How did it go . . . or haven't you tried yet?"

"You mean going round the church?" says Landrus. "No . . . not yet. There's plenty of time for that. And by the way, it's not always a good thing to know your future fate, for suppose it's a ropy one, what then? Who wants to do anything in this life then? And you see, Torkel, God's perfectly well aware of that and that's why in His wisdom He lets us go around without knowing. The Devil, on the other hand, he's nothing against our being able to see. He knows that it will make us unhappy, and then he can really be glad . . . in that empty dustbin he has instead of a heart."

Landrus thinks he has spoken well and found the right words. Torkel bends his head over his wicks.

"Well," continues Landrus. "I actually came to talk about something completely different this evening. You've promised young Gotfred to go with him on the spring fishing, haven't you?"

"Promised and promised."

"Perhaps you'd rather stay at home?" asks Landrus cheerfully.

Torkel glances at him. "Well, you see, being at sea makes me

ill . . . I can't stand all this rolling and pitching – it gives me earache. And besides I got my foot caught today up in the Spirit Hill marsh . . . it was all I could do to hobble home. I've got a terribly bad foot . . . I'm all blue round the ankle and it hurts right up to my stomach if I only try to support myself on it. See, oohh, oohh. No, I can't go anywhere with that foot."

"Stomach," Landrus says. "That can be dangerous. You oughtn't to go with them. I'll arrange that for you. Besides, I want you spinning and knitting for me. I can't really do without you, Torkel. No, shall we agree that you stay at home, even if your foot does get better?"

He holds out a hand to Torkel and gives him a genial nod and is much relieved.

FALSE PROPHETS

I

There comes again a lengthy period of gales, a westerly wind and rain with showers of wet snow in between. The Reverend Martens should have given a sermon in Trymø Church on the Sunday after Christmas, but the weather was anything but suitable for him to travel. And most of January passed before the minister and his wife were able to come to the island.

The minister had a great deal to do when he finally arrived. There was both an ordinary service and Holy Communion, funeral rites and a baptism to be seen to. Mr Martens was feeling a little unwell after the boat journey and had to rest for an hour or so before setting about his work.

While he was asleep, his wife went around paying visits. She knew the entire village by now, and she was well liked, indeed loved, by all; the children flocked around her and were given sweets and goodies, and old people trusted in her and came to life when she turned up and said a few words to them. A strange thing about the minister's wife . . . although she was quite ordinary in the way she spoke and behaved and was more inclined to talk of everyday things, there was more comfort and warmth in her than in any minister. She was as it were made of a lighter and livelier stuff than most people are.

Mrs Martens had her own down-to-earth way of talking to people, even when she was visiting the sick or the bereaved. Magdalena, who was left alone in her empty house, had since the death of her daughter only seen sad faces around her and only heard voices that knew not what to say for pity. Now Mrs Martens came. She took Magdalena's hands and shook them heartily.

"God's been hard on you," she said. "Really hard. But

that's how He tests some people's loyalty time after time. You remember how he tested St Peter? But that was only because He loved him. And it's the same with us human beings . . . we want to be quite sure of the one we love."

Magdalena's wrinkled face adopted a mild and youthful expression for a moment.

"Yes, I suppose so," she said.

Mrs Martens took time to visit the people in Redstones as well. It was poor Inga's child that was to be baptised. A lovely child, incidentally, a big boy with good-natured, dark brown eyes. His grandmother was sitting with him on her lap. She smiled apologetically: "It's a bit late for a christening, but the weather's been so bad over the last nine months, and then Inga has wanted to delay it all the time, because she's not really happy about what's happened, of course . . ."

Mrs Martens stroked the child's round cheeks.

"Oh, a little baby's lovely, however it comes. And what a pity it was about the young man who drowned. Who knows, he might have married her after all, for that's what often happens."

"Aye, who knows?" nodded Ole. "I think he was really all right after all. He was so young."

"Where's the girl, by the way?" asked Mrs Martens.

Inga was brought in. She was red in the face and weepy, and she took up a position in front of Mrs Martens as though she thought she was going to have to justify herself.

"Aye, she's not been herself since she got herself into trouble," said Ole. "She's not dared to show herself outside the house."

"Good Lord," said Mrs Martens stroking her hair. "I wouldn't have thought it was all that bad. I wish I were as young and pretty as you are. I wouldn't mind being in your place."

The girl's mother sighed, "Yes, if it wasn't for the shame . . ."

And suddenly, she, too, started to weep.

Mrs Martens took the child in her arms.

"I've many a time dreamt of having one like that," she

smiled. "But it wasn't to be, and so I've had to forget it. By the way, who's going to be godmother?"

"I suppose it'll have to be my wife," said Ole. "She's the obvious person, and we haven't really been able to ask anyone else . . ."

"What about asking me?"

Ole and his wife looked completely overwhelmed, and Inga raised her head.

"Yes, I really think you should do that," nodded Mrs Martens. "I'd love to be the little chap's godmother. So that's agreed, isn't it?"

And with that, she handed the child back.

"But I must be off," she waved. "I'll see you before long."

She hurried across to Gotfred's house.

The minister was awake and sitting on the edge of the bed, nervously leafing through a Bible. He was very upset, breathing quickly through his mouth as though after some enormous effort, and he was bathed in sweat.

"Sit down and wait," he said. "I'll have it in a moment."

He found the passage and sat there rocking to and fro:

"I cried by reason of my affliction unto the Lord and he heard me; out of the belly of hell cried I, and thou heardest my voice. For thou hadst cast me into the deep, in the midst of the seas; and the floods compassed me about: all thy billows and thy waves passed over me. Then I said, I am cast out of thy sight; yet I will look again toward thy holy temple. The waters compassed me about, even to the soul: the depth closed me round about, the weeds were wrapped about my head. I went down to the bottoms of the mountains; the earth with her bars was about me for ever: yet hast thou brought up my life from corruption, O Lord my God. When my soul fainted within me I remembered the Lord; and my prayer came in unto thee, into thine holy temple. They that observe lying vanities forsake their own mercy. But I will sacrifice unto thee with the voice of thanksgiving; I will pay that that I have vowed. Salvation is of the Lord. And the Lord spake unto the fish, and it vomited out Jonah upon the dry land . . ."

The minister closed the book. A broad, warm smile spread

across his face. He closed his eyes and folded his hands for a while. Then he got up and placed both hands on his wife's shoulders. "Do you understand this, Karen? The sign. The sign I have prayed for for so long . . . I've got it now. Let's sit down and I'll tell you. I'm still quite shaken. But thanks be to God in Heaven. So it was to come today, here on Trymø, in dreams. It is the greatest and happiest day in my life. For you see, I dreamt that I was standing alone in a dark, oppressive room, all on my own in pitch darkness, entirely deserted by everything and everybody, even by you, Karen, for you, too, had deserted me. And the worst of all was that a voice inside me told me I was in the forecourt of Hell. Just look how my hands are still trembling with fear."

Mrs Martens took his cold hands and stroked them to calm him down.

He went on: "I was in distress such as I have never known before. And I was deep down on the bottom of the sea as well, for there was water all around me, and I was even full of water in my mouth and nose and ears, and inside my body . . ."

"But then what?" whispered his wife. She was herself trembling with excitement.

The minister raised his voice solemnly.

"Then the darkness was broken by a shining figure standing before me, an indescribably figure . . . perhaps it was an angel or God Himself, I don't know. Perhaps it was the Lord Him-self . . ."

He bowed his head.

"And what then?" whispered his wife, squeezing his hand.

He sat up. "Well, there really wasn't any more. I was quite dazzled by all that light, you see. I felt uplifted, liberated, bliss-ful. And then the dream was gone. But I woke up with a phrase on my lips: Jonah 3–11, and I lay there unable to move for a long time, repeating those words: Jonah 3–11. And that was the passage I just read to you."

He got up and repeated in a subdued but happy voice, "I cried by reason of my affliction unto the Lord and he . . . heard me!"

★★★

Gotfred wanted to ask the minister's advice regarding a difficult matter, and it was as well to do it before the service, for Gotfred could not settle until he had heard the minister's opinion.

The matter was as follows: Lars Dion's son Egon, who had been converted to the sect over in Holmvige during the autumn, was to go to England to be trained as a missionary, and he came home to Trymø yesterday evening to say goodbye. But he was not alone. Reinhold Vaag, the preacher, had come with him, and now these two confessionists wanted to use the opportunity to hold a confessionist meeting for the people of Trymø. The intention had been to hold this meeting in the open, but it was starting to rain, and so they had asked for permission to use the school. The question was whether to allow them to do that. Most people Gotfred had spoken to had thought not. These people should be left to their own devices, and people ought even to be advised against going and listening to them. But Gotfred himself didn't agree.

"We're strong enough in our faith to be able to take up the struggle against these sectarians," he said. "We ought not just stay at home but go in large numbers and confront them."

"Quite right," nodded the Reverend Martens. "Just let them come."

Gotfred shook the minister's hand, happy to have his backing.

"Then we'll let them speak in the school. They shall see we're not afraid of them."

The minister smiled happily. "Afraid? No, from now on, we aren't afraid any more. A mighty light has been lit for us to show us the path through doubt and sorrow."

He placed a hand on the parish clerk's shoulder and whispered, "I fear no more. The Lord our God shall scatter the hosts of the enemy."

And in a loud voice and with a fiery look, he repeated, holding his clenched fists before him: "But I will sacrifice unto thee with the voice of thanksgiving; I will pay that that I have vowed!"

It was an unforgettable Sunday. The Reverend Martens was scarcely recognisable; all the slowness and signs of tribulation were gone, and there was a sense of elation and warmth in his sermon . . . a mighty and infectious joy in faith.

The congregation was deeply moved. People sat there with open mouths and with their features rigid with amazement and ecstasy. And the amazement increased as the sermon progressed. For it was more than a sermon, it was the utterance of a prophet.

The Reverend Martens spoke of the trials of a human soul . . . of the evil forces at play seeking to cause its fall, of the despair that could overcome people so they felt banished to the interior of the earth, crushed between its unbending bars, or the dark bottom of the ocean, where the abyss surrounded them and the seaweed wrapped itself around their heads. But just as your soul is about to languish within you, then you see God's light, and your prayers come to Him in His holy temple.

"You people of Trymø," the minister concluded, raising his voice to a shout. "A great day has dawned for you. You have buried one of your dead and you have brought a new life to baptism. You have heard the voice of the Spirit of God. For the spirit speaks through me, the instrument of God. And more great things shall happen which will fill your breasts with trembling and fear. For I cried to the Lord in my anguish, and he answered me. Out of the belly of hell cried I, and thou heardest my voice, O Lord. Amen."

II

It was turned four o'clock and darkness was falling. The boatmen from Greypoint were starting to be impatient. If they did not get away now, they would miss the favourable current. Besides, the weather looked as though it was going to turn rough again. And in that case it would be an unpleasant journey.

But the minister was not minded to leave.

"Wind and weather, current and darkness . . . are they anything to fear?" he replied to the boatman. "Have *I* not overcome the dark? No, quite different things are at stake."

Gotfred suggested that the boat should leave alone, and then the minister could spend the night on the island and go home in Kristoffer's motorboat tomorrow.

And that was agreed.

"And now let us arm for the struggle," said the minister animatedly.

He sent his excuses to the farm, where he and his wife were accustomed to dining, and shut himself up in his room to pray.

Mrs Martens had difficulty keeping her concern and worry in check. She opened the door gently and whispered, "Are you not going to have any supper? Wouldn't it be better to have a bite?"

The minister was kneeling by his bed. "Do come in, Karen, but don't disturb me."

She sat down wearily on a chair by the door. Oh dear. If only they were safely on their way home now and could get some rest after this demanding day. Never before had she sat with her life in her hands as in church today. This was completely unreal, and she feared the worst. This sudden transformation . . . what else could it signify but that his madness had broken out in earnest. She folded her hands and prayed in her fear and powerlessness: "Dear God, let him fall asleep, or in your mercy prevent him somehow from going to that meeting in the school."

The minister was finally finished with his lonely prayers. He got up and whispered as though in deepest confidence, "Karen, I think now I know for certain . . . *I am the prophet Jonah.*"

He dried the sweat from his brow, sat down on the edge of the bed and continued in a perfectly everyday voice: "You understand that all this about the whale is a metaphor. It's meant symbolically, like everything in the Bible . . ."

"Yes, but the Prophet Jonah died many hundreds of years ago," Mrs Martens interrupted in despair. She sat down by

him and held his hands tight. "Do you hear? He died . . . thousands of years ago."

His eyes suddenly assumed an unhappy expression, and his mouth betokened a loss of the determination that had been there.

"You mean . . . that I'm not the prophet Jonah?" he asked dismally. "Not even in a . . . metaphorical sense?"

She stroked his hair lovingly and whispered in her tenderest voice, "No, my dearest, you aren't the prophet Jonah."

He nodded heavily and relaxed. "No, I'm not the prophet Jonah. I was on the wrong track."

And slowly he awoke from his ecstasy. The old tired lines emerged in his face. His eyes became dark and frightened, and his forehead once more showed all signs of despondency and torment.

Karen sighed deeply and relieved.

"You must be tired now. Just you get a bit of rest, and then everything will be all right . . ."

"Yes, get some rest," said the minister in a dull voice.

III

The schoolroom was full to overflowing. Gotfred himself had gone round encouraging people to turn up. No one should stay away. It was important to show these sectarians that the people of Trymø were genuine and unwavering Christians who were not afraid of asserting their ancient and well-established faith in the face of the new foreign heresies that were aimed at undermining child baptism and Holy Communion and the old church hymns.

The two sectarians had placed themselves to the right of the lectern. The preacher was sitting looking at the gathering with gentle, concerned eyes. Egon had a folder full of books and pamphlets on his knees. Opposite him sat his mother, Annette. Lars Dion, on the other hand, was not present, and neither was Balduin.

The minister and the parish clerk had not yet arrived.

366

Landrus was very excited and could hardly stay quiet. Breathing heavily, he was walking backwards and forwards in the entrance, showing himself in the doorway now and then and scrutinisintg the gathering. The whole of Trymø was here, from Farmer Harald to Torkel Timm and Jakob the Granary. Even the crippled Elias from the River House had risked coming despite his paralysis; he had had them carry him up to the school and was now sitting leaning back among some cushions in a corner of the room.

Landrus looked at his watch. His hand was trembling with anticipation. Now the two sectarians were starting to sing. But their singing sounded thin and weak in the tightly packed hall. Besides, the wind was getting up and shaking the building. The two candles on the desk were flickering restlessly.

Finally, Gotfred appeared. He was alone.

"Is the minister not coming?" asked Landrus uneasily.

"He's not well," said Gotfred brusquely. "We'll have to manage without him. Oh, so they've started to sing. Hm."

He went over to the door.

"I see Lars Dion and Balduin are staying away," remarked Landrus.

Gotfred the parish clerk entered the room. All eyes were on him. He looked solemnly around as was his custom when entering the church through the sacristy door, and raised his sharp, bespectacled face.

The two sectarians' singing sounded alien, more like a sea shanty than a hymn:

> Remember now that he is near
> Obey his call, for he holds you dear,
> O hear him saying to one and all,
> Come now, my child, obey my call.

Egon goes up to the lectern. He bows his head and begins to pray, his face weak and limp with piety: "Jesus, our Saviour, whose blood was shed in torrents for us, be present with us here this evening and help us to find the only right path to you. Bend our stubbornness, break our self-assurance, make us

humble in our hearts, lead us through repentance to conversion, through conversion to salvation. Amen."

He raises his head and gets straight to the point: He has no intention of preaching a sermon for general edification, a sermon of the kind you remember for an hour or perhaps a couple of days. No, he has different and more important things in mind. He has found salvation . . . this is the message he wants to pass on to his friends and fellow citizens before leaving his native island perhaps for ever. He has grown up here and lived here for twenty-three years; he knows conditions as well as anyone; he knows there are good people as well as evil people here just as there are everywhere else in the world. And he also knows that there are people here who are committed to Christ's teaching, some with all their heart, but most simply out of habit, because the custom is such . . . just as he himself once did. But the great transformation of the mind, the terrible but at the same time indescribably beautiful experience called conversion . . . they still have that to look forward to.

And Egon abandons himself to confession. He has tears in his eyes and makes no effort to control his voice.

"Come," he prays. "Cast aside all self-assurance, all falseness and vacillation, come to Jesus, repent and throw yourselves into the Saviour's embrace. Accept conversion, as the disciples did one and all, as Saul did on the road to Damascus."

Gotfred casts a glance at the listeners. He feels relieved: there are no ecstatic faces here, only closed mouths and cool looks.

Egon continues, more and more emotionally and with tears in his eyes: "Come, for soon it will be too late. For what does the Gospel say? For as the lightning cometh out of the east, and shineth even unto the west; so shall also the coming of the Son of man be. And then shall appear the sign of the Son of man in heaven: and then shall all the tribes of the earth mourn, and they shall see the Son of man coming in the clouds of heaven with power and great glory . . ."

Egon takes out a handkerchief and wipes his face. He is not accustomed to speaking, and the powerful texts have as it were

left him out of breath. He breathes deeply a couple of times before continuing, but all that comes is a series of repetitions. Then he folds his hands and ends with a new prayer.

The sectarians sing another hymn. And now it is the turn of Gotfred the parish clerk to speak. He goes up to the lectern and tosses his head.

"Well," he says. "The young man who has just spoken to us is right when he says we all need to be converted. The fact is that we are all sinners and in need of God's mercy. But I will ask you, all of you sitting here, and as members of our Christian congregation: Does your church not preach the same? Of course it does. And we both speak and read and sing. So for us there is nothing new in what the budding missionary has said here this evening. We agree with him and are pleased he has been converted. The only thing limiting our joy is that he has moved into an alien communion that declares infant baptism to be invalid and refuses to believe in the wonders of the Sacrament, and who prefers to sing English tunes rather than our splendid, ancient hymns."

Gotfred surveys the congregation. Calm faces, trusting looks.

He goes on: "I won't start praying or singing here. We have our good holy church for that. And today we have heard great and powerful words in the church, words which we will never forget. I have only come here to give my opinion on the alien teachings that are now seeking to gain a foothold among us. And my opinion in brief is that it is a false doctrine that we cannot accept."

The parish clerk adjusts his glasses and turns towards Egon, who is sitting flushed, staring ahead with tense, thoughtful eyes.

"Let me finally ask you, Egon, on behalf of the church and those listening to you this evening: Are you no longer a member of the established church? Have you formally left it?"

Egon looks down and wrinkles his brow.

"I've been reborn and baptised again."

"Yes, but have you formally left the established church?" repeats the parish clerk rather impatiently.

Egon blushes. No, he has to admit that he has neglected to do that.

He wants to explain how it has happened that he has not sent a notice to the church that he is leaving it, but Gotfred interrupts him sharply: "I suppose you think that's a matter of no importance? You don't think that this is the church your forefathers have belonged to for hundreds of years, where they were baptised confirmed, married, received Holy Communion and been buried. No, before going your own way, you have to inform the church properly, you understand."

And addressing the congregation, he goes on: "Alas, our old church is ordinary and everyday, like life itself. Perhaps we don't think much about it from day to day. But it still stands as it has stood for centuries, like a rock that can take storm, frost and surf, and which not even lightning can damage. It is faithful and mighty. The sect . . . may well burn more brightly, but these are flames that will soon be extinguished. And so it is with the mind of the sectarian; it seems to glow and sparkle, but it only lasts for a short time, as when a wood shaving goes up in flames."

Gotfred has spoken soberly and sharply. He had said what the congregation felt in their hearts. There was a sense of calm exaltation among his listeners, as he descended from the lectern and sat down beside his wife.

Now Reinhold Vaag stepped forward.

The preacher also spoke soberly. There was as it were a quiet dignity in the air after Gotfred's words, and it was as though Reinhold sensed this and went out of his way not to disturb the mood too suddenly. He wanted first to say that he was not an enemy of the church, and he did not hate it. He had himself been born and brought up in the established church and had retained a certain affection for it, just as one always retains an affection for childhood memories and the people you have known in your early, immature years. But the church had not been sufficient for him. He would make use of Gotfred's image from earlier: Perhaps the mission's teaching was like a blazing wood shaving, but it nevertheless

370

burnt and created light, while the ancient rock of the Church was dark and cold.

And now the spirit had taken Reinhold and he would attempt to gain a hold on his listeners.

He went on, looking up with a firm gaze: "It is this *warmth* that the Church is unable to give, this heat and sincerity in devotion to Jesus Christ. Perhaps all we can give Him in return for His ardent, burning love is to be compared with a poor, burning wood shaving. But if we can even get as far as *that!*"

He paused and looked around the hall.

"Gotfred said before that the church is like a rock that not even lightning can damage. And so it is, too, although in a different way . . . the church encloses us in custom and preudice. The Spirit of God is not allowed to speak freely; God's lightning cannot force its way through the hard shell."

The listeners were becoming restless. Gotfred shook his head disapprovingly and Landrus interrupted the speaker. "You can't say that. You are twisting his words."

The preacher saw which way things were going and calmly answered: "No, I am not twisting his words. I am merely giving them a different interpretation."

"Yes, a false interpretation," shouted Landrus. He was red in the face and ready for battle.

Gotfred rose. He, too, was agitated.

"I must agree with Landrus," he said. "That interpretation was dishonest. We are a Christian congregation gathered here today, and it was as the guardian and spokesman of that congregation that I spoke earlier. And I will now ask Mr Vaag: If it should not be God's spirit that rules in the church, then whose spirit is it?"

"Aye, whose spirit is it then?" repeated Landrus. He looked around uneasily.

"I do not say it is not God's spirit," said the preacher in a placatory voice. "Of course it is God's spirit. But we could wish that this spirit asserted itself more powerfully, encouraged us to more ardent devotion, overturned the old-established forms and revealed itself in all its warmth. For no

371

one who lights a candle hides it under a bushel or places it beneath a bench, but he puts it in a candlestick, so that whoever comes should see the light. Does the Bible not tell us this?"

There was a sort of gentle, conciliatory friendliness in Reinhold's voice that was not lost on Gotfred. And it would be best if they could continue this conflict in an orderly fashion. He sought to find an appropriate but not too caustic reply. But Landrus beat him to it, stepping forward and taking up a challenging stance just in front of the lectern and shouting in a resonant voice:

"You blind guides. You, who strain off the midge but swallow the camel."

Reinhold started and looked at him open-mouthed.

"Aye," continued Landrus. "That's what I said. For you needn't think you have a monopoly of Biblical texts."

He clenched his fists and shook them in the air. And now he turned away from the preacher and took up a position in front of Egon.

"And as for you," he shouted so that the entire hall shook. "I will address you with the words of St Peter: 'But there were false prophets also among the people, even as there shall be false teachers among you, who privily shall bring in damnable heresies, even denying the Lord that bought them, and bring upon themselves swift destruction.'"

Egon got up and involuntarily placed his trembling hands before him as though protecting himself. He made as though to answer, but the words remained stuck in his mouth.

"Yes," continued Landrus, turning to the congregation: "*Beware of false prophets, which come to you in sheep's clothing, but inwardly they are ravening wolves.*"

He made some impatient motions with his hands: "Come, we have now heard enough scandalous and blasphemous words and now we will all go to our own homes and leave the false prophets behind alone."

All eyes were fixed on Landrus. He was standing in front of the lectern with his back to the candles, so his dark figure threw a double giant shadow in the hall. Should they do as he

said and break up? Some rose, others remained seated. The preacher went across to Gotfred. They spoke in whispers. Reinhold shook his head as though worried.

"Right," commanded Landrus, making a sweeping gesture with both arms. "We refuse to hear more. We will be ourselves here on Trymø. We are not used to being brought to heel by others."

"That's enough, Landrus," Gotfred interrupted him anxiously. "Don't go too far; there's nothing for us to be afraid of."

He raised his voice and said in explanation, "Yes, we have here this evening heard what it is these alien folk, these people who call themselves confessionists, want, and we have told them what we think of their teachings as they must be judged on the part of the Christian church. And I do not think we have more to add. We shall not agree, and I for my part think it best for our visitors to return to places where there is more fertile soil for this message of theirs which is so inimical to our Church."

Reinhold asked to be allowed to say a few words in conclusion. He was not angry, but his voice was trembling with profound sorrow:

"Harsh words have been directed to us, harsh and unjust words. But we will bear them without complaint, as we have done before, for the sake of Jesus Christ, He who suffered death on the Cross for us. And perhaps we have caused a little apprehension on the part of some of our listeners, perhaps we have sowed a little seed that might cause alarm and unease, but finally bear fruit in repentance and conversion."

He bowed his head and said in a low, urgent voice: "For you are not saved, my dear friends. May you yet be. Amen."

"But I suppose you are," Landrus entered the fray anew. He had stood waiting impatiently for an opportunity to say something. "You think you have the sole rights to redemption."

He clenched his fists threateningly and went on with a trembling and accusatory voice: "O generation of vipers. You speak evil of the church and sacred things! And woe unto him from whom the offence cometh. It were better for him that a

373

millstone were hanged about his neck, and that he were drowned in the depth of the sea."

The two confessionists had started to sing.

"They shall not have the last word," said Landrus. He suggested to Gotfred that the assembly should sing a hymn in conclusion. Gotfred was against it, but finally gave in. He ransacked his memory for a suitable hymn, and as soon as the Confessors' last note had died, he got up and sang in a loud voice:

> The dark of night is falling fast,
> And daylight giving way to gloom
> The sun is sinking in the west,
> The day as ever to entomb.

The hymn was well chosen. The congregation listed and fell quiet. They were themselves again, at home on Trymø and in the merciful vicinity of God. It was remarkable how the words suited the occasion.

> Let darkness try its very worst
> I fear no thing that it can do.
> When dark the air and storms do burst,
> Our Jesu's light will e'er break through.

Gotfred felt how the words of the hymn caught and acquired life. This was the *Church* rising in its solemnity and might. He had to think of his childhood . . . of his father, old Gotfred, who had brought him up as his successor and taught him these hymns by heart. He saw him with his inner eye as he used to stand in the entrance door to the choir on dark winter Sundays, with his head back and a stern forehead while the storm raged outside like a merciless threat.

The preacher sat listening with an infinitely patient expression. When the hymn finally came to an end, he stepped forward and said humbly, but clearly so that all could hear him:

"Well . . . then I will say thank you for allowing us to come today. Thank you for allowing us to hold our meeting in the school. I must return to Holmvige tomorrow. But I shall come back to Trymø, and I look forward to speaking to you again, each one individually. We are not so far from each other, and we can perhaps even walk the same path together. But before we go off each in our own direction, I would ask you to join me in a prayer for Egon, the young man who has decided to sacrifice himself for the Kingdom of God alone. He was one of yours, of course. So let us together, and irrespective of whether we are agreed in all matters, fold our hands and pray that God may give him His blessing. He had no choice . . . he met his Saviour and had to follow Him. Let us pray in silence each one for himself."

The preacher knelt and bowed his head. Egon did the same. Annette, his mother, followed their example. And hands were folded and heads bowed everywhere.

Landrus glanced at Gotfred. He, too, had folded his hands.

This was an ambush. The preacher was obviously a man who always had a way of retreat open. But this was not good enough. There had to be a counter move.

"You must read a closing prayer or something," he suggested to Gotfred.

No, Gotfred would not. "Leave it at this . . . It wasn't unreasonable to give Egon our good wishes as he leaves us. Let's just close with that and leave everyone in peace."

"Yes, but he's *not* going to have the last word," protested Landrus. "If you won't, I will."

Gotfred pulled his arm and wrinkled his brow: "What are you going to do, Landrus?"

"You'll hear."

Landrus took up a position in front of the lectern, coughed noisily and shouted out over the congregation:

"*And again, Praise the Lord, all ye Gentiles; and laud him, all ye people. Amen.*"

IV

In the early hours of the morning, Mrs Martens was awakened by her husband calling to her in a whisper. For a moment she could not remember where on earth she was. The darkness was total. Her ears were filled with a rushing of wind and water.

"Karen," came the voice again, a little louder. "I can't find them."

The minister was up, obviously going around searching for something or other.

"What can't you find?" she asked.

"The matches. I wanted to light the candle."

"What do you want a candle for? It's the middle of the night."

"Sshh. Don't speak so loudly," warned the vicar. "They're watching everywhere."

He came across to her bed and placed his mouth against her ear. "It was a trap, you see, this idea that we should stay the night on the island. I didn't realise it at the time, fool that I am. But now you shall see, now everything's going to be for the better. I am certain now."

"Rubbish," said his wife, suddenly painfully awake. "There's no one lurking here. It's something you've dreamt. . . . and the matches are on the table just at the side of the candlestick."

The minister found them and lit the candle. There was a remarkable gentleness and peace over his face. He smiled, "Yes, I'm beginning to understand. – Oh well, just you lie and sleep a little longer, Karen dear."

He took out the Bible and settled to read. His wife lay watching him for a moment.

"Be careful, you don't catch cold," she said.

The minister read and fell into deep thought. The rain was lashing the windows with a sound of paper being crumpled up, large quantities of wrapping paper.

Mrs Martens dozed off. She seemed to see a figure bending over her husband and carrying on a whispering conversation with him. She opened her eyes . . . No, he was alone, of course. She fell asleep again.

It was not long before she was awakened by the minister standing by her bed and whispering to her. "Karen. It was as I thought."

The vicar looks hot and tense, but there is a light in his eyes that she does not remember seeing before. He smiles, dreamily, with raised eyebrows: "Yes, at last I have understood the call."

And the distant smile slowly disappears. His face adopts a look of unflinching determination.

"But you see . . . we must leave straight away."

"Now? Tonight? In this weather?" asks his horrified wife.

"The weather mustn't prevent us," says the minister unmoved. "It will actually help us."

Karen is appalled.

"Well, wait until daybreak at least," she asks. "For my sake."

"I would like to wait," says the minister, "but it can't be put off. *The day must not dawn!* You will understand later. I can't go into detail now. So . . . now I'm going to wake the parish clerk."

"No, don't," she moans. "Lie down on the bed for a moment and gather your thoughts."

But the vicar was already out of the room. She heard him call Gotfred. There was nothing for it but to dress. But how hopeless this was in every way! For what would people think of a man who insisted on leaving in the middle of the night, in pitch darkness and a furious gale? It was impossible to excuse it, impossible to explain it away. So the hour had struck, and it would all come out now . . .

The parish clerk was up already. She could hear his voice in the living room and listened with her heart in her mouth.

What could Herman have invented as a reason for wanting to leave in these unusual circumstances?

"I'm afraid the weather's too bad," she heard Gotfred say. "Especially for your wife. Can't it wait until the morning, when the weather might have improved?"

"It can't wait," said the minister. "I do not fear the weather."

"I'll have a talk to Kristoffer, then," said Gotfred.

The minister returned.

"It'll be all right," he said gaily.

He stroked his wife's cheek. "You're not frightened, are you, Karen? You know that nothing happens that God doesn't want to happen. But when He wants something, it's no good defying Him either."

He lowered his voice and continued in a confidential voice, "Don't you think it best, too, to obey His command? Would you know a moment's peace if you knew you had defied Him?"

"I don't understand," she replied despondently.

"No, you don't understand." The minister nodded.

"Why ever didn't we leave yesterday?" Karen shook her head in despair. "It was that meeting in the school that you were so keen to attend. Oh, if only we'd gone with the rowing boat then!"

The minister shook his head impatiently. "I'm tired of all these arguments for and against. We know what we've got to do now, don't we?"

Karen considered things and tried a ruse: "Yes, but do you realise that you're revealing everything, all this about the trap they're trying to set for us . . . you'll give it all away by wanting to leave all at once. Because you'll have to give them an explanation."

The minister gave her a smile to calm her down. "Don't worry, Karen. The fact is that it *must* be revealed. And it must be revealed this very night. But at the same time I want to reveal myself in all my might. Things will happen, things greater than you have ever dreamt of."

His wife fought back her tears. She made one last desperate objection: "Yes, but . . . dare you trust your own life and mine to the people who'll have to take us in the boat. You say yourself that they're thinking of . . . bringing you down, don't you?"

"You don't really understand the situation," explained the minister patiently.

"They can't harm us when we're face to face with them. And besides . . . what shall be, will be."

Gotfred returned with a message from Kristoffer: "It was a doubtful undertaking for people who weren't used to sailing to go off in this weather unless it were absolutely necessary . . ."

"It *is* absolutely necessary," said the minister.

"Surely we could wait until daybreak," suggested his wife. Her voice was trembling.

"As for that," Gotfred thought, "the current will be better if we go straight away, and there's not much sign of the weather getting better later in the day. It won't be totally dark, either . . . there'll be a bit of moonlight."

He looked at his watch: "It's four o'clock."

"Then let's get off, in God's name," said the minister.

His wife touched Gotfred's sleeve.

"We're not going to be in danger of our lives, are we?" she whispered.

"No, it's not that dangerous," said Gotfred. "As the wind is now, it won't be long before we're in the shelter of Kjovø, so most of the trip will be quite reasonable, so to speak."

"Are you coming youself?"

Gotfred nodded, "Yes, I'm coming."

Before long, the entire household was up and about. The stove was lit, and the kettle taken out to make coffee. Gotfred's wife came with an armful of shawls and scarves, for Karen had to be well wrapped up for the journey. The minister borrowed a heavy jersey and a pair of skin boots.

Karen greedily drank the hot coffee. She, too, had begun to feel calmer. How good it would be to get home again. The minister was usually calm at home . . . it was almost always during these trips to the outlying islands that this strange mood came over him.

But when they went out into the wet and windy darkness she was again overcome by a great fear. Everything went black before her eyes. "Oh, Lord God," she whispered in her powerlessness.

Down in the boathouse, the minister and his wife were

dressed in oilskins and sea boots. Kristoffer and Gotfred dragged the boat into the water and rowed it a short distance along the shore to a small opening where there was shelter. Here, the minister and his wife were taken on board and settled down low in the stern. The engine started, and Kristoffer took the rudder.

Once they came out into the night, the darkness was not so intense. There was a light behind the mountains of Trymø – the rising moon.

Out at the mouth of the inlet the boat started tossing violently.

"God help us," screamed Karen.

"It's nothing to be frightened about," said Gotfred to calm her. "It will only last for a good quarter of an hour, and then we shall be in the shelter of Kjovø, and the sea will be as calm as your sitting room floor."

"Oh, we ought to have stayed," complains Karen.

"There's nothing to be afraid of, Karen," says the minister. "The wind will die down."

It has stopped raining. The moon appears, large and brownish red, but only for a moment, and then it has again disappeared in spray and clouds. The boat works in the seething waters, sometimes up, sometimes down. Kristoffer tensely takes the measure of each wave as it approaches and skilfully avoids taking in water. Gotfred is ready to bale out.

The minister has again stood up. He shouts as loud as he is able, "*In the name of Almighty God, I command the ocean to calm down*".

His wife pulls at his sleeve. "You hear, it's going to be calmer shortly," she says, completely at her wits' end.

A fresh huge wave approaches, and Kristoffer does not quite manage to avoid it. The moon appears again. The foam blows around the minister's ears, and he shouts out in a strangled voice, "Hear me. Do not desert me."

Now Kjovø is quite near. Its north point rises black and wild against the moon.

The minister is on his knees, clinging on to the thwart.

"Alas, I am abandoned," he groans. "I am forsaken, even by Him in whom I had faith. My God, my God."

He relaxes his hold on the thwart and slides back in the boat in limp despair.

"No, no," his wife seeks to comfort him. "Don't you see that the sea's getting calmer?"

"Is that possible?"

The minister's voice is trembling with joy and emotion.

"Yes, I really believe it is."

He clings on to her hands.

"Yes, you're right. It's far calmer already," he exults. "It improved so suddenly. So my prayer has been answered after all."

He gets up and leans over the edge of the boat.

"What now?" shouts his wife. "What's he doing now?"

"He's just a bit seasick," says Kristoffer. "No wonder in this weather. But now we're over the worst, thank God."

The minister gets up, pale and trembling, but he smiles, "Oh, how suddenly it fell quiet."

"Are you seasick?" His wife gets up, too. He gently puts her hand on his shoulder.

"A bit," nods the minister.

The moon has again disappeared. It is almost pitch dark. They slip along the tall coastline of Kjovø. The water is quite calm here.

The minister lies down and settles in the boat with his head resting on his wife's shoulder. Before long he falls into a light sleep.

The night is still deep. The monotonous throb of the motor is echoed by the mountain. Now and then a frightened bird cries out in the darkness. The rain starts to fall again.

"We've only got about half an hour to go now, and then we shall be in Greypoint," says Gotfred.

"Oh, thank God," sighs Karen in relief.

"I really think your husband's asleep," says Gotfred.

"Yes, he is asleep."

She sits for a moment, considering . . . what to do. The minister's strange words out in the sound . . . what must these

fine men not be thinking? She feels an urge to confide in them and tell them about the minister's unfortunate illness, for she owes them an explanation, and she is convinced that they will understand and make allowances for him, her poor, tormented husband.

"He was fairly . . . frightened before," she starts.

"Well, he's not used to the sea," says Gotfred. "And between us two, this trip wasn't without its dangers. The Trymø Sound isn't to be played with. I wouldn't have risked the journey if Kristoffer hadn't been at the rudder."

"No, but he behaved in a rather strange way," Karen goes on. "I mean my husband, of course . . ."

"Well," says Gotfred. "But he's not the first minister to do that. Mr Schiødte, who was the minister here when I was a young man, it's told of him that when he was going from Trymø in bad weather one Christmas he recited the first chapter of St Matthew several times running without knowing what he was doing – that's how confused fear and seasickness can make a man."

The minister's wife could not prevent a smile. "The first chapter of St Matthew . . . it's the one saying Abraham begat Isaac; and Isaac begat Jacob and so on?"

"Yes, exactly," said Gotfred. "The Reverend Schiødte was a very learned man, and an excellent minister as well. But, as I say, he was very learned, and terribly forgetful. It even happened once that he entered the church wearing his overcoat instead of his cassock! My father was parish clerk in Trymø in those days, but he was ill and had taken to his bed that Sunday, otherwise that wouldn't have happened, of course. And the Reverend Schiødte had no wife to look after him, for he wasn't married . . ."

Karen had to laugh. She felt quite intoxicated with relief.

"Aye, these ministers," Gotfred continued. "They've got a lot to think about and deal with, so it's no surprise they become confused now and then."

"No, that is only too true," laughed Karen, sighing at the same time.

FOR MY DAYS ARE LIKE
UNTO A SHADE

I

Vitus was still expanding his little business. With the money he earned, he bought new bits and pieces, and he was full of ideas. He had recently discovered he could order his goods direct from Copenhagen. It was very easy indeed. He had obtained a price list, full of numbered illustrations, so all that was needed now was to fill in an order form with reference numbers and the number of items required and post it off, and then after some time a parcel arrived full of the most wonderful things: birthday cards with coloured pictures and writing in gold, paper serviettes with flowers and Christmas elves, small watches that could be wound up and go for a moment, music boxes, magnets, scent of violets and Bengal lights. It was not difficult to get rid of that sort of thing even if he sold them at twice what he had paid for then.

Vitus had more money to play with and started to be bolder. With the last post he had received ten Jew's harps, three alarm clocks and what was called a miracle barometer. These things cost almost twenty kroner altogether, but he reckoned with a profit of at least ten kroner. And then he had been sent a packet of "Devil's Firescript".

Vitus had only half believed in the miracle barometer; he had ordered it in something like a fit of curiosity and had regretted it since. But now it had come. It was in the shape of a small pink house with a green roof and two open doors, and when you looked in through these doors you could see the people who lived in the house, a man with a raincoat and umbrella and a woman in a pale dress and holding a parasol. This was already worth the three kroner in itself, Vitus thought, but you couldn't actually demand an entire miracle as well. And, as was only to be expected . . . the little

inhabitants remained safely indoors: the husband did not come out in rainy weather or the wife in sunshine, as had been promised in the catalogue.

Vitus had not yet had the courage to try the Devil's Fire-script. He had certainly read about this remarkable stuff in the catalogue, but had refrained from buying it before now although the price was low, only 25 øre. It didn't look danger-ous, almost like a box of ordinary matches except that there were not so many sticks, and there was a curious vapid, heavy smell to them. With these sticks you were supposed to be able to write fiery letters in the dark . . . not on paper or anything else cold, but on the palm of your hand or "any other part of the human body", as it said. And this latter condition didn't sound particularly attractive. It smacked almost of selling yourself to the Devil.

Within three days, Vitus sold six Jew's harps and an alarm clock in Kirkevaage and Greypoint. He could without any great difficulty have sold the entire consignment in the same villages, but he wanted now to save the rest for Holmvige. He had long felt he would like to go there for various reasons. It was a couple of months now since he had last been there. He would like to see Simona again. And the lawyer . . . he was said still to be there. And Frida Olsen and the hotel, and Reinhold Vaag the preacher.

The time had gone when Vitus had had to beg a lift from village to village. Nowadays, he only needed to go on board the mail boat and buy a ticket. And the only person he had to thank for this happy progress was the minister's wife from Greypoint; she had helped him not only with money and things to sell, she had actually taught him the art of trade. Before he met her, Vitus in his foolishness and complacency had considered it to be something of a sin to trade and to bargain, but the minister's wife, who was herself the daughter of a tradesman, had explained to him the difference between honest and dishonest trade, and she had impressed on him that trade was in any case more honest and respectable than beg-ging. And Vitus could also clearly feel that he had begun to rise in folk's estimation now that he could pay everyone what

he owed and no longer needed to be a burden on anyone. Indeed, in several places he actually felt he was respected. The lovely clothes the minister's wife had found for him had naturally also had their effect.

Vitus had thought of going to Holmvige by the regular steamer. For that reason he had walked the long road from Kirkevaag to Storefjord. It would be an experience for him to go on board a real, big steamship, and now he could take the liberty of doing that; he could afford what it cost. But when the steamer had arrived and lay out in the fjord, noisy and self-important and enveloped in its own smoke and fumes, it was as though he suddenly lost courage. Rough voices mingled with the rattle of the steam winch. The unpleasant thought struck him that these unfamiliar people on board might take him for a thief and keep his suitcase. He remained on the quayside, considering, until it was too late. So he had to wait and take the post boat that was due to go later in the day.

II

All is quiet and peaceful at the Welcome Hotel, and there is no one about. Sara, Søren Smelt's daughter, is sitting alone in the shop, smoking a cigarette.

"Can you have a room here?" She yawns condescendingly. "Yes, if you'll pay in advance we'll see what we can do for you."

Vitus takes out his purse and smoothes out a couple of five kroner notes on the table.

"It's curious how strict you are for a small hotel like this," he says in a tired voice. "How much do you want in advance?"

"Oh, never mind, it'll do later," says Sara in a more accommodating tone. "Sit down for a minute until Roberta comes and relieves me here, and then we'll find a room for you."

Roberta comes before long. The two girls put their heads together in a whisper. Vitus senses that something unusual is

going on. Roberta has feverish red patches on her cheeks, and her nostrils are palpating.

"Oh, heavens above, heavens above," she puffs.

Vitus would like the small room in the basement that he had last time, but it has been put into use as a storeroom for wool and jerseys. However, there's a small attic room above the café he can have for the same price. It's a narrow room with a low ceiling, hardly more than a cupboard, with only just sufficient room for a bed and a washstand.

"Do you want anything to eat?" Sara asks.

"Please . . . just a little cup of coffee perhaps."

Vitus opens his suitcase and takes out the miracle barometer. He puts it on the washstand. It makes a lovely decoration in the simple room, and you can never know whether it might start to work after all when it is left undisturbed for a time.

There is no mirror in the room, but there is a way round that . . . Among the other things in his suitcase Vitus has a miracle mirror, an eternity mirror as it says in the catalogue, one of the kind that won't break even if you tread on it with an iron heel. He carefully combs his hair and beard in front of this mirror and sprinkles a couple of tiny drops of violet water on his lapel.

There is an appetising, warm smell of coffee down in the kitchen.

"Oh, so Frida's turned to the wool trade?" he asks Sara, who is sitting on the worktop and showing signs of listening intently.

"Ssshhh", she whispers, pointing with her elbow in the direction of the door to Frida's room. "You'd better stay out in the lounge, and I'll bring your coffee to you there."

Sara comes in with the coffee. She opens her nostrils and sniffs: "Good God, I really believe he's started using eau de cologne. Eh, Vitus? Can you afford that? What a surprise."

Vitus takes out a tiny flacon and shows it to her: "Genuine violet water. It only costs thirty-five øre."

"Where do you get all these lovely things?" asks Sara in a flattering voice. She snatches the bottle from his hand and holds it up to the light. "It's so lovely."

"You can have it if you'd like," says Vitus, blushing. "I've got a dozen of them."

Sara hides the little flacon in her apron pocket. The cups come on the table together with a large dish of bread and cakes.

"Is the solicitor still here?" Vitus goes on to ask.

"Oh yes."

Sara pours coffee into the cups.

"And now I don't think there's much prospect of getting rid of him. He's joined the sectarians, and he's entirely given up saying he's leaving tomorrow."

Vitus gives a dubious smile. Sara is probably enjoying making a bit of a fool of him.

Sara lowers her voice: "And perhaps Frida doesn't want him to go . . . after all."

"Really?" Vitus inquires of her in an excited voice.

Sara shrugs her shoulders and purses her lips. "Well, what's one to say to that? . . . She'll soon have had her day. Oh, but I'm not saying anything, you understand."

"Yes, it's long been obvious that they're living together," whispers Vitus.

"Living together?" Sara shakes her head hard. "Not at all. You're quite wrong. I could put two and two together other- wise, but Frida's above all that kind of thing. She's more respectable that either you or me, I'll say that for her."

Sara becomes quite flushed with her unwillingness to accept this.

"Yes, but then you actually mean that she's . . . really fond of him, if I can put it that way?" asks Vitus with a benevolent look in his eyes.

"Something like that," says Sara. "But the funny thing is that she behaves to him in such a way you wouldn't believe it. She gets at him and pushes him around whenever she can see a chance . . . I simply can't understand it."

Vitus is not entirely convinced of Frida's respectability. This is a rather strong expression to use of a woman who keeps an open house for drunken seamen. He asks Sara dir- ectly how things are going with the Trawler Café.

She hesitates. "Well, they have a drop too much now and then, but these Englishmen are all right otherwise."

Vitus looks rather doubtful.

"Of course," Sara adds, "they don't talk as though they were in church, and they're men after all. But I assure you, Vitus, that Frida doesn't allow them to get up to anything either with herself or with us girls. I'll say that for her."

And Sara suddenly starts to look angry and adds: "And if there's anything about you, Vitus, you can go and tell that to everybody instead of running around with a pack of lies and gossip."

"God have mercy on us both," replies Vitus in a plaintive voice, "you should have left those words unspoken, Sara. Let that be said in the name of Christ. For if there's anything I despise and loathe it's evil gossip. In fact I do everything I can to put an end to it whenever I have the chance, so I do."

"Well, I hope so for your own sake," says Sara placated. She remembers the little gift and again speaks in a confidential tone.

"Every word of what I say's true," she whispers. "I've no reason to defend Frida, you know, 'cause she's often nasty to me."

Sara moves closer and goes on in a nervous voice: "But even so, I think there's something wrong with Frida today, 'cause she's been locked in her own room since this morning, and . . . I'm afraid she's in there drinking, all on her own."

Sara grasps his sleeve and asks him to go with her into the kitchen. They tiptoe past the door to Frida's room, and Sara asks him to put his nose up against the crack in the door. Yes, it's right enough. Vitus notices a strong smell of gin.

"Yes, can you understand it" asks Sara. "She never drinks spirits otherwise . . . You can believe me or not, I don't care."

And suddenly, Sara sighs deeply and looks Vitus in the eye: "Something must have happened," she says. "I have a feeling that something terrible's happened, I don't know why . . ."

Vitus feels extremely uncomfortable.

"Where's she got the gin from?" he asks.

"I imagine she's got it from Morberg. He's just had a whole crate. It's up there under the bed in his room."

Vitus stares ahead and is filled with wonderment and melancholy. Sadly, he shakes his head: "But where does that man get all that quantity of drink?"

Sara's eyes take on an ugly look: "Oh, from the ships I suppose . . . from the trawlers . . . There are plenty of people with no conscience who'll get it for him. Smugglers," she adds darkly.

"And where's Morberg today?" asks Vitus.

"I don't know . . . He's gone off somewhere. He went just after lunch; perhaps he's gone to the preacher."

"Yes, but . . . Does she ever shut herself up in her room?" Vitus goes on to ask.

"Never." Sara shakes her head. "She's always on the go from morning to night. And she got up about seven o'clock this morning and went across to the post office to get the post from the steamer."

"Post?" Vitus interrupts her. "Did she lock herself in after getting the post?"

"Yes."

Sara looks at him in surprise.

"No, it's just something that struck me," Vitus dismisses the idea. "She might have had bad news . . . who knows, perhaps she's finding it difficult to make ends meet after all, because she's taken quite a lot on, you know."

"If only she's not drinking herself to death," says Sara, her eyes wide open in fear.

"Try knocking on the door," suggests Vitus. "Knock real hard."

"I've tried twice," says Sara, "but she's not made a sound."

"Well, knock again, really hard," Vitus repeats.

Sara takes a broom and knocks several times on the door with the handle. But not a sound comes from the room.

"Perhaps she's already dead," says Sara, her mouth drooping.

But suddenly a few sounds can be heard through the locked door . . . some incoherent, lisping words. They listen

excitedly. But they can't make sense of them; it just sounds like someone talking in their sleep or like the words of a drunken person.

"What shall we do?" says Sara helplessly.

"We must wait and see. There's nothing else we can do," says Vitus in a solemn voice. "I suppose she'll come round from it sooner or later."

"Oh, this is dreadful," complains Sara, no longer seeking to speak in a whisper.

She flings the broom across the floor.

Vitus sits down at his table again. There is still a drop of coffee left in his cup; he drinks it and eats a lump of sugar with it as he becomes lost in thought.

There can't be much doubt that poor Frida Olsen has received upsetting news in the post. And it is an obvious assumption there is some problem with Magda . . . she is probably dangerously ill, perhaps dead. Dear God, dear God, things don't always go well for people. Vitus feels oppressed by his knowledge. But he goes on to think: suppose on that occasion he had not committed the sin of looking in Frida's letters. In that case, he would probably in his own mind have been forming a wrong judgement of this woman. He wouldn't have been able to think other than that it was the result of fornication and debauchery when Frida locked herself in there and lay drinking. So perhaps it was God's will that he should commit that deed. At all events, he would now do everything in his power to cleanse poor Frida's reputation.

Sara is filling the boiler with water. She is making a noise and struggling the best she can and happily talking aloud to herself as though actually to challenge Frida and tempt her out.

"Aye, I don't know what Morberg's going to have for supper," she says. "And I don't care . . . If I did what's right, I'd buzz off and leave her to take the consequences."

Vitus offers to help her with the odd thing, but Sara shrugs her shoulders and twists her mouth angrily . . . "No, never mind about that. I don't imagine you've come to Holmvige just to sit around here?" she adds irritably.

Vitus decides to take his suitcase and go into the village. He might just as well start this afternoon as tomorrow. But on the steps he bumps into Morberg, who is standing with a cigar in his hands and puffing thick clouds of smoke up in the air. "Welcome, Vitus, welcome, you little Tibetan high priest! Let's see what sort of remarkable relics you've brought with you this time."

"Oh, they're only a few simple things," smiles Vitus. "It's nothing for a man like you."

Nevertheless, Morberg goes up to his room with him.

"You've got a fine room here," he says, sitting down on the bed. "A little monkish cell, a real place for a philosophical navel-gazer like you. Here you can sit and mortify the flesh and sing hymns while you're doing it. Come on, let's have a bit of light."

There is a candle standing on a cardboard box at the foot of the washstand, but Vitus has no matches, and the lawyer has just used his last one for his cigar.

"Never mind, we'll sit in the dark," he proposes. "If you'll sing me one of your songs or hymns, my happiness will be perfect."

Vitus opens his suitcase and takes out a little box and hey presto the room is bathed in a powerful light.

"Splendid," says Morberg. "A crazy illumination. A divine mustard for the soul. Have you any more of that kind?.. Come on, let me! I'll buy a box – what does it cost? Here you are, one krone."

"It only costs thirty-six øre," says Vitus. "But I've got some red matches as well. And some blue ones."

"Good. We'll try them all . . . I'll pay whatever you want for this festival of light."

Morberg lights a fresh Bengal light, which splutters and gives off a drunken red glow.

"Ah, balsamic! And how it suits you, Vitus, this red light. You ought really always to let people see you in that light . . . It's contrary to nature that the image of a saint like you should float around in dreary everyday surroundings. You've come to the world too late or in the wrong place, that's the trouble."

The room gradually fills with fumes, and they both start coughing. The solicitor lights a blue match: "Just look at this. This is Hell, this is the real blue of sulphur. And now you look like a loathsome little devil . . . a real little cunning Devil's assistant. And I suppose that's what you are, isn't it, Vitus?"

Vitus coughs and feels both spiritually and physically ill at ease.

Morberg holds the spluttering match out to the candle. "Oh . . . that's the trouble with these wonder matches – they smoke. But so does the torch of truth, doesn't it, Vitus?"

"Yes, the light of the world produces smoke," says Vitus solemnly. "But God's clear sunlight . . ."

"Aye, now that really produces smoke," laughs Morberg. "It gives off smoke for thousands of miles around."

"I don't know anything about that," says Vitus. "I only know that there's nothing as clear and full of blessings as the sun."

"No, that's true, little Wise Man," says Morberg, leaning back against the wall. "By the way . . . Let me offer you a cigar."

Vitus thanks him. He lights the cigar from the candle.

"This . . . God help me, it reminds me of my younger days," says Morberg. He smiles: "Many was the time I sat in a garret like this and smoked until I had a headache and then embarked on endless discussions, in love with everything as I was. There's nothing like youth . . . this intoxication in the blood. Youth and being in love are the only things that make life worth living. Those are and always will be the supreme words of wisdom."

Morberg exhales a thin stream of smoke and stares into the candle's flame.

"You see, Vitus, when you're too old to be in love, then you're finished with life. But . . . I nearly said the trouble is that you never are too old. It's like a great magnificent bird that flies past . . . it's only close to you for a moment, and then it's gone again. But you can still see it at some point far in the distance. And occasionally you can pick up a feather or a bit of

down that it's left behind. And that's what you have to live on . . ."

Morberg closes his eyes, and his face assumes a blissful, rather foolish look. He goes on: "And sometimes you actually believe that the bird has come back. You know, that time, you remember, when the preacher's sister knelt and prayed for me down there in the café. It was bloody well like experiencing what it was like to fall in love for the first time as a child all over again. And of course I fell for the girl . . . and I still go and dream about her. Aye, what do you say to that?"

Morberg looks up and stares into the light; there is something strangely mild and shy about his eyes: "For, you see, she's out of reach, that's the crazy thing about it. The only happy love is the unhappy variety, as the poet says. Of course, she's not the least bit interested in me, that's to say not in me myself . . . why on earth should she be? But she'd like to help to save my soul. It's so touching . . . just imagine: there's someone, a young life, a Madonna, who's concerned about my soul."

"Earthly love's one thing, heavenly love's something else," remarks Vitus.

"Absolutely right," nods Morberg. "It's this heavenly love she's filled with, this patron saint of mine. It's a love without desire, a mystical, divine attachment. And those who cultivate it are perhaps the only happy souls on earth . . ."

He turns his eyes towards Vitus: "Are you one of them perhaps? Not a hope. It's only women and children that are allotted this heavenly love, as far as I know. We men are too heavy to rise sufficiently above the earth; our thoughts are always ugly and unclean; we lack divine naivety, you see."

Vitus nods and sighs, "Ah yes, what you say is so true."

Morberg smiles, but immediately becomes serious again. "Aye, broken dreams and filthy thoughts, that's our lot, Vitus."

"Yes, but Jesus is the friend of all sinners," objects Vitus emotionally.

Morberg thoughtfully blows the ash from his cigar. "Yes, but listen to me, Saint Vitus: a *friend*, a loving friend who puts

his arm round your neck . . . that's a thought more suited to a woman than a man, don't you think? No, the Catholics understand better how to speak to a man's heart. Mater dolo-rosa! Didn't you have a mother, too, Vitus? A poor human mother who sat by your bed when you were ill? One who sang good-night hymns for you and prayed to a jealous God for your lost soul?"

Vitus puffs eagerly at his cigar to hide his emotion. Yes, indeed, he did have a mother . . . the only living being who was ever fond of him, incidentally. This lawyer's a strange man, though. There must be something good about him after all . . . he must at least have been fond of his mother.

"Oh well, we can't sit here any longer," says Morberg suddenly and gets up. "Aren't you going to the meeting this evening as well, Vitus?"

"Perhaps I ought just to look in," says Vitus.

"Yes, do," Morberg encourages him. "It's divine, I assure you. And we've got Sylverius and his wife with us as well now."

"Good heavens . . . Is that true?" says Vitus in a shocked voice. "Well then, in that case I must really come."

Morberg laughs quietly: "I must really come! . . . You're basically a human being, Vitus, in spite of your saintly face and your coloured torches."

III

Sara had laid a small table for Vitus's supper in a corner of the kitchen. There was a cloth on the table and a cruet with pepper, mustard and vinegar. And there were herring and sardines, fried eggs, jam and two kinds of cheese.

"Eat your fill," Sara encouraged him. "It won't cost you any more."

Vitus was not used to that kind of luxury and thought there must be some ulterior motive. And it turned out that he had guessed right. Sara daren't be left on her own under the same roof as Frida. Roberta had let her down and gone out with

her boyfriend, and she assumed that Vitus would stay at home and keep her company.

"Of course, I could have sent for my father or one of my brothers," she said. "But I can't be bothered explaining things to them, 'cause it'll be all over the village in no time."

Vitus thought this an attractive side of Sara, and he also felt flattered to be her only confidant in this strange and ominous matter. But that meant he had to give up going to the meeting and hearing Sylverius's and Simona's and perhaps even Morberg's confessions. As a sort of compensation he persuaded Sara to tell him what she knew about Sylverius' and Simona's conversions.

It hadn't really been a surprise to anyone, for Sylverius had long been spending a good deal of time with the preacher, and he had received the Storefjord sectarians as his guests at Christmas when they were visiting Holmvige. It was not long after this visit that Sylverius had stood up before the gathering for the first time and announced his conversion. This had probably taken place on board the schooner Yvonne one evening.

"But what about Simona?" asks Vitus. "Has she gone over as well?"

"No, I think Sylverius is doing it on behalf of both of them," is Sara's opinion. "Simona's not quite herself at the moment either. She's expecting."

"And what about Morberg?" Vitus goes on. "Has he really joined them? Oh Lord, oh Lord. But surely he doesn't actually get up and confess?"

"He's supposed to have made a confession at a meeting once . . . I wasn't there, so I didn't hear him. But Roberta was there, and she maintains he was pretty drunk that evening."

Sara sighs and adds, "All this is a lot of curious nonsense, don't you think, Vitus?"

She lights a cigarette.

"Well, I think we'll have a proper cup of strong coffee," she winks at Vitus. "I don't know what I'd have done if you hadn't been here," she adds gratefully. "It's not all that nice in the hotel in any case, and now this is simply awful . . ."

She moves her chair closer to Vitus and lowers her voice. "And will you believe me . . . there are *ghosts* here as well."

Vitus frowns and starts eating more eagerly in order to overhear her as it were. He is not keen on ghost stories. But Sara refuses to leave him in peace.

"Yes," she goes on. "It's all in the café. There's someone rummaging about down there during the night, moving the chairs about and sighing and mumbling . . . it's a tormented soul of some kind, wherever it comes from. And one night it was particularly bad, and neither Roberta nor I had a wink of sleep that night. It wasn't only that we could hear all those strange sounds down in the café, but there was a dog howling outside as though for a dead body . . ."

Vitus screws his eyes together in his distress.

"It's just something you've dreamt." He attempts to make light of it.

"God bless you," Sara is hurt now. "I was sitting up in bed and I was completely wide awake."

Vitus' eyes become troubled. He remembers the little box of Devil's Firescript and is filled with pangs of conscience.

"Aye, then there are evil forces at play," he says plaintively. "Christ have mercy on us."

Sara sits staring with wide eyes.

"Yes, you must admit I've got reason to be a bit nervous," she said.

"When was it you heard that dog howling?" asks Vitus.

Sara thinks for a moment and works it out: "Well, it must be a good week ago."

Vitus nods and thinks his own thoughts. If it's right that this Magda is dead, the dog might well have been announcing that death . . . "And you only heard it that one night?" he goes on to ask.

"Yes, thank God."

"And the curious sounds?"

"No, I've not heard them since then, either. But . . . I've been in the habit of sleeping with cotton wool in my ears recently."

"Sshh. Listen," says Vitus suddenly.

They both listen.

"Oh, it's only the boiler now." Sara laughs in relief. "You can just hear the water boiling."

"Aye, so it is."

Sara takes another cigarette and offers the packet to Vitus.

"Let's talk about something else," she suggests. "Where have you been recently, Vitus? Have you been in Østervaag? Are the women all wearing the latest fashions there? Tell me a funny story to please me."

But Vitus is not in the mood for funny stories. He sits there and can't get his Devil's Firescript out of his mind. The little box is at the bottom of his suitcase, carefully wrapped in thick brown paper. He pictures it to himself and can't rid himself of the image. The sticks are greasy to the touch and smell mysterious like poison or sulphur. He regrets not having got rid of this godless stuff. He's thought of doing so several times, but then he has put it off and done nothing about it.

But as long as the little box is in his possession, it's almost as though the Devil has some hold over him. The thought makes him run all cold inside.

Sara has started making the coffee. She has become more self-confident now she has told Vitus about the ghosts, and she stands there with a cigarette wobbling in the corner of her mouth.

"Thank heavens," she says, "I've not tied myself to Frida for life, and let me tell you I'm giving in my notice to leave at the end of the month and moving to Østervaag, for life in this hole . . . good Lord, Vitus. It's not a place fit for people to live in."

Vitus embarks on a conversation in order to escape from his own unpleasant thoughts. "No, she might be right in that. Holmvige has turned into a forbidding place, unfortunately. At one time it was a good old-fashioned farming community . . . but what are farmers worth these days? They don't count any more. And that's really their own fault, for they only had thought for themselves when they had influence. But it was nice in those days, as though there was more substance to people; they stayed where they were, and they were faithful

both to each other and to God. Now it's as though people can't agree on how to worship God; it's all one great Babylonian confusion nowadays with each group pulling in its own direction ... confessionists, evangelicals, Adventist's and whatever else they all call themselves. Alas, alas .. it's probably not pleasing to God that they fight over Him in this way."

Vitus remembers what Reinhold once said to him here in the hotel . . . about how pointless it was considering yourself a believer if you didn't feel a fundamental urge to share salvation with others. Strange that both Sylverius, Simona and Morberg had joined the confessionists.

He had to admit to himself that this urge to confess, to take part in spreading the Word, was something he lacked. Perhaps he was not a true, living Christian. In this sense, things had perhaps taken a turn for the worse with him recently. He had been rather preoccupied with earthly things; success was turning him into a child of this world . . ."

"Sshh," Sara suddenly whispers and sticks out the tip of her tongue.

They both listen. Vitus can hear nothing, but Sara is quite pale.

"There *was* something," she says with fear in her voice.

"What was it?" asks Vitus with a frown.

Sara closes her eyes and draws her breath through clenched teeth. "Oh, I don't know . . . I'm so afraid."

She comes across and rubs her arm against his shoulder.

"I . . . I can't help imagining Frida's hanged herself in there."

"Hanged herself . . . Yes, but why should she just have hanged herself?" asks Vitus, trying to strike a tone that will calm her down.

"Oh, I don't know," moans Sara. "I just think she's like one of those people who hang themselves . . . there's something about her neck that looks hanged . . . and remember how heavy she is."

Vitus feels his scalp turn cold, as though someone had put a wet comb through his hair. He suddenly understands Sara . . . she's right; he can just imagine Frida Olsen hanged . . .

They both stand there for a moment silent and paralysed with fear.

"Listen, there it was again," whispers Sara.

And now Vitus can hear it plainly, a gentle creaking sound coming from Frida's room. Perhaps even at this moment she is putting the noose round her neck.

And now there is a sound of a short, waking cough. And a drawn out "uuugh".

Sara pushes her lower lip forward and looks at Vitus with eyes that explain everything: "She's awake. Perhaps she's getting up now. Let's get rid of some of those tins of food."

And suddenly the girl comes to life. At great speed she gets plates and cups down into the washing up bowl and opens a window to get rid of the cigarette smoke. Vitus feels superfluous, but remains standing in a corner with his hand on the door catch.

Frida starts rummaging around in her room. She knocks a chair over. And now the door opens. She enters the kitchen, screws her eyes up in the lamplight and blows her nose.

"Good evening," says Vitus meekly.

Frida makes no reply. She goes over to the sink and fills a jug with water, empties it at a single draught and then fills it again.

"You'll have to find somewhere else to live, Vitus," she says in a calm voice and without turning round.

"Won't you have me here any more?" says Vitus in amazement.

"This isn't an hotel any longer," is Frida's brusque reply. Her voice is a little hoarse.

"Isn't this an hotel any longer?" asks Sara, flushing scarlet. "What's that supposed to mean?"

"You'd better go as well," Frida goes on, drinking and still without turning round.

Sara's features stiffen a little.

"Thank you very much," she replies, on the point of tears. "But I'd thought of doing that of my own accord, 'cause this is no place for decent people."

Frida makes no reply.

"But . . . Is the hotel to close already this evening?" Vitus asks in a matter-of-fact voice.

Frida makes an impatient movement with her elbow. "I've told you, you can get out. Now, straight away."

Vitus and Sara exchange glances. Sara snorts and looks as though she's going to give Frida an unadorned piece of her mind. But all that comes is a brief, scornful laugh.

"Oh well," sighs an appalled Vitus. "If that's how it is . . ."

He goes up to his room. Matches . . . that's right, he's forgotten to provide himself with any. So there's nothing for it but to sacrifice another Bengal light. He lights one of the blue ones and takes hold of the candle. The torch splutters and gives off its flickering light. Vitus's eyes light on the miracle barometer, and he gives a start . . . the man with the umbrella has come out of the house! He can't believe it. He drinks in the sight with greedy eyes and can hardly persuade himself to pack the wonderful thing down in his suitcase again. But there is nothing else for it . . .

For a moment, Vitus is overcome by a strange feeling of uneasiness. He has landed in a strange situation. And what might it develop into? One thing is certain, and that is that it is all very unpleasant.

Sara, too, has packed all her things together. She stands outside the hotel, waiting for Vitus.

"You can leave your suitcase at our house" she says in a kind voice. "Then we might be able to find somewhere for you to sleep as well."

"Oh, thank you very much," says Vitus gratefully.

"But have you got any idea what it's all about?" whispers Sara, giving a new laugh that is both scornful and despondent.

It is a dark and windy evening with thick cloud. They remain standing outside the hotel as though they can't quite tear themselves away. The light is put out in the kitchen.

"Perhaps it was silly of us to go," whispers Vitus. "Because she was, you know, not quite . . . in her right mind."

Sara takes a deep breath and then exhales with a whistling noise. "I'm thinking the same. But when you're thrown out, because that's what we were . . ."

"I wonder whether she'll lock the door and keep Roberta and Morberg out," Vitus goes on. "It sounded as though she wanted to be entirely on her own."

"Let her do what the blazes she likes," says Sara decisively. "She's a grown woman and we're not her nursemaids. Come on, to blazes with the daft old bag."

Down at Søren Smelt's house, everyone has gone to bed, and the door is locked. But Sara manages to tease a cellar window open and crawls inside. She returns before long and puts her head out through the window.

"I don't really know whether to wake them," she whispers. "You know . . . then we'll have to explain things, and then there'll be a fuss."

"Yes, you're probably right," Vitus nods.

"Well, I mean . . . it'd perhaps be best if we secretly keep an eye on the hotel after all. 'Cause if it's all because she was drunk, she'll perhaps regret it tomorrow. You know, it's all very strange after all when you think about it."

Vitus agrees.

"We can put your suitcase down here in the cellar for the time being," Sara suggests.

No, Vitus daren't risk that. He'd rather hang on to it. You never know what might happen.

"Remember there's a whole shop in it," he says apologetically.

Sara climbs up from the cellar again. "I think the confessionists' meeting will be over by now," she says breathlessly. "We'd better go and see whether she lets Morberg in."

They walk past Sylverius's warehouses. There is still a light in the windows of the meeting room, but the participants are breaking up. Dark figures can be seen in the door, disappearing silently or in quiet conversation in the darkness. Vitus fails to recognise any of them. But Sara has eyes like a cat.

"There's Morberg," she whispers, pulling at Vitus.

Morberg is walking home with rapid strides.

"See how he's hurrying," whispers Sara. "It's the gin he's after. You bet he'll be mad if the door's locked."

They follow the solicitor. He is merrily humming one of

the confessionists' hymn tunes. Now he arrives at the hotel. He pulls at the lock, knocks, mumbles in irritation.

"That'll do you good, you old toper," Sara says exultantly. "That'll do you good!"

"Open the bloody door," shouts Morberg, hammering away on it.

"Oh, I say . . . and he's coming straight from a prayer meeting," Sara laughs.

But Morberg is left standing there. The building is closed and as impregnable as a rock.

Vitus moves uneasily.

"Can you smell something burning?" he says suddenly.

"Yes." Sara has noticed the smell of burning as well.

"I hope there's not a fire."

"If there was one, we'd be able to see it."

"Yes, but my window . . . it can't be seen from where we're standing," says Vitus in a trembling voice. "You see, I think I forgot to put the candle out. And it was standing on the lid of a cardboard box. Oh, Heavens above."

"Well, don't make such a fuss." Sara tries to calm him down. "You stay here while I run round to the back and have a look."

Morberg is hammering on the door with both hands. "It's not good enough, this. Open the door, or I'll smash the windows," he threatens.

Vitus can't stand still for excitement. He puts his suitcase down and puts his hands to his head. How could he be so careless as to forget to put his candle out? Everything turns black for him for a moment; his knees give way, and he has to sit down on the suitcase.

"Fire!" he hears Sara shriek. The mountains echo with the sound. "Help. Fire! Fire!"

Morberg stops his banging and shouts out, "What the hell?"

Sara's cries echo in the air. Other voices join in, and people come rushing to the scene. Vitus is trembling as though he were up to his neck in water. Now he can see the thick, light smoke pouring out of the roof. He folds his

hands and whispers, "Oh God, oh God, I've set the hotel on fire."

But smoke is not only pouring from the roof . . . it is coming from the windows and the kitchen as well. The whole house is on fire already. It is incredible that it has been able to happen so quickly, that the flame from the little candle in the attic has already spread to the whole house. But it has happened nevertheless. It's dreadful. Vitus bursts into tears, silently and intensely, like a helpless infant.

Grey figures come running up. The air is full of sounds, of horrified and indignant voices, of footsteps and knocking, of windows breaking, of dogs barking. And now the fire itself can be seen . . . red and black flames are licking at the rooftop.

Vitus sits huddled up on his suitcase, with wide open eyes as though under a spell. They have managed to open the door down there. The house is full of noise; people are running up and down stairs; heavy objects are overturned; there is a rattling of buckets; axes are chopping. And the scene becomes light . . . almost as light as in daytime. The flames pour out of the roof and send up tongues of fire into the night sky . . .

"Vitus." Someone shouts. "Where's Vitus?" And he hears Sara's voice, "He's out, he's all right."

And suddenly it is as though Vitus awakens from a spell. He gets up . . . his legs will support him again now. He staggers down to the house with his suitcase in his hands. He mingles with other people and is knocked over by some men bringing a ladder. He gets up again and makes his way through the crowd until he catches sight of Sara.

"Sara," he groans and tugs at her arm. "What about Frida? Have they got her out?"

"She's over there," Sara points to where Frida is standing.

Vitus does not take the time to discover where it is that Frida is to be seen. At least she has not been burned alive in there. He grabs his suitcase and pushes his way out of the throng again, out of his mind with the fear of being grabbed and held back. He runs as fast as he can and without thinking where he is going, simply wanting to get away as fast as he can from the blazing inferno.

"Hi, Vitus," he hears Morberg's voice, and a hand is stretched out and latches on to his jacket. "Where the Devil do you think you're going at that speed? Have you stolen something?"

"No," moans Vitus. He tears himself away, falls, gets up again and runs on.

"Wait for me," shouts Morberg. "Wait for me, damn it, man . . . are you completely crazy?"

But Vitus rushes on. He can hear Morberg's steps behind him. It's like a bad dream.

Only when he is a good way out of the village does he stop and throw himself down on the ground, worn out. For a moment he senses nothing except that the patch on which he is lying is wet and cool. And pitch dark. His mind is full of confused thoughts. This is like death and the grave, and that is only a good thing. So perhaps a passing angel will come and take him along. There is nothing he would wish for more. If only he can find Heaven open to him. He thinks he hears sheep braying, quietly and intensely. Ah, the throne of the Lamb, perhaps he will never see that. He, who has left a smoking ruin behind him on earth . . .

Again this subdued braying. It's real. Vitus lifts his head . . . he's alive and on earth, lying in some cold morass, perhaps a quagmire, perhaps he's sinking! He gets up with difficulty, grabs his suitcase and wades through oozing marshy ground until he feels firm ground beneath his feet. The night is not entirely dark, and he can make out boulders and hillocks and a small hut, a small, shapeless stone hut with a turf roof. The sky is pale grey. He is at the bottom of a small hollow. There is a stream running peacefully and gently nearby. He listens in sickly infatuation to its burbling; the isolation wraps round his soul and heals it. Many's the time he has played beside such a stream as a child while his mother sat knitting in the lee of a boulder. But what has happened since . . . he has set a house on fire, an hotel! He, Vitus, is an arsonist, a homeless, wandering criminal. Sooner or later he will be caught and punished.

"Vitus," comes the sound of Morberg's voice calling him. "Where on earth has he got to?"

Vitus kneels on the grass beside his suitcase in the hope that, if he comes, Morberg will take him for a boulder among the other boulders. He will pray to God that he might have patience to bear his heavy fate. Nor could it be different. Retribution had to strike him some time. Not for nothing had he lived in sin and worldly thoughts for months, without thinking of virtually anything but how he could sell his useless and partly actually harmful things to his own advantage. In a way, he was even glad that God had chosen to reprove him in this way. What could have happened otherwise? He had actually been in need of this cruel humiliation.

It starts to rain.

Vitus becomes calmer. He decides to go back to the village and let justice take its course. In his original confusion, he had of course sought to escape . . . that didn't lessen his crime.

But the thought of the burning building, the crowd of people, all those eyes that would be on him, the arsonist, again made him frightened to the bottom of his soul. And in any case, he could wait until morning. He feels tired and worn out, hardly capable of going all the way back. And neither is he sure of the path.

"Vitus!" The solicitor's voice is further away now.

Vitus feels he is on the point of fainting. Perhaps he will lie here and die, quite quietly and unnoticed. And why should he really hide from Morberg when he intends to surrender himself in any case sooner or later . . .

He gets up and shouts, "Hello, here."

No reply.

"I'm here," he repeats.

"Hello." Morberg's voice sounds closer.

And with indescribable relief, Vitus feels that there is a human being near him. Even if it is only Morberg. He continues to shout his "Here!" until Morberg has found him.

"Oh, thank God," exclaims Vitus involuntarily.

Morberg smells strongly of spirits. There are bottles of gin sticking out of his overcoat pockets.

"What the devil are you so frightened of?" he asks with a

laugh. He is quite out of breath. "Was it you who set the house on fire?"

"Yes, it was," says Vitus meekly.

Morberg laughs louder than ever. "What's that you say? Did you set the place on fire? But how on earth . . .?"

Vitus sighs and abandons himself to his moaning.

"It was the candle in my room . . . I forgot to put it out, and it was standing on a cardboard lid . . ."

"Oh, so it wasn't on purpose," says the solicitor.

"No, I swear by God in His goodness," Vitus assures him, seriously, as though he were standing in a court of law.

"And . . . Were you trying to put an end to yourself now?" asks the solicitor.

"Oh, I don't know what I was trying to do," says Vitus. "I was simply beside myself."

"You're a fine chap," says Morberg, giving him a friendly tap on the shoulders "I didn't like the fire, either, let me tell you. I can't stand fire . . . just imagine being choked by smoke – that must be one of the most unpleasant ways of dying."

"Did you run away from the fire as well?" asks Vitus enthusiastically.

"Yes, to be honest . . . I stayed there until Søren Smelt saved my gin for me . . . and then I stood wondering what to do with myself, and then you came up like some kind of giant Sudanese ground beetle. And I thought to myself that that imaginary animal probably knew a way out. Oh well! But let's find some kind of a shelter, Vitus, so that we two homeless, shipwrecked souls can abandon ourselves to our hermit's existence."

"There's a little building over there," suggests Vitus in a weary voice.

"Yes, I was just thinking of that," says Morberg. "Let's go over and take a look at it. But see, have a dram first, Vitus. You must need it."

There is a padlock in the door to the little hut, but the lock has not been set. Vitus opens the door and is met by a luke-warm smell of sheep. He goes inside, feeling his way in the

dark . . . it is obviously a peat store, but there are a couple of sheep here, rams for fattening, probably, standing in a small pen, and in front of the pen there is a pile of hay.

"I think this is a good place to stay," says Vitus.

"I can't see a hand in front of my eyes," pants the solicitor. "And I still haven't got any matches. Let's have one of your torches, Vitus."

Vitus opens his suitcase and hands a box to him.

Morberg takes out some money: "How much were they? See, here's two twenty-fives."

"Oh, that doesn't matter now."

Morberg strikes a light. The sheep move back in fear and bray loudly in their pens.

"This is fine," says Morberg. "We'll stay here. Just you lie down on the hay . . . it's you who've had the worst time of it this evening. And then I'll sit on this box. Splendid. Cheers."

"May God in Heaven forgive us all our sins," sighs Vitus nervously, adding, with chattering teeth, "I suppose there's a stern punishment for arson. Do you know anything about that – you're a solicitor?"

"Rubbish," says Morberg to calm him. "There's not a dog that will bark because you've been a bit careless. It's an accident, and all that's come of it is that we two no longer have a place to stay. And in any case, it wasn't you who set the house on fire. But never mind about that. Cheers."

Vitus sighs and stretches out in the hay. The rams are restless and braying quietly in their pens, wanting some hay. He gives them a few handfuls from the pile to quieten them down. Morberg hands him a bottle of gin.

"See, you can drink as much as you want. And we'll drink to each other. Cheers for the loneliness and the darkness. Just listen how it's raining now. Here are we two as the only survivors from a world-wide catastrophe. Or a pair of settlers in a desolate prairie. An ocean of loneliness. We and then the two rams! We're sitting here with our animals like Noah and Lot in their Ark."

"It wasn't actually Lot that was with Noah in the Ark,"

comments Vitus quietly. "Lot . . . didn't come until later, during Abraham's time."

"Oh well, call yourself what you like, wise man," says Morberg. "At least, I'll be Noah. And so now we're sailing in our ark high above all the drowned lands. Can't you hear how mightily the flood is rushing? And up in the inexhaustible gulf of clouds sits Jehovah, looking at the Ark like an impudent boy sitting by a pond and playing with a boat."

Vitus makes to reject this, but Morberg interrupts him: "Yes, a really bad, impertinent boy. Didn't you play at floods when you were a boy . . . when you were tired of playing sensibly with your boats, when you were tired and wet and your fingers were numb and when it started getting really cold towards evening? Then you got up like an angry, jealous Jehovah and took hold of a big stone and threw it down in the pond with a tired shout. And then you sat there and watched how the waves rose like gigantic creatures and the wharves and towns you'd taken so much trouble to build were destroyed, and the ships overturned! I've played that game at least, in this very stream out here . . ."

"But God's not like that," Vitus maintains. "He wanted to renew the human race and so in His wisdom He destroyed the world."

"No, He was simply tired and cold," Morberg continues unmoved. "He was tired of the game and filled with an urge to destroy. That's what creative forces are like. And then He went home and slept, and the next day he started all over again . . . a new world arose. Noah and his people landed on Mount Ararat, which lay there like an island in this breaker-breathing flood, a wet mountain island with a white ring of surf all round. That's how we'll land tomorrow, you know, on just such an Ararat island. The only trouble with it is that there are people living there beforehand, ghosts from the time before the flood . . . narrow wingless creatures without a thought for anything but their little shops and their little redemption calculations that refuse to come out unless they make use of tricks and cheating. No, Vitus, we won't go ashore, we'll just sail on. Cheers."

Morberg drinks greedily and sits silent for a moment. Then he goes on in a subdued voice. "And yet there's just one among them who has an unselfish interest in your soul. Aye, it's touching after all . . . When it comes to the point, the human heart is the only acceptable reality in the world. In the face of goodness, everything pales like . . . Well, like Bengal lights in the sunshine. When you make up your life's account . . . what's left of value except a little handful of goodness you've gathered, almost by mistake, while you've been busy with other more important things."

"God is goodness," Vitus puts in.

"Goodness is god," Morberg corrects him. "But . . . it's not a mighty, fuming Jehovah, but rather a shy little Cupid. You'll see, there's no other real goodness apart from the erotic, which assumes every conceivable shape, keeps on changing its mask, but is fundamentally always the same. Don't you think? What does our wise man say?"

"I only know that God is good and merciful," says Vitus.

"Rubbish," Morberg interrupts him." The god you're talking about is not merciful at all. He's a jealous god who stamps on goodness and Cupid, who smashes the world of mankind under his foot, just as I'm smashing this empty gin bottle."

Morberg flings the bottle against the stone wall, but it only gives a hollow thud and rolls across the earthen floor to end in the pile of hay near Vitus.

"Aye, there are a few of us who stick it out . . . in spite of all evil rejections by a higher authority," Morberg laughs.

He opens a new bottle. "Cheers, Vitus. Now we'll forget all the evil we've had done to us and inflicted on others in this vale of tears. Cheers for the profound darkness in which the animals bray. If it wasn't so cold here, it would almost be like in Bethlehem, in the stable. Then we could be two of the three kings who've stopped here on their pilgrimage in search of the world's profoundest wisdom."

Because of the cold, Vitus has taken a few gulps of the gin, and Morberg's sombre speech has put him in a strange disconsolate and yet gentle mood. Aye, here sit two poor sinners

with their uneasy and helpless thoughts, lonely and unhappy each in his own way, in a miserable hut, in a dark night heavy with a sense of misfortune. God must have arranged it thus to bring them closer to Him.

"Wouldn't it be a splendid idea for a new apocryphal addition to the Scriptures," Morberg continues. "There were originally five kings. Three of them found the road to Bethlehem, but two mistook the path and came to a desolate barn where there was neither mother nor child, only two hungry rams. We're those two unfortunate kings, Vitus. Let's drink to that. Come on, let's live out our parts. What does one of the kings say, the one called Vitus and known as he who was brought into life by accident and through no fault of his own?"

"Oh," Vitus refuses to take up the theme. "That king hardly has a realm, God help him . . . if only he doesn't find the door to the Kingdom of Heaven closed."

"Good," says Morberg. "The other king's called Mortus, with the nickname of 'he who thinks of death'. And he says . . . well, what the devil does he say? The word of wisdom of course remains hidden when you need it. This Mortus is an unusually clumsy and stupid king. Cheers. Yes, that's what he says, 'Cheers'. Did you hear that, King Vitus . . .? He said cheers. What does King Vitus say to that? Think of a good answer, otherwise our legend will go to pot."

Vitus has sat wondering whether he perhaps ought to use this moment to say a few pious words to Morberg, in which case the night would not have been lived in vain. He thinks of one of the penitential Psalms . . . Morberg was fond of hymns.

"Poor King Vitus," he says pitifully," has no wisdom apart from what he's learned from others . . . but he remembers what King David said in *his* great trouble and spiritual need."

"Great," says Morberg. "You'll save the situation as usual, King Vitus. Bring out King David."

Vitus clears his throat and starts on the hymn:

> O Lord, give heed unto my prayer,
> And let my cry come unto thee;

And in the day of my distress
hide not thy face from me.

O, hear me, do; whene'er I call,
to answer me make haste:
For, as by fire my bones are burnt,
my days, like smoke, are waste.

My heart within me smitten is,
and wan it is and withered
Like very grass; so I would fain
forswear to eat my bread.

By reason of my groaning voice
my bones cleave to my skin.
Like pelican in wilderness
forsaken I have been:

My bitter en'mies all the day
reproaches cast on me;
And ever filled with hate and rage
against me sworn they'll be.

Yet why? I ash to eat did crave
like bread, in sorrows deep;
My drink I also mingled have
with tears that I did weep.

Thy wrath and indignation
did cause this grief and pain;
For thou hast raised me up on high,
and cast me down again.

My days are like unto a shade,
which doth grow dim and pass;
And I am dried and withered,
ev'n like unto the grass

Vitus suddenly comes to a stop. He can't remember the rest.

"And I am dried and withered, ev'n like unto the grass", he repeats. "That's strange."

"My days are like unto a shade", whispers Morberg in a dreamy voice.

Vitus sought and sought in his memory for the continuation, but he was unable to think of it. He had stopped because he had suddenly remembered Devil's Firescript. It had struck him that it was perhaps because of the little box that things had gone so terribly wrong. It was probably one of those things that brought misfortune in its trail. And now it was in his suitcase in all its doom-laden power. The thought was more than he could stand. He must get up and take the box from the suitcase and throw it out of the door, out into the darkness, where it rightly belonged.

"Where are you going?" asks Morberg. "You're not buzzing off, are you?"

"No," replies Vitus. "It's just something I want to find in my suitcase."

He lights a torch. The sheep draw back in fear in their pen. Morberg screws his eyes up. Vitus finds the little box and takes it out of the paper in which it is wrapped. He waits until the torch has burned out, and then he opens the door a little and throws the abominable stuff out.

"Cheers," says Morberg. "Now we'll have a decent drink."

And in a deep voice he adds, "For my days are like unto a shade, And I am dried and withered, ev'n like unto the grass. Cheers."

"The worst thing is that I can't remember how it goes on," says Vitus, "try as I might . . ."

Morberg is becoming paralytic, and his speech is ever more indistinct and incoherent.

"Here we sit in the night of life," he says. "We two and the other two poor rams . . . you could give them a bit of hay from your abundance, Vitus, and then you'll be doing them a good turn before they're put out. Cheers. Yes, for you're presumably aware that this means the end is approaching. We're

drifting down the river, down towards the abyss. You can hear the last rush. What we've found is no ark, it's a sepulchre. A sepulchre, you understand, my little psalmist. King David and our own psalmist Kingo will soon be coming knocking on the door, and they'll have a third man with them, and then it'll all be over. They're the three kings, you understand, and one of them is Death. He'll simply point his finger at you, and you'll stiffen up as you're lying there in the hay, with your godly intentions and everything. After that it'll be the rams' turn . . . He'll point at their foreheads, and they'll sink down braying and Kingo'll carry them over into Abraham's lap because like all animals they are without sin."

Vitus coughs and clears his throat to drown out the dark and ugly things being said, but Morberg goes on regardless: "And then it'll be my turn . . . I'll be the last, for I'm the greatest sinner of the four of us. And I'll slide down from the bed into the grave. And what then? Then they'll sing a hymn for me, saying that our days are like unto a shade. The preacher's sister will come and place a flower and a little text from the Scriptures on our graves and perhaps shed a tear, a single child-like, foolish tear as clear as a pearl, because she doubts whether my soul really is saved. But you, Vitus, there's no one who'll miss you . . . they'll just say 'Is Vitus from Greypoint dead? Fancy that.' And then they'll not talk about it any more. Not even a worm will bother to wriggle on your grave."

Vitus has tears in his eyes. Those were harsh and terrible words. But . . . it's quite possible that's what will happen. But the minister's wife from Greypoint will perhaps give him a little thought. And Simona . . . no, that's probably more than he can expect.

Morberg's words become increasingly unpleasant. He mumbles in his sleep, and it is all the time about death and judgement and the great void that will occur when God, the Devil, life and eternity have all gone and there is only a little handful of goodness left, like a gently shining, almost invisible, but imperishable patch in the darkness.

Vitus is overcome by distress and sleepiness. He slides into

an uncertain doze and dreams that someone is knocking on the door shouting "Does the fireman live here? Does the arsonist live here?"

And those voices keep on inventing dreadful new terms of abuse for him that hurt him to the bottom of his soul: torch bungler, the Bengal madman, the mad firewriter . . .

IV

Vitus awakens, stiff with cold, and looks around him. His teeth are chattering. It is fairly dark in the little hut, but through cracks in the stone walls a whitish morning sky can be glimpsed. The rams bray quietly in their pens and look at him with shining, observant eyes.

It takes Vitus a moment to come round completely. Everything is spinning before him, and he cannot remember why he has slept in this strange place. But then his eyes fall on the light brown gin bottle standing on a box, and suddenly the events of the previous evening and night engulf him like a foaming wave of merciless misery. For a moment he wishes he had not wakened again, but he catches himself in this profane thought and rejects it in disgust.

And how thirsty he is. There is nothing strange about that, as he has been drinking. Even though it was only a couple of mouthfuls. He has been *drinking*, as though to make his shame complete. Perhaps it was more than a couple of mouthfuls . . . He was so cold and tired, and he knew no shame.

Morberg has disappeared. Hunger and cold have presumably forced him to return to the village and human habitation. A man like him, a man who lives in an hotel, is accustomed to a certain standard, however much of a drunkard he is.

Vitus sits up and says his morning prayers. How strange . . . however cold and shivering he is, however thirsty he is and however strong his feeling of nausea, he manages this morning as never before to find the right words. It is as though his spirit is inspired, and he feels a great and profound sense of comfort as a result. It is as though a voice is whispering in his ear: "God

414

is gracious unto thee". Yes, his thoughts are taken on radiant paths. He is able for the first time to realise that it was completely contrary to his will that he set the hotel on fire. And secondly: Who knows what the poor drunken and perhaps even crazy Frida would have done to herself if she had been left alone in the house? She might have hanged herself, as Sara feared, or perhaps she would have taken poison or at least have drunk herself to death. And thirdly: the fact that the Welcome Hotel had been destroyed now was not such a bad thing. Whatever else could be said of this hotel, it couldn't be denied that it was a place where drunken seamen hung out and a source of drinks for that poor solicitor, who would perhaps long ago have left for and found somewhere better if he had not had the hotel to hang around in.

Not that he meant . . . Vitus didn't feel that his own sin was lessened by all this. His sin was presumably to be seen as a mild punishment for self-righteousness and self-indulgence. And yet . . . by punishing him in this way, God had as it were let him go on a superior errand . . .

Vitus gets up and starts brushing the hay from his clothes. This good suit looks awful. The knees of his trousers are brown and stiff with half-dried mud; his coat is creased beyond recognition, and there is something white, like bird dirt, on his velvet collar. Only his hat is undamaged. That is hanging on a nail by the door. But it does not really matter about that . . . he is still more like an animal than a human being.

Oh well, it is presumably part of the punishment to be suffered, the penance to be undergone. But it is a shame for the minister's wife; it would hurt her deeply if she could see him in this mess now.

Vitus is thirsty, and his throat is parched. He must go down to the stream. He is longing to refresh himself in the cold morning water and to wash his face and hands. Perhaps he can do something about his clothes, too, perhaps scrape the worst of the mud off his knees at least.

The air is dazzlingly light and cold. The sun has not yet quite risen. The sea is heaving gently, and the mountains are

full of solemnity as they stand there outlined dark and austere against the sky, like giants or cherubs awaiting an order from God. White in the sunlight, the stream is snaking through a small valley, disappearing further away in a lake with a dark reflective surface. Vitus lies down by the bank and drinks, filling himself with the clear, innocent water. As he gets up he notices a figure rather further down, among some stones . . . a man lying down and drinking from the stream. It must be Morberg!

Yes, it is Morberg. He is lying there washing his face in the water . . . no, he has pushed all his head into the water. Vitus holds his breath while waiting for Morberg to lift his head out of the water again. Heavens above, man, he murmurs to himself, you can't lie there like that for ever. But the solicitor does not change his position. Vitus turns cold at the back of his head and right down his back; indeed the cold spreads to his arms and legs and makes him incapable of moving. It is some time before he can drag himself away. At least, he can move sufficiently to fold his hands.

"God have mercy on his soul," he prays.

But at that moment it strikes him that it still might be possible to save Morberg. He tears himself free from his distress and runs to the scene of the mishap, gathers all his strength and drags the upper part of Morberg's body on to dry land.

"Are you dead?" he shouts, starting at the sound of his own words.

Again he summons up the strength to turn Morberg on his back. There's no doubt. Not only is the solicitor stone dead, but he has been for a long time. There is a bluish pallor to his face, his eyes are glazed, his mouth open and his tongue just visible . . . Death has given the solicitor an indescribably pitiable and helpless expression.

Vitus looks at the body for a moment and calms down. His eyes become warm with tears. He turns away and starts plucking tufts of the winter grass from the bank of the stream.

He sits in this way for a long time, rocking backwards and

416

forwards in silent agony. The sun rises, big and dark. The rams bray and complain in the little hut. Now he hears a human voice, the kindly voice of an old man . . . "There, poor things, now you shall have something to eat and drink." And shortly afterwards – Vitus hears it as though through a deep sleep – "Oh, there's been someone here during the night, I see."

The man comes out of the hut carrying a bucket, and screws his eyes up against the sun. Vitus knows him . . . it is Ole, an old farm hand from Indrevig, but it is as though he is seeing him through a veil, half obscured.

Ole comes down to the stream to fetch water. He catches sight of Vitus, gives a start and stops. "Are you here, Vitus, and so early in the morning?" But at that moment he catches sight of Morberg's body. He drops the bucket and exclaims, "Lord Jesus Christ."

It is as though Vitus awakens at these words.

"Aye, Jesus, our only shield and support," he cries.

"In God's name," Ole goes on. "How has this happened?"

He bends over the corpse, makes the sign of the cross on the dead man's face and chest and tries to pull the eyelids down over the sunken eyes.

"May God rest your soul," he prays.

Vitus gets up and in a trembling voice explains what has happened. "Morberg's drowned. He wanted to take a drink from the stream, but then he wasn't able to get up again, perhaps because he was drunk, perhaps because he had a stroke . . . in any case he was lying with his head down in the water when I found him."

Ole takes the dead man's hands and tries to fold his fingers.

"We'll have to get some men to help us to get him carried down into the village," he says. "You stay here, and I'll go for help."

Vitus nods gratefully, and Ole hurries off.

The sun is vanishing behind a bank of clouds; everything is grey and miserable. Vitus is stiff, and his feet are so cold that he can't feel he has any at all.

Suddenly he is overcome by a strange fear. He walks a little way up along the bank of the stream and climbs up to sit on a

417

large boulder. It is as though he feels safe here; he can keep the body in sight, but at a distance.

He comes to think of what Morberg said last night about death coming to fetch them. This had sadly come to pass in the case of the solicitor himself. Not even a worm will bother to wriggle on your grave. These were mischievous words, but he should be forgiven for them now, in all eternity.

And while he is sitting staring at the dead body down on the bank of the stream, Vitus thinks further. Many appalling and profane things had passed the poor solicitor's lips in the course of this disastrous night. But he had spoken so beautifully about goodness. And one of the last things he had had on his lips was the fifth penitential psalm of King David. These words of repentance nevertheless shone out amongst all that had been said, resplendent like clear pearls. Perhaps, for the sake of these words, God would mercifully forgive the madness and misunderstood hostility that had otherwise filled the solicitor. And in that case, he, Vitus, would not have lived in vain, as it was he who had put the words of the psalm in his mouth . . .

Ole returns with six men. They are farmers from Indrevig, dressed in their everyday clothes, but all wearing the dark blue caps worn on solemn occasions. Two of them are carrying a stretcher. It is a roughly carpentered, unpainted stretcher, but it is covered in a black shawl. The men form a circle around the body and bare their heads. Vitus knows most of them: the farmer from Toftegaard and his two sons and son-in-law, and two of the sons from the Kvidal farm. The farmer from Toftegaard is carrying another black shawl over his arm. The body is lifted on to the stretcher and covered with the shawl, and the procession moves slowly away.

The sky is overcast. It starts to rain a little.

"Shall we sing a hymn on the way?" says the farmer from Toftegaard. He sighs deeply a couple of times and starts singing in a dark and serious voice:

> With sorrow and tears and in pain,
> With sudden hurt I complain

418

And humbly stand forth
By the throne of God's grace
For my sins to seek solace apace,
Sins overcome by Christ's birth

Slowly the little procession moves forward, step by step. But finally the village comes into view . . . the cove, the islet, the ships, Sylverius' buildings, the church. Vitus' heart starts pounding in his breast as his eyes search for the burnt-out ruin . . . alas, there is nothing left of the hotel except some miserable charred beams. So the building has burned down to the ground. Round about the ruins there are piles of rubbish, smashed woodwork, cardboard boxes, paper fluttering in the damp morning breeze. Standing in a group on their own there are some undamaged tables and chairs, a couple of empty iron bedsteads, a white washstand, a box of dishes and plates, and under a tarpaulin can be seen the outline of a sofa and the legs of Frida Olsen's writing desk.

"Where shall we take the body?" asks the Toftegaard farmer.

Well, Vitus doesn't know what to say. He hasn't given that a thought.

"Morberg lived in the hotel," he says tonelessly.

The funeral procession stops just outside the gate to the village.

"Well, we must be told where we're going," the farmer continues.

Vitus considers in despair. "Well, where can one give shelter to a corpse? Who wants a corpse in their house?" He really has no idea.

"There's the church," suggests Ole quietly. "The church must be the place in a case like this . . ."

The village is starting to stir. People are coming out of their houses, and dogs are barking.

"I could go down and get hold of the parish clerk," says Vitus.

"Yes, do that, and we'll wait outside the church," nods the farmer.

Vitus hurries through the village . . . he has suddenly thought of his neglected appearance and realised he has forgotten his suitcase up in the little hut by the stream.

Someone shouts after him, "What's going on, Vitus?" But he makes no reply and doesn't want to talk to anyone not directly concerned.

Sigvard Hovgaard receives him with a frown. "What's this you say, man? Is Morberg dead? And you want to have the body rest in the church? That's not the custom here, let me tell you. I must at least have time to consider."

"Yes, but they're standing outside the church with the body," wails Vitus. "And it's raining."

The parish clerk flushes. Morberg never attended church, whereas he spent a lot of time with the preacher. What does *he* say now? – Does he want the body in the church as well?

"How did he die?" asks the parish clerk, fixing Vitus with a stern eye. "Suicide perhaps? Or . . . murder?"

"Murder?" asks Vitus. And suddenly he is beside himself with sorrow and anger. He shouts so that it can be heard throughout the house: "Well, if you won't open the church for a poor dead sinner, then Jesus will keep the door of Paradise shut on you when your time comes. That will be your fate as sure as there's any justice."

And he slams the door in the face of the speechless Sigvard.

Over in front of the church, the Indrevig farmers are grouped around the stretcher with bared heads. Clusters of people from Holmvige are standing some way away, mainly children and young people. They stand close together with open mouths and eyes, petrified by the presence of death. But there comes the preacher. He goes straight over to the stretcher, and Vitus hears him say, "Is the body to be put in the church? Is that necessary?"

"It seems to be the only place," replies the Toftegaard farmer.

But now Vitus joins them. "I didn't get the key," he says. "Sigvard refused to give it to me."

The preacher gives the men a benevolent look and says in a

loud and sententious voice: "No, for I believed . . . our late brother was one of us. He was a repentant sinner, whose soul is saved."

The people of Indrevig look down and shuffle gently. The Toftegaard farmer says, "Thanks be to God that his soul is redeemed."

"You can take our late friend to the house where we live," says the preacher. "I'll show you the way."

Reinhold and his sister have recently rented Elisabeth's house. The solicitor's body is taken in here. The people from Indrevig stand for a moment, looking at each other. Then the farmer from Toftegaard bends forward and places his right hand flat on the dead man's breast. The others follow his example, one by one, followed last of all by Ole, who whispers, "In the name of Christ."

"Goodbye, and thank you for your help," replies Reinhold in a warm voice.

Vitus, too, says goodbye, as though he were one of the strangers. But the preacher holds him back. He wants to know everything about Morberg's last night and his death.

"Come with me into the other room," he suggests in a kindly voice. "I'm sure you must need something to warm yourself on."

Vitus nods emotionally.

"So the parish clerk wasn't keen on having the body in the church?" Reinhold continues.

Vitus tells him what Sigvard has said and how he answered him. The preacher nods approvingly.

"That's how I would have answered, too, Vitus."

Tekla comes in with tea and sandwiches. She is pale and serious. But she has not been weeping . . . Her look is firm and sober. Vitus has to think of Morberg's words about the little tear as clear as a pearl. He himself has sat there fighting with his emotion, but now he suddenly becomes strangely cold and hard. And he begins to regret that he has betrayed Sigvard the parish clerk. He feels almost as though he has let down the church itself. He knew perfectly well that Sigvard was quick-tempered, so he could have kept quiet and not

answered him back so sharply, and then Sigvard would probably have given in. Now Vitus had given the confessionists a good card to play. And as for Morberg's faith, he had not been exactly what might be called an enthusiastic churchgoer, but nor had he been any more of a confessionist either. On the contrary, he had so to say died with the words of one of the church hymns on his lips . . .

The preacher asks Vitus to tell him about Morberg's death and the events preceding it. And Vitus tells him. He avoids touching on the way in which the fire arose, but otherwise he does his best to be completely open; indeed he even feels a certain satisfaction now and then in seeing how parts of the story displease Reinhold. The preacher had obviously imagined that the solicitor's conversion would have expressed itself more clearly. But he finally fastens on Morberg's words on goodness, this goodness that remains when everything else is gone.

"Those are true words," he says. "Profound words. Morberg had explored and sought, and I believe that he had finally found the right path."

Vitus thanks him for the meal. He has only drunk the tea and not touched a single sandwich.

"But you've not eaten anything," Reinhold reproaches him.

Vitus shakes his head. He has completely lost his appetite.

"We will now pray for Morberg's soul," says Reinhold with a sigh. "But what about you, Vitus . . . Have these terrible events in which you have taken part not opened your eyes to the timeliness of conversion?"

Vitus looks down and feels how his soul is filled with opposition.

"We are all fragile vessels before God," he prevaricates. And he adds in a broken voice, "As for me, I will first be put before a secular court. We'll see . . ."

"A secular court?" asks the preacher in amazement.

Vitus gets up and turns his head away as he says, "Yes, because it was me who set the hotel on fire."

Reinhold has also stood up. He grasps Vitus by the

shoulder and asks in a subdued, slightly reproving voice, like someone disapproving of a bad joke: "What are you saying, Vitus? Did you start the fire? But . . ."

Vitus nods reluctantly and frees himself from Reinhold's grip.

Tekla is standing out in the kitchen. Vitus hurries past her in silence. The preachers and everything to do with them fills him with a certain sense of disgust at the moment. He cannot forgive himself for having been unfaithful to the Church.

But what now? He stands for a moment looking at the houses, looking at the village of Holmvige lying there wet and dismal beneath the grey, rain-laden February sky. If only he had never come back to this village. That was what he got for being so confoundedly inquisitive. It was that and nothing else that had moved him to come back here. That was presumably why the punishment had been meted out to him. Just at this moment there was only one thing he wanted: to get away. How was it . . . the mail boat would be going south about midday. Then he could take it as far as Storefjord and go up to the sheriff and confess he was an arsonist. And take his punishment. Yes, he would do that. And then never again set foot in Holmvige.

But what about the suitcase and all his things . . . they were perhaps getting spoiled up there in the turf hut? That was a pity. The miracle barometer at least didn't deserve that fate. And suppose the suitcase were stolen!

Vitus became quite frantic. He must really get that suitcase back, however he should do it. He pulls his hat firmly down on his forehead and sets off with determined steps.

THE SHIP

I

A dry frost with grey hoarfrost on the mountains and a biting north wind. Only now, at the end of February, does the really cold weather take hold.

Landrus is busy fixing a flagpole on the gable of his storehouse. To do this job he has appointed a couple of young men from the crew Gotfred hired for the Gregoria during his Christmas visit. He himself is watching from the flat stretch of rock outside.

It is no problem for six strong men to fix that bit of a flagpole. The work progresses easily . . . one, two, three and the two iron hoops have been nailed to the wall. The pole is put down into the rings and fixed.

"Bring the flag, Landrus," they shout.

"That can wait till the ship appears," says Landrus.

"But wouldn't it be best to see how it works?" asks young Martin, sitting astride the roof ridge.

No. Landrus won't have them fooling around with the flag. A flag's a serious matter.

"You ought to get a sign fixed up here on the gable end," suggests Martin. "Landrus Gregoriussen, Trade and Shipping".

"No, I don't like boasting," says Landrus. "Besides . . . every fiddling little sweet seller in Storefjord's got a sign up, so it's a lot of nonsense when it comes to the point. No, you'd better come down from the roof now, there's nothing else for you to do up there."

Landrus is going around in constant fear that something heralding misfortune will happen. If a man on a day like this should fall down and be injured, it would not only be sad in itself, but it must also be seen as a sign heralding accidents and misfortune.

424

It is also a good old custom on a day that you want to be a day of good fortune to ensure the favour of all things. Landrus remembers how his grandfather on such days when something new and important was to be started, and especially at the winter and summer solstices, would bless doors, windows, stairs, boats, knives and other tools, fireplaces, saucepans and much else. And he took auguries from everything, from the sun and moon to cobwebs in the darkest corners of the cellar. The old man had been an outstanding prophet, and he had inherited the gift of seeing into the future. Landrus was often secretly irritated that these valuable gifts had not been passed down to him. Like now, for instance: he would have given a great deal to know how you could best make a flag into a bringer of luck. He had tried asking Torkel Timm about it. But a flag was something new, of course, so the old rules could hardly be adapted to it. Torkel had suggested to him that he should let his wife have the flag under her pillow for three nights running. This had been done, but Landrus had no real confidence in this idea.

He had recently been bothered by dark presentiments as never before. It was as though a threat was hanging in the air . . . something indeterminate that seemed to be connected with the cold weather and the start of lighter evenings: a huge indifference or enmity on the part of the supernatural powers.

Landrus goes up to the warehouse where the flag hangs on a rope. It is a beautiful flag; the red fields have a fine, virginal nap; the strong, pure colour is as it were full of good humour and warmth. Perhaps this flag would after all come to wave above progress and good fortune. If not for himself, then for his children and grandchildren.

Landrus finds consolation for the first time in that thought. Strangely enough, it is as though it has never struck him before. He is filled with gentle thoughts and feels gratitude towards the flag . . . it is almost as though it had spoken to him, this happy, red banner, as though it has said, "I shall wave over your children and grandchildren."

And Landrus's eyes grow all misty and he has a vision of himself as an old, old man surrounded by a host of children all

talking to him with eyes full of joy: "It was you who bought the ship . . . you put yourself in debt and almost impoverished yourself for our sakes, but now we thank you for it, for see, it has borne rich fruit."

"Ship in sight," someone shouted outside. "Landrus! Where's Landrus?"

Landrus takes the flag over his arm. Little Martin is ready with the halyard. A moment later, the red flag rises in the air and flaps in the frosty wind.

And the ship, the Gregoria glides closer. The brown tanned sails stand out fiercely against the grey heavens.

Landrus feels his heart starting to beat. The ship . . . this is his ship, no one else's, the Gregoria of Trymø. He must go up and make sure that his wife and daughter don't miss this sight.

"The ship! Can you see the ship?" he asks and his voice becomes light and youthful with enthusiasm.

Yes, they are both at the window watching the ship, drinking in the sight in fascinated silence.

Landrus nods in satisfaction and hurries down to the jetty again. It is thronged with people. Everyone is standing staring out at the ship. The entire village is one single vast staring eye.

Landrus stands there with a tight throat and can scarcely manage to draw breath for sheer joy and pride. It is admittedly not the first time a ship has made for Trymø, but this time it is the island's own ship, the new provider for Trymø, its guardian angel. And Landrus, almost without realising it, breaks out in intoxicated giddy ideas: "Hail to you, Oh ship! Gold and riches shall you sail in to our poor island. More ships shall follow after, a whole fleet . . . The Trymø fleet. And its fame shall be heard throughout the land."

II

Young Gotfred is if possible still more serious and taciturn than he was during his Christmas visit. He has visibly changed

during the couple of months that have passed; he has become thinner and more determined in appearance.

"You're getting more and more like your father," says his mother. "And when you were little everyone said you were the living image of me . . . you had such a little red snub nose. Aye, it's strange how that sort of thing changes."

Gotfred wants to talk to his son privately and asks him to come up into the loft for a moment. It is about something there is no point in letting others hear.

"Tell me quite honestly," he says. "What's the engine like on that ship? I've heard it's pretty poor."

Young Gotfred tosses his head impatiently. "It's an old engine, a bit old-fashioned in its construction, but it's been thoroughly overhauled, and provided it's looked after properly it won't give us any trouble. Besides . . . we've got the sails as well."

But the parish clerk does not feel convinced. "It would have been safer to have a good engine. And would it have cost all that much more?"

"Yes, thousands more," young Gotfred smiles. "But well, five or six years ago most ships had to manage on the sails alone, and they managed fine. Besides, our engine's not at all bad. We've got a man on board that's looked after it for two years and knows it in and out."

"Even so," says his father, "I don't like this. Oh well. There's nothing for it but to put it in God's hand. The ship's all right otherwise, isn't it?"

"The ship is first rate," nods young Gotfred. "Let's hope the catch turns out just as well."

"Well it was just this question of the motor I wanted to talk about," says his father in conclusion. "Yes, and then another thing: I suppose you've got a Bible and hymn book on board?"

Young Gotfred blushes: "Yes . . . We've got a hymnbook at least."

"But no Bible?" says his father in a worried voice.

"I'm sure someone or other has made sure he's got a Bible with him. It'd be strange if no one had."

Young Gotfred stares fixedly out of the window.

"But what about you?" says his father. And he adds emotionally, "Gotfred, never forget to ask advice of your God and Creator. Now I'll find a Bible for you. Wait here a moment."

Young Gotfred lights a cigarette. He opens the window and throws the match out. He can hear his father's heavy tread as he goes down the stairs. Good Lord, he could have spared the old man that worry by simply saying he had a Bible on board. But it was not good to lie about that sort of thing.

Young Gotfred has otherwise gone around all day with a curious elusive feeling that has made him remember the first time he was to leave home . . . a cold, frosty February day like today. If only he was on his way! He knew the difficult moments before departure and hated them. And this time it was worse than ever . . . He had more or less got used to his mother's tears, but now there were Gregoria's as well. And it could unfortunately not be denied that she was a cry baby. The first thing he had noticed when he came ashore was her puffed–up eyes and tight lips.

There is again the sound of steps on the stairs, but they are not his father's. The door opens and . . . Gregoria enters, with the Bible under her arm.

"There, your father said I should give it to you," she smiles.

"Good Lord . . . He surely doesn't want me to drag that old family Bible around with me?" says Gotfred, looking crestfallen.

"Can't you wait to go until tomorrow?" asks Gregoria quickly.

He lifts her up and holds her in his arms as though she were a little child. "See the ship out there . . . Just look how it's pulling at the anchor chain. Does my little Gregoria think we dare leave it like that tonight in this dirty cove? If the wind only veers a little to the east, we'll have the entire sea on us, and the surf will wash us ashore. And then your father and I can both pack up."

He sits down on the bed and takes her on his knee. She smiles, but she has to keep her lips tight so as to prevent the smile from cracking.

"You must take my gramophone with you," she says.

"Oh no, of course I won't take your gramophone; you must have it to enjoy while I'm away."

"Yes, but you *must* take it," urges Gregoria. "I'm giving it to you. It's to be yours."

He dismisses the subject: "Do you think we've time to sit listening to a gramophone on board? No. If we've got a moment to ourselves, we sleep, let me tell you. Besides, we've got three or four accordions with us, and I'm sure you agree that can be more than enough?"

"I want you to have it even so," whispers Gregoria stubbornly.

"Rubbish."

Gotfred holds her tight. "Come on, let's say goodbye here, straight away, and get it over with."

"Yes, but you're not going until this evening," Gregoria wails.

"We're going to have to leave within the hour," says Gotfred. "We've got to get over to Storefjord and sign a crew on, and it's best to get away before it gets dark."

"But then you'll be sailing past here again this afternoon or evening?" asks Gregoria.

"Yes, in the dark, I imagine. That's to say, we'll be sailing through Trymø Sound . . . You'll probably not be able to see us at all from the village."

"Well, I'll keep watch," Gregoria promises.

Gotfred smiles. "Yes, see if you can catch a glimpse of us. You can sit in the loft window."

"No, I'll go out to Highpoint, 'cause I want to be sure of seeing you."

"Don't be daft, Gregoria. You'll only stand out there and catch cold." Gotfred takes hold of her shoulders. "If you don't promise not to be silly, I'll sail a different way."

"But I'll put plenty of clothes on," says Gregoria defiantly. Gotfred gets up and looks at her with a mock strict expression in his eyes. "You're not going to, Gregoria. I won't have it."

"Yes, but if dad comes with me," says Gregoria in an effort to get round him.

"Rubbish. He won't. No one's going to stand out there and keep watch when it's no use."

Gregoria pulls him down on the bed and holds his head between her hands. "Well, I'll be there even so," she whispers in his ear. "And then you can see if you can see me in your telescope."

Gotfred looks at her earnestly for a moment.

"Is that really what you're like, Gregoria?" he asks. And soon afterwards he adds thoughtfully, "Well, in that case I'll get away from Storefjord as early as I can . . . for your sake. So it'll be between half past four and five o'clock. But do put plenty of clothes on, you must promise me that, because it's bitterly cold."

"Will you look out for me in your telescope, then?" asks Gregoria happily.

"Yes, I will. If you'll promise me not to stand and get cold, but to go home again as soon as you've seen us."

III

Magnus has shown his father round the ship. They are sitting down in the skipper's cabin.

Kristoffer is full of admiration.

"Aye, if only I were younger," he says. "Then I'd know what to do. I'd go to sea with you instead of messing around here on land. For I must admit that you're folk that know where you want to go."

"Well . . . you could perfectly well come on a trip with us. You're not as old as all that."

Kristoffer brightened at the thought. "That's perhaps not a bad idea, now you say so. I wouldn't mind coming with you in the summer for instance. Yes, really . . . If you'll have me, I'll come. I can at least hold a line. And heavens above, there's really nothing for me to do here at home now you've all three flown the nest. I just wander around, tripping over myself."

Up on deck, Landrus is walking up and down with cheeks red with cold and feverish eyes. He is not still for a moment,

asking, pointing, wanting to see everything, demanding to have every detail explained to him, but he nevertheless takes the time to listen to young Gotfred's patient explanations. Jakob the Granary leans over the railing and shouts down into the empty waters, "Hey there, are you all right down there?"

"Can you see anything down there?" asks Landrus nervously as he passes by.

Jakob winks at him. "I can see a fish, I can see a fish, I can see a fishy-wishy."

By the steps down to the engine room, Redstones Ole is standing lost in admiration at the miracle of tubes and wheels that disappear into the blue mist down there. Landrus pats him on the shoulder and good-humouredly shouts, "Aye, just you look, Ole . . . It wouldn't be nice to get your head stuck in that sort of clockwork, would it? But you can come down with me if you want."

Ole nods meekly and goes with him.

The engine is like some sort of sea monster, a kind of giant crab lying on its back so that all the secret parts are on view. Landrus wants to see it working. Young Gotfred gets hold of the engineman, and a moment later the monster starts wheezing and giving off a suffocating stench of oil. Redstones Ole turns pale and gasps for breath . . . Landrus laughs and coughs and slaps his thighs: "That's a bit too strong for you, Ole, eh?"

But the engine continues to belch out fumes without even starting; it is soon too much for Landrus, and he is soon angrily gasping for breath. "Are you wretches trying to do us in?"

"I think it would be best for you to go up on deck again," coughs young Gotfred, exchanging looks with the machineman. "It's sometimes difficult to get it started."

"Aye, that's more than we landlubbers can take, isn't it, Ole?" says Landrus.

Ole smiles politely and is about to say something, but he suddenly reels and falls over. Gotfred leaps over to him quick as lightning and lifts him up on his back and carries him up on deck.

"He's dead, of course," wails Landrus in a voice choking

with smoke. "Of course, *of course,* that sort of thing had to happen today."

He takes hold of Ole, who is sitting there deathly pale. He pushes and shakes him, thumps his back and shouts in his ear.

"No, don't do that," warns Gotfred. "Leave him alone. He'll be all right."

"No, he must be . . . he must be shaken to bring him round again," groans Landrus. "Are you deaf, Ole? Answer me when I talk to you. Have you been choked? Are you dead? For heavens' sake say something, man."

"Just let him lie down," says Gotfred impatiently.

Landrus lets go of the limp body so it can lie on the deck and looks at Gotfred with tears in his eyes. Gotfred bends down and puts his cheek close to Ole's open mouth.

"For God's sake," says Landrus, wringing his hands.

Gotfred sends a man for a bottle of cognac. Ole's lips start quivering a little. And now he opens his eyes and looks around, limp and smiling. Landrus kneels beside him, raises his head a little and pats his forehead encouragingly.

"Do you want another drink?" Gotfred asks.

"Oh, that's too much," Ole replies.

Landrus strokes his hair and pets him as though he were a child. "You managed fine, Ole. You're a real fine lad. See, have another drink, and you'll be all right again."

Gotfred feels a little embarrassed on account of his father-in-law. Fortunately, it is only the machineman and a couple crew members who have witnessed this scene.

"Well, I hope he's out of danger now," sighs Landrus in relief and gets up.

He shakes off his fear and tension and adopts a stern and impatient expression. "It's pointless having all these extra people on board. It's gone on for long enough now, at least, so now we're finished."

He raises his voice and commands, "Now then. The ship's about to leave. Everyone ashore."

Gotfred the parish clerk and Kristoffer emerge from the wheelhouse, where they have been having things about navigation explained by Magnus.

"We've got to go ashore now," Landrus waves to them. "The ship's leaving."

The parish clerk draws him aside and says in a low voice, "Listen, Landrus . . . I think we ought to follow the old custom and have a short service before we take leave of our sons and the other lads. Don't you agree?"

"Oh, what a fool I am," replies Landrus contritely. "That I can completely forget things like that. But I assure you, I lay last night and thought of the old sailors' hymn because I was going to suggest we should sing it on board."

He gets hold of Young Gotfred: "All the crew is to be gathered for a prayer, now, straight away. And as soon as we've finished, we'll go ashore."

A few hefty gusts of wind suddenly come from the mountains. The sea suddenly turns choppy with bluish black, spiralling areas of water, and the rigging on the ship starts to whistle and hum.

"We're going to have a shower," says Kristoffer.

A moment later, the air turns white, and big, dry hailstones shower on the deck, bounce around and settle in woody fillets in all the cracks and grooves. But the shower is only short-lived and disappears to the south like a small cloud of smoke. The sky again turns firm and grey.

The crew has gathered in a half circle around Landrus and the parish clerk. Twenty weather-beaten faces, stiff with a sense of a solemn and serious occasion. Redstone Ole stands with his arm round Ansgar and is staring ahead imploringly, lost in thought.

The parish clerk clears his throat and raises his head. He breathes in deeply and starts singing. Landrus, Kristoffer and Redstone Ole join in and one by one Simon Peter, Little Martin and Magnus also start singing. Young Gotfred, on the other hand, cannot force a note from his throat; he stands looking in at the shore, where the flag is waving from the warehouse roof. And in Landrus's kitchen window he can clearly see two pale patches, two faces . . . one of them is Gregoria.

The sombre words of the ancient sailors' hymn roll like a heavily laden boat in heavy seas.

Our sail we raise before the wind,
God grant we be not destined
To go towards our final sleep
And find our rest in waters deep

IV

It started to snow even before the ship was out of sight. Gregoria hoped it would only be a shower, but one hour passed, and then two, and still the snow fell, so soft and dense that it was only possible to make out the nearest houses.

Well, even so, she would go out to Highpoint at half past four even if she was not able either to see or hear the ship.

Gregoria sits watching the falling snow. The flakes draw grey curlicues in the air . . . there are so many that it is impossible to imagine their numbers. And the ship has to find its way through all that snow, and in the dark at that, when evening comes. And out in the open sea, where no land is to be seen.

Gregoria cannot settle to anything. She regrets not having gone on board. Gotfred wanted her to, but she had refused because she was so tearful. And she had not really said a proper good-bye to him. She had not even wished him God speed on his journey . . . she had finally been so confused, and she had only had one thought, and that was to make herself hard for the sake of general respectability. And the gramophone . . . Gotfred would not hear of taking it. But one thing was certain: it was going to be left in peace where it stood; she wouldn't touch it while he was away.

It is almost four o'clock now. But it will soon be dark . . . already, and this wicked snow has to be thanked for that. Why did it have to start snowing just now? Gregoria raps on the windowsill with her knuckles and again feels tears in her eyes. Perhaps the ship will lose its way in the thick snow and be grounded. Perhaps Gotfred will come too close to Highpoint for her sake and be wrecked. . . .

The constantly swirling snow is enough to drive one

crazy . . . she can see it whirling and twirling even when she dozes off a little. She turns away from the window. For a moment she can even see snow eddying in the darkening kitchen. She can only indistinctly make out her mother sitting over by the stove knitting. And the cat stretched out in the corner. It's all right for those two!

"Come on, Gregoria," says her mother gently. "Find something to do, otherwise you'll simply sit around and get yourself upset."

Gregoria is not far from feeling a little envious of her mother . . . *She* has never needed to feel anxious for *her* husband. He's never been away from home for more than a couple of days at the most when he's had to go to either Storefjord or Østervaag on business. And suddenly it seems to dawn on Gregoria for the first time that she is to be a seaman's wife . . . that it is going to be her lot for the rest of her life to sit and wait and worry.

"I think I'll pop down to Margrethe's for a bit," she says.

"That's a good idea."

Gregoria goes out into the passage, opens the outer door and looks out. The swirling snow almost takes her breath away. She puts on a shawl and a headscarf. But what should she put on her feet . . . clogs are no good, for the snow is already lying thick on the ground. She catches sight of her father's waterproof boots . . .perhaps she could put those on, although they will probably be a bit heavy to trudge through the snow in. If only her father doesn't discover they have gone. Oh, never mind, she will risk it, whatever happens.

It is almost impossible to find the way in all that snow. And the boots don't seem to want to obey her . . . It's like dreaming that you are in a hurry and can't move off the spot. She wraps the shawl tight around her, bends her head and with a beating heart fights her way out through the thick snow.

How on earth is a ship going to find its way in such weather? Perhaps Gotfred will stay in Storefjord and wait until visibility improves. Yes, of course he will; it would be silly to do anything else. He will presumably take it that *she* will stay at home when the weather is like this. Perhaps he'll be busy

with other things and won't give her a thought. But never mind that . . . she *will* go out to the point; nothing in heaven or earth shall prevent her!

Except perhaps if she can't find her way . . . if she gets lost.

Gregoria stops to catch her breath. There is nothing to be seen except the milling walls of snow. She suddenly has a sense of standing on a piece of flying earth and being transported upwards, up towards the ferocious grey gulf of the heavens. She stamps hard on the ground in her heavy boots as though to assure herself that she is on firm ground. But she cannot quite divest herself of the frightening feeling of floating in the air. And now there is a ringing in her ears; the silence becomes heavy with sound.

But she holds her lips tight together and moves off again. Forward, just forward . . . she will not be put off by foolish imaginings. And now it can't be long before she's out on the point.

A huge dark object emerges in the snow . . . it is a boulder with a little cairn on top. Gregoria warms with happiness; she knows this stone, she has often played here together with her friends. She now knows exactly where she is and in which direction she must go. She goes across and pats the good, kind boulder standing here all on its own, covered with snow and full of patience and helpfulness. She smiles and speaks to it: "Thank you, old friend. I hope you'll be kind enough to stay here until I come back. . . Good bye for the time being, stone."

The boulder disappears in the woolly mist. Now it is no more than a quarter of an hour's walk to Highpoint. If only she could get rid of these boots. Not only are they heavy to walk in, but they are rubbing her heels and cramping her toes and are in every way unhelpful and difficult. But plop – there her foot went through the ice into a pool, and now the boots show what they are made for . . . They suddenly become so kind and gentle and carry her chivalrously across the marsh, leaving black, oozing tracks as though to say, "We are doing this for your sake, and you can get as irritated with us as you like!"

And Gregoria forgives the boots. She will soon be out on the point now. She has a happy feeling that everything is kindly disposed to her and wants to help her to reach her destination. She is a friend of the boulders, of the grassy hillocks and the peat trenches, indeed of the snow itself, for it no longer feels so cold and irreconcilable; the flakes are smaller and are falling less densely. And indeed, the air is growing lighter. The view is improving all the time, and now she can see the shore, dazzling white against the dark, seething waters. And there is Highpoint.

She hurries up towards the cairn at the top of the point. Her boots produce hollow, coughing sounds and bite her feet as never before, but now she has reached her goal. In a short time, the entire sound will be visible, the whole of Trymø Sound except the approach from the north, which is hidden by the jutting black bosom of Blaaberg fell. And surely it must be half past four now. Hot and sweating, she sits down among some boulders and tears the scarf from her head. And there: there the ship's red sails and flag come into sight against the grey-black background.

Gregoria gets up and swings her scarf so much that the snow is swirled up by it.

The ship glides closer. Now she can hear the hum of the engine. However close is Gotfred going to sail! She hopes he won't come too close for her sake ... That's making too much of a fuss of her. And suppose the others on board discover she is sitting here!

She realises that Gotfred might perhaps be standing looking for her through his telescope and can see her as clearly as if he were only a few steps away from her. She blushes ... What should she look like? Should she smile and wave? No, that would look ridiculous. And in father's boots! She sits there biting the thumb of her mittens and is so embarrassed she wishes the earth would swallow her up. Perhaps Gotfred will let Magnus look as well. Perhaps they are both there having a good laugh at her. But no, she's doing Gotfred an injustice. He might well like making fun of people, but laugh at *her* – that he would never do!

The ship is now so close that she can make out the crew as small dots on the deck. And one of them is waving with something white . . . that must be Gotfred, of course. But nothing in the world will persuade her to wave in return, that would be far too embarrassing. She would rather hide behind a boulder, for he *has* seen her now, since he's waving. But she contents herself with holding her mittens up to her face and looking out between them. He continues to wave. But no, she can't persuade herself to wave in return. The entire ship will see it and roar with laughter at such a show of devotion.

Now Gotfred stops waving, and at that moment she bitterly regrets not having waved back. But it's not too late yet. But she still sits there as though spellbound and unable to move a limb.

But what's this? . . . Now the flag is lowered to half-mast! She runs all cold . . . What does that mean. Has there been an accident on board? Now the flag is raised again. What sort of a game is this? And now at half-mast again, and up again, faster and faster.

Oh, now she realises what is going on: Gotfred is waving with the flag. He probably doesn't think she can see him waving from the deck. No, now she can't refuse to wave back. She tosses her head, gets up and waves her scarf around in the air, time after time, and the tears come into the corners of her eyes; she is weeping with embarrassment, gratitude and joy . . .

A gust of wind comes from the mountain, howling among the boulders, and the snow is whirled into the air here and there. A huge fan of darkening water can be seen crossing the sound, spreading out to the ship. The sails start to rake and fill with wind. And before long a shower of hail comes on . . . great bouncing hailstones smack against the boulders and are followed by smaller hailstones and then by snow. And the ship merges into them and disappears.

Gregoria stands there until the sound of the chugging motor has disappeared. She is shivering with cold. But she is profoundly happy, really warm and delighted in her soul.

She is already almost a seaman's wife, a skipper's wife. At least she is a skipper's fiancée, and if she were not so bitterly cold she could have laughed aloud with amusement and pride.

THE TRUTH

I

Several days passed before Vitus could appear before the sheriff. Four bizarre days. He spent most of the time in the cells, but was otherwise allowed to go about freely and do whatever he wanted.

Immediately on his return to Storefjord he had gone to see the people in the sheriff's office, but had been told that the sheriff was away. He had then explained things to the sheriff's assistant, Jacobsen. But this strange man had merely shaken his head and with a knowing look in the corner of his eye advised him to think about it at least once an hour until the sheriff returned: "There's only one truth, Vitus."

He was moreover kindness itself. Vitus could be entirely at liberty provided he stayed in town. They would get to the bottom of things if he would only follow the way of truth. But as Vitus only had a small amount of money left in his purse and did not know what to do with himself while waiting, it had been agreed that he could stay and eat in the lock-up in the cellar in the sheriff's house.

Jacobsen was a youngish man with fair curly hair and yellow horn-rimmed spectacles. He always seemed to be in the best of moods and had the habit of rubbing himself hard at the back of his neck when he was laughing. He often came and had a chat with Vitus, asking him about various things and in return telling him one or two good stories. As for the hotel fire in Holmvige, he made no secret of his belief that Vitus had been bribed by Frida. She already had a bad reputation, and it was an obvious conclusion that she had seen an advantage in getting the building set on fire. The insurance money had probably tempted her. You heard about that kind of thing now and then.

However much Vitus tried to vouch for her innocence, it was no good. Jacobsen merely nudged him and gave him a sideways look through half-closed eyes. "Aye, you play your part well, Vitus."

It ended with Vitus for the time being abandoning his attempt to defend Frida and tell the truth. It would be better to save his strength for the real trial, for justice could not be cheated in the long run.

During the evening, when he had lain down to rest under the clammy cotton sheets on the oilcloth-covered bench, Vitus heard the sheriff's wife playing her zither. The distant, brittle tones filled his soul with a deep sense of melancholy. O Lord . . . mankind, mankind. Poor Mrs Skjoldhammer had a difficult time with her quick-tempered and unfaithful husband. There she sat now, abandoning herself to music and seeking comfort in its power. Sometimes, she sang a snatch of a song while she was playing. One evening, Vitus woke up to hear the subdued voice of a man singing to the sounds of the zither. It was a deeply sad and heart-breaking song:

> I ask you not for the rose on your breast,
> Nor yet for a lock of your hair . . .

Vitus's first thought was that it must be Jacobsen. But it couldn't be Jacobsen after all – the voice was too deep. Jacobsen had a high-pitched, rather sharp voice. Could it be the sheriff who had come home? The song became more and more subdued and finally dissolved into an inconsolable sobbing . . . No, it couldn't be the sheriff. Vitus lay there for a long time listening, but there came nothing more; not a sound was to be heard after the singing ceased.

The following day he asked Jacobsen who it could have been singing.

Jacobsen pursed his lips to produce a gentle whistle, which he stopped with his index finger.

"The fish grader," he said with an excited look in his eye.

"The fish grader?" asked Vitus in amazement. "Yes, but . . ."

Jacobsen waved his hand as though dispersing a cloud of smoke. "Yes, just you think about that one, Vitus."

"Yes, but isn't he a confessionist?" asked Vitus.

Jacobsen nodded. "He certainly is. But is it a sin to sing a little song when madam's playing the zither?"

He lent towards Vitus as though going to speak to him in confidence and whispered, "They were childhood sweethearts, you see. Childhood sweethearts. Understand?"

Vitus nodded and did not dare ask more.

But suddenly, Jacobsen started rubbing the back of his neck quite violently. "O, heavens above. You'll see a thing or two," he laughs.

He makes a funnel with his hand, opens his bright blue eyes wide and speaks quickly: "What's the sheriff doing in Østervaag? He's being brought to book. And what's he being brought to book for? Aye, wouldn't you like to know? And what else? He's getting divorced from his wife. And then the fish grader can sing for her both night and day. Understand?"

Jacobsen yawns and rubs his face. "And if things get even worse than that, then I shall be made sheriff, you understand," he adds, assuming a fierce look. "And if you tell anybody what you've heard here, you'll be shot. Shot without mercy."

And Jacobsen turns away and looks at him over his shoulder through half-closed eyes.

The sheriff returned that same evening.

Vitus lay in his cell and heard him moving about restlessly in the sitting room. Now and then he uttered some threat or curse in a low voice. There was no sign of his wife. "She's probably hiding," Vitus guessed. "Or perhaps she's left him."

Vitus was interrogated the following day.

The sheriff was unshaven and had red, angry patches under his eyes. His black moustache hung limply around the corners of his mouth. He had heard about the fire in the hotel in Holmvige on his way home and seemed to be very interested in it. He tried to adopt a stern look while listening to Vitus's account, but he did not quite succeed, and his mask kept slipping. He put his hands to his head and whispered, "Bloody hell."

Jacobsen was present during the interrogation and sat with a blank look on his face, deeply engaged in recording the proceedings.

Vitus had decided to purge his conscience to its innermost corners. He went to great lengths not to forget any detail . . . the frightening moment when he and Sara were sitting waiting at Frida's door, their being expelled from the hotel, the smell of burning, the tumult, the night in the peat hut, the death of Morberg . . . he told it all and felt relieved and refreshed on revealing all these dark happenings in the bright light of justice.

In time, when there was no more to be told, the sheriff had him returned to the lock-up. Weary but relieved, Vitus lay down on the bench and looked at the knots in the unpainted wooden walls without really thinking about anything. Jacobsen came in with a cup of coffee and a slice of bread, gave him a sideways look, pursed his lips and disappeared again. Vitus enjoyed the sweet, hot coffee and for a moment felt completely empty and happy.

After lunch he was again put before the sheriff. This time, Jacobsen was not present. The sheriff was still unshaven and tense.

"Now you're going to tell me the *truth*, Vitus," he commanded. "I don't want to hear a word of lying, so now you know. You'll pay for it if you do."

"Yes, but I *have* told the truth," complained Vitus, hurt, and showed the empty palms of his hands.

The sheriff laughs ominously: "But me no buts! You only answer what I ask you. Understand?"

Vitus nods obediently, and the sheriff continues, "To begin with, if you set fire to the hotel by accident, why come here and make a solemn confession? No one's been looking for you."

"No, but I thought it was the honest thing to do if I came of my own accord," Vitus explains.

"Perhaps you weren't the only one thinking that," laughs the sheriff.

Vitus understand and blushes. So the sheriff also thinks he's

been bribed by Frida. Well, there's nothing to be done about that.

The sheriff gets up. "Well then, let's have the truth. Understand? It's no good producing a false explanation, an incoherent and incredible explanation, a made-up story! How much have you been paid, Vitus? I'd rather you told me that; that's much more interesting."

"I can only say I've told you the truth," says Vitus quietly.

"So you're being stubborn, are you," thunders the sheriff. "Well, that'll be worse for you. You must bloody well realise I'm asking you on behalf of *justice*. If you don't confess immediately, it's going to cost you dear."

"I can only say that I've told you the whole truth," repeats Vitus with a helpless smile.

"You've nothing more to add?" asks the sheriff in a voice trembling as though from worry and concern on behalf of Vitus. "So you're not afraid of punishment and judgement either temporal or . . . divine?"

"I have told the truth," says Vitus once more

"All right, then you must take the consequences."

The sheriff takes down a book from the shelf.

"Take him out," he shouts and thumps the table.

Jacobsen comes and takes Vitus back to the cell. He nudges him and makes a noise midway between a whistle and a sigh through his nose.

But Vitus is quite calm. He doesn't feel broken, rather elevated. For he has been a witness to the truth. And he will of course continue to be that. This is surely God's will.

He kneels beside the bunk and gives sincere thanks for the confidence he has been shown, and he humbly prays for the strength to show that he is worthy of it.

II

At midday, Vitus was again taken before the sheriff. In addition to Jacobsen there were two elderly men in their Sunday clothes. The sheriff had shaved. His moustache

had been pomaded and twisted so that it pointed upwards.

"I'm going to Holmvige to hold an inquiry," he said in a serious voice. "You have a last chance now, Vitus. If you retract and confess the truth now in the presence of these two gentlemen, you shall be permitted to go free until I come back. But if you persist in your deceit, but will be placed under lock and key."

Vitus is quite calm. He actually feels sorry for the sheriff and these two solemn men.

"I can only say once and for all that I have told you the whole truth," he says in the tone of an everyday communication.

"You have no more to add?" asks the sheriff.

"No."

"Make a record of that," the sheriff nods to Jacobsen.

He gets up and takes his gold-braided cap from a hook.

"For the very last time," he adds. "Will you swear to the complete truth and unfailing honesty of your statement?"

"I am willing to do that," says Vitus unconcernedly.

"Note that," says the sheriff. He sighs. "Right, take him away, Jacobsen."

Vitus is taken back to his cell. Jacobsen rubs the back of his neck. "Well, I'm going to lock the door now, Vitus. You'll have to put up with that. I'm going to Holmvige as well. Olaf the Shoemaker, St Olaf as we call him, will bring you your food. But don't talk to him. He'll give you such a trouncing. We'll be back this evening, and then the fun will begin, my hard-boiled friend. I'll see you later."

Jacobsen gives him a friendly wink and disappears. The key turns in the lock.

Vitus sits down on the bench and looks around. Now that he is locked up and is unable to go about as he likes, the little cell looks quite different from before. It is a forbidding cellar, half underground . . . only a tiny amount of grey light makes its way in through a minute window high up in the wall. There are bars to this window, something he has not noticed

445

before, and there is also wire netting. The window panes are of a misty greenish glass.

"Oh well, so now I've been put in prison," thinks Vitus to himself. And curiously enough, not as a punishment for setting a building on fire, which he has admitted, but because he is suspected of having given false evidence. Aye, the world's a funny place at times. If he'd been tempted by the sheriff to make a false statement, he wouldn't be locked up, but would have all his freedom. That's something you can both laugh and cry about. Cry, because he's been thrown into prison accused of lying and cheating . . . laugh because this accusation is unjust. And yet, it's ultimately sad rather than amusing. For it was an example of how the world often treated those who bore witness to the truth. Now, God help him, he was only here as an insignificant figure and a misunderstood witness to the truth. All he had done was to make a statement about an insignificant matter relating to this world and not the Kingdom of God as the Apostle Peter had done when *he* was unjustly thrown into prison . . . by King Herod, who in his boundless evil had already had James, the brother of John, beheaded with a sword.

Vitus is overwhelmed by gloom. He comes to think of what Morberg said to him that night about God who in His anger inflicts flood and tempest on the world. And he imagines the world as a vast, grey well with bottom and sides milling with human creatures, one layer above the other. High up above this foaming, unhappy well sits God. Human beings can see Him, they know His commandments, but they refuse to obey them. Alas, if they would only consider things for a moment and repent . . . the complaints would cease immediately, and God's healing sun would burst forth. But they refuse to do that, they tempt God. He is sorry for them and His patience is vast, but it nevertheless has its limits, for justice must be done . . .

Vitus stretches out on the bench. His suitcase is over by the door. He ruefully thinks of the brief period when he was doing well for himself. That time is past now, never to come again. But it was a thoughtless, worldly time actually.

He had gone far from God and the truth during those months. But God had still not forgotten him and he had awakened him from his slumbers through horror and pain . . .

The key turns in the lock and St. Olaf enters. He brings food for him on a tray.

"Hm. Get up and have something to eat," he mumbles and puts the tray down on the floor.

Vitus gets up; he daren't do anything but obey the gaoler. Olaf is a giant with a swarthy face and stony grey, lifeless hands. He is rumoured once to have strangled a mad cow, all on his own.

Vitus is hungry. He takes the plate on his lap and sets about cutting a large, steaming potato. Olaf sits down at the side of him on the bench and watches.

"What is it you've been doing, Vitus?" he asks, touching him on the shoulder.

"I've set fire to the hotel in Holmvige," Vitus answer in between bites.

"Why?" asks Olaf. "Revenge?"

"No."

"Just so as to see a fire?"

"No . . . by mistake."

Olaf growls and breathes heavily out through his hairy nose.

"How long are they going to give you for that?"

"I don't know."

"It was probably not quite an accident even so," Olaf continues. "Isak accidentally set fire to Johannes Nordbø's boathouse with a carbide lamp, and he wasn't punished because he didn't do it on purpose."

"Wasn't he punished?" asks Vitus, stopping eating.

"No, you see he couldn't help the lamp exploding."

Olaf straightens up with a heavy sigh. "But it's different with you, Vitus. I've heard in town that you've been lying to the court, you poor wretch . . .'Cause you've been paid for setting fire to it; you've sold yourself, sold yourself like a dog, so you have."

447

"Don't condemn me until the truth comes out," says Vitus placidly, returning to his meal.

Olaf gets up, folds his hand across his stomach and says in a low, earnest voice, "Do you know what you are, Vitus? A poor lost sheep. Repent before it's too late, before you've got so far away from the shepherd that you can't hear his voice any more. That's my advice to you. Repent before grace is taken from you and the darkness of sin enfolds you."

Vitus makes no reply. Olaf nods, slowly and thoughtfully.

"I'll fetch you some more to eat now," he adds in a kindly voice and lumbers away.

He returns before long. He has another man with him, Peter Hammer, the baker. He is dressed in baker's clothes and is wearing a tall white hat on his head.

"The baker would like to give you some cakes," says Olaf.

"Yes," nods Peter amicably. "Some pastries and buns. Here. I hope you like them."

"Thank you very much."

"But listen for a moment," the baker continues, looking up. "Now, Vitus, that you've come to an end of your long, wandering existence and are sitting here alone in prison . . . don't you feel terribly lonely and deserted? Don't you feel the need for a friend, a friend for life and a friend for death? A friend you can confide in and who will understand you, and who has both the power and the will to forgive you your sins, however many there are? This friend's close to you at this difficult moment in your life. He's standing outside near the door, knocking every time your cell grows quiet. Vitus, open your heart to Jesus. Repent now, in the hour of your visitation. For your sin is great, Vitus. You are a liar and a cheat . . . you have become terribly entangled in Satan's net and have wounded yourself on those arrows of his that are poisoned with sin. Let him not drag your down into the depths, where devils abound like fish and creepy crawlies among the seaweed. Do you hear, Vitus? Take hold of the line of redemption that He is throwing to you in His mercy. Hold on to the sinker and let Him draw you up into the light and the clear air . . . See, there's something for you to

read here. May it open your eyes, poor straying sheep that you are."

"Aye, may they guide you into the fold," sighs Olaf.

Vitus accepts the tracts. For a moment he considers saying a few words in defence of himself, but feels it would serve no purpose.

"I'm afraid I must go now, as I've got some bread in the oven," says the baker, shaking Vitus's hand heartily as he takes leave.

"Eat your fill," says Olaf. "I'll come back with a snack later. And when you've finished eating, read the baker's pamphlets. That's the best thing you can do now you're locked up here. I'll see you later. God bless."

Vitus looks through the tracts . . . They are few issues of "The Light of Grace", printed in very small letters of just the same kind as those in his catalogues. He has come to hate these worldly letters. And why bother to try to understand the sectarian contents? Better to take Bishop Pontoppidan's good book of homilies out of his suitcase. He can rely on that; it's both good to read and elevating for both heart and mind.

He opens his suitcase. The miracle barometer . . . he can't resist taking it out and placing it on the floor. The man with the umbrella is out. That's probably as he should be, for the weather's pretty showery. He leaves the other things untouched. They actually appear to be undamaged. He takes Pontoppidan's book and sits down on the bench to read. The book was a gift from the minister's wife, God bless her.

But his thoughts slip away from the contents. His eyes only see the letters, the big, beautifully designed Danish letters that are so full of memories from his childhood and the church.

He remembers an occasion many years ago when the bishop came on a visitation. Vitus would so much have liked to see him. He went to Østervaag, where the bishop was staying, but he arrived there exactly an hour too late. The bishop had just left again to return to his see in Denmark. But as though to comfort him, God had let him see the bishop in a dream and he could still remember that dream, more clearly than anything he had experience in reality. The bishop was a

big, heavily built man with fair, curly hair and a beard and compelling eyes; he looked just like Moses or one of the prophets, and he was wearing a tunic of heavy white silk inlaid with gold and silver, and on his chest a red shield with the sign of the Lamb . . .

It is starting to grow dark. Vitus lies down on his back and folds his hands above the book of homilies. Before long, he falls asleep. He is awakened by a female voice. "It's me, Vitus. Am I disturbing you?"

It's the sheriff's wife. She has a blanket over her arm.

"I thought you might be cold, because it's started to freeze outside," she says in a kindly voice.

St Olaf is standing in the doorway. Vitus gets up and puts Pontoppidan's book down.

"Don't let me take your time, Olaf," says the sheriff's wife. "You can go. I'll stay and talk to Vitus for five minutes."

Olaf goes. He doesn't lock the door. Vitus accepts the blanket that Mrs Skjoldhammer offers him.

"Thank you very much . . . It's very kind of you, but you're making too much fuss of me."

"Here you are, Vitus," says Mrs Skjoldhammer gently, adding in a pleasant voice, almost as though she were humming, "Yes, but I've not really come to put questions to you, Vitus. I won't get mixed up in your affairs. There's no unfinished business between us. But tell me: Is it true that Sylverius Eide and his wife have joined the confessionsts?"

"Yes," Vitus nods.

"Have they been baptised?"

"No, not yet, but they are soon going to be. Simona's expecting, so it'll probably not be before she's got that behind her."

Mrs Skjoldhammer sighs and smiles. "Fancy those nice people coming to that end. Aye, for I don't give a tinker's curse for all this confessing; it's sheer hypocrisy, that's all it is."

"No, I can't see anything else either," sighs Vitus.

Mrs Skjoldhammer lowers her voice and says scornfully, "Just look at what it's like here with us . . . you've perhaps heard that I've been legally separated from my husband and

that I'm now engaged to Kjovnæs. I'm sure you've heard all about that, so I don't need to tell you any more about it. But . . . What do you think: Kjovnæs is in awful trouble with the confessionist community because he intends marrying me. Do you know - they're going to forbid it. Because they say that anyone taking a divorced woman as his wife is committing adultery! Adultery. Have you ever heard the like?"

Mrs Skjoldhammer breaks out in ringing laughter. "Yes, as though leaving a notorious lecher – to say things as they are – in order to live legally married to an honest man . . . as though you can call that living in adultery! No, that's a bit far-fetched. Oh, but we don't care much. Kjovnæs is getting out of the sect, and then we're moving to Østervaag . . . and he'll settle down there either as a grader or a fish buyer, and then that's the end of that."

"Oh, then you *are* divorced from the sheriff?" asks Vitus, fascinated by the news.

"Yes, thank God. But Vitus . . . there are so many things I'd like to ask you about."

Mrs Skjoldhammer sits down on the bench. Vitus must tell her about the fire, about Frida's private life, about Morberg's death, about Bernhard Thomsen and his sister Elisabeth, and about the sectarians. But mainly about Sylverius and Simona.

"Do you think they're happy together?" she asks. "You know, Simona once confided in me that she simply couldn't stand the preacher and his sister. But she's obviously changed her mind."

Yes, Vitus thought she had: "That's what usually happens – when one half of a married couple joins the sect, the other follows sooner or later."

Mrs Skjoldhammer is insatiable with her questions and hardly gives him time to reply. But suddenly she gets up and listens.

"There's the motorboat back," she says. "Heaven help me . . . you'll keep quiet about this, won't you, Vitus, because he mustn't know I've been here. You just say that Olaf's brought

you this blanket if anyone should ask. Goodbye, Vitus. Look me up when you . . . when you . . ."

And Mrs Skjoldhammer has disappeared.

III

Vitus lies listening to the drone of the motorboat as it comes closer and closer. He starts trembling with emotion. And suddenly, quite of its own accord, the thought suddenly strikes him: "I wonder whether they could make me responsible for Morberg's death?"

No, of course not, no. He scornfully dismisses the disagreeable thought. But it won't quite go away, and it steals back to him: If you hadn't happened to set the hotel on fire that evening, you wouldn't have run away from the village, and then Morberg wouldn't have followed you, and what happened that morning wouldn't have happened. He turns almost giddy at the thought. You could even go further back and say that if Frida Olsen hadn't locked the hotel. Or: if she had never had the hotel built. Or: if she had never been born. Or: if Morberg himself had never been born. Or: if sin had never come into the world or if God had never created Man, indeed if He had abandoned the plan of creating heaven and earth and dividing the darkness upon the face of the deep. No, it was not up to a poor sinner to consider these things. They could confuse you, and you had to be content to recognise that the ways of God are beyond comprehension and understanding.

And yet, the wretched thought keeps coming back. He feels that if the sheriff returns and accuses him of being complicit in the death of Morberg, he will be unable to defend himself. Of course, he could have not fled from the fire. But he had been driven away, senselessly, as though by some evil power. It had all been evil and terrible, a trick of the Devil, in which he had been whirled around . . .

There is the sound of someone opening the lock. Jacobsen comes in with a lighted lamp.

452

"Well, how are you doing, Vitus?" he asks merrily. "Has St Olaf been good to you?"

Vitus gets up. Jacobsen is flushed from the weather after his boat journey. He strokes his fat chin and looks benevolently at Vitus over his glasses.

"Well, what do you think the result was?" he asks "You'd better come with me to the office . . . I'm here alone. The sheriff went straight to Østervaag with Frida."

"With Frida?"

Vitus goes after Jacobsen. There are two plates of sandwiches on the table there. Jacobsen asks Vitus to sit down and points to one of the plates: "That's your supper, Vitus. And you have as much strong beer with it as you want."

Vitus sits down and asks again, "Frida and the sheriff have gone to Østervaag, you say. Yes, but . . ."

Jacobsen disappears for a moment and returns with the beer. He rubs the back of his neck, looks up at the ceiling and laughs out loud.

"You are a liar, Vitus," he says. "You have offered to swear by Almighty God that it was you who set fire to the hotel . . . The Well Done Hotel, as it ought to have been called. And then it was all a lie, a lie, you understand."

"Is it a lie?" asks Vitus despondently.

Jacobsen nudges him. "Of course it's a lie, you silly twit. Drink your beer and be glad. It was Frida herself who set fire to the Well Done."

Vitus makes to voice objections, but Jacobsen interrupts him and orders him, "Drink your beer, I say, and listen to what I have to say."

Vitus takes a gulp of the beer. Jacobsen sits down at the table and starts to eat and tell the story. Yes, things had gone better and faster than anyone had expected. The sheriff hadn't needed to press Frida to get her to confess. She had already confessed virtually everything at a meeting of the confessionists a couple of days after the fire. The preacher had got hold of her and persuaded her to confess; the entire village knew about her various sins, and she hadn't tried to hide anything,

neither setting the hotel on fire nor smuggling and selling alcohol. And she was as friendly and amenable as you could wish; she was more than willing to go with the sheriff and take her punishment.

Yes, it was Frida Olsen herself who had set fire to the hotel. It wasn't done because she wanted to cheat the insurance company; she had done it in a fit of repentance and despair. Or perhaps rather of mental confusion, for she had scarcely been herself since the deed.

Vitus sits listening open-mouthed.

"Eat up now, Vitus. You're a free man," Jacobsen encourages him. And he goes on, "No, you see, as far as you're concerned, Frida Olsen admitted that she had not made the least bit of an agreement with you. It may be that you forgot to put out the candle you talk about, but in any case that wasn't what caused the fire. She used far more efficient methods: wood shavings, paraffin, newspapers and account books, and she even got hold of a can of petrol, and that was probably what decided things. And you see it was actually her intention to burn herself at the same time. She was in the part of the building that was on fire until she couldn't breathe any more for smoke and heat."

"Well then . . . so it wasn't me?"

"No, it had nothing to do with you," laughs Jacobsen. "It's no use your going on insisting on it, because you've now been proved to be as innocent as can be. You're as innocent as a baby's bottom. Just you sit down again and eat your food, otherwise I'll eat it for you because I'm famished after the trip."

"And Frida's . . . joined the confessionists?" asks Vitus.

"Yes, that's the path she's taken, and that's probably the best thing for everyone. At least it's eased everyone's task quite a lot. The sheriff had otherwise loaded his cannon, let me tell you. You heard yourself how he got at you . . . quite illegally, strictly speaking, for he threatened you with death and damnation. But you just eat your food now and forget all your troubles and worries."

Vitus takes a piece of liver paste and puts it in his mouth.

But he is too emotional to be able to chew it. It is as though he is completely paralysed.

"And . . . smuggling and dealing in drink?" he asks in a flat voice.

Jacobsen empties his glass. "What do you mean? . . . Oh, Frida? Well, you see, she was working with the man known as Søren Smelt, selling large quantities of drink to the trawlermen, partly for cash, partly for fish and coal and other products of nature, and she's been smuggling tobacco and other things into the country. This Søren, incidentally, I think he's a real scoundrel, for he's done all the organising for her; she's simply lent him the money to buy drink. And she's not been so bad that she hasn't regretted all this a few times and suggested to him they should stop it. But he's kidded her that if the foreign sailors didn't get real spirits to drink, they'd mix tobacco and gunpowder up in beer and let it stand and ferment, and that would produce a drink that would turn them both mad and blind."

"Yes, I've always had a feeling that Søren Smelt was a crafty bird," says Vitus, gradually beginning to feel more like himself.

"Crafty!" hisses Jacobsen derogatively. "That's not the word . . . he's a thorough-going rogue. And naturally he buzzed off as soon as he discovered things were getting too hot for him. Left the country, if you please. On a trawler."

Vitus gradually settles down. He sits staring ahead and rubbing his knee.

"You really are an ungrateful wretch," laughs Jacobsen.

"Ungrateful?" Vitus gives him a questioning look.

"Yes, you don't look at all pleased that it's all taken such a happy turn for you."

"Of course I'm pleased," says Vitus, attempting a smile.

But in reality he is not particularly happy; he is aware of that. Perhaps it's ungrateful of him. But . . . it's all come so completely unexpectedly to him. He feels like someone going down a staircase in the dark and believing there is another step, and then there isn't one. Or when you have stood fiddling with a door to unlock it, and it suddenly turns out that it

is unlocked; you have simply not realised it opened the other way. "And I, who thought I was a witness to the truth," he thinks. "And against my will I've done the opposite."

Jacobsen lights his pipe.

"Well, if you *won't* have any more to eat, Vitus, you can take your food with you for later."

He fetches a newspaper and packs the sandwiches in it.

"There we are."

There is a knock on the door to the outer office. Jacobsen gets up and opens it. A young girl enters – his girl friend. She gives first one then the other an embarrassed look. "Am I disturbing you?"

"No, I think I'm the one who's in the way," says Vitus apologetically and gets up.

Jacobsen points to him with his thumb and, addressing his girlfriend, says, "There you behold a free man if you've never seen one before. He's been in prison, accused of arson, you see, but he's been released now. Just look at him; that's what an innocent man looks like An honest man, indeed a man who ought to have a prize for being over-honest."

Vitus cannot resist smiling at Jacobsen's joke. But there is some truth in it. He really has been almost too honest.

"Incidentally, where are you going to sleep tonight?" asks Jacobsen. "You can stay here in the cell until tomorrow if you want. I'll lend you a candle."

"Yes, thank you very much," says Vitus.

"But don't forget to put it out," adds Jacobsen, rubbing the back of his neck. "And don't put it on a cardboard box."

Vitus takes the candle in one hand and the packet of food in the other and nodding and smiling retires to the lock-up.

SPRING SUNSHINE

I

The Reverend Martens had lain ill at Graaøre for over two months, and there was still no sign of improvement. It was a difficult time for Sigvard Hovgaard, the parish clerk in Holmvige. For at the same time as the parish was being neglected, the confessionists were in constant, tireless activity. Their new meeting house was now finished and was to be inaugurated on Easter Sunday. Sigvard was looking forward to this day with considerable anxiety; it was going to be a day of triumph for the enemies of the church, and so as not to seem to be doing nothing, he had on behalf of the parish sent a letter to the dean with the request that a locum should be sent to Holmvige at Easter. This request had been granted. Pastor Erhardt from Skaalesund would come and hold a service in Holmvige Church on Easter Day.

Sigvard was, however, only moderately pleased with this arrangement. He felt a lack of confidence beforehand in the Reverend Erhardt, the *vicar of commerce* as he was known. If the rumours circulating about this man came anywhere near the truth, he was scarcely worthy of taking on the tasks of a clergyman. He was said to be a very worldly and parsimonious nature and very deeply engaged in his brother-in-law's business in Skaalesund. In fact it was rumoured that it was he who was the true head of the business, while his brother-in-law was only a kind of straw figure.

The Reverend Erhardt arrived in his brother-in-law's motorboat on the Saturday evening. He was a small, agile man with child-like rosy cheeks and a fair pointed beard. He was dressed as though on an expedition to the Arctic.

"It seems we are going to have the same poor weather at

Easter as we had at Christmas," he said as he shook hands with the parish clerk.

Sigvard said he thought they could expect milder weather; the wind was veering to the south, and the barometer had risen steadily throughout the afternoon.

"Let's hope so," sighed the minister. "We could really do with a bit of spring after all this bitterly cold winter and all the snow and sleet."

The Reverend Erhardt brightened up visibly when he saw there was a fire in the stove in Sigvard's living room. He rubbed his hands: "It's lovely to have a bit of warmth . . . and I shall have to sit up for a couple of hours this evening to do some work."

Sigvard enquired about Mr Martens. It was sad that his health was so poor that he was forced to neglect his parishes, and it was particularly unfortunate at this time of the year.

The Reverend Erhardt shrugged his shoulders. "Poor Mr Martens, yes. I'll wager he's fighting some form of chronic gastritis. It's something that saps your strength. I had it myself when I was younger . . . I had to keep a strict diet for a whole year, and even then I can't say I've got rid of it completely."

The table was laid. The minister was hungry after his journey and made the most of the tasty lamb.

"Lamb stew, that's about the best thing you can get in this country," he said. "It's a tasty dish, and then it's so easily digestible, and that makes it a real delight."

Sigvard turned the conversation on to religious matters. He complained of the confessionists, who were making constant inroads. In this outlying area out here, people were hardly interested in going to church any longer. The farmers from Indrevig were really the only regular churchgoers. But even a few of them had started staying away recently. Not that it was all that surprising, for little effort was being made on the part of the church to counter sectarianism.

Sigvard sat and became almost eloquent. He spoke of how shamelessly the alien preachers behaved. No approach was beneath them when it was a case of gaining adherents . . . They could be said so to speak to have *stolen* the late Johan

Morberg's body. Sigvard gave an account of this unpleasant event. And that was what they were like in every respect, brazen and without shame . . . incredible that people didn't consider themselves too good to go to their meetings.

The Reverend Erhardt nodded and frowned thoughtfully: Yes, indeed. These confessionists . . . he had heard about then. Strangely enough, they had not yet made many any inroads into any of his parishes. The problematic element there was the extreme evangelical wing of the national church. They could be difficult enough at times, but at least they were not antagonistic to the church as such.

Mr Erhardt had eaten his fill and sat sipping his coffee. Sigvard took out a box of cigars from the drawer in his desk.

"I hope they've not got too damp," he said as he held out the box. "This room does tend to be a bit on the damp side."

The minister took a cigar and held it up to his nose. "I honestly think it's a bit too strong for me. I have some that are milder. Can I offer you one of mine?"

He took a leather case from his inner pocket. "Try one of these. I've got used to them . . . they are really good cigars, quite mild."

"No thank you," said Sigvard. "I don't smoke cigars myself." He jerked his head: "We were talking about the evangelicals . . . I wonder whether we don't need just some of that kind here in the north. Unless church life is to die out entirely."

He tried to catch the minister's eye.

Erhard sat staring thoughtfully into the cigar smoke. "I'm glad you drew my attention to the circumstances here, the confessionists, I mean. I think I'll build my sermon around that subject now."

He drew a long new pencil from his breast pocket.

"You couldn't lend me a sharp knife, could you? Thank you, that's fine."

He started sharpening the pencil over his plate. The table was cleared, and Sigvard fetched the minister's suitcase from the hall.

The Reverend Erhardt walked backwards and forwards

with a thoughtful furrow on his brow and making small, brief movements with his hands.

"I think you are mistaken in believing you need an evangelical movement up here," he said, believing his small, knowing eyes. "The evangelicals work on the emotions and make people more receptive to sectarian influence. No, what you need here is not more squalls. You need solid *ballast*."

"Ballast?" said Sigvard hesitantly. "What am I to understand by that?"

The Reverend Erhard looked at him briefly and replied, "Well, genuine confidence in God . . . a confidence such as people had in times past. There was nothing hysterical about them. They kept their feelings in check. But they believed humbly and patiently. This humble attitude must still exist somewhere; it can't have been wiped out entirely. It must be the genuine, supporting and stable element, and all the rest is only ripples on the surface, which last for a time until the water has again fallen still and deep."

Sigvard looked down as he listened. These were true, valuable words. He had often thought the same. Perhaps he had misjudged the Reverend Erhardt. You should beware of gossip, which usually led to no good.

He retired to the kitchen. After all, it gave him a feeling of security to know that the minister was there working on a sermon under his roof. Perhaps the confessionist movement was only a ripple on the surface. One thing was quite clear: the people the movement had got hold of were mainly those who had been uprooted by this new age and the new trades. They were traders, skippers and girls working in the fishing trade. The farmers on the other hand, the good old core of the population, remained immovable.

Oh yes, perhaps when it came to the point he had been too pessimistic; perhaps these squalls that had arisen so quickly would soon calm down again.

Not until half past midnight was the minister finished with his work. Sigvard showed him to the guest room in the attic and asked his wife to take him some hot milk and a piece of bread.

The minister had kept the fire going in the stove, and the sitting room was still warm and cosy. A book of sermons lay on the table, full of blue marks and underlinings. Sigvard flicked through it . . . He was surprised to see that a minister would study other people's sermons in this way, but that was presumably common practice. As he put the book down again, he discovered a blue envelope lying on the floor under the table. He picked it up. The address on it was Ellender Skaalesund, Merchandise. Sigvard felt uneasy at this . . . could it be that the minister had sat working on business matters? He shook the contents out of the envelope . . . It was a bill from a feather factory. Disappointment and anger began to well up in him. These rumours about the minister of commerce . . . they were not without foundation after all. The minister's suitcase was standing over in the corner by the stove. It was not locked. Perhaps it was shameless to examine it to see what it contained, but Sigvard swallowed the shame; he was upset and wanted to have his suspicions confirmed.

The suitcase contained the minister's vestments, a few pairs of socks and . . . wrapped in a woollen scarf, a bundle of letters to Ellender Skaalesund Merchandise together with a small book of invoices.

Sigvard called his wife.

"Look, there's a letter here to Ellender Skaalesund Merchandise," he said.

The guestroom was immediately above the sitting room; it would do the minister good to hear this.

He added, "I must admit I find that strange. I thought actually that the minister was working on his sermon."

II

The wind dropped during the night. The rain stopped and the mountains were enveloped in a mild, spring-like veil of mist. The morning came with sunshine and fine weather . . . it was as beautiful an Easter morning as anyone could wish for.

Sylverius woke about seven o'clock and positioned himself

so he could read his Bible. It had become a custom of his to start the day in this way. This early hour was more suited than any other throughout the day to prayer and thought.

A broad stream of sunlight fell through the window and filled the room with a tremulous radiance. Simona was still asleep, and her breathing made the silence even more intense.

With unspeakable joy, Sylverius felt how remarkably the gentle words of the Easter gospel harmonised with all the silence and all this light and gave it a deeper meaning. Since his conversion, he had time after time been forced to admit that earthly things were only a kind of reflection of the spirit. It was with everyday life and its things and happenings just as with the sea, which in itself was dark and cold and murky, but had the priceless ability to reflect the pure and blessed blue of the sky. Yes, and the human soul, however unclean and imperfect it was in itself, that too, when it was purged through repentance and purified of scruples, had the same reflected gift of grace.

He liked the image that had occurred to him. The ability to be reflected . . . He would talk about that today at the inauguration of the meeting house.

And he went on to compare the human spirit with Mary Magdalene, who met the resurrected Christ in the garden, but failed to recognise Him until He called her by name. That is how we all go about, he would say, and fail to recognise our Saviour until He suddenly calls us by name one day, and we learn to see.

Sylverius came to think of an Easter morning seven years ago, when he was on his way home from the spring fishing on his ship, the Sea Lion. There had been a pretty strong wind all night, and the ship had been blown a little off course. By morning, the wind had grown into a gale, and the waves were constantly washing over the deck, and he had had to have himself lashed to the rudder to prevent him from being washed overboard. Only later, when the storm had abated, did he realise how dangerous the situation had been; it was something of a miracle that the rickety old ship had not been badly damaged. But only now, seven years later, did he remember

with amazement that he had hardly had God in his thoughts at that time. He had not so much as uttered a single prayer. And with horror, he had to think how dreadful it would have been that stormy morning if he had been called home without having had an occasion to repent his sins and without knowing the glory of conversion and grace.

Alas, he had lived unseeing for a whole generation without the real meaning of life having dawned on him; he had gone around groping his way in the darkness of a spiritual winter. Thirty-four times, the Easter sun had shone its light on him, so to speak in vain. Only now in his thirty-fifth year had he realised what this light *meant*.

Sylverius gets up and goes over to the window. His spirit feeble from overwhelming happiness. Out there, the mighty, golden cross of the spring sunshine is resplendent over the entire world . . . a sign of a pact, raised by Him who conquered darkness and death.

III

Kristoffer would have liked to make a trip to Holmvige during Easter to visit his daughter. But as he had heard that the confessionists' meeting house was to be inaugurated on Easter Day, he had decided to put off his visit until after the festival. Landrus, who was very keen to go to Holmvige precisely on Easter Saturday, had for several days tried to persuade Kristoffer to go with him. He made no secret of the aim with his visit: it was that Kristoffer and he together should try to prevent the confessionists from completely making off with Sylverius and Simona. As long as they were not baptised, there must be some hope of saving them for the church. At least it must be possible to save Simona.

"It's our joint duty as Lutheran Christians, and your special duty as her father," Landrus had said.

But Kristoffer was not to be moved. He had decided to wait until after Easter, and no amount of persuasion could make him do otherwise.

On the morning of Easter Day, Landrus made a last attempt.

He turned up, ready to go, and addressed Kristoffer earnestly: "Come on, Kristoffer, don't hold back. This is a sacred cause."

When he still made no impression, he started to tease him: "Do you know what, Kristoffer? There's no go in you. You're getting old and weak. The fire's gone out of you."

Kristoffer looked at him with a smile and made no reply.

"All right, then I'll go alone," said Landrus. "But . . . then I'll give your love to your daughter and say that you deeply disapprove of her lapsing from the faith."

"No, don't do that," Kristoffer shook his head.

He looked wearily into the air and added, "I suppose I'd better come along after all."

"Good for you," laughed Landrus. "I always knew I'd persuade you. You're a stubborn brute otherwise, Kristoffer."

Landrus's twelve-oared boat was ready down by the jetty. Jakob the Granary was in the prow eager to be off.

"What are you sitting there for?" shouted Landrus. "You don't imagine you're coming with us, do you, you oaf? Out you get and make sure you go to church, otherwise you'll have me to deal with."

He turned to Kristoffer. "Aye, we'd probably better take your motorboat. It looks more impressive, and besides it's so calm today that there's no point in trying to use the sail."

They got the motorboat in the water, and Kristoffer started the engine.

Landrus took out his pipe and lit it. He had made it a rule only to smoke on Sundays and during the year's religious festivals, thereby saving his throat and lungs and at the same time making smoking into something festive and unusual.

"I'd otherwise thought we could have the parish clerk with us on the trip," he said. "But he had to see to the church. If we'd been together, we could have put all those sectarians over there in their place . . . Believe me, we've taught this preacher chap to have a bit of respect for us."

"Yes, but . . . Are you thinking of going to the actual dedi-

cation and really getting up and speaking out against them?" asked Kristoffer.

"Of course," Landrus nodded and expelled a cloud of smoke through his beard.

Kristoffer considered carefully. "Yes, but remember *they* are the majority there today. One man on his own won't be able to assert himself in the face of the whole bunch. And they are practised speakers . . . these folk from Storefjord are no joking matter."

"*I'm* not afraid," smiled Landrus. "They might well let fly at me, but at least I shan't have sat twiddling my thumbs."

And ready for a battle, he added, "We're going to do what is in our power, Kristoffer. We were able to get the better of them on *one* occasion, and what an occasion that was!"

"I've not really been thinking of attending this inauguration," said Kristoffer, looking away. "I prefer not to stick my nose into those matters."

"Of course you will, Kristoffer," said Landrus seriously. "You, who are such a brave fellow, at sea at any rate. Don't you tell me you're frightened of a poor handful of stray sheep. That can't be your intention."

Kristoffer raised one eyebrow and gave Landrus a sharp and sober look: "We're at least not going to do anything rash or foolish. That sort of thing does more harm than good."

Landrus looked down and waved his arm to dismiss the idea. Kristoffer felt safer. It was perhaps a good thing that he had come after all.

The sun was shining bright. It was almost like midsummer. There was the odd cloud to be seen, a brownish, tattered cloud that had strayed almost by mistake into the blue skies of this beautiful day.

Landrus sat and looked out across the waters sliding past in slow, light-drowned, sinuous movements. Suddenly, a round, coal-black bladder-like object came into sight between two walls of water. A second later, it had gone again.

"Did you see that?" asked Landrus, taking his pipe out of his mouth. "See, there it is again. What can it be?"

Kristoffer made no reply.

At that moment, one, two, three, four black and shiny tentacles flashed in the air, quite close to the boat. Landrus turned round and bent down as though to defend himself. Kristoffer had to smile.

Landrus got up.

"What were those things?" he asked nervously. "They can't sink the boat, can they?"

"Oh, they're not dangerous," said Kristoffer. "Just you sit down and relax."

The tentacles drifted off south with the current. Landrus let out a brief laugh. "Good Lord. Were they sharks?"

"I don't know what they were," said Kristoffer in a serious voice. "They surely can't have been the giant squid?"

There came a look of disgust and loathing on Landrus's face. "You don't mean to tell me that was just one animal?"

"Yes, I think it probably was," said Kristoffer. "It probably was the squid, you'll see. And that doesn't usually augur well." Landrus lit his pipe, which had gone out. His hands were trembling.

"Well, there's no reason to be frightened," he said dismissively. "But one has to pray to God to be spared monsters of that kind. There's nothing more disgusting than all those devilish monsters lying in wait down in the depths of the ocean."

He suddenly looked distracted. His pipe went out again.

Sylverius had recognised his father-in-law's boat from a great distance and had come down to the quayside to receive him.

"Welcome, and a happy Easter," he said in greeting.

"Thank you, and the same to you," replied Landrus. "And God's peace on earth," he added, whatever he meant by that.

They went ashore. The sun backed down on the broad, light quay and was reflected in the windows on the end of the shop. Landrus had to think of the simple quayside at home. And now these big buildings, these huge salt cellars and fish stores. And the drying shed . . . there it was, almost finished, the new zinc roof reflecting the sunlight like a mirror. Oh, when would he get as far as that? He was a mere beginner, and

everything was still uncertain. If only he was as firmly founded as Sylverius. Yes, indeed, he was home and dry. And then he was still only a youth compared with Justinus Forberg in Storefjord. Aye, there were some people who could call themselves wealthy and powerful.

Sylverius was in high spirits.

"It's ages since we had visitors from Trymø," he said. "Magnus and Josva don't come this way any more. And my word, Landrus, you're a ship owner as well, now, aren't you. Congratulations."

"Oh, only in a small way," smiled Landrus.

"You're said to have been lucky buying that ship," said Sylverius. "And young Gotfred'll manage fine. Aye, but it's not everyone who's so lucky . . . for instance Johannes Nordbø from Storefjord – the French schooner he bought last winter has arrived in Reykjavik with a big leak that's going to cost a fortune to have repaired. And it's probably going to be on the slipway for weeks, just in the middle of the best fishing season. So he's going to make quite a loss on that."

"Yes, but . . . how did the damage arise?" asked Landrus in high spirits.

Sylverius shrugged his shoulders: "More or less of its own accord, they say . . . The fact is that Nordbø bought a poor ship. The same thing's happened to poor Niklas Næs here. It's difficult even for a specialist to value a ship, and the world's full of dishonest shipbrokers. And Nordbø was even careful enough to send Klein's son, you know, Klein the slipway supervisor, to Fécamp to examine the ship."

"That son must have been a bit of a dolt," said Landrus scornfully. "But Nordbø's a rich man, so it probably doesn't matter all that much to him."

"Nordbø's pretty well off," explained Sylverius, "but in recent years he's had a few major losses. He got redwater in his fish last year . . . and lost quite a lot on that occasion. No, he's certainly not been lucky."

"But what about you?" asked Kristoffer. "Have you heard anything of your ships?"

Yes, Sylverius had had telegrams from two of his ships, good

news. The Yvonne had already caught 45,000, so it showed every sign of being a good fishing year. He hadn't yet heard from the Isabella, but he was expecting a telegram at any time, for the skipper had promised to send word before Easter.

"Aye, and the weather's been good, hasn't it," asked Landrus.

"It's been unusually good . . . until now at least, thank goodness. But there's the postman . . . He's probably coming here."

Sylverius waved to the postman, who was bending forward as he hurried up to the house without noticing him.

"Is there a telegram for me, Vinfred?"

The postman stopped suddenly, the sun reflected in his glasses. No, there was no telegram, only a letter that had arrived late yesterday evening . . . the mail boat had been delayed. He gave the letter to Sylverius. It's actually for your wife . . ."

But now Vinfred is pleased to discover Landrus and taps him on the chest: "But here's the grocer from Trymø. That's lucky. Wait a moment . . . we've got a telegram for you, so you might as well have it straight away, seeing as you're here."

"A telegram for me?" Landrus flushes scarlet. He shuffles uncomfortably. "Just you go on, I'll wait here," he stammers.

"Go on?" says Kristoffer. "No, I'm dying to know what good news there is in that telegram."

"I'm afraid it's not good news in that telegram," says Landrus in an almost broken voice.

"Rubbish . . . that's what you always think before you open it," smiled Sylverius.

Vinfred returns out of breath and hands the telegram over. Landrus grabs it and tears it open. He moves away from the others a little and turns his back to them. Reykjavik, it says. Caught 38,000 coming home this week. Gotfred.

Landrus could have howled with delight and pride, but he kept himself under control, turned towards the others and said soberly, "They've got 38,000, and now they're coming home to land the catch. 'Cause there's no room for any more on board, that's obvious."

"That's really well done," nodded Sylverius. "And if they go off again as soon as they've landed it they can almost manage another thirty thousand. That was a pretty good start, Landrus."

"Aye, you can be content with that," smiled Kristoffer.

Yes, Landrus was delighted. He was flushed and had a shy look about him like a young man in love. And he had the strangely sweet sense of feeling sorry for poor Johannes Nordbø, who had been unfortunate. Just think if that had happened to him . . . if the Gregoria had been taken in to Reykjavik as a disabled vessel and had had to lie there for a series of expensive repairs while other ships gorged themselves on the golden abundance of the ocean . . .

IV

Kristoffer was curious to see his daughter again. Sylverius had not changed much after his conversion – it was strange to hear him talking about all kinds of worldly things, exactly as before. Kristoffer had expected to find him quite changed. But what about Simona?

She, too, was as she had always been. She gave her father a hearty welcome and immediately started asking for news from Trymø . . . Josva had gone abroad, of course – had anyone heard from him since? And Trymø had got its own ship! And poor Jane was dead – How was her mother coping with this new tragedy? And Hilda . . . but fortunately she had recovered.

Kristoffer told her the news and felt relieved to see Simona unchanged.

Sylverius had things to talk to Landrus about . . . he had had a visit from Lars Dion, who had suggested setting up a branch in Trymø, but Sylverius hadn't thought he could go along with that.

"I know so little about that man," he said. "And besides, I don't want to get in your way."

"I really appreciate that," said Landrus emotionally, after

which he started telling all about Lars Dion. He didn't need to start a business, he was quite well off and had only his wife to provide for, and his son Balduin had recently got the teacher's job on Trymø, and Balduin was unmarried and could support his parents . . . no, if Lars Dion wanted to set up a business, it was only to damage Landrus, and that he knew perfectly well.

"Yes, to be perfectly honest, that was my impression, too," smiled Sylverius. "But as I say, he'll get no backing from me."

He added, "And naturally it was also very doubtful whether a branch of that kind could pay. I can't imagine it would. Two shops in such a small place, and even in the same building! And you're doing so well, Landrus, that there's surely no point in a beginner coming and competing with you. And besides . . . now that you've got a ship and are going to start in the fish trade on a grand scale . . . it would be far more sensible if you and I had a talk about working together. We'd be able to help each other in many ways . . ."

Landrus nodded, "Yes, indeed, that's how I feel too."

As soon as Simona had got her father and Landrus seated at table, she went up to the loft to be on her own while reading the letter that had arrived for her. It was from Mrs Martens.

"My dear Simona," it said. "My husband and I are leaving next week, and I am so sorry, but I shall not have the opportunity to come and say goodbye to you. Nor shall I be able to come out to Trymø or anywhere else and take leave of all the many people we have got to know and love during the little more than a year we have spent up here. So I have decided to send you a few lines. But first I would ask you to be so kind as to burn this letter as soon as you have read it. You will remember, of course, that I once spoke to you in confidence about us, about my husband and myself, and you are the only person who knows the truth about the sad conditions under which we have lived. They have grown worse over the last couple of months. And yet it is perhaps best thus, and at least it could have gone far worse for us. You see – that strange madness that has plagued my poor, poor husband, and which I told you about, things have developed in such a way

that he has become more and more lethargic and has spent most of his time dozing. Without his knowledge, I have spoken to Doctor Bonæs about it, and he has actually been over to see us and has examined my husband, and he says that he is afraid the condition will not improve. So Herman will be forced to resign his pastoral duties. But there is one good thing, and that is that he will receive a pension, so we shall be all right in that sense.

As for me, I must openly confess that it is as though a great weight has fallen from my mind. I now no longer need to go around fearing how terrible it would be if my husband's condition became obvious to all. Now all that needs to be said is that he is ill, not that he is mad. And as he is now, he needs my constant attention and loving care, and I assure you that I shall do my utmost. If only he does not become worse and die, for that would be the worst thing of all.

So you will understand that I am not so unhappy as you might think. It is as though I have now found peace. God has heard my prayers and arranged things for us in the best way. It is as though He has made the cross lighter that He has placed upon us, and so it has become easier to bear.

And I am looking forward a little to getting home and seeing all my family and friends again.

I will say goodbye to you, my dear Simona, and thank you for your kindness towards me and for your willingness to accept my confidences and for keeping them entirely to yourself. You must promise me to continue to do that. God be with you and your husband and the children you will be having. I will wish you all the best now, and do give the occasional thought to your sincerely devoted Karen Martens.

Simona sat for a long time on the point of tears. Oh, that poor minister's wife. She would make sure of writing a few lines to her straight away so they could reach her before she left.

V

Every seat in the church was taken. Everyone from Indrevig who was capable of it had turned up for the Easter service, from the oldest to the youngest. Sigvard had seen to that yesterday. But there were also people from the neighbouring villages, from Kvandal, Sandefjord and Kirkevaag, indeed from as far away as Skaalesund. These were the Reverend Erhardt's wife, brother-in-law and sister-in-law with their children – the minister had had them fetched in the motorboat that morning as the weather was so good.

It was almost as in the days before the sectarians has established themselves, and Sigvard would have felt both delight and pride on behalf of the church if he had not at the same time been bothered by a presentiment that many of these people would be going to the confessionists' meeting afterwards. There was no end to people's curiosity. This was what the sectarians were so adept at exploiting. So they had let the news out that there would be baptism after the inauguration. Three young women were to be baptised in view of everyone. With bait of this kind they would probably have no difficulty in filling the hall. In its honest ordinariness, the church was quite powerless in the face of this kind of weapon. Sigvard suspected Justinus Forberg of being the source of the idea of a public baptism . . . Reinhard had so far had baptisms carried out rather more privately.

If only the church had had a more fiery and courageous preacher to turn to! A man who could flame and thunder against the false faith. A minister such as this little, worldly Reverend Erhardt, God help him, would probably do more harm than good.

Now Erhardt entered the pulpit, blew his nose and looked round at the congregation with small, blinking eyes. He looked like a little shopkeeper behind his counter and uncertain about a new group of customers.

"Aye, God forgive me for that thought," Sigvard prayed silently, "but that's what it is; he's a shopkeeper, not a minister."

The Reverend Erhardt used the words of the Easter Gospel for his sermon: "And they came and held him by the feet, and worshipped him." It evolved into a sermon about a Christian attitude and humility: humility being the sign of the true Christian. He does not inveigh against others and judge them, no he embraces Christ's feet in humility and worships him.

Sigvard sat there listening, with his head raised. He had a suspicion that these words about humility were aimed especially at him, getting back at him. Could they be? Could a minister really behave in that way? It was to bring shame on the church. But at all events, these cheap exhortations about showing humility were out of place on an occasion such as this.

"A humble spirit is the greatest gift God can give a human being," the Reverend Erhardt went on. "For, as the Bible says, 'Blessed are the gentle, for they shall see God . . .'"

Sigvard gave a start: "That's not what it says," he said to himself. The words are 'Blessed are the pure in heart, for they shall see God'. The man doesn't even know his Bible!"

Sigvard could not resist a slight snort . . . it was not really fitting here in God's house to show his disgust, but did a minister who got the scriptures wrong deserve any better?

And of course, the Reverend Erhardt finished his sermon without addressing as much as a word to the situation threatening the Church here in Holmvige. Not a word of consolation or encouragement for the hard-pressed congregation, not a word of warning or an exhortation to stand firm!

Sigvard reached a conclusion. He would go to Østervaag and personally explain to the dean how things were in Holmvige. And he would submit a fresh complaint from the congregation and suggest that a young, dynamic and *evangelical* minister should be appointed to this neglected parish. He would not give in until the Church received the support it needed.

. . . Landrus had found it extremely difficult to follow the minister's words. He had all the time had the telegram in his thoughts; he could not stop thinking of how good it would be to go home with the good news. After the dismissal he

remained in his seat for a time with his head bowed and hands folded. Here, in God's own house, he wanted to give his personal thanks to the Almighty from the bottom of his heart at the same time as addressing to Him a humble request: "Great God, you for whom everything is possible, let the spring be sunny so that the fish can be successfully dried. I ask this not only for my own sake, but for that of the entire island, indeed the whole country. You know what it means to all of us, both rich and poor, young and old. Let Your grace shine on us poor sinners and be patient with us in Your infinite mercy. Amen."

The light sparkled on the white sills of the church windows. He felt the blissful warmth of the sun on his back. Perhaps the ship was already on its way home at this very moment. Already tomorrow he would set about preparations for receiving the fish. Everything must be in tip-top order when the ship arrived: the warehouse cellar must be washed down until it was completely clean, the tubs for cleaning the fish had to be scrubbed and put out in the sunshine, and the tarpaulins had to be taken out and beaten. Actually, there might not be enough tubs . . . perhaps while he was here in Holmvige he ought to either borrow or buy some from Sylverius; he must have more than he needed of that kind of thing, and there was no end to his helpfulness and interest. Perhaps it might also be possible to hire one of Sylverius's lighters, for it was important to get the fish ashore as quickly as possible, especially if it happened to be raining while the job was being done, which God forbid!

No, Landrus could not settle after receiving the telegram.

"When have you thought of going home?" he asked Kristoffer as soon as they came out of church.

Kristoffer gave him a brief, searching look.

"As far as I'm concerned we can go straight away," he said.

"Well, you see," nodded Landrus," I'm going to have so much to do in the coming days that I'd better get down to thinking seriously about it this afternoon."

"Fine, but then let's just pop in and say goodbye to Sylverius straight away," suggested Kristoffer.

"Hmm, but .. what about the . . . the prayer meeting?" said Landrus, looking slightly tired at the thought.

"I don't think it'll hurt us to miss that meeting."

"Yes, but wasn't it really because of the meeting that we came her, so perhaps . . ."

"Well, was it really?" Kristoffer interrupted him. "My aim was to visit my daughter and son-in-law. And as the confessionists' boat hasn't arrived yet, it might be some time before they hold their meeting. Perhaps it won't be until this evening, who knows?"

"Right, then we'll put it off to another day," said Landrus resolutely.

The table was set for dinner in Sylverius' dining room.

"You're surely not in all that much of a hurry to get away," said Sylverius. "In this lovely weather. And besides, it's a holiday tomorrow as well . . ."

"Good heavens, so it is," thought Landrus to himself. He had forgotten that. The thought irritated him dreadfully. But there was nothing to be done about it. Holiday was holiday.

"I just hope the weather will hold for a time so we can get the fish dried," he sighed.

"Well, we'll see," said Sylverius. "We were very lucky with all that last year."

"Yes, it was a lovely spring, an awfully good spring," said Landrus and became quite animated at the memory of the sun-drenched weeks at the time of Sylverius's and Simona's wedding.

"But the year before," Sylverius went on, "we had sleet and rough weather until well into May. I remember we lost money on a contract for delivering dried fish by the twelfth of May. We finished the job on the 27th, a fortnight too late. But then summer came in July."

There was a knock on the hall door, and Reinhold Vaag entered.

"Good morning," he said. "And happy Easter."

Landrus became all worked up again. He reluctantly shook hands with the preacher.

"Yes, this is Reinhold Vaag . . . I don't know whether

you've met," said Sylverius. "Oh, of course, Reinhold was out on Trymø once during the winter of course."

The preacher smiled amicably and with no sign of bitterness. "Yes, I was out there with Egon, when he went to say goodbye. Fancy, it's already three months since. Indeed, time flies . . ."

Landrus turned his back on him and went over to the window.

"Don't let me disturb you," said the preacher. "Could I have a word with you, Sylverius? It won't take a minute."

Sylverius and the preacher went into the other room.

"We'll have the whole bunch of them here in a minute, of course," Landrus whispered to Kristoffer, wrinkling his nose.

"Take it easy, Landrus. In any case, they'll probably not be here until this afternoon."

"Yes, but that preacher . . ." Landrus ground his teeth. "The very sight of him makes me feel sick. No, I'm not lying . . . I really got stomach ache when I saw him come in, and it's awful to think how he creates havoc around here and scatters his poisonous seed around just as he likes. If he says a word to us, he'll get the end of my tongue all right."

"Don't let your quick temper get the better of you," warned Kristoffer. "Remember the good news you've had today."

Sylverius and Reinhold came back, both nodding seriously. Landrus raised his head and assumed an irreconcilable and watchful expression.

"You've had good news, I hear," said Reinhold amicably. "That's a good start, I must say."

Landrus rocked to and fro a little. His face broke into a smile: "Yes, it was . . . of course."

"And you're taking the entire catch home to dry it yourself, I hear," the preacher went on. "You're doing the right thing there . . . it provides work. I just hope we're going to get some good drying weather."

Landrus nodded, his stern gaze dissolved.

"If there isn't enough drying weather," said Sylverius," you've always got the solution that you can send the fish over

476

to us to have it finished off artificially . . . I imagine the plant can be taken into use in the middle of May at least."

"Yes, thank you," said Landrus in a warm tone. "If it's necessary . . ."

"Yes, let's hope we have a good fishing year this year," said Reinhold with a sigh. "And are spared all kinds of misfortune. God grant that."

Sylverius went to the door with the preacher.

Landrus took out the telegram again and carefully smoothed it out.

"It's strange even so," he said. "Here am I, sitting with a letter that was posted yesterday evening . . . so it's crossed the sea during the night, right down at the bottom, and now it's here. It's almost more than I can understand."

"No indeed," said Sylverius, "it really is a miracle."

And he went on: "Telegraphy is one of God's modern miracles that we forget the existence of in our everyday lives. We become used to them and consider them as matters of course. And that's really what it's like with everything . . . God reveals Himself in everything, even in the smallest thing, but people simply don't notice. Except at special, quite special moments when their minds are prepared. Then . . . well, then it's as though the interior world, the world of the spirit, comes closer and makes people appalled at how dull and lethargic they are in their everyday lives."

"Aye, that's true enough," nods Landrus. "God's present in all things. That's plain to see."

"Yes, then the spirit opens our eyes," Sylverius added quietly.

Landrus nodded again. "Yes, God's spirit is revealed even when hidden . . . for any honest Christian."

Sylverius sat down on the edge of a chair and leant forward, supporting a hand on each knee. "Yes, as far as I'm concerned I went around unseeing until recently, concerned with anything but the . . . the one thing necessary. I spent all my youth, so to speak, in darkness. But then I suddenly became seeing. Well, not all that suddenly; it took time, it was a while before my eyes had grown used to really seeing the light . . ."

Landrus folded the telegram up and put it in his pocket. He glanced at Kristoffer and said, "Yes, we all have moments when we see clearly . . . But may God simply help us to see *the right thing*."

"The right thing and the only thing," said Sylverius with profound feeling, "is the redemption of the soul through Jesus, conversion to the life in Jesus."

"Conversion?" Landrus savoured the word for a moment.

"Yes, conversion is necessary." Sylverius raised his head and looked fixedly at Landrus. "That is my experience. If I hadn't had the divine experience of this conversion, I would still have been going round as a profoundly unhappy individual, fumbling my way forward."

While Sylverius was speaking these last words, Simona had entered the room. She was going to ask the guests to sit down at the table, but when she heard the subject of conversation, she remained standing, listening seriously at the door.

Kristoffer answered him quietly: "But I also think that . . . fumbling . . . can have an importance in itself, as it were."

He was on the point of referring to the parable of the Pharisee and the publican, but he refrained . . . Sylverius might take it that he considered *him* to be a Pharisee.

The same thought appeared to have occurred to Landrus, who stared fixedly at Sylverius: "Yes, God have mercy on us poor sinners."

Sylverius got up and went across and stood beside his wife.

"Listen, Simona," he said in an emotional voice, "let's do as we said."

In explanation, he added, "Simona and I have decided we will not miss any opportunity to bear witness to our redemption, and as you are here now . . ."

He bowed his head and folded his hands, and Simona did the same. Landrus glanced at Kristoffer . . . he, too, had folded his hands.

Sylverius closed his eyes and breathed deeply. "O God, for the sake of the sacred blood of Jesus we pray You receive our humble confession. We thank You for teaching us to understand that You allowed Your Son to be wounded for our

misdeeds and crushed for our sins. For, as it says in the Good Book, by grace are ye saved through faith; and that not of yourselves: it is the gift of God. Let the light of your grace spread until every knee is bowed before you and every tongue proclaims God. Amen."

Landrus had refused to fold his hands. He sat staring listlessly out of the window. This was a scene that called for pity rather than anger. These two poor people believed they were redeemed, but the redemption they were so happy with was only a delusion, a misunderstanding. Sylverius, that rich and fortunate man . . . on this one sole point he was not particularly fortunate! Rather he was cheated and deceived. Here he lived in his big, comfortable house in the midst of a thriving business . . . Perhaps his ships had together fished ten times as much as the Gregoria – that was a thought to make one dizzy. But as for things spiritual . . . Poverty, the insuperable poverty of aberration and the darkening of the mind!

During the meal, Landrus sat considering how in a firm and uncompromising but not impolite way he could say what had to be said about the confessionists' delusions. This had been his purpose in coming to Holmvige today, and now he had his best opportunity to discuss it with Sylverius and Simona.

But it was more difficult than he had expected. The right words failed to come to him, strangely enough. That was the result of the unaccustomed surroundings. You were not really yourself away from home.

Besides . . . Sylverius's calm and assuredness had a compelling effect on him. There could be no doubt that Sylverius was a man of faith, of profound faith, whatever could be said about the contents of that faith.

And . . . suppose he really had ended on the right side, in this respect, too?

But it was noticeable how both Sylverius and Justinus Forberg and so to speak all the powerful men in the country were going over to the new faith. This really provided food for thought. For if it was displeasing to God . . . He could crush them in His almighty power, and he could shower misfortune

and unhappiness upon them. But it almost looked as though they enjoyed His special favour . . . Someone like Justinus Forberg was a man whose wealth didn't stand still; it was growing year by year, growing at a furious pace, so that he would soon dominate the whole of Storefjord.

Perhaps Landrus had been too sure of himself after all!

The thought filled Landrus with an appalling sense of distaste. He dismissed it with disgust. But it came back: Well, who can give me a guarantee that *we* are the ones in the right? Or the clergy? Just because a man is a minister, the Devil can still dwell within him. Landrus came to think of the Reverend Tobiasen, who had confirmed him and later been unfrocked on account of immoral behaviour . . . that man had been an emissary of the Devil, however much he had appeared in clerical attire and proclaimed the Word of God.

And as for the confessionists . . . Were many of them not good people, able and conscientious at their work and untiring in preaching the Gospel even if the message they preached was peculiar in certain respects. Even the preacher . . . how he had worked to guide poor, drunken Morberg and that sinful hotel keeper into better ways.

Yes, suppose they really were better Christians, these sectarians, deeper and warmer believers than the people of the church. And suppose their teaching was pleasing to God!

Landrus's mind was full of dark forebodings. He started sweating and forgot to eat.

Sylverius and Simona spoke quietly and openly about their conversion and the wondrous change that had taken place in their minds after they had understood the real truth and meaning of life on earth. What they had experienced was a rebirth; they had been born again, as it is said in the Scriptures. And now they were preparing for baptism, the new pact.

Kristoffer sat and listened with his head bowed.

"Well, it's something so . . . alien to the rest of us," he said quietly. "We rely on the old pact, if I may put it that way."

"The main thing is presumably that you feel you have a pact with Jesus," said Sylverius. "That you feel you are redeemed through Him and live in Him."

. . . Immediately after dinner, Kristoffer and Landrus say goodbye.

Sylverius had thought of showing the interior of the drying shed. The actual heating plant was not finished yet, but they could even so get an idea of what it would be like. But Landrus preferred to wait until another time.

Sylverius went down to the quayside with them. Just as they had freed the boat from its moorings, the motorboat from Storefjord appeared from behind the promontory at the mouth of the inlet. It was decorated with flags and was crowded with people all over the deck.

"Well, goodbye and many thanks for the welcome," said Landrus in farewell and pushed the boat out with great force.

Kristoffer started the motor.

When they had come half way out in the inlet, he moved across to Landrus and said, "There was one thing we clean forgot . . . the new meeting house. We didn't even see the outside."

"No, you're right about that," replied Landrus, turning his head. "It must be that new building over there a bit above the church. It looks quite ordinary. No, we didn't see it . . . but well, the trip wasn't without benefit even so."

He took the telegram and read it through once more. Then he folded the paper again and sat for a time with thoughtful eyes and a despondent twist to his mouth.

AT DAWN

I

Balduin had become a shadow himself. His features were sharp, his eyes hollow and his forehead incredibly high.

Lars Dion had several times advised him to go to Storefjord and let the doctor examine him, but Balduin would not hear of the idea.

"I'm not physically ill; I never cough," he protested. "If I look bad, it's because of the struggle that's going on inside me."

"Rubbish." Lars Dion shook his head.

It was not really that . . . Balduin would have preferred to be physically ill. Good Lord, a bit of tuberculosis! If you had that, you went off to Østervaag and had yourself made better. Or, if the attack was more serious, then you faded away and died. Balduin was not really afraid of death. It was only an inter- mediate state, a healthy and fruitful state even, during which the soul drew nourishment from the primal spiritual source of existence and was receptive to *involution*. No, the bitter strug- gle for life, the constant close conflict with the lower forces . . . he was sometimes tempted to fall back on the belief in devils and Hell that he had had during his childhood and early youth.

A few days after Easter, Doctor Bonæs arrived on Trymø to see to an old woman from Blackwater Farm.

"Now you've got a good opportunity to ask the doctor to examine you straight away," Lars Dion urged him.

"No, there's no need." Balduin dismissed the idea.

"Well, I insist," said his father angrily. "Suppose you're infectious and go and spread disease around you."

"All right, then . . ." Balduin would have himself examined for the sake of peace and quiet.

The doctor came to see him in the loft above the school. He looked around the tiny room in amazement. "Ah, you've got both Spinoza and Goethe as well as Byron here! But who's the fat, offended-looking woman over there . . . I've never seen her before."

The doctor pointed to one of the pictures in the series.

"That's Madame Blavatsky," Balduin informed him coldly.

The doctor coughed slightly. "Does she really belong in that company? I mean . . . together with Schiller and Rembrandt and Ibsen?"

"Yes, I think she does," replied Balduin firmly.

Doctor Bonæs looked at him with a slight smile in the corners of his eyes. "Are you an anthroposophist?"

"Yes." Balduin met his gaze with a frank look.

The doctor started his examination. Balduin awaited the result without any sign of tension. He was convinced that he was physically healthy. And that also turned out to be the case. The doctor put his stethoscope back in his pocket. "There's nothing to hear. And your chest's fine. But why are you so keen on mortifying the flesh? Is that supposed to be good for you? You need more nourishment. And if you get tired of being a bachelor . . . it wouldn't do you any harm, because Madame Blavatsky might be all right, but . . ."

Balduin ignored the doctor's joke.

When he had been left to himself once more, he went across and switched the pictures of Ibsen and Madame Blavatsky. Ibsen had taken up the best place on the wall for long enough. Madame Blavatsky was a greater genius and a warmer spirit.

Lars Dion came to hear what the doctor had said. Balduin was lying on the bed, reading.

"There's nothing wrong, of course," he said without looking up.

"Well, you can be pleased about that," his father nodded and looked about the room.

"You've got a dreadful mess in here," he remarked. "And what about the schoolroom? Who keeps that clean now that Magdalena's gone?"

"No one."

"But that's no good in the long run."

"No, but Judika from the River House has promised to come and do the cleaning."

"Judika." Lars Dion shrugged his shoulders disparagingly. "She doesn't look as though she can keep herself decently clean. Besides, she steals."

"Tittle-tattle." Balduin wriggled impatiently. "I take who I want . . . I'm boss in this house."

"But the teacher's house?" Lars Dion refused to be budged. "Is that to be left empty?"

"For the time being."

Balduin frowned and ran his index finger along a line in the book. His father went on: "If you won't move into it yourself, do you know what could be done with it? You could let it out. I don't mean to anyone from the village here, but to strangers. As a summer cottage or whatever it's called. You could advertise it in the papers . . . a first class summer cottage to let on Trymø. There would probably be some wealthy family from Østervaag that would come and live here. What do people do elsewhere? And now the hotel in Holmvige's no longer there."

"Nonsense," said Balduin wearily. "I don't think I'm allowed to do that. And besides . . . there's the danger of infection. You don't think about that, at least not when it concerns other people."

Lars Dion got up.

"Can you lend me two hundred kroner next week?" he asked without any kind of preparation. "I need them. Skule Mortensen wants them as security."

"Skule Mortensen?" asked Balduin in amazement.

"Yes."

Lars Dion explained the situation to his son. He had written to Skule, the Kirkevaag grocer, and suggested setting up what he called a consignment stock here on Trymø. And he had had the reply that it might well be possible if he could produce some security . . . partly in property and partly in cash.

"That'll never work," warned Balduin. "And I've got no money."

"You've got no money?" laughed Lars Dion. "Now you've stopped wasting your money on Magdalena . . . you must have something put aside. Don't make yourself so hard to get."

He got up and went over to the door.

"I've told you I need two hundred kroner, and it's only reasonable that you should lend it to me in view of all I spent on you while you were studying. Everyone will agree with me on that. Think it over until this evening."

Balduin had neither the time nor the inclination to consider that question. When his father had left, he lit the lamp and settled down at the desk to absorb himself in "The Secret Doctrine". He had recently acquired this fascinating book and was keen to discover whether it had anything to say about his particular case. But it seemed not. It contained some interesting information on the Mahátmas, the great souls, with whom it was possible to get into contact – provided you were at an advanced stage. But no, no more than any of the others did this book provide an explanation of what he was most eager to achieve a little clarity about.

Balduin made a quick decision. He would get in touch with theosophist circles in Copenhagen or Stockholm. He would ask the advice of wise and experienced co-believers and tell them of the strange and alarming things he had experienced in his solitude and ask them for a straightforward explanation. He wanted to know whether he was on his way up or down.

It would be difficult . . . sweat appeared on his brow at the very thought of having to initiate others into these strange and disturbing things. But what a relief it would be once it was done. He could do a draft, put his thoughts on paper, give a general account of what was going on. He would tell them how, soon after her death, Jane had come to him in dreams in a new, transfigured form. The joy he had at first felt at this. Her comforting words and encouragement to him to stand firm whatever happened. And then the terrible time that followed.

Appalled, he recalled it all in thought . . . how the dead girl assumed an increasingly lifelike and voluptuous shape, how she sought to convince him that physical love was more powerful than death, wanting him to enter a physical marriage with her.

And then, how he had fought against this. He refused to believe that it really was Jane revealing herself to him every night and gradually becoming more insistent and shameless. It must be something else . . . a temptation sent to him by higher powers to test the strength of his mind, to train him in spiritual self-control. But he had been unable to find any books that confirmed these suspicions. He had gradually ended up completely confused, insecure and afraid. So far he had never given in, but it had cost him his spiritual peace and his sleep at night. He had accustomed himself to waking every time the dreadful dreams came. But he had often been on the point of giving in . . . Jane, or this tempting monster, had recently been coming to him in all conceivable shapes such as it was almost impossible to describe. But he *would* describe it.

He took out paper and ink, gritted his teeth and started writing; there was a throbbing in his temples, and his hands were wet with sweat.

He sat writing far into the night. He had gradually managed to concoct a letter. It was all there now. He had managed to find expressions that were sufficiently unveiled for the truth to emerge, but nevertheless of such a kind that they could not have a directly repellent or offensive effect.

With a certain sense of satisfaction, he read the letter through, made a fair copy and put it into an envelope. In one of the books, he found the address of the Theosophical Society office.

Balduin slept peacefully that night and had no dreams. But when he woke the following morning, there were shooting pains in his head and every move was agony to him. And the headache continued throughout the day. He had to send the children home from school. He was ill, and he was unable to gather his thoughts on anything at all.

There was a knock on his door at midday. It was Judika. She came to ask whether she could start on the cleaning.

Balduin lay on the bed with a wet towel over his forehead.

"Are you ill?" Judika tried to look sympathetic but was not quite able to conceal a smile.

"No, I'm not well. You can start on the schoolroom straight away."

"Have you got a headache? You should have a cup of hot tea with pepper and sugar. That helps straight away. I know 'cause I've tried it. Haven't you got a primus stove? I'll heat some water straight away."

"Heat's no good for a headache," said Balduin sullenly.

Judika found the primus and lit it.

"Just knock on the floor when the water boils."

Balduin lay listening to the water as it started singing. It was a pleasant sound, full of emptiness and nothing. The sound actually made his head feel better. Through the sound of the kettle singing he could hear Judika rummaging about and humming down in the schoolroom.

Now the water's boiling. That's up to her. Balduin makes no move.

Julia returns before long. "I thought as much – the water's boiling. Why didn't you knock on the floor? I'll just pop home for some tea and pepper and sugar."

"There's tea and pepper here," says Balduin. "And there's no need for anything else."

"Sugar?" Judika laughs. "That's the most important of all. Wait a minute."

She disappears again. The primus has been turned down . . . Balduin's headache is getting worse again. It feels as though his skull is splitting, like an egg that is being cracked. He feels irritated with Judika's tiresome helpfulness.

Now she returns. Her wispy reddish hair hangs down around her face, and she is smiling to show big, fresh teeth. The drink is ready a moment later, and she brings a steaming cup to the bed. Balduin reluctantly swallows a mouthful of the over-sweet tea.

"You read and study too much, that's the trouble," says

Judika with a percipient look in her eye. "You shouldn't over-stretch your brain like that."

She looks around and goes on, "And there's too much in this room . . . all these books and papers. Believe me, that's something that gathers the dust. Didn't Magdalena use to clean up here?"

"No."

"Then God knows it must need it. . . . Well, is the tea doing any good?"

"Not yet." Balduin breathes out heavily and lies with his eyes closed.

"It'd have been best if you'd had a drop of something to put in it . . . rum or something."

"There's some gin in a bottle under the table."

Judika fetches the bottle. The cork is so tight she has to use her teeth to get it out. "There. Now you can have a drop of spirits in your tea, and then you'll see it improves things. And then a drop more hot water. Drink it down quick."

She hands the cup to him.

"Whose phizog's that hanging on the wall?" she asks in surprise. "It makes me feel all frightened . . . That old man over in the corner looks so fierce."

"It's Leo Tolstoy," is the chilly response.

Now he actually feels that the drink is doing him good. His headache is less and more distant. He sighs in relief.

"Do you feel better now?" Judika is pleased with herself. "You should have another cup . . . Here, let me."

She mixes another cup.

He makes an attempt to sit up, staring into space with wide open eyes.

"Can I make myself a cup as well, Balduin?" says Judika. "You see, I've got a bit of a headache today as well."

"Yes, but you probably oughtn't to put any gin in it. You might not be able to stand it."

"Rubbish. Of course I can stand it."

Judika laughs and half closes her eyes coquettishly. She mixes herself a drink that includes a large quantity of gin.

"What are those books you've got over there? "The Ocean of Theophy" — what's that?"

"Theosophy," Balduin corrects her. "What's that? Well, it's . . . well, what is it? It's not easy to explain on the spur of the moment. Are you good at reading, Judika? You could borrow that book to try it. It would be fun to see whether you get anything out of it. It's not all that difficult to understand."

Judika shrugs her shoulders and tightens her mouth. "Yes, but haven't you got anything . . . more amusing?"

"I don't have any amusing books," says Balduin significantly.

"Nothing about love and that sort of thing?"

"No." Balduin looks away.

Judika suddenly puts the book down. "I'm in your way . . . but I'm off now."

"You're not in my way. Thank you for being so kind, Judika."

"Oh, it was nothing."

She smiles and puts her head on one side. Soon after this, he can hear her moving around and singing in the schoolroom.

He gets up, feeling well again now. The hot, spicy drink has given him a pleasant feeling in all his joints. He fancies another cup. The water is still hot. But will it be all right to have more gin? He hasn't touched either drink or tobacco since Jane died. This would be like relapsing. During the three months since her death he had made good progress in self-discipline. But if he had just one cup to make sure that the headache didn't return?

No.

He takes out the letter and starts reading it through. It's a good letter. Honest and open. He is not far from feeling a kind of admiration for himself. He has gone through a good deal recently. He has undoubtedly *risen*. The *higher* element in him has increased. He has done penance, exercised and trained his spirit. He would have been incapable of putting a letter like this together even a month ago.

He takes "The Inner Life" out and starts to read, noticing how receptive he is and how easily he understands everything now the headache has gone. He can read page after page

without it costing him the slightest effort. How he *understands* this writer, and what a delight it is almost to be able to talk to someone of like mind.

Judika is singing loudly down in the schoolroom. But then there is suddenly the sound of something falling, and then a little scream. He starts . . . What can be the matter? Can she have hurt herself?

He runs downstairs. Judika is stretched out on the floor in a corner of the room. She is lying on her back with her hands folded round one knee.

"Oh, I've given myself such a knock," she is sobbing and laughing at the same time. "I was standing on the table, and I slipped and knocked my knee on the edge of the bucket. Oh, it does hurt."

She tries to get up, but is unable to support herself on that leg.

"Oh . . . Balduin. Come and lift me up. This is a fine mess . . . That drop of gin was too much for me after all. That's why I fell."

She puts her arm round his neck.

"Is it better now?"

Balduin can feel her hair against his cheek and it is as though he is short of breath.

"Oh, thank you, Balduin. It's feeling a bit better now. If I could just lie here and rest for a moment."

And Balduin suddenly feels her cheek against his. He starts and gasps for breath.

Judika whimpers a little. Her lips are closed, and she sounds rather like a hen gathering its chickens.

He guides her to the door and helps her up the stairs, but he is almost on the point of collapse himself . . . It is naturally the weakness resulting from the headache. Half way up the stairs, Judika becomes strangely limp; she can't manage any more and clings closely to him. He feels her neck and breast against his mouth, takes hold of her with both arms and drags her the rest of the way.

"You're so heavy," he groans with chattering teeth.

He manages to stretch her out on his bed.

"Oh, that's lovely, a lot better."

Balduin goes backwards and forewards between the bed and the bookcase. The letter to the Theosophical Society. It is some time before he can recover from the effort of helping Judika up. And why did he in fact carry her up here? He is not really sure. He thinks that he will go round to Landrus this afternoon to buy a stamp for his letter. It's an excellent letter. And when the reply comes . . . that will be ever so exciting. That will be a great day. A red letter day in his life, perhaps.

Balduin is still trembling a little. He breathes deeply and asks, "Well, Judika, are you feeling better now? Do you think you can stand on that leg now?"

Judika smiles as she tries to catch his eye. But when she succeeds, she gives a start.

"Oh," she groans. "Yes, I think . . . I think I can stand on it now."

She climbs out of the bed.

"Yes, it's better now."

"Well, just you get off home, Judika," says Balduin calmly. "And come again the day after tomorrow. And thank you for the headache medicine – it did the trick wonderfully."

II

The good Easter weather was perhaps going to last for some time. There was real spring warmth in the air. So strong was the sun that steam rose from the ground by lunchtime. Down by the water's edge, there were thick rows of sweet-smelling seaweed that had washed ashore . . . the fresh, sweet scent could be smelt everywhere, bringing with it memories of summer growth and God's generous grace.

Sylverius's broad barge was tied up out in the cove. It had been left there for Landrus. He could choose whether he wanted to rent it or buy it as it was.

It was a clumsy old barge, patched and worn, but the price was not unreasonable. There were also five washing tubs in the barge, and Landrus could hire those as well, and if he bought the vessel, these tubs would be included in the price.

They were very favourable conditions. Landrus had come to think highly of Sylverius. He was now regretting the pointless ill will he used to feel for this unique man. He almost had a feeling now that this important Holmvige merchant was behind him. Sylverius had told him that if there was anything else he needed, he should simply come and talk to them.

Landrus had also heard of the pleasing concord that existed among the confessionists. They helped each other through thick and thin. If one of them was unfortunate, the others came and helped out. Johannes Nordbo was said to be considerably indebted to Justinus Forberg – to the tune of 30,000 kroner, it was said. And that was no small sum. And as for Peter Hammer the baker, Justinus had looked after him, too . . . his bakery was in serious difficulties before he was converted, but now Forberg had got him going and helped him on his way. You could look on that kind of thing as you wanted, but it could hardly be denied that these confessionists were inspired by the Christian spirit of brotherly love and unity.

Landrus is going around getting everything ready to unload the fish. The workers are at home waiting or wandering around with nothing to do on the drying grounds or down on the shore. The weather is clear and the sunshine golden. The evenings are light, and the mountains are sharply profiled against the expectant light of the golden sky. The oyster catchers have returned and are filling the air with their boasting and bickering. Here and there, bright green patches can be seen in the meadows, appearing like blushes on a cheek.

Out at Highpoint, there are people keeping watch all the time. Landrus has given Jacob the Granary and Redstones Ole orders to take it in turn to keep watch, night and day. As soon as the ship is in sight, they are to tell him.

But the days pass, and the week passes. Saturday arrives, but there is still no sign of the ship.

At midday on the Saturday, the wind is getting up, and it turns showery during the afternoon. Redstones Ole, who is on duty out by Highpoint, is drenched. Jacob the Granary is to relieve him and turns up in Landrus's oilskin coat and

sou-wester. In the evening twilight a ship sails through the Trymø sound. However, it is not the Gregoria, but a grey-painted schooner . . . and it sails on towards the south.

Landrus wanders listlessly backwards and forwards in his living room. He stops in front of the barometer every three minutes. It is falling, steadily and surely.

He grows more and more worried. He has to go down to have a talk to Gotfred the parish clerk.

Gotfred is reading to his wife and daughters. He stops, and all eyes turn on Landrus in anticipation.

No, there's still nothing . . .

Landrus sits down heavily on the bench by the stove.

"It's almost blowing a gale now," he goes on, his eyes flickering around the room.

Gotfred looks at his barometer.

"If they come this evening, they'll at least stay for the night off Holmvige. Or perhaps Kirkevaag."

"They'll not come tonight," says Landrus with a sigh.

"I'm most inclined to think they will come tonight," says Gotfred.

Landrus looks down and smiles wanly in the direction of the floor. "It seems to me otherwise they've had good weather to sail in."

The parish clerk frowns. "What do you mean?"

"Well, I just mean . . . Why aren't they here by now?"

Landrus takes the telegram from his pocket. "See, it says 'Home this week'. And the telegram was sent last Saturday evening. By *this week* of course, he means *next week*, that's to say *this week*. If he's only wired *next week* he might have been understood to mean *next week again*. But as it is now it can only mean *this week*."

"What on earth are you talking about?" Gotfred finds it difficult to follow the argument.

Landrus shrugs his shoulders impatiently: "I'm saying that the week's almost at an end. It'll be over in an hour."

He gets up, sticks his hands into his jacket pockets and solemnly nods to himself, "Aye, it'll be at an end in an hour . . ."

493

The parish clerk's wife shuffles nervously and exchanges glances with her husband. "Oh God, oh God," she whispers.

"You know, Landrus, you say it as though it was the ship that was at an end rather than the week," Gotfred smiles. "But fortunately it's only the week. And, as I say, I expect the ship will be here tonight."

"Do you?" Landrus's voice is flat, and he heaves a deep sigh.

"I say, shouldn't we go up and see what Kristoffer's doing this evening?" suggests Gotfred.

He puts a friendly hand on Landrus's shoulder and pats him on the back at the same time.

When they are outside, he scolds Landrus gently: "You mustn't go and get the womenfolk worried, Landrus . . ."

"Oh . . ."

Landrus stops: "Just listen. If *that* isn't a gale, I don't know what is."

"Aye, what we can hear now is the wind blowing through a slatted shed, and that sort of thing usually sounds more than it is."

"And who's going to guarantee it won't get worse? If you've got eyes in your head you can see what the barometer says, and that doesn't usually exaggerate, does it?"

III

Sunday comes and Sunday goes, but there is still no ship.

On the other hand, there is more wind. It is a strange, southerly wind, dry and strong. The lighter lies there dragging at its moorings, dancing about awkwardly and foolishly like some old dame pretending to be a young girl.

"Wouldn't it be an idea to get it in before it breaks its moorings and drifts ashore?" asks Gotfred.

"Landrus shrugs his shoulders indifferently. "Oh, I'm less concerned about *it* . . ."

"Let's do it before it gets dark," suggests Gotfred.

He gets some men together. The lighter is drawn into the

bottom of the inlet. But it's as heavy as a house and almost impossible to get up on to dry land.

"We need to get hold of some more men," says Gotfred. "Ole, will you run up and fetch Torkel Timm."

"I've been there, but he couldn't come. . . . He's still got a bad foot."

"Lars Dion," suggests Kristoffer.

Landrus gives him a disapproving look. "You're not going to bring Lars Dion. I won't have it."

"If only we'd got some heavy tackle," says Kristoffer," we'd be all right."

"Landrus's warehouse tackle," suggests Ole with shining eyes.

"That's right. We must be able to use that." Kristoffer gives Ole an approving look.

But now the remarkable thing happens that Landrus refuses to bring out the tackle.

"It can't be taken down," he says sullenly. "Besides, it's only made of wood. It's intended for sacks of flour, not ships."

"A wooden tackle would be useful," says Kristoffer. "It's worth a try, Landrus."

"What do you mean: the tackle can't be taken down?" says Gotfred impatiently.

"It's fixed too firmly," replies Landrus stubbornly. "And even if we get it down, who's going to put it back so it's as good as it is now?"

Gotfred gives him a furious stare. "Of course we're going to use that tackle. And if it's not enough, we'll take a horse as well to help us pull. You're not actually going to try to stop us saving your lighter, are you, Landrus?"

"The tackle's staying where it is! It's my tackle and no one else's."

"But isn't it your lighter as well?"

"No, it's not my lighter."

"Well, at least it's your responsibility. Don't you understand it's for your own good if we get it brought into safety? Or do you think we're standing here just for our own entertainment?"

"I didn't ask you to come."

"Well, did you ever hear anything like it?" Gotfred frowns. "Let's get the tackle . . . Where is there a ladder?"

Landrus clenches his fists in his jacket pockets and moves away, bending forward and mumbling to himself. He walks slowly up from the beach towards the church and stands there for a while leaning against the churchyard wall. A moment later he is knocking on Torkel Timm's door.

Torkel is sitting by the fireplace, stirring a saucepan.

"You devil," snarls Landrus.

"For God's sake," Torkel exclaims in fear and gets up.

Landrus looks at him with half-closed eyes full of hatred. "Yes, you ask for God's mercy. But you call on someone else."

"What do you mean?" Torkel's voice is trembling.

But suddenly a transformation comes over Landrus. He lowers his voice and his eyes take on a pleading look.

"I beg of you Torkel," he says in a broken voice. "If you've got a finger in this . . . then, not only for my sake, but think of all the others whose lives are at risk . . ."

"In God's name, what are you accusing me of?"

Landrus raises his right arm and goes closer to Torkel beside himself with fury. "You're going to confess, you devil."

"Oh my God," moans Torkel. "What do you think I've done, Landrus?"

His voice becomes tearful and pitiful: "Just . . . just sit down a moment. Aye, I'll tell you the truth, Landrus . . . You're completely mistaken. I can neither see into the future nor conjure up spirits . . . That's something you've made up . . . when you came and told me about Ole the Valley . . . it was you yourself who made him into my guardian spirit. I've never as much as dreamt of him a single time. I don't have a guardian spirit, Landrus, that's all I can say."

Landrus grunts ominously and suspiciously. "You're lying. How did you know about my row with Ole before he died otherwise?"

"Well, I got to know it from Lars Dion," admits Torkel. "And he got it from you yourself . . . he heard you through

the wall telling your wife about Ole. He was lying there listening, you see."

Landrus lowers his arm and strokes his face and beard. He is gradually beginning to understand what has happened. "And then you went along with him . . ."

"There's no question of going along," Torkel stammers, blinking his small inflamed eyes helplessly.

"So it was all lies from one end to the other!" Landrus is laughing now, but there is a crazed look to his eyes.

And suddenly he is gone. Torkel sees him hurrying down the road to the village. And there, just outside the River House he meets Lars Dion. They stand and stare at each other for a moment. Lars Dion makes to ask a question. But Landrus is over him straight away, grasping him by the throat, shaking him and seething. Lars Dion shouts out, "Murder. He's murdering me."

Lars Dion finally manages to resist, thumping his neighbour in the chest and stomach. But this has no effect on the furious Landrus, who is still in well command of his opponent. He grasps both his arms and forces him down on the ground and puts his knee on his chest.

People have started rushing to the place. Women and children are screaming and moaning. Now Kristoffer and Gotfred come running up.

"Have you got a rope?" roars Landrus. "This beast's got to be tethered."

"Have you gone out of your mind?" shouts Gotfred.

He goes up to Landrus and grabs him. "Pull yourself together, man. What are you doing?"

"He's got to be made so he can't do any harm." Landrus is foaming at the mouth and staring with the eyes of a drunken man.

"If you don't let him go, you'll have to be made harmless as well," threatens Gotfred. "Get up. You ought to be thoroughly ashamed."

Landrus tightens his lips and raises his hand threateningly, but lowers it again, glances up and suddenly looks afraid. Then he gets up, hesitantly and trembling all over his body.

An unpleasant silence spreads over the assembled figures. What has happened? A fight . . . a fight between two grown men? It's the first time anything like that has happened on this island.

But suddenly, the silence is broken by a new whine. It is Oline, Elias's wife whining . . . at first in horror, but gradually more and more in delight. She is gazing at her own kitchen window. All eyes are turned towards the little window in the River House: *Elias is standing there!* He has opened the window and is standing hanging out of it, pale and with his mouth open in amazement. His eyes are dazzled as he stares out at the sun. His huge white beard is waving in the wind.

"Elias, Elias," shouts the little woman. She turns towards the others, saving her arms about. "Do you see? Do you all see?" And with tears streaming down her cheeks, she disappears inside the house.

Several people follow her. This new event is even more incredible than what has preceded it. Elias from the River House, that man who was paralysed and has not been able to support himself on his legs or use his hands for eight years . . . Can this be possible?

Yes. The miracle has happened.

Elias has sat down on the edge of his bed. He looks pale and exhausted. But he is smiling, intoxicated with delight and proclaiming, "Yes, I *can* walk. I heard the shouting, and I *had* to go to the window. And then it was as if my legs could go of their own accord. And then my hands could get hold of the handles."

He gets up and takes a couple more steps. Then he groans with a look that is wild and horrified with delight: "I can walk. I can walk."

His wife is smiling and weeping at the same time. She stands pinching herself in the chin with both hands. "No, this is . . . this is . . . But it's true. You can all see it."

Elias is worn out and sits down again.

"He can walk. Elias from the River Cottage has been cured." The exciting, joyful news is on everyone's lips, and the rumour spreads from house to house. The wind howls,

and the sea is seething and frothing on the beach and there is a hollow, complaining rumble of the wind in the mountains. But people stream from all parts of the village and want to see this great thing that has happened. They want to see it with their own eyes.

Elias is sitting on the edge of the bed with shining eyes and greeting all his many visitors, waving merrily to the children who are standing in the doorway and not really daring to come any closer. He is wearing a pair of old, patched underpants; they consist of nothing put patches, and the patches are even of different colours . . . Never before was such a garment seen. But who notices *that*? A miracle has taken place. A lame man has regained the power to walk.

There is only one person in the entire village who is unmoved by this glorious piece of news, and that is Landrus. He has shut himself in his warehouse and sat down on a packing case with his face to the wall. He has turned his back on the world and sits abandoning himself to profound regret as dark as the night.

IV

Gregoria has heard about the fight and feels terribly ashamed on behalf of her father. But this is as nothing compared with the anxiety and excitement she is feeling for the sake of the ship and Gotfred.

She has not had a wink of sleep for the past two nights. Now night is approaching again. She sits by the kitchen window staring out into the windswept dusk, trying as best she can to think of nothing, for it's no use thinking. Her mother is knitting over by the fire, and the cat is sitting on the bench beside her, washing its face.

Gregoria tiptoes into the sitting room to have a look at the barometer. She lights a match. It has not fallen, but neither has it risen, and it remains low.

The cat has followed her into the sitting room. It rubs affectionately against her leg and miaows piteously as though

trying to console her. She bends down and strokes its fur, and it purrs contentedly. A thin strip of light falls on the floor in the sitting room from the fire in the kitchen, striking one of the shiny corners of the gramophone under the chest of drawers. Gregoria looks away . . . she hates that gramophone, and if it were not that it was too valuable, she would have taken it down to the shore and thrown it into the depths, she is so fed up with it.

She suddenly has an idea . . . She can at least destroy the records. At least the record of the song about there being no one who knew . . . that was the record she hated most. Yes, that was easy to do, and no one need know . . .

She goes over and takes out the record. There it is . . . she recognises it from the blue label, while the others are all red. She puts it under her blouse.

"I'm just going to pop down to Gotfred's," she says.

Out in the hall, she suddenly becomes afraid that someone will discover what she is up to. She feels almost like a thief, although it is her own record. And without really knowing why, she bursts into tears. She gets hold of her headscarf and buries her face in it for a moment, and then she is all right again.

There are her father's rubber boots, the ones she had on when she went through the driving snow to Highpoint to wave a last farewell to Gotfred. Good Lord, how sad everything is now . . . the wind is shaking the house, and Gotfred has perhaps drowned and will never come home.

She hurries down to the shore and stifles her sobbing in her scarf. It is dark, as dark as at the bottom of the sea. The wind is blowing in from the inlet . . . harsh and merciless in its activity and indifference. Perhaps this same wind has blown the ship off course and buried it in darkness and high seas . . .

There is surf down by the beach, and so she cannot even manage to drown the miserable record. Of course, she could simply smash it against the rock . . . but what when someone later found the bits – she would have to explain them. Oh, never mind. She quickly takes the record out and flings it down against the wet rock. It breaks with a dry sound, and

there it lies, dull and dead in the darkness. It will never play any more. She thinks how strange it is that she has smashed and destroyed a song, a human voice singing. But it is done, and that is a good thing.

There is the sound of footsteps on the rock . . . she starts, could shriek with fear, presses the scarf against her mouth and stands there breathless. The steps come closer. Now she can dimly make out a figure . . . it is her father. He is walking slowly up towards the house. She goes after him and sees him open the door. That story of his attack on Lars Dion is so terrible. She can't persuade herself to go home. There's no comfort to be found in her father. And her mother . . . she hasn't heard about the attack yet. Gregoria hasn't been able to tell her about it. She has only told her about Elias's sudden recovery.

A violent gust of wind comes down from the mountains, tearing her scarf out of her hands. She turns around to get hold of it, but it has already vanished in the darkness.

Gregoria presses both her hands against her face and stands sobbing for a long time. Why did this gale have to come just now? Couldn't God have kept it away, just for a couple of days, and then this dreadful thing wouldn't have happened?

Gregoria is shivering with cold. The wind is tearing at her clothes, blowing down on her breast and apparently seeking to do away with her. She bends forward and fights her way down to Gotfred's house.

The parish clerk and his family are sitting together in the living room. It is warm and light in there. But they all sit stiff and serious and look as thought they are cold.

"Well, Gregoria," says Gotfred, patting her cheek. "Are you worried, my dear?"

Gregoria hugs him and again bursts into tears.

"Don't lose courage," he consoles her. "It's no more than a fairly strong wind, this, a moderate gale as it's called. The ship will be all right, there's nothing to worry about. You'll see, with God's help we'll have them here tomorrow."

Gotfred sits down and takes hold of her hands. "See, rest a little and try to calm yourself."

Gregoria sits down beside him. No more is said, and time passes. She is overcome by weariness and falls asleep.

It is morning when she wakens up with the parish clerk stroking her hair.

"See, Gregoria. The weather's improved now."

She gets up, drunk with sleep, and at first does not know where she is.

"Your mother was here yesterday evening asking about you," says Gotfred. "I told her you'd stay the night so you could come out to Highpoint with me when it starts to get light."

The lamp is still burning. The parish clerk's wife has poured out a cup of tea. She looks from her husband to Gregoria, and there is a strange deep glow in her eyes.

"I don't know how it is," she says with a sigh. "But it's as though I'm starting to feel a bit of courage again."

Gregoria has a cup of tea. Gotfred comes with a shawl: "See, put this on, and then we'll go out to the point."

It is dark outside, but in the east the sky is beginning to grow light.

"We might even have some sunshine and fine weather later in the day," says Gotfred.

They walk quickly along the shore. Gregoria is feeling warmer, but she is still trembling, whatever the reason.

Highpoint rises black and alien against the dawn sky.

"There's someone out there," says Gregoria.

"Aye . . . Can you see who it is?" says Gotfred. "I can. It's Kristoffer and Redstones Ole, and that little chap's Jeser."

They go up on the point. Kristoffer and Ole nod good morning to each other.

"Well, the weather's improving," says Gotfred. "The barometer's been rising for the past four hours. Have you been here long?"

"All night."

"And the lad here as well?"

Ole smiles. His features are stiff from the long watch. "Yes, he wanted to come. I said he should stay at home and I sneaked out on my own, but he was there a moment later . . ."

Jeser is wearing an old cap that is far too big for him. Gregoria can hardly stop herself from smiling at him.

The sea is still rough, and here and there a breaker raises a white crest. The wind is obstinately whistling and hissing in the yellow winter grass.

"Listen," says Jeser suddenly, taking off his cap.

"What is it? Can you hear something?"

"I can hear an engine."

The others hold their breath and listen intently.

"I can't hear anything," says Gotfred.

"The boy's talking nonsense," complains Ole.

Jeser ducks down, ashamed.

But before long it is Gregoria who says, "Listen."

"Aye, it's right enough," nods Kristoffer.

"If only it's them," says Gregoria.

She hardly dares to look out towards Blaaberg, which projects its black and foam-covered outline into the sound and blocks off the view of the open sea. No, she daren't look . . . for suppose it's a quite different ship! Her heart starts beating wildly, beating quite indecently inside the shawl. She moves a little away from the others so they can't actually hear it in there, and she has to close her eyes to keep her audacious tears in check.

"See. There they are. There they are," she hears Jeser shout in a voice that is almost breaking with excitement.

"God be thanked and for ever blessed," says Gotfred the parish clerk, heaving a long sigh of relief.

Only now does Gregoria dare to look up. Yes, it's them. The sails stand out almost black against the dawning morning waters. A few gusts of wind come down from the fells, and all of a sudden the whole sound turns black. All the waves acquire a white crest on top. The ship exerts itself to rise above one breaker and bores its nose down into the next so that the foam splashes over the prow.

And now it is quite close . . . greeting them with its flag.

Gregoria wants to wave back, but she has nothing to wave with. Her shawl is far too big for that purpose. Besides, it's not certain that he will be able to see her at all in his telescope

when she is so well wrapped up. She lets the shawl fall, raises herself on tiptoe, stretches her arms in the air and waves with both hands.

Recommended Reading

If you enjoyed reading *Windswept Dawn* there are two other novels by William Heinesen which should appeal to you:

The Black Cauldron
The Lost Musicians

If you like fiction about small isolated communities where life is very different from the world outside the novels of Yuri Buida and Yoryis Yatromanolakis should appeal to you, especially:

The History of a Vendetta – Yoryis Yatromanolakis
A Report of a Murder – Yoryis Yatromanolakis
The Spiritual Meadow – Yoryis Yatromanolakis
The Zero Train – Yuri Buida
The Prussian Bride – Yuri Buida

These can be bought from your local bookshop or online from amazon.co.uk or direct from Dedalus, either online or by post. Please write to **Cash Sales, Dedalus Limited, 24–26, St Judith's Lane, Sawtry, Cambs, PE28 5XE**. For further details of the Dedalus list please go to our website www.dedalusbooks.com or write to us for a catalogue.

The Lost Musicians – William Heinesen

"William Heinesen was, by a long way, the best writer that the Faroe Islands have ever produced. Many have him down as the most important Scandinavian novelist of the 20th century, and he only declined a Nobel prize because he thought it should go to someone who wrote in Faeroese, which he didn't. *The Lost Musicians* is peopled by villagers and fishermen who heartily enjoy drinking, dancing, feasting, a little fighting and, more than anything else, playing music. 'Now if these music makers whose story is to be told below had seen to their work here on earth instead of striving to reach the heavens in that curious way of theirs, then things might have gone far better for them in this, the pettiest of all known worlds.' Thus the way is set for Ankersen, the puritanical bank manager and villain of the piece, to infiltrate the community and convert the villagers to his cause. A patchwork story told in a peculiar omniscient but disjointed voice that seems to align it with the oral tradition, *The Lost Musicians* builds towards a crescendo of farce and tragedy in which nothing less than 'the cosmic struggle between life-asserting and life-denying forces' is played out."

Laurence Phelan in The Independent on Sunday

"Marooned in the north Atlantic between Iceland and Norway, the Faroe Isles are famous for little besides dried mutton and twice drawing with Scotland at football. Indeed, the thinly fictionalised island of this new translation by W. Glyn Jones of William Heinesen's 1950 novel often seems as much a prison as a homeland. The pursuit of happiness is hardly helped by the local Baptists, headed by tactless Ankersen, the spearhead of the prohibition movement. Set against his priggish faith are a colourful crew of musicians and layabouts: Sirius is a frustrated poet, the Crab King a mute dwarf, Ole Brandy a belligerent pillar of the community and Ura the Brink a cliff-dwelling fortune teller. One of their glorious but destructive drinking sessions is the stage for the novel's key incident, in which money is stolen and a young cellist blamed. The result is a tale of stereotypically northern European sensibility, in which merriment is bright, brief and viewed through the fug of booze, and desperation chips at the hardiest of souls. Heinesen's intriguing novel walks a fine line between a fable and a social document."

Jane Smart in The Guardian

£9 .99 ISBN 978 1 903517 50 5 320p B. Format

The Black Cauldron– William Heinesen

" In *The Black Cauldron* Heinesen provided an unsparing portrait of speculation, violence and intrigue in the Faeroes under British wartime occupation."

The Times

Spanning the tragedy of war, the clash of sectarian interests, the interplay of religion and sex, *The Black Cauldron* develops into a presentation in mythical form of the conflict between life and death, good and evil.

"William Heinesen's novels are intensely Faeroese, but so universal in their appeal that the reader automatically surrenders to their charm, their energy, their easy intensity and is overwhelmed by the perspective they convey."

The Independent

£8.99 ISBN 978 0946626 97 7 363p B. Format

The Prussian Bride– Yuri Buida

"The Kaliningrad region is in an odd geographical and historical situation. Since the collapse of the Soviet Union it has been cut off from the rest of Russia, sandwiched between Poland and Lithuania. The region itself is only recently Russian – it was once East Prussia and its Russian inhabitants replaced the indigenous German population after the Second World War. Yuri Buida's magnificent collection of stories about his hometown reflects these anomalies and presents a powerful and hilarious meditation on dislocated identities. The name Buida, as he tells us, means liar in Polish, and this appropriately reflects the imaginative invention that gives meaning to the lives of a populace who lack a clear place in history. Everything here is transformed, but only to give a greater force to the depiction of human suffering and joys. The whole effect is of a people's imagination confined by historical and geographical forces bursting forth in Rabelaisian splendour, without losing the stoicism that enabled them to endure the hardships of Communism. The stories show an ironic awareness of the power and dangers of self-deception, while seeing it as the only way of living a coherent life. As we read through the stories in *The Prussian Bride*, we get a Brueghel-like picture of a community held together by ragged threads. The families in these stories are disjointed, cobbled together from casually adopted orphans and catatonic or otherwise absent wives and husbands."

Tom MacFaul in The Times Literary Supplement

"His prose is crisp and he successfully conjures a world as fantastic as any in contemporary literature."

David Archibald in Scotland on Sunday

£9.99 ISBN 978 1 903517 06 2 363p B. Format

The History of a Vendetta – Yoryis Yatromanolakis

The History of a Vendetta won the first Greek National Prize for Literature and the Nikos Kazantzakis Prize for Literature in 1983.

A murder in a small Cretan village: its motive and the fortunes of two families reflect the history of the Greek nation in the early part of the twentieth century. A magical, intricate tale, rich in peasant myth and narrated in the detached yet ultimately moving style of a modern Herodotus.

"*The History of a Vendetta* is a substantial artistic achievement. Yatromanolakis tells his tale with grace, patience and mastery, gradually unfolding causes and effects with meticulous care, as if were excavating a great archaelogical find. His superb handling of language and style, his paradoxes, asphoristic reflections and attitudes of aesthetic anarchism towards life and death all work together to produce a magnificent novel."
 World Literature Today

"Helen Cavanagh's translation does full justice to the convoluted subtlety of this remarkable novel."
 Peter Mackridge in the Times Literary Supplement

£6.99 ISBN 978 0946626 74 8 128p B. Format